M.C. ESCHER: Visions of Symmetry

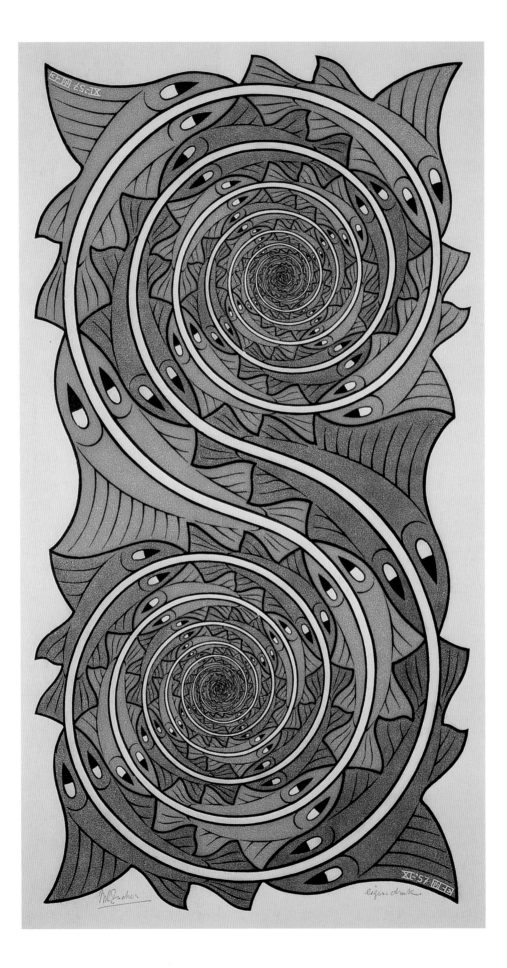

M.C. ESCHER: Visions of Symmetry

Doris Schattschneider

NEW EDITION

Foreword by Douglas R. Hofstadter

Abrams, New York

Revised edition designed by Ellen Nygaard Ford with Shawn Dahl

Library of Congress Cataloging-in-Publication Data

Schattschneider, Doris.
 M.C. Escher : visions of symmetry : notebooks, periodic drawings, and
related works / Doris Schattschneider.—2nd ed.
 p. cm.
 Rev. ed. of: Visions of symmetry, 1990.
Includes bibliographical references and index.
 ISBN 978–0–8109–4308–7
 1. Escher, M. C. (Maurits Cornelis), 1898-1972—Sources. 2. Symmetry (Art)
3. Color in art. I. Title: Visions of symmetry. II. Escher, M.
C. (Maurits Cornelis), 1898-1972 Visions of symmetry. III. Title.

 NC263.E83S3 2004
 760'.092—dc22

 2003025109

This is a revised and expanded edition of *Visions of Symmetry: Notebooks, Periodic Drawings,
and Related Work of M. C. Escher,* published in 1990 by W.H. Freeman and Company.

Illustration credits:
The illustrations on the following pages are produced from
photographs provided by Cordon Art: Graphic works on pages 6, 30,
113, 242, 249–253, 259, 261, 288 (right), 290–291, 294, 295, 296, 297
(upper), 298, 300 (upper), 301 (upper), 302–304, 305 (lower), 310 (lower),
311 (right), 315, 316 (lower), 321, and 322 (lower). Hand-printed designs
on pages 11 (upper right) and 271 (lower); sketches on pages 17 (upper
left), 252, and 270; executed commissioned works on pages 268, 269,
202, and 312; Endsheets, p. ii.

The following pages contain illustrations of original Escher works from
the collection of Michael S. Sachs, Inc., P.O. Box 2837, Westport, CT
06880, U.S.A.: 7 (lower), 11, 13 (upper right and lower), 17 (upper right
and lower), 18, 32, 37, 45, 49, 50, 53, 55, 102, 106, 107, 108, 111, 114, 230,
231 (upper), 233 (lower), 234, 240 (left and center), 242 (upper), 244
(center and right), 246 (left and center), 247, 267, 271 (upper), 273

Text copyright © 2003 Doris Schattschneider
Reproductions of Escher's work © 2003 Cordon Art B.V.

(lower), 286 (center), 295 (lower center), 297 (lower), 305 (upper), 308,
314, 319, 322 (upper), 337 (lower); also, in Chapter 3, periodic drawings
numbered: 2, 5, 19, 24, 26, 28, 29, 30, 31, 32, 34A, 34B, 38, 47/48, 49/50,
51, 52, 53, 55, 57, 62, 64, 69, 70, 72, 79, 81, 82, 87, 88, 96, 98, 104, 106, 107,
109, 109II, 115, 117, 119, 124, 125, 126, 127, 129, 130, 132, 133, 136.

Additional photo credits:
p. vi, Ralph Raimi; p. 12, Michele Emmer; pp. 260, 317, 318, columns,
George Nixon; p. 273, Hans Cornet; pp. 303, 310, 312, tiled columns,
Jacob Dijkstra; p. 313, Dutch Ministry of Agriculture and Fisheries; p.
46, photographs of tile arrangements, Nancy Lee Katz; all photographs
of original three-dimensional work and hand-printed textiles in the
Sachs collection, Stanley Livingston; all photographs of drawings and
watercolors in the Sachs collection, Carlo Pappolla.

Illustration acknowledgments continue on page 355.

Printed and bound in China
10 9 8 7 6 5 4

Abrams books are available at special discounts when purchased in quantity for premiums and promotions as well as fundraising or educational
use. Special editions can also be created to specification. For details, contact specialmarkets@hnabooks.com or the address below.

HNA
harry n. abrams, inc.
a subsidiary of La Martinière Groupe

115 West 18th Street
New York, NY 10011
www.hnabooks.com

DEDICATED TO

Carolina H. MacGillavry

and

Jeremiah J. Lyons

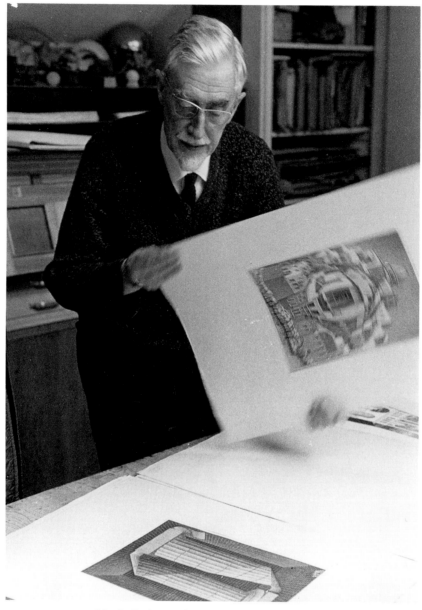

M. C. Escher in his Baarn Studio in
1967. Photo by Ralph Raimi.

Contents

Foreword: Patterns that Haunt the Mind

What is this book about?

It is about one man's obsessed exploration of a magical space of potentialities that he discovered on his own when quite young, and then worked on for decades in a frustratingly isolated manner, bewildered by the fact that no one else seemed to see anything like what he saw. It is about Maurits Cornelis Escher's lifelong pursuit of poetry and surprise in the flat world defined by the rather mundane-seeming words "repetition," "rotation," and "reflection." It is about visual patterns built by the intricate interlocking of shapes that repeat and repeat forever, filling every crack in the Euclidean plane (or even in non-Euclidean planes).

To some, this art will perhaps appear "merely mathematical"—but then, to some, the sublimely powerful fugues of J. S. Bach sound like nothing but a sewing machine mechanically clicking and clacking away. The connection is not made idly. Not only was Bach, like Escher, fascinated by patterns created through repetition, but Escher, in return, revered Bach's music and was deeply inspired by it over his entire lifetime.

Above, I used the word "poetry" to characterize Escher's tessellations, and I would like, in a few words, to defend my use of this word here. Once Escher's work had become world-famous and a select few of his paradoxical prints (such as *Belvedere* and *Relativity*) had been exploited on book covers and posters galore, people inevitably tried to imitate his style. And unfortunately, as is nearly always the case, most of the imitators, despite their sincere admiration of the artist's work, seized only upon its superficial aspects and missed its deeper essence. The resulting tilings of the plane, whether produced by hand or with the aid of computer programs, simply were dull, lackluster mimicry, and there was no spark to them.

By contrast, the original vision so beautifully realized by Escher himself weaves magic across every sheet. The subtle beauty of the lines that define the contour of a bird, a fish, a crab, a lizard, a horse cannot be captured in algorithms or in words. There is something ineffable about the way that Escher looked at animal shapes (or, for that matter, shapes of objects in the world in general) that simply defies formal characterization or capture. To me, Escher's sinuous lines are nothing if not haunting. The more I look at them, the more I long to imitate them by moving my fingers in the air or even sliding the tip of my tongue around on the roof of my mouth—it doesn't matter where or how, but I feel that irresistible urge.

Who can say what the fount of Escher's inspiration truly was? I can make but a crude stab at it. It seems rooted in his joy in discovering the subtle in the mundane, and in his unshakable belief that pattern is sublime. It springs from his passionate pursuit of the visual poetry around him, and his irrepressible urge to share this poetry with others by passing it through the filter of his eye, his hand, his mind, and his heart.

M. C. Escher's art of tessellation is a unique brand of visual poetry that, thanks to this labor of love by Doris Schattschneider, we all can savor over and over again, for the duration of our own lives.

Douglas R. Hofstadter
November 2003

Veldhuysen, and Mark Veldhuysen. I am also indebted to those who read and commented on drafts of the manuscript: Marianne Teuber, Marjorie Senechal, George Escher, Branko Grünbaum, and Anne Fontaine.

Generous financial support for this project was provided by Moravian College and the National Endowment for the Humanities. A sabbatical leave from teaching and a grant through the Humanities, Science and Technology category of the NEH provided the time and funds to travel to research sites and to prepare the book.

It has been a pleasure to work with the staff at W. H. Freeman. I appreciate the special care that was taken by the project editor Stephen Wagley, the book designer, Nancy Singer, and the production coordinator, Julia De Rosa. Jerry Lyons deserves special thanks for guiding this complex project to its final realization. Throughout the two years of labor (albeit a labor of love) on the project, an epigram by Beaumarchais—"*Les livres sont comme les enfants des femmes: conçus avec volupté, menés à terme avec fatigue, enfantés avec douleur!*"—reminded me that the birth of a book is much like the birth of a child—it just takes much longer. I thank my husband David and daughter Laura for their support throughout all of it.

Finally, thanks to M. C. Escher for his unique legacy which never ceases to surprise me.

Doris Schattschneider
Bethlehem, Pennsylvania, July 1990

Preface to the New Edition

In the years since the first publication of this book, Escher has been the focus of new attention—the 1998 exhibitions and conferences in celebration of the centennial of his birth; a new museum devoted to his work; appearance on thousands of Internet sites; and a body of work by scientists, mathematicians, artists, teachers, and others who pursue ideas inspired by Escher. I am grateful for the opportunity to extend the astonishing story of Escher's symmetry work told here, with the addition of an afterword and an expanded bibliography. One of the pleasures of writing a book about Escher is that so many people want to share with you their stories, questions, and original work. I want to thank all those who have kept me informed of Escher-related happenings, and have encouraged my work. I also want to thank the librarians, museum staffs, computer technicians, and friends who have helped with my research. Special thanks to Eric Himmel, editor-in-chief, and the staff at Harry Abrams, whose careful attention to this new edition is much appreciated.

The first edition of this book was shepherded by my editor and good friend Jerry Lyons. I regret that he did not live to see this new edition, which I dedicate to his memory.

Doris Schattschneider
Bethlehem, Pennsylvania, November, 2003

CHAPTER 1

The Route to Regular Division

*E*arly signs

The urge to fill the plane with pieces, fitted snugly next to one another so as to leave no unoccupied space, seems to have been with Escher longer than even he could remember. In his lectures and writings, he frequently mentioned that he had often wondered at his unusual mania to create regular divisions of the plane. He relates that in the beginning he puzzled quite instinctively, apparently without any well-defined purpose, driven by an irresistible urge to repeat one or a few forms to fill a page without gaps.

His compulsion to fill a space neatly with small pieces was a trait he showed even as a boy. His son George relates the following story:

> One day in the early fifties father was riding in the tramway in the Hague when a lady passenger looked at him and asked: "Mauk Escher?" Although he did not recognize her immediately, he soon remembered her as a girl with whom he had often played when he was a small boy. They chatted for awhile, during which conversation it appeared that she was familiar with his recent work. Then she said: "Do you remember the game . . . which you always played when eating your bread?" Father did not remember, but he was quite amused to discover that he had not changed much. It amounted to this: the Dutch generally have two cold meals a day in which they eat *boterhammen,* single slices of bread spread with butter, then covered with slices of cheese, ham or chocolate, or peanut butter, honey or other tasty food. That lady still remembered the care with which this little boy had selected shape, quantity and size of his slices of cheese, so that, fitted one against the other, they would cover as exactly as possible the entire slice of bread. This particular trait never left him. . . . [1974]

Maurits Cornelis Escher was born on June 17, 1898, in the town of Leeuwarden, the youngest son of George and Sara Escher. Called Mauk by friends and family, he grew up in the town of Arnhem. He had four brothers; the two eldest, Edmond (Eddy) and Berend (Beer), were borne by his father's first wife Charlotte, who died shortly after Beer's birth in 1885. His mother Sara married his father in 1892 and bore three sons: Johan George (George) in 1894, Arnold (Nol) in 1896, and finally Mauk. It was in Arnhem that as a young boy, Mauk received lessons in carpentry from a contractor's apprentice, Van Eldik. During that time, he developed a love for working with wood and learned how to remove the grain patiently from the surface of a plank of pear wood, a technique that would later be of practical use in producing fine woodcuts.

From 1912 to 1918, he attended the *hogere burgerschool* (H.B.S., public high school) in Arnhem. Although he was not particularly good in his lessons in mathematics and the sciences, he absorbed the attitude and methodological approach of the scientist at home. He once wrote in a letter, "My affinity with the exact approach to natural phenomena is probably related to the milieu in which I grew up as a boy: my father and three of my brothers were all trained in the exact sciences or engineer-

ing, and I have always had an enormous respect for these things" [Broos, p. 30]. His father, a civil engineer, was a keenly observant and methodical person, open and matter of fact, and he seems to have passed these qualities on to Mauk.

During his school days, he formed friendships that would last throughout his life. Four friends who were especially close were Bastiaan (Bas) Kist, Jan van der Does de Willebois and his sister Fiet, and Roosje Ingen Housz. Mauk, Roosje, Bas, and another friend formed an impromptu string quartet in which he played the cello. Although he claimed no particular musical talent, he loved music; he found it a great source of inspiration for his work and often mentioned this in his letters and essays.

In high school, drawing was the one subject which he enjoyed. He preferred to draw in black and white and often made drawings at home. He showed these drawings to his art teacher, F. W. van der Haagen, who recognized and encouraged Escher's talent, and taught him how to make linoleum cuts. Escher's first prints were mostly portraits or bookplates; the earliest dated one, done in 1916, is of his father. He also made a few etchings; these he felt were unsuccessful.

In the fall of 1917, then a senior at the H.B.S., Escher sent some of his linoleum prints to the well-known Dutch graphic artist R. N. Roland Holst and asked for his opinion. Holst sent a kind reply almost immediately and encouraged him to send further work. The following June, Escher sent him a couple more prints. In the fall of 1918, Escher attended lectures at the Higher Technical School in Delft in order to retake some of his final examinations which he had failed in August, but health problems finally led him to give up his studies, and he concentrated on his drawings. In February 1919 he visited Roland Holst, then a professor at the Rijks-Academy in Amsterdam, and talked about his future. Roland Holst strongly advised him to begin making woodcuts and to consider studying architecture at the university in Zurich.

Escher immediately made a woodcut; a small piece of wood for a bookplate was all he could afford. The design was for his close friend Roosje and showed a single rose, together with her initials. He wrote enthusiastically about the graphic technique in his letter to her. "It is splendid work, but much more difficult than working in linoleum, because it is terribly hard to cut palm wood against the grain."

Escher was further encouraged when, a short while later, the first published review of his work—some linoleum prints he had entered in the annual exhibition of the Artibus Sacrum society—appeared in the weekly paper *De Hofstad (The Court Capital)*. "The works that first attract our attention include the beautiful woodcuts (?) by M. C. Escher, who entered a few portraits and a sunflower, soberly executed and with a beautiful contrast between black and white." Escher added the question mark to his clipping of the review; the linocuts were mistaken for woodcuts.

The following September Escher moved to Haarlem to attend the School for Architecture and Decorative Arts with the intention of preparing for a career as an architect. Soon after he began his classes, he met Samuel Jessurun de Mesquita, who taught nature drawing and graphic arts. Escher showed de Mesquita his graphic work, and the

teacher advised him to devote his studies to the graphic arts. With the permission of his parents and the director of the school, Escher began a full program in the graphic arts, under the tutelage of de Mesquita.

A lifelong bond developed between Escher and de Mesquita; over the years, their relationship matured from that of pupil and teacher to one of deep friendship and mutual respect as younger and older colleagues devoted to a common profession. In 1946, in the catalog of a retrospective exhibition of de Mesquita's work, Escher described his friend as graphic artist and teacher:

> His work bears the marks of being able to be appreciated and understood by only a few people. He always went his own way, headstrong and sincere; he underwent the influence of others only to a small degree, but strongly influenced the work of many younger people and especially that of his pupils, a circumstance at which he was often annoyed when it resulted in mimicry, which was all too often the case. Most of those who came under his influence sooner or later broke away from it. Thus he didn't gather a following and consequently his solitary and strong personality becomes even more fascinating.
>
> Was he a "good teacher"? Many of his pupils wouldn't like to have missed his lessons, but he was not the ideal educator for whom teaching is a necessity of life. He didn't really teach, but let his pupils go their own way and criticized their products, often mercilessly. He often indicated clear-cut principles that were sometimes of fundamental importance for their further development. . . .
>
> His personality was simple, sincere and unaffected, and the woodcut, which of all the graphic techniques forces the most restraint, was the medium he was most attached to. . . .
>
> He wasn't afraid of chance; he would sometimes look for an accidental aesthetic beauty, e.g., when he had printed a woodcut with black ink on white paper (because black ink and white paper just happen to be the materials with which books and prints have been printed for ages), then he would wonder: what would be the effect if I'd print it with gold on black paper? . . .
>
> De Mesquita was mostly, I should say, in principle dissatisfied with a direct print of his graphic cliché, which after all shows its mirror image. . . . By making counterprints he came to his remarkable woodcuts in which symmetry plays an important role, and which originated in the following way: the sheet of paper on which a direct print has just been made and on which the ink is still wet, is covered with a blank sheet and, together with it, put under pressure. . . . If one now slowly pulls one sheet apart from the other, then one sees a symmetric representation arise of which one half is formed by a part of the direct print and the other half by a part of the mirror image on the counterprint. De Mesquita was just like a child with the symmetric figures of little beads and scraps of paper like a kaleidoscope shows, so delighted with what he saw while he separated the two prints, that several times he took the trouble of cutting in wood the symmetric image that formed itself in its entirety. . . .
>
> One of the most important factors of his personality in general is that steady self-discipline, that active and alive maintenance of his criticism, that strange intuition that makes him cease his work at the moment the most powerful expression has been attained, so that any additional line would weaken it. Few artists are sensitive and strong enough to be able to tear themselves away from their work and to leave it as it is then. . . .

As he grew older and his health failed, the artist let his other work rest more and more, but indefatigably went on with those playful fantasies for which he finally, when he was virtually confined to his chair, used only his sketchbook and his fountain pen.

De Mesquita taught Escher many aspects of woodcut technique and encouraged him to experiment. Escher's drawings and woodcuts done during those Haarlem days show the pupil executing images under various constraints, imposed either by de Mesquita or by himself. He did portraits of friends and of animals, detailed and stylistic studies from nature, and sharply geometric compositions. Always, he experimented with technique: gouging lines in one direction to create shading and to mold contours and using form to resolve the fundamental problem of the graphic artist—how to use the white of the paper and the black of the ink to define images in a composition. The white, to be gouged from the block, and the black to be printed, must each assume, with equal ease, the role of figure or ground, of highlight or shadow, and always define each other's role.

In the fall of 1921, Escher produced a series of 15 woodcuts as illustrations for the booklet *Flor de Pascua* (*Easter Flower*), written by his friend Aad van Stolk. Two of these woodcuts show his budding interest in duality on several levels. One purely geometric print, *Beautiful*, is composed of alternating black and white triangular facets, like a cut diamond, and has pure central symmetry; that is, turning the print around 180° so it is upside down does not change its appearance at all. The same print also shows black-white duality: the black and white portions of the composition are in balance. A second print, *The Scapegoat*, is divided into black and white halves; neither can claim dominance. Beyond the level of symmetry and contrast, this print also presents visually an eternal philosophical duality: the devil and the saint, each a scapegoat, each balancing the other on a pinpoint pivot.

In April 1922, Escher ended his residence in Haarlem and set out for Florence, Italy, with his two friends Jan van der Does de Willebois and Bas Kist. The friends had great fun and, for two weeks, drank in the sights, particularly the Renaissance art in the many museums and churches in that city. When his friends had to return to Holland, Escher traveled to San Gimignano and began serious sketching. He spent over a month traveling extensively in Italy and filled a folder with his drawings. In the coming years, there would be many such trips, especially in southern Italy, in which Escher would explore and sketch in cities, villages, and open countryside. He would capture architectural details of monumental buildings from unusual vantage points, portray views of small towns clinging to mountain slopes which plunged to distant valleys, and record as if through a magnifying glass the tiny details of nature—a moss, a beetle—so often trod underfoot. These sketches would provide the raw material for him to create in his studio in the fall and winter compositions that were a synthesis of his observations and that were then executed as woodcuts or lithographs.

In 1931, the art historian G. J. Hoogewerff wrote an extensive critical review of all of Escher's graphic work for *Elseviers geïllustreerd maandschrift* (*Elsevier's Illustrated Monthly*) in which 17 of Escher's prints

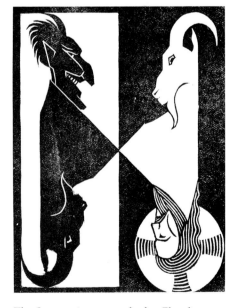

The Scapegoat was made for *Flor de Pascua*, page 19. 1921. Woodcut, 120 × 92 mm (cat. 69).

were reproduced. In commenting on Escher's scenes, he said, "Every one of Escher's plates is a résumé, gives a quintessence, a synthesis of observed reality and that mostly in a constructive way. And the reality appears to be not only what can be said to have been sensed accurately, but what has been experienced intensely. . . . If necessary, he constructs for himself his own world. There are undoubtedly more people who do this, but not in such an original and efficient way."

After that first sketching trip in Italy in 1922, Escher spent most of his time in Italy; it was there at a pension in Ravello in 1923 that he met Jetta Umiker and was captivated. A year later they were married in Viareggio, and that fall they settled in Rome, where they would live for eleven years. In 1926, their first son, George was born; Arthur was born in 1928. During these years, Escher perfected his woodcut technique and learned the additional techniques of wood engraving and lithogra-

Castrovalva. February 1930. Lithograph, 530 × 421 mm (cat. 132).

phy. In his introduction to *Grafiek en tekeningen* (English title: *The Graphic Work of M. C. Escher*), he writes of his single-minded enthusiasm to master technique:

> Anyone who from early youth has wholeheartedly surrendered himself to the study of graphic techniques may arrive at the stage where he begins to regard complete mastery of his craft as his highest ideal. The fine points of craftsmanship take up all his time and demand his attention so completely that he will even make his choice of subject subordinate to and dependent on his desire to explore some particular facet of technique. There is indeed great satisfaction in acquiring skill, in coming to thoroughly understand the qualities of the materials at hand and in learning to use the instruments we have—in the first place, our hands!—in an effective and controlled way.
>
> . . . The period during which I enthusiastically devoted myself to exploring the characteristics of graphic materials and in which I came to realise the restrictions that one must impose on oneself, reaches from 1922 until about 1935. . . . During that time a large number of prints came into being (about 70 woodcuts and wood engravings and some 40 lithographs).

[*Plane-filling motif with two figures*]. [1920 or 1921]. Woodcut, 370 × 427 mm (cat. 65).

Although it did not become a major preoccupation until after 1937, when he discovered the "open gate" of mathematics, Escher made a few attempts in his early graphic work to satisfy his urge for filling the plane. In 1920 or 1921 he cut a small woodblock containing two human caricatures; the outlines of the figures roughly filled a diamond made up of two equilateral triangles. By rotating it about a central point and repeated hand-printing, Escher made a print with the block that filled out a shape similar to a large snowflake.

He also made a lithograph of these caricatures; this print shows a central block surrounded by eight repetitions of itself, which together with the central block form a large rhombus. These prints show rhythmic repetition of a motif, but the individual blocks do not interlock with each other; the "cement" of black ink or colored background defines their individuality while simultaneously holding them together.

Such simple repetitive designs give little challenge. Instinctively, Escher turned to the creation of shapes that would fill the plane by interlocking with one another so that the boundary between adjacent pieces would also form their mutual contours. Even at this intuitive stage, he imposed what to him were self-evident rules of the game: the plane-filling shapes must be concrete, recognizable figures, and adjacent shapes must have contrasting colors. In 1965 he wrote:

[*Plane-filling motif with two figures*]. [1920 or 1921]. Lithograph, 432 × 312 mm (cat. 66).

> The recognizability of my own plane-filling elements not only makes them more fascinating, but this property is the very reason of my long and still continuing activity as a designer of periodic drawings. . . . I myself have always used contrasting shades as a simple necessity, as a logical means of visualizing the adjacent components of my patterns. These two main rules could briefly be formulated as follows: without recognizability, no meaning and without shade contrast, no visibility.

His first print to conform to these principles was a woodcut, *Eight Heads,* made in 1922 while he was still a student at the School of Architecture and Decorative Arts in Haarlem. The single woodblock from which it is printed is packed with eight heads, of four women and four men, but an innocent viewer is unlikely to see them all at first glance. The heads of two elaborately coiffed women and two foppish men, defined by contrasting black and white regions, are immediately visible. But these black and white regions, as well as their contours, serve a double function. A 180° rotation of the print reveals the heads of two sinister bearded men and two demure ladies. The single woodblock can be printed contiguously above and below, to the right and left of a single image of the block of eight heads, again and again, in theory at least, to fill the plane. In the print that is shown, the basic block is at the center of the print, and eight parts of the block have been printed surrounding the central block so as to create a rectangle in which each different head is repeated four times.

Although many prints Escher made while at the Haarlem school show his interest in symmetry of various kinds, at that time he made no other print showing regular repetition.

Eight Heads. 1922. Woodcut, printed with nine impressions, using the whole block once (center) and eight sections of the block, 325 × 340 mm (cat. 90).

*T*he fascination of regular division of the plane

In the fall of 1922, after leaving Haarlem, Escher embarked on his first sea voyage by freighter, a trip from Amsterdam to Tarragona in Spain. He found it marvelous and would repeat this relaxing and adventurous form of travel several times over the years. Once in Spain, he journeyed by train to several cities, and in Granada, visited the beautiful Alhambra, a fourteenth-century palace which had been built to serve as an aristocratic and administrative center for the last Moorish court in Spain. There he saw for the first time the decorative majolica tilings and stucco designs that encrust many surfaces of the buildings and was surprised at his own reaction. The great wealth of decoration, the dignity and simple beauty of the whole place moved him. However, he noted in his diary, "The strange thing about this Moorish decoration is the total absence of any human or animal form—even, almost of any plant form. This is perhaps both a strength and a weakness at the same time." He spent an afternoon carefully sketching an intricate star-burst tile design that fasci-

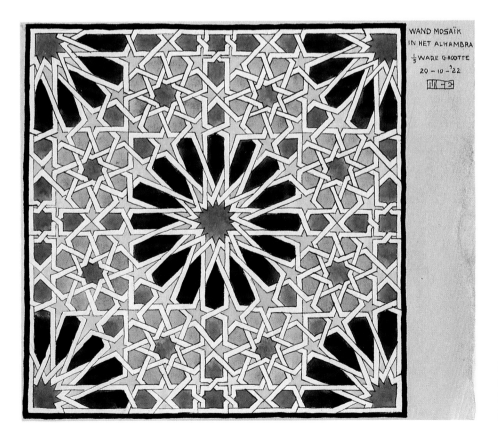

Escher's sketch of a portion of a wall mosaic in the Alhambra, 20 October 1922. Watercolor and ink, 210 × 258 mm.

nated him by its "great intricacy and geometric artistry"; that evening he worked on the sketch in his hotel room and finished it the next morning.

Escher wrote in an article in the art periodical *De Delver* (*The Digger*) in 1941, "The problem of how to fit congruent figures together . . . — *particularly when the shape of such figures is meant to arouse within the viewer associations with an object or natural form*—began to intrigue me even more after my first trip to Spain in 1922. Although my interest at that time was mainly focused on free graphic art, every now and then I would return to the mental gymnastics of my puzzles."

It was sometime between 1924 and 1926 that Escher again attempted plane-filling designs, this time with a single animal figure. In a lengthy article, "M. C. Escher en zijn experimenten" ("M. C. Escher and His Experiments"), published in *De vrije bladen* (*The Free Press*) in 1940, the art critic 's-Gravesande gave the following account:

> He left this hobby alone for a few years, but returned to it in 1925 or 1926. At that time he tried one single closed contour, in the shape of a lion-like animal repeating itself on the picture plane. The animal motif can be viewed from two directions by turning it 180° around a vertical axis and it fills the plane without leaving any intervening space. This was the first effort to systematize, though Escher himself told me that he really did not yet understand what he was doing.
>
> He printed this motif—as well as the heads [*Eight Heads*]—several times on cloth, and exhibited it among other places in Rome in 1926 and in Amsterdam, but it was not very successful. Somewhat discouraged, he dropped this approach, all the more so because such a simple lion-motif had cost him a great deal of trouble and time.

Escher briefly mentions this disappointing attempt in his own article in *De Delver* the following year:

> About 1924, for the first time I printed on cloth a single animal motif cut out of wood which repeats itself according to a certain system, thereby adhering to the principle that no blank spaces may occur. I needed at least three colors; with each in turn I rolled my stamping block in order to contrast one motif with its adjoining congruent repetitions. I exhibited this cloth together with my other work, but I did not have any success with it.

Escher made at least two versions of two different animal prints on fabric; they seem to have been intended as furniture scarves, fringed or bound on the edges. The first design, shown here printed with silver and gilt ink on black satin, was also printed in another version on red satin. Its docile animal motifs resembling dogs were called "lions" by Escher. The second design, whose motifs more nearly resemble lions, is on a very long scarf of ivory silk of which just a portion is shown; a second print was made on a rectangle of turquoise satin.

Although the published articles do not mention it, it is likely that Escher also produced a third fabric print during this time, a large wall-hanging of bats. It is printed on black satin in exactly the same manner as the other two fabric prints, but the color scheme is more elaborate.

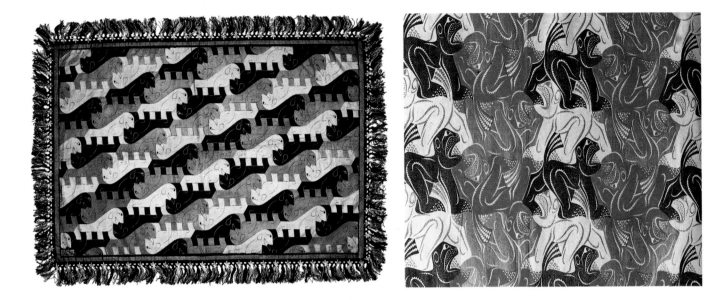

Some of the bats are gold, some silver, and some the black of the fabric, but Escher then overlaid the metallic ink of some of the motifs with transparent red, blue, or green, so that the bats occur in six different colors. It is quite possible that this motif was inspired by designs Escher saw in the Alhambra in 1922; motifs with similar outline are common there in decorative designs having the same symmetry. (See, for example, Escher's illustration 5, page 32, which he found in the Alhambra, and sketched in 1936.)

For each of these prints, Escher carved woodblocks with a single motif, but in two versions: one to print a colored figure on the fabric, the other to turn a surrounded patch of fabric—the ground—into a figure by printing just the interior detail lines. For the lion print, two pairs of blocks were carved to stamp both the image and the mirror image of the creature. In the print shown here, the motifs occur in four different positions, each position identified by a designated color; this arrangement required the use of only three of the four carved blocks. To create the prints on fabric, Escher hand-printed each motif in an interlocked array of repeated creatures; the lower corner of each of these prints bears the same imprint from another carved block: "HANDDRUK MCE" ("hand-printed MCE").

About ten years later the first pattern of "lions" would become number 1 of Escher's periodic drawings, and the second design of lion-like figures would be reworked and become number 2. In printing the first design on fabric, the individual "lions" were made to interlock with each other by turning the block 180°—thus the symmetry present in this design is the same as that in Escher's woodcut *Eight Heads*. Here, however, turning the printed rectangle of fabric does not reveal any new images; the pattern looks just the same right side up or upside down.

Although Escher obviously derived great personal pleasure from creating these hand-printed designs, it is not surprising that they were "not successful" when exhibited. Of all his prints involving regular division, these are perhaps the closest to "pure" regular repetition, like

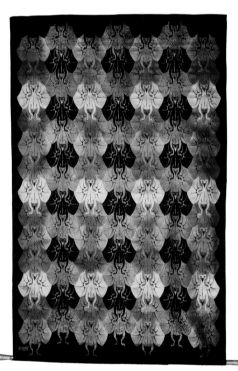

Top left: Hand-printed "lion" pattern on satin, c. 1926. Gold and silver on black, 705 × 1022 mm (fabric). Top right: Detail of hand-printed lion pattern on silk, c. 1926. Red, blue, and gold on ivory, 595 × 1890 mm. Above: Hand-printed bat pattern on satin, c. 1926. Gold, silver, red, green, and blue on black, 1460 × 946 mm.

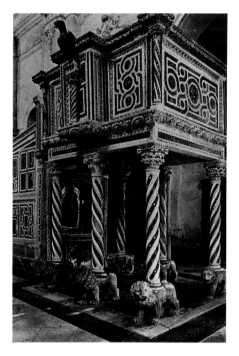

Twelfth-century pulpit in Ravello cathedral, designed by Nicola di Bartolomeo of Foggia. Escher's drawing of mosaic bands (facing page, upper left) are from this pulpit.

wallpaper. Only the individuality of the motifs at the edges of the design reveals that these were not printed by a roller. It is likely that this quality of strict regularity was largely responsible for the disinterest they received when on exhibit. Regular repetitive design, even with unusual motifs, is perceived as primarily static decoration, not to be a focus of interest, but rather to provide a bit of color and texture to otherwise bare walls, floors, and furniture surfaces. Only those who share the passion for creating interlocking motifs will give such pieces more than a passing glance.

In addition to the decorative printed fabrics, in 1926 Escher designed majolica tiles which were manufactured for the floor of the family apartment in Rome, as well as for his studio on the floor above. The design, painted on white tiles, was a geometric meander, interlacing two different colored ribbons that twisted on a path of many right-angled turns and filled out a large square. It could well have been inspired by similar designs which he had seen in the Alhambra. In 1942 he recorded the designs of the four individual tiles, as well as the scheme of the whole tiling (see page 85). While Escher may have intended his young sons to enjoy following the mazelike path of the ribbons, in later years the children found additional enjoyment in the tile floor. George recalls, "The tiles had not been properly laid and most of them had worked loose, so that they tipped slightly when you walked on them. For the children it was good fun to race through the house on a tricycle because the tiles would rattle in a very satisfying way—which was less appreciated by the people living below." [1982, p. 45]

After his visit to Spain in 1922, Escher maintained his interest in decorative majolica tilework often found in churches and other public buildings and he and Jetta made several color sketches of such geometric designs. The coastal town of Ravello where he had met and courted Jetta in 1923 was a favorite summer vacation site for the family, and they returned there several times while they lived in Rome. Nearby Amalfi was an important port in Italy during the thirteenth, fourteenth, and fifteenth centuries, and the churches and many buildings on the Amalfi coast reflect the influence of the Moors. In the thirteenth-century cathedral in Ravello, decorative bands of geometric designs formed by colorful mosaic tiles encrust the ornate elevated pulpit. Escher recorded several of these in color sketches, even to the extent of using gilt paint. Similar decorative mosaics cover the pulpit in the Basilica of San Giovanni del Toro in Ravello. Escher gathered a folder of color sketches of geometric tile designs, several made by Jetta.

During the years in Rome, in addition to making graphic works based on his on-site sketches of Italian scenes, Escher also produced illustrations for two books. The first, a collection of emblemata, was a collaborative work with G. J. Hoogewerff, Director of the Dutch Histori-

Facing page, upper left: Escher's studies of designs on the pulpit of the Ravello cathedral, c. 1923. Watercolor, ink, 278 × 201 mm. These bands of inlaid tiles are on the façade of the elevated box. Upper right and below: Some of the designs collected by Escher; many were made by Jetta. The sketches are not identified, but they were likely made in and around Ravello during summer visits, 1924–1933. Watercolor, ink, 272 × 198 mm (each).

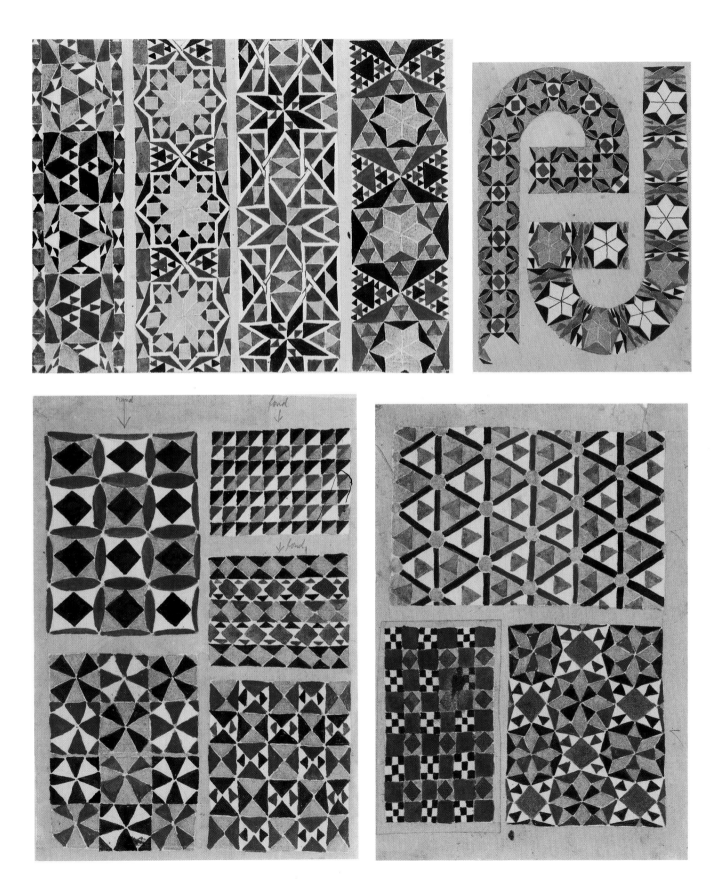

cal Institute in Rome. This was a revival of a seventeenth-century form of expression, each page containing a Latin motto, interpreted both by a visual symbol and a four-line epigram. In his 1931 article on Escher's work, which included reproductions of two of the emblemata, Hoogewerff attributed the epigrams of the emblemata to a fictitious A. E. Drijfhout, and indicated why Escher was especially suited to be the visual interpreter: "The double pregnancy of word and image [in the emblemata] agreed wonderfully well with the spirit of his own art." He concluded the article, "Possibly on becoming acquainted with his 'emblemata,' one might again call Escher's art 'cerebral.' One may give this term the meaning one desires, but in our opinion, his work in *all* of its manifestations is characterized by deep reflection and true spirituality. Carried by quiet inspiration, it is born of a conviction that is as strong as it is honest. Art in our day too rarely possesses precisely these attributes."

The *XXIV Emblemata dat zijn zinne-beelden* (*24 Emblemata Which Are Symbols*) was published in 1932, and that same year, Escher was asked by Jan Walch to illustrate a fantasy he had written many years earlier, about the Witch of Oudewater. The book, with 19 woodcuts by Escher, was published in 1933 as *De vreeselijke avonturen van Scholastica* (*The Terrible Adventures of Scholastica*). Some of Escher's woodcuts for these publications show his careful observation of architectural and decorative uses of regular divisions of the plane. In his portrayal of symbolic scenes are the details of brickwork, floor-tilings, pavements, wall coverings and window grilles. Also in 1933, one of his hobbies, that of word puzzles, led to his first commercial commission in decorative art. Hoping to interest different department stores in original designs for wrapping paper, he made several interlocking repeating patterns using the store name as motif in each: De Bijenkorf, Gerzon, Zingone, Jemoli. He was successful in selling one design to De Bijenkorf (The Beehive), and the wrapping paper, which was a visual play on words as well, was manufactured.

Although family life was happy in Rome and Escher was successful in his work, with numerous exhibits and purchases of his prints by museums and collectors, residence in Italy would soon end. The political situation was becoming increasingly ominous, and indoctrination was reaching into the schools. In July 1935, the family left Rome for Switzerland, where they lived for almost two years in the mountain village of Château-d'Oex. It was from there, in the spring of 1936, that Escher and his wife set out on an extensive Mediterranean journey which proved to be an important turning point in the development of his artistic work. Although their young boys enjoyed the new scenery and the wintry climate of Château-d'Oex, the Eschers were not happy in these surroundings, and in August 1937, they moved to Ukkel, a suburb of Brussels. Their youngest son Jan was born there in March 1938. The war was to uproot them once more: on May 17, 1940, the Germans invaded Brussels. By the end of the year, they had decided to settle in Holland, in the village of Baarn; they moved there in February 1941.

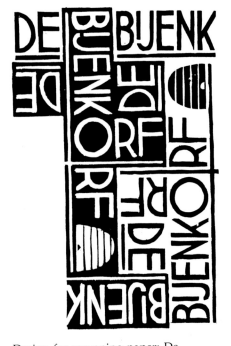

Design for wrapping-paper: De Bijenkorf. September 1933. Woodcut, 60 × 88 mm (cat. 232).

In the peaceful village of Baarn, Escher could bury himself in his work during the war, but that reality, and especially the German occupation of Holland, still left terrible memories that were fresh even

twenty-five years later. In 1968, the Dutch journalist Bibeb interviewed Escher at length, and his vivid recollection of those events can be felt in his response to her final question, "Were you able to work during the occupation?" Escher replied:

> Yes. By then I was living here [in Baarn]. My most important ideas were worked out best during the war. I still have the greatest difficulty with the Krauts. . . . I was not involved with the Resistance, but I had many Jewish friends who were killed. My old teacher, de Mesquita. He did not want to go into hiding. They were Portuguese Jews and the Krauts had always allowed that they belonged to the elite. One night they were all taken away. His son, Jaap, a clever boy, had worked day and night. . . . He had often gone to see the Krauts in order to talk with them about his ancestors. They were not noble, but almost. . . . One bad day they were all gone. In 1944, during the famine winter, I wanted to bring them something, apples. . . . I walked to their house. The windows on the first floor were broken. The neighbors said: "You hadn't heard? The de Mesquitas have been taken away."
>
> This (a drawing) lay on the floor with the impressions of the cleats from the Krauts' boots. It was lying under the staircase. And in his studio everything was a mess, everything on the floor. I took home two hundred prints. . . . No matter what you do, you cannot forget such things. I cannot. . . . Taken away in the middle of the night. And he could have been saved. I tried so hard to convince him. No he was protected, he said. Why should he hide? Afterwards I blamed myself. But they did not wish to. Jaap in his talks with the Krauts had produced all sorts of genealogical registers. They were half noble. The Krauts found that impressive. They almost never left their home. Really terrible, you know, such sweet people, carried away like cattle to be butchered.
>
> . . . I owe him a great deal. He was my graphics teacher. . . . He saw something in my woodcuts. He insisted that I go on with them. If he had not talked with my parents, I would have gone on into architecture. And I never really wanted to build houses. Only *mad*houses.

For thirty years, Baarn was Escher's home. He spent his last two years in nearby Laren, and died there on March 27, 1972.

An important journey

The winter of 1935–1936 in Château-d'Oex was a snowy and desolate one for Escher, and by February he ached not only for the sun of southern Italy, but for the scenes that had always provided inspiration for his prints. He was restless to make a Mediterranean journey, to revisit some of the places from his earlier travels, and to enjoy again the pleasures of a sea voyage. This time Jetta would be with him for most of the journey. To help finance the cost of the trip, Escher made an unusual proposition to the Italian shipping company Adria in Fiume, which maintained a regular service around Italy's boot. In the 1940 article in *De vrije bladen* by 's-Gravesande, he described his bold idea and what happened:

I suggested to the Adria company that they take me along as a free passenger, i.e., with passage, food, and drink for myself round trip and one way for my wife who couldn't be away for the whole time. In exchange I would give them four copies of each of twelve graphic prints which I would finish the following winter from sketches made during the voyage; these then could be used for advertising purposes in the tourist trade. To my great surprise, they agreed to this proposal although they did not know me, and my reimbursement would not be in their hands until a year later.

The trip, which lasted two months, began on April 26. Escher visited with the management of the Adria company in Fiume and then boarded the ship *Rossini.* Jetta joined him in Genoa when the ship arrived there about two weeks later. Throughout the journey, in which they voyaged in three different vessels, there were frequent stops in Mediterranean ports. Escher and Jetta would disembark to visit the towns and often travel by bus or train to an inland village. Escher filled his sketchbooks with studies that he would later use for the promised prints. In a few instances, he was able to sketch a scene from a specially selected vantage point inside a nearby building, which the Adria company had obtained permission for him to enter.

This journey was both a return to places visited in Escher's student days and an exploration of new places. It also marked the onset of an important turn in his own artistic journey. While he sketched scenes of Mediterranean harbors and villages with practised eye and hand, when he returned to the Alhambra on May 23, he was a student all over again. He was stirred anew by the colorful geometric patterns of the majolica tiles and the decorative tracery in the stucco and wanted to record as much as possible in the short stay of three days. His travel diary for that day notes, "This morning to the Alhambra. I thoroughly enjoyed this delightful aristocratic work of art. In the afternoon back there again, and started copying majolica motifs. What a contrast: the quiet, elevated, princely palaces up there and the dirty, neglected, decaying city below! There are hardly any foreigners. We're being gaped at like creatures from another planet, and that in a town that used to be a center of tourism!"

On May 23, 24, and 26, amidst crowds of local villagers, both he and Jetta made careful drawings of the Alhambra designs; then they spent hours elaborating them in their hotel room. Some of their color sketches are shown here. They show several different examples of regular plane fillings with colored majolica pieces of one or more different geometric shapes and regular-division designs traced in stucco.

On May 30, the couple traveled to Córdoba and visited the mosque La Mezquita, built during the eighth through the tenth centuries as an Islamic sanctuary. During the next few days, Escher sketched not only the wonderful array of arches and pillars of the mosque, but also several examples of regular patterns found in its decorative red brickwork.

They next traveled to Seville and visited the Alcazar, also a showpiece of Moorish decorative art, but in comparison with the Alhambra, they found the palace disappointing. They left Spain by ship on June 7, and five days later, Jetta disembarked in Genoa to return home. Escher spent two more weeks on the return voyage to Trieste and added to his folio of sketches at each port of call.

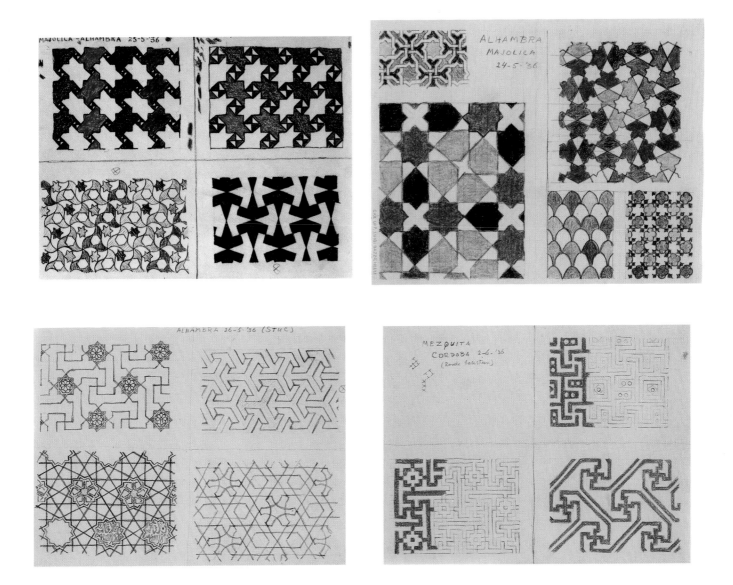

From September 1936 until March 1937, Escher transformed his travel sketches into woodcuts. Although this work occupied most of his time, he could not forget the decorative patterns of the Moors that had so intrigued him. The urge to create his own interlocking patterns had been reawakened, and he now had a small collection of geometric designs that could serve as a point of departure to develop his own ideas. The design used for his first attempt in October 1936 was from the Alhambra and was one that would serve him often over the subsequent years as a fundamental source.

Vaguely suggestive of a flying bird, the motif in his on-site sketch repeats in black and white (see drawing at upper left, above). He also must have noted a colored version of this design since he later used it as an illustration in one of his lecture slides (see page 32, number 4). Escher transformed the geometric shape into a human weightlifter. Or, more accurately, the geometric grid of the Alhambra design served as a scaffolding for his interlocking design of human weightlifters. It was not the

A few of the sketches by Escher and his wife Jetta of Moorish designs in majolica tile, in stucco, and in brickwork at the Alhambra (Granada) and La Mezquita (Córdoba), May–June 1936. Pencil, colored pencil, watercolor, ink.

Escher's preliminary sketch shows how a geometric design from the Alhambra provided a scaffold for his design of "weightlifters" (drawing 3). Pencil, colored pencil, 428 × 428 mm.

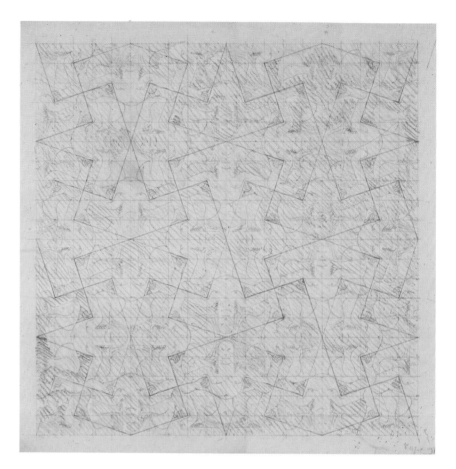

geometric shape of a single majolica tile that led to Escher's human shape, but rather the relationship of a single tile to every other copy surrounding it. Each single weightlifter in Escher's drawing can be transformed into one of the five weightlifters which adjoin it by making either a quarter turn (where elbows touch) or a 180° turn (where two heads meet). Escher's final color drawing of this design is on page 117.

Two other new interlocking designs were made by Escher that October in Château-d'Oex. His renewed interest in interlocking shapes led him to re-examine his earlier patterns of animals, and in so doing, he developed a new motif, a squirrel (page 121), with the same symmetry as his very first motif, the doglike "lion" which had been printed on fabric. Another new design utilized a different symmetry found in one of the copied Alhambra patterns. In this case, the geometric shape of a single tile—three arrows in tripod formation—may have been more suggestive of Escher's derived figure of a hatted Chinese boy (page 118).

In March 1937, Escher finished the last woodcut, *Porthole*, of his series for the Adria shipping company. In May he produced a new woodcut unlike anything he had done before—a visual parable. Later to be called *Metamorphosis I*, it was a curious work, blending a subject and

style familiar in his prints of Italian landscapes with his latest interlocking design of Chinese boys.

Depicting a gradual transformation of form, the print was to be scanned from one edge to the other: it was the first "picture story" of many that he would create in later years. The story unfolds with the scene of an Italian coastal town (Atrani), whose boxlike buildings evolve into a stack of cubes, which, losing detail, evolve into packed hexagons, which in turn evolve into the shapes of Chinese boys. Finally, one of the boys cartwheels free of the jigsaw puzzle and lands grinning as if to say "I've arrived."

When Escher showed this print to his father, who always took great interest in his work, the elder Escher noted in his diary that the woodcut was enigmatic and wondered if the print had intentional symbolic significance. On many occasions, Escher denied the symbolic significance read into his work by others, yet it is hard not to view this print as a visual parable of the metamorphosis of Escher's thoughts and inspiration that occurred during 1936–1937. The wellspring of ideas for his graphic work, typified by a village on the Amalfi coast, had been transformed into a collection of interlocking figures, signaling his new passion for regular division of the plane.

It was not just the second visit to the Alhambra which changed the focus of Escher's work, but the abrupt and irreversible move from Italy in 1935 as the grip of Facism began to be felt. He wrote in 1959 in his introduction to his book *Grafiek en tekeningen*,

> The fact that from 1938 onwards, I concentrated more on the interpretation of personal ideas was primarily the result of my departure from Italy. In Switzerland, Belgium and Holland where I successively established myself, I found the outward appearance of landscape and architecture less striking than that which is to be seen particularly in the southern part of Italy. Thus I felt compelled to withdraw from the more or less direct and true-to-nature depiction of my surroundings. No doubt this circumstance was in a high degree responsible for bringing my inner visions into being.

*T*he open gate

The geometric tilings copied in the Alhambra yielded many new insights to Escher, who found himself not just tinkering with the polygon shapes

Metamorphosis [I]. May 1937. Woodcut, printed on two combined sheets, 195 × 908 mm (cat. 298).

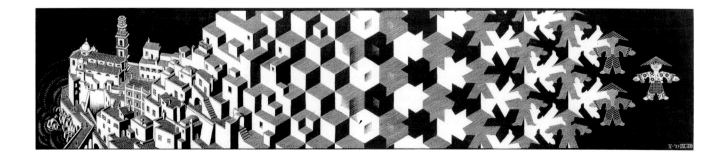

to derive new animal motifs, but also trying to discover the distinct ways in which individual figures could interlock with adjacent copies of themselves. Squared graph paper was most convenient for these explorations, and he began to fill the pages of small student copybooks with sketches and notes.

Upside-down, or half-turn, symmetry had intrigued him since his student days; his first regular division pattern with "lions" exhibited that symmetry. His special fondness for this symmetry extended to word puzzles as well. In 1968 he recounted to his old friend Bas Kist an entry he had once jotted in his diary: "An English swimming teacher no longer felt like keeping his bathing establishment open on Mondays and wrote on a sign (he could just barely write):

NOW NO SWIMS ON MON

He attached the sign by means of a single nail through the middle. Some angry boys, finding themselves in front of a closed door one Monday, turned the sign around 180° and were amazed to see that it made no difference when read upside down." [J. R. Kist, 1973]

The pages of Escher's first sketchbook of early fall 1937 show him trying to achieve two goals. First, he wished to make as large a variety as possible of different animal motifs. But he also wanted to discover all the ways in which such shapes could fill the plane in a systematic manner with copies of themselves, using just half-turns (180° rotations) to repeat the individual forms. He clearly grasped the idea that a geometric grid of congruent parallelograms has the property that rotating a single parallelogram 180° about one of its corners or the midpoint of one of its sides turns it into an adjacent parallelogram. Thus the key to making an interlocking animal motif was to develop a figure which had an area exactly equal to that of one of these parallelograms and a special additional property. Its outline must be shaped so that when it cut through one of the corners or midpoints of a parallelogram, a rotation of 180° about that point would turn the animal into an adjacent copy of itself. In order to fulfill this second requirement, portions of the boundary of such a figure must have a center of symmetry, such as that found in the letters S, N, or Z. (These letters, when turned 180° around their center points, look exactly the same, but top and bottom as well as left and right portions of the letters have changed places.)

Guided by the small squares of the copybook pages for accuracy, Escher drew parallelogram grids and, with rough, angled outlines, sketched rudimentary, recognizable figures which satisfied his requirements. He refined these and later made careful colored drawings of them. Although his dating of the polished color drawings indicates that several of his first designs were created in the winter of 1937–1938, the work in his little copybooks indicates that they were more likely first created in September–October 1937. To his original two designs (one of doglike "lions" and one of squirrels), he added six new designs; the first was a horse (page 122), whose outline is very similar to that of his first "lion" of over ten years before. Others, in the numbered order in his sketchbook, are a strongman (page 119), a bird (page 123), a fish (page 124), a seahorse (page 125), and a camel (page 120). He also re-

fined his second lion motif which had been printed earlier on fabric; now it was drawn with closed mouth—a proud sphinxlike creature (page 116).

In addition to these quite methodical studies of designs with half-turn symmetry, Escher also continued to develop motifs based on some of the copied Alhambra patterns. Two years earlier, he had obtained a specimen of a large mounted dragonfly from the zoo in Amsterdam and, before leaving on the Mediterranean journey in the spring of 1936, had made a woodcut featuring the insect. Now he saw the silhouette of the dragonfly as a perfect motif to stylize and adapted it to the grid provided by the geometric design that had earlier led to his weightlifter motif. The regular division design of dragonflies (page 126) is very similar to the Alhambra pattern (page 17, upper left); it is even colored in the same manner, with alternating dark and light motifs. Another design from the Alhambra suggested butterflies (page 125). One idea for a motif seemed to taunt Escher: he wanted to create a reptile, a squirming lizard, that would pack copies of itself like arms of a pinwheel, with four of the creatures spiraling around a single point. But the motif was stubborn in coming to life.

Twenty years later, in his book *Regelmatige vlakverdeling* (*Regular Division of the Plane*), Escher would describe this period of exploration in metaphorical terms:

> A long time ago, I chanced upon this domain [of regular division of the plane] in one of my wanderings; I saw a high wall and as I had a premonition of an enigma, something that might be hidden behind the wall, I climbed over with some difficulty. However, on the other side I landed in a wilderness and had to cut my way through with a great effort until—by a circuitous route—I came to the open gate, the open gate of mathematics. From there, well-trodden paths lead in every direction, and since then I have often spent time there. Sometimes I think I have covered the whole area, I think I have trodden all the paths and admired all the views, and then I suddenly discover a new path and experience fresh delights.

The "circuitous route" by which he found the gate of mathematics began in October 1937, when Escher made one of his frequent visits to his parents at their home in the Hague. His half brother B. G. (Beer) Escher, who was Professor of Geology at the University of Leiden, was also visiting, and he showed Beer the work he had done on regular division. It was a timely visit, for Beer was exactly the person to connect Escher's investigations with similar interests of the scientific community. It was he who would point Escher to the "open gate."

In 1940, with those events still fresh in his memory, Escher was interviewed by 's-Gravesande, who related the story in his article in *De vrije bladen:* "Professor Escher took an interest in the motifs also from a scientific point of view, and declared that his brother without realizing it was applying a kind of 'crystallography on a plane surface,' or two-dimensional crystallography. He advised him to read up on this in the *Zeitschrift für Kristallographie.*"

Beer promised to send Escher a list of recommended articles published in that scientific journal relating to his investigations. Two days later, on November 1, Beer wrote from Leiden:

Dear Mauk,

 After some searching I found the following papers on *regular partitions of the plane* [emphasis in original]. It is all very theoretical, but you may have some use for the pictures in them. There is however so much that I cannot send it all to Brussels. The Zeitschrift für Kristallographie which is present in our Museum is not only consulted again and again by us, but by chemists and physicists too.

Then followed a list with complete bibliographic information on ten articles, all written in German and published in the crystallography journal between 1911 and 1933. (This list of articles is given on page 337.) Beer concluded the letter, "Perhaps you could gain access to a library in Brussels which possesses this journal. Otherwise you could look over the articles here sometime."

 Escher must have immediately followed Beer's advice and found the journal articles in Brussels. The full title of the journal and an identification number is written in Escher's hand on the typed letter. Three weeks later, a second letter from Beer answered Escher's request for the addresses of authors of some of the papers.

 The account by 's-Gravesande continues:

 Most of the articles were far too difficult for a layman, too dry and too theoretical, but among them there was one in particular by a certain Polish professor in Zürich entitled "Über die Analogie der Kristallsymmetrie in der Ebene" ["On the analogy of crystal symmetry in the plane"] which Escher thoroughly read and studied. It contained many nice illustrations which he copied along with the entire article. He was struck by the sentence with which the article ended: "Dass das mathematische Studium der Ornamente auch vom künstlerischen Gesichtspunkte aus etwas Interesse hat, will ich anderswo erörtern." [I will discuss elsewhere the fact that mathematical study of these ornaments is also interesting from an artistic point of view.]

 Shortly afterwards Escher cut *Development I* and sent a print of it to that professor in Zürich, kindly requesting him to tell if he had ever come to give that further "explanation." He received a kind but rather formal reply, thanking him for the gift but telling him that he had never pursued the subject any further (the article was dated 1924).

 However, Escher maintains that he owes a great deal to this man because of his article. In it he described the laws to which he [Escher] unknowingly had submitted himself until then and he gave him a clearer understanding of his own drive. In another article by a German professor there appeared a brief definition of regular division of the plane as follows: "Die regelmässigen Planteilungen bestehen aus kongruenten, lückenlos aneinandergereihten konvexen Polygonen; die Anordnung der Polygone um jedes einzelne ist die nämliche wie um jedes andere." [Regular divisions of the plane consist of congruent, convex polygons joined together; the arrangement by which the polygons adjoin each other is the same throughout.] . . .

 It is understandable that Escher attaches much importance to this, since scientists were the first men with whom he had points of agreement, and since their dry science made many things clear to him and helped him to achieve what he sought.

Escher's notes on a 1923 article by F. Haag. The only text copied is Haag's definition of regular division of the plane with convex polygons. (See translation in quotation at right.)

The professor in Zurich (who was Hungarian, not Polish) to whom Escher owed so much was the mathematician George Pólya; he was then at the ETH (Swiss Federal Institute of Technology). His 1924 journal article was a technical one, in which he indicated that designs in the plane which repeat a motif regularly can be classified according to symmetry groups and that there are just 17 different kinds of such symmetry groups. The reason that his article so struck Escher is that it contained a page of 17 illustrations, one for each symmetry group; each of these gave visual evidence of the ways in which congruent shapes (tiles) could fit together to satisfy the classification criteria of a particular symmetry group.

Some of the patterns were familiar to Escher since they were chosen by Pólya from well-known Islamic mosaics or from common parquet patterns; four Pólya had created "ad hoc" for the article. Except for the few types with a high degree of reflection symmetry, each pattern showed an array of congruent figures suggestive of living forms, and several showed symmetry that was uncommon in Moorish decorative art.

Escher's interest was not in classifying existing patterns, but in learning the rules that governed such patterns so that he could create his own regular divisions of the plane. Although he copied the full text of Pólya's paper, it is clear that he learned most from his careful study of the illustrations. These he copied two to each of his copybook pages; like his copied Alhambra designs, they became sources from which to derive his own motifs. It is possible to see in some of Pólya's illustrations the suggestions of motifs found in some of Escher's later regular division drawings, flying birds or fish, for example. This source material was so important to Escher that the cover of his copybook in which he had copied the article and illustrations was identified with the single word "Pólya."

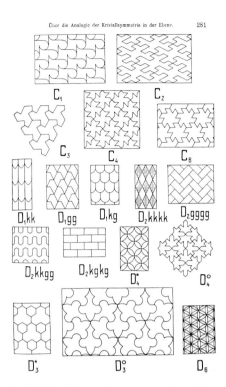

G. Pólya's illustration representing the 17 different plane symmetry groups, from his article "Über die Analogie der Kristallsymmetrie in der Ebene" that appeared in *Zeitschrift für Kristallographie* in 1924. The four designs C_1, C_3, C_4, and D_1gg are Pólya's original creations.

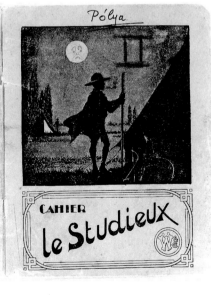

The cover of Escher's copybook containing his handwritten copy of Pólya's 1924 article. 210 × 167 mm.

F. Haag was the German professor mentioned in 's-Gravesande's account; from Haag's 1923 article "Die regelmässigen Planteilungen und Punktsysteme" ("Regular Divisions of the Plane and Point Systems") Escher learned two important things. First, he found the mathematician's definition of regular division of the plane, quoted above in 's-Gravesande's article. In fact, the title of Haag's article and that one-sentence definition are the only *words* that Escher copied from the mathematician's paper (see page 22).

The other important new information was illustrated by Haag with careful drawings of regular patterns of packed convex polygons marked with small circles, which showed simple underlying geometric scaffolding. Here Escher found regular partitions of the plane with pentagons and with hexagons of a type he had never seen in Moorish tessellations. Haag's diagrams in this paper as well as an earlier 1911 paper (also on Beer's list) showed how the pentagon patterns were based on simple square grids, and he gave precise geometric information on the angles and sides of the special hexagons which could fill the plane. Escher carefully copied several of Haag's illustrations; like Pólya's, these would be frequently consulted in subsequent months and years and used as a source from which to derive new motifs.

Almost immediately, Escher tested the necessity of the word "convex" that was part of Haag's definition of regular division of the plane; none of Escher's motifs would ever be convex. He needed to know if the geometric relationships which governed the ways in which convex congruent shapes could regularly fill the plane would still hold for noncon-

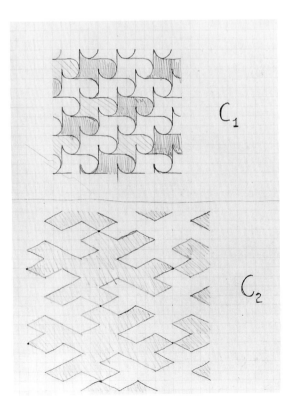

Escher's sketches of the 17 tilings in Pólya's illustration (here and on pages 25 and 26).

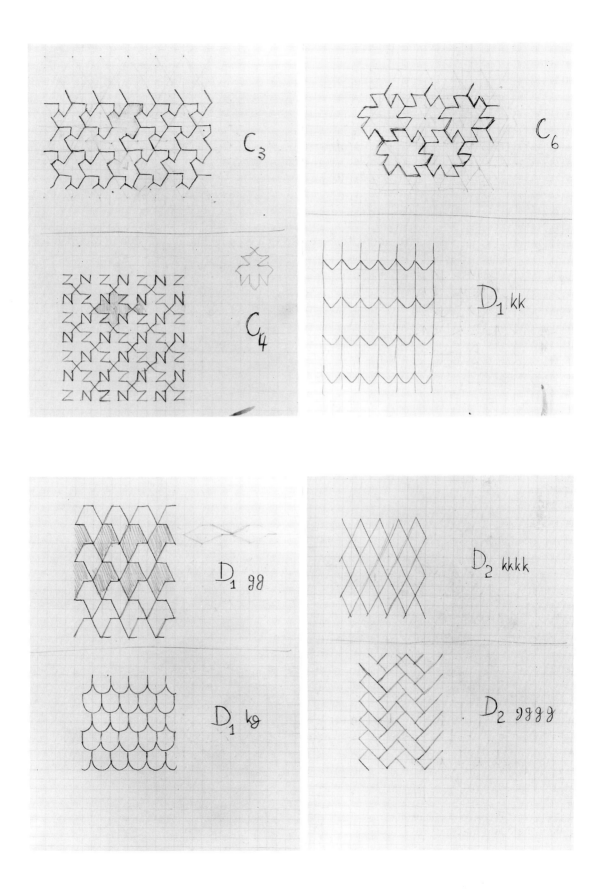

Escher's sketches of the 17 tilings in Pólya's illustration (continued).

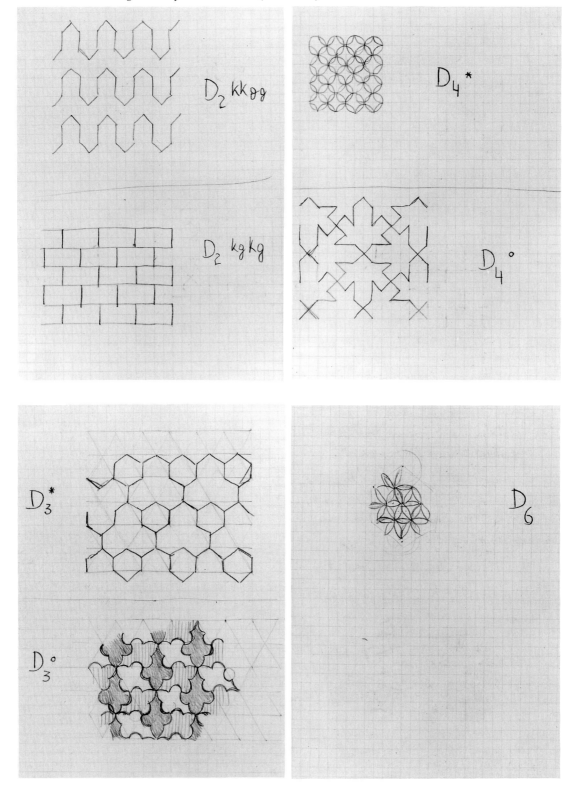

vex, dented shapes. Immediately after the copied title and definition of Haag's paper, a single page of Escher's copybook shows two drawings: a packing of congruent convex polygons, copied from Haag's paper, and below it, Escher's own experiment in packing congruent dented polygons, following the same geometric rules for packing as Haag's pattern.

Later Escher copied Haag's definition of regular division of the plane on the first page of his folio/notebook of colored drawings. However, he made one tiny, yet significant addition to Haag's sentence, indicating his own adaptation of that definition: he surrounded the word "convex" with parentheses (see page 112). He had learned through his own investigations that Haag's restriction to figures that were convex polygons was not only too strict for his creative interests, but indeed unnecessary. The important geometric laws that governed the mathematician's analysis applied equally well to regularly repeating interlocking patterns of curved and zigzag shapes, and even to forms which seemed to crawl or fly.

The first motif that Escher successfully completed after studying Pólya's illustrations was the reptile, whose partial form had until then defied further resolution. The swiftness with which he finished this design in two different versions (page 127) and then immediately

Escher's own experiments (here and on pages 28 and 29) can be seen on the pages with his sketches of tilings from Haag's paper: a tiling with nonconvex hexagons, colorings of Haag's designs, and some attempts at recognizable motifs.

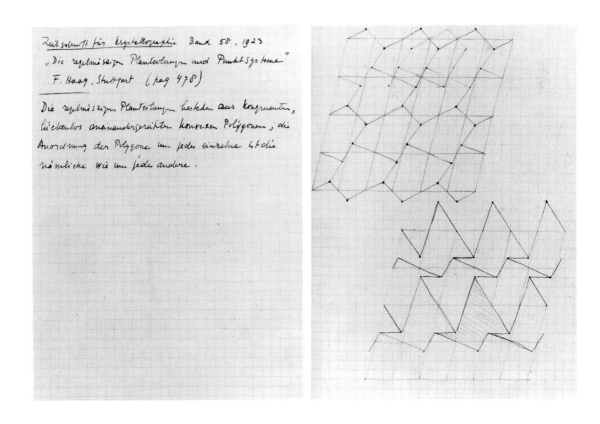

Escher's experiments with Haag's paper (continued)

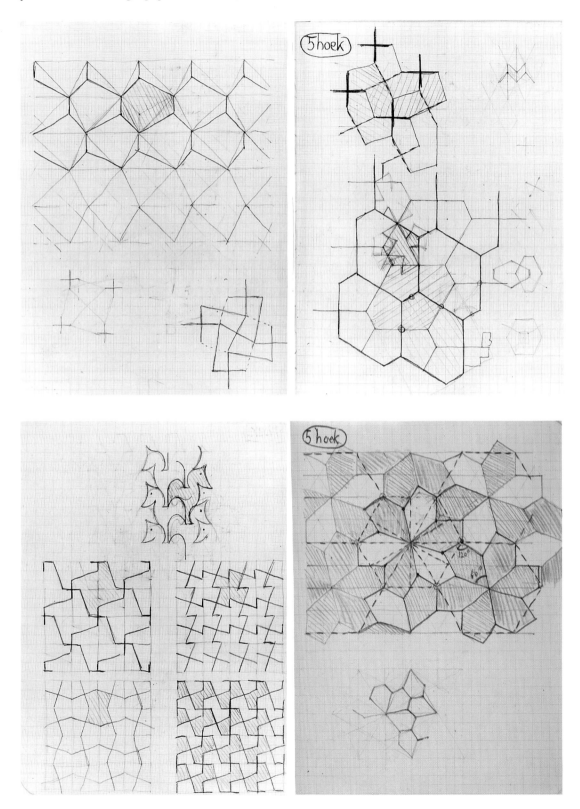

Escher's experiments with Haag's paper (continued)

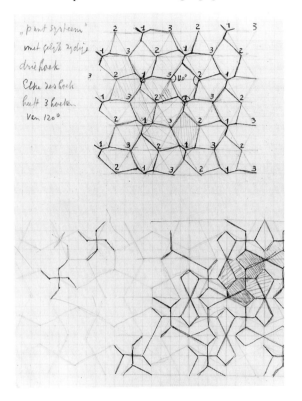

"point system"
with equilateral
triangles
Each hexagon
has three vertices
with 120° angles.

utilized it in his woodcut *Development I* indicates how much he learned in what must have been an intense period of study.

In less than a month, he had found the mathematical gate to the garden of regular division, opened it, and, filled with curiosity, explored several of the walkways within. Once in that garden, he began to blaze new paths to regions ignored by the mathematicians and crystallographers in their literature. In 1958 he wrote in *Regelmatige vlakverdeling*, "Crystallographers have put forth a definition of the idea [of regular division of the plane], they have ascertained which and how many systems or ways there are of dividing a plane in a regular manner. In doing so, they have opened the gate leading to an extensive domain, but they have not entered this domain themselves. By their very nature they are more interested in the way in which the gate is opened than in the garden lying behind it."

Three aspects of regular division that were not of interest to the crystallographers at that time, yet were indispensible in Escher's view, were the recognizability of the motifs, the use of contrasting colors to ensure both individuality and equal value of adjacent motifs, and the dynamic evolution and transition of forms. After copying illustrations from the articles by Pólya and Haag, Escher colored several of them, following his own rule that no two adjacent motifs may share the same color. In the next few years, he would make an extensive investigation of several questions concerning the coloring of regular divisions of the plane.

Development I. November 1937.
Woodcut, 437 × 446 mm (cat. 300).

His print *Development I,* created that November of 1937, gave a visual declaration of his principles by simultaneously showing two developments: one in form and one in contrast. From the purely abstract, static geometric form of a square, a squirming lizard evolves and from the neutral gray at the outer edges, contrast gradually builds until at the center, sharp black-and-white identical forms emerge and delineate each other. Each development is made with such apparent ease that the viewer might well believe that Escher's creatures grew by themselves from the checkerboard grid. Not quite, although the arrangement of checkerboard squares is essential as a geometric underpinning to this design. These and other aspects of Escher's theory of regular division of the plane will be discussed in more detail in Chapter 4.

Escher was understandably disappointed at the brief reply he received from Pólya when he sent him some drawings and a print of *Development I,* and it is likely that there was no further correspondence. He never knew how pleased Pólya was to receive his letter and its enclosures and how much it meant to the mathematician to have been of help, through his article, to Escher's work on regular division. Pólya wrote to me in 1977, after I had sent him a photo of Escher's hand-copied version of his article, "Some time after the publication of my article . . . I received some drawings from a then unknown Dutch artist

accompanied by a nice letter in which he said that my article was very useful to him—the artist was Escher. Unfortunately, in my wartime moving from Switzerland to the U.S., the letter and drawings were lost—your discovery is some consolation for this loss.''

*T*he geometric rules

Escher's study of Pólya's article provided him with sufficient knowledge and insight to embark on his own investigations of regular division of the plane. He learned that there are only a few basic geometric motions which preserve exact shape and thus relate a single motif to each congruent copy which adjoins it in a repeating pattern. Many years later Escher would be cast in Pólya's role as teacher and lecture on regular division of the plane to diverse audiences. He often began these lectures with slides of three posters he had made expressly for the purpose of clearly explaining the fundamental geometric rules that govern such patterns.

The first poster showed that regular divisions of the plane can be found as decorative art in various cultures. The eight examples in Escher's illustration were drawn from his own experience: Number 1 is from a Japanese pattern book he owned and is quite similar to the Moorish number 3, which he copied in the mosque La Mesquita in Córdoba. Number 2 he saw frequently as a design on clerical garb or on icons in the Orthodox church. All the remaining examples were copied in the Alhambra. He found it remarkable that the motifs in all of these designs are symmetric: in 1 through 7 the motifs show mirror symmetry, and in 8 the motif has rotation symmetry. He had not encountered asymmetric motifs in classical repeating patterns, nor had he seen any designs exhibiting glide-reflection symmetry. In lectures from 1965 and later, he acknowledged patterns found in the ruins at Mitla in Mexico. These wall-relief designs, likely Zapotec or Mixtec (called Aztec by Escher), displayed exactly the characteristics Escher found lacking in the eight examples chosen for his illustration.

In the second poster, Escher noted the underlying geometric structure, or framework, which is present in every regular division of the plane. Every interlocking jigsaw-puzzle pattern of congruent pieces which repeats in such a way that every piece is surrounded in the same way can be associated with one of the six geometric regular divisions shown in his illustration: of parallelograms, of rectangles, of squares, of triangles, of 60° rhombuses, or of regular hexagons (see page 33). Escher identifies these as fundamental, or basic, forms for regular division of the plane (his word *''oer''-vormen* translates literally as ''primeval'' form). These six categories were Escher's own synthesis of what he found in the articles by Pólya and Haag. The various ways in which the individual pieces in these simple geometric tilings can be related to adjacent congruent pieces by geometric motions are the only ways that motifs with complicated shapes can relate to adjacent copies of themselves in any regular division of the plane.

The poster of eight illustrations of regular divisions of the plane (c. 1960) that Escher referred to when lecturing. Colored pencil, watercolor, gouache, 490 × 650 mm overall.

Each of the simple geometric shapes can represent an asymmetric motif which occupies exactly the same area. (The term "asymmetric" indicates that the motif cannot be divided into two or more smaller congruent parts by lines which meet at a center point.) It is much easier to see and understand how such simple geometric patterns form a sup-

„OER"-VORMEN VAN REGELMATIGE VLAKVERDELING.

parallelogram.

rechthoek.

vierkant.

driehoek.

ruit.

zeshoek.

Second illustration that Escher used in his lectures to explain the theory of regular division of the plane, c. 1960. Watercolor and ink, 220 × 292 mm. Escher's title reads "'Fundamental' forms of regular division of the plane." The examples in the top row are labeled "parallelogram, rectangle, square," and in the bottom row "triangle, rhombus, hexagon."

porting skeleton for even the most complex repeating patterns by studying Escher's own regular division drawings reproduced in Chapter 3. There one can note how the simple polygons in the geometric grid, which can be clearly seen in many of these drawings, are related to the motif with a complicated curved contour.

Using the final poster, Escher would explain and even demonstrate the three geometric motions that preserve exact shape: *translation (verschuiving), rotation (assen* denotes "axes" of rotation), and *glide-reflection (glijspiegeling).* These three motions, and no others, are those that can be used to move a given motif to an adjacent congruent motif in a regular division of the plane. Here, Escher shortened the mathematician's list of motions which preserve shape and size of plane figures; such a motion is usually called an "isometry" (for "same measure"). Reflection of a plane figure, to create its mirror image across an imaginary mirror line in the plane, is the fourth (and last) isometry. But for Escher, no motif would ever have a straight line for part of its contour, and so no motif would reflect into an adjacent copy of itself.

The geometric motions are best explained by pointing to illustrations, and our illustration on page 34 shows how each of these motions can move a simple figure to a new position and create a replica of it. If the contours of the figure are chosen carefully, such a motion will make it interlock with its replica and then if the process is repeated again and again with deliberately chosen motions, a regular plane filling is created.

Escher used his poster to demonstrate not only the geometric motions, but some of the various ways they can occur, alone or in combination, to move a single motif to any of its adjacent copies. His poster gives

five different examples of regular division of the plane, each based on an underlying square grid. In each of these examples, the square grid is easy to find: simply connect the points where four motifs touch each other. For convenience, we will call these points the "corners" of the motifs. Each of the motifs is asymmetric, and although the contours of each of the five different motifs are formed from line segments and simple curves, each is faintly suggestive of a bird.

If the square grid which joins the corners of motifs is superimposed on these patterns, each motif is caught by one square, and the shape of the parts of the motif that protrude beyond the square exactly match the shapes of the indentations of the motif inside the square; thus the area of the motif equals the area of the square. In each of Escher's five examples, the motifs are numbered; these numbers correspond to the distinct directions (or aspects) in which the motif is repeated in the interlocking pattern. Also, in each of the five patterns, a single motif is touched by exactly eight others: four of contrasting color share a portion of a common boundary with the motif, and four of the same color touch the motif at its corners.

In the first pattern (upper left), all the motifs are numbered 1, since all face in the same direction. By sliding a given motif left or right, up or down, it can be moved to any of the four adjoining motifs of contrasting color. By sliding it diagonally, northeast or southwest, northwest or southeast, it can be moved to any of the four motifs of the same color which touch it at a corner. Translation is the motion of sliding, and in this pattern, only translations are needed to move a given motif to any of the surrounding eight positions.

The second pattern (upper right) is one in which a given motif rotates into any adjacent motif. In a simple geometric grid of squares, a single square can be rotated about a pivot point at any one of its corners. A rotation of 90° (a quarter-turn) will move it to an adjoining square, and a rotation of 180° (a half-turn) will move it to a square which just touches that corner. The pivot points are called "centers of rotation," or "rotation axes," by mathematicians and crystallographers. Escher adapted from the mathematical literature the symbols of a small square □ and a small circle ○ to label a 4-fold center of rotation (a center of 90° rotation) and a 2-fold center of rotation (a center of 180° rotation), respectively, in a regular division of the plane. In his second pattern with asymmetric motifs, the shape of the motif determines which of the possible rotations about the corner of a square in the underlying grid can be utilized. Here a quarter-turn about a marked 4-fold center moves a motif to an adjacent

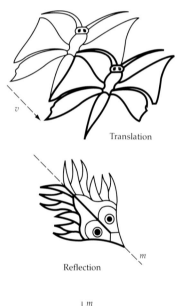

Translation

Reflection

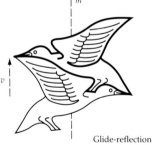

Glide-reflection

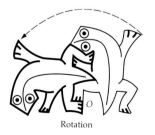

Rotation

The four isometries of the plane, geometric transformations which preserve exact shape and size. A translation slides all figures the same way; a vector v shows the direction and distance of the slide. A reflection transforms figures to their mirror images across a line m (the reflection axis) which acts as a mirror. Here, the left and right sides of a fish are mirror images of each other. A glide-reflection is a two step transformation: a translation with vector v followed by a reflection across an axis m which is parallel to v. A rotation turns figures about a fixed point O (the rotation center) through a specified angle. Here one lizard rotates 90° onto the other.

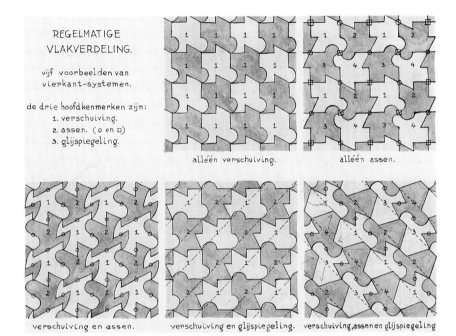

REGELMATIGE
VLAKVERDELING.

vijf voorbeelden van
vierkant-systemen.

de drie hoofdkenmerken zijn:
1. verschuiving.
2. assen. (o en □)
3. glijspiegeling.

alléén verschuiving.

alléén assen.

verschuiving en assen.

verschuiving en glijspiegeling.

verschuiving, assen en glijspiegeling

Third illustration that Escher used in his lectures to explain the theory of regular division of the plane, c. 1960. Watercolor and ink, 220 × 292 mm. Escher's title reads "Regular division of the plane. Five examples of square systems." On the left he notes "the three characteristics are: 1. translation, 2. axes (\bigcirc and \square), 3. glide-reflection." The two upper patterns are labeled "translation only" and "axes only"; the lower patterns are labeled "translation and axes," "translation and glide-reflection," and "translation, axes, glide-reflection."

one of contrasting color, while a half-turn about a marked 2-fold center or 4-fold center moves it to a motif of the same color. These rotations also change the direction of the motif; for example, a quarter-turn of a motif labeled 1 moves it to one labeled 2 or 3, and a half-turn moves it to one labeled 4.

The third pattern (lower left) shows four 2-fold rotation centers on the boundary of each motif; these are at the midpoints of the sides of the underlying square grid. Half-turns about these centers move a motif to an adjacent one of contrasting color and different label; translations in the four diagonal directions move it to a motif of the same color and same label.

The fourth pattern (lower center) has no rotation centers and shows motifs in two directions. A translation in one of four diagonal directions— in a direction either along a dashed line or perpendicular to a dashed line—moves a motif to one of the same color that touches it at a corner. To move a motif to an adjacent one of contrasting color takes a glide-reflection. Focus on one motif, for instance a light one, and think of it sliding along double "rails" formed by dashed lines: a "center rail" through two corners of the chosen motif and an "outer rail" through one corner of that motif. When it slides along these "rails," the chosen motif overlays an adjacent dark motif, and if it is flipped over in the direction of the "outer rail" at the moment the two motifs are superimposed mirror images of each other, it will land exactly on top of the dark motif. In his lectures, Escher had a cardboard cutout exactly the shape of one motif in this pattern, with a long piece of rigid wire (a straightened coat hanger) through it, exactly in the position of the dashed lines in the illustration. He could then actually demonstrate to his audience this glide-reflection in which a (nonstop) combination of a translation (glide) and a reflection (flip) moves a motif to an adjacent one of contrasting

color. The mirror axis about which the moving motif is reflected after a glide is parallel to and halfway between the dashed lines.

The last pattern (lower right) shows motifs in four distinct directions, and all three motions are needed to move a given motif to any of the surrounding eight positions. If the chosen motif is labeled 1, for example, then translations move it to an adjacent one labeled 1, half-turns about the centers marked ○ move it to an adjacent one labeled 2, glide-reflections in the direction of the dashed lines move it to an adjacent one labeled 4, and glide-reflections in a direction perpendicular to the dashed lines move it to an adjacent one labeled 3. In his lectures, Escher also used a cardboard cutout to demonstrate the eight geometric motions for this most complex pattern.

With this knowledge of the geometric rules, Escher no longer needed to waste time in frustration, hoping to discover shapes that would interlock to fill the plane. He could now explore with confidence and purpose. Ultimately, his quest would result in his own systematic organization of the discoveries he made.

*D*eveloping a "layman's theory"

During the winter months of 1937–1938 Escher pursued regular division almost single-mindedly, working separately and simultaneously on three fronts: mathematical investigation, creation of regular divisions with recognizable motifs, and composition of graphic works using regular division of the plane. First, he was seeking to discover all of the possibilities for regular division, based on his own guiding principles. He posed and then sought to answer his own questions, and like any methodical investigator who breaks new ground, he found that sometimes the questions led to dead ends, sometimes they led to the same result from two different directions, and sometimes they yielded important and unifying insights to the large picture he was trying to fill in. He filled the pages of small copybooks with his trials and refined and changed his first tentative classifications as the larger picture became clear. The covers of two of the copybooks are labeled "'Theorie' Regelmatige vlakverdeeling"; in these he recorded a rough draft of his developing theory. They served as his reference manuals as he worked on his second goal: to create motifs of recognizable creatures to verify the applicability of his theory.

Two facing pages from Escher's first "Theorie" workbook are shown at the right. From the sketches, the many annotations, changes, and erasures, it is not hard to imagine how he worked and the way in which he developed the theory. Here he has, as any good scientific investigator might, invented a way to express symbolically a great deal of information in an extremely clear and concise manner. Words are hardly necessary to read the message.

On the left page, he is methodically cataloging the ways in which a motif, corresponding to a rhombus in a geometric grid, can be related to the eight congruent copies which surround it. He has marked each

rhombus with a hook to designate the direction of an asymmetric motif; noting the directions of the hooks in the rhombs is enough to describe the geometric motions that relate a single motif to those that surround it. The last scheme, shown at the bottom right of the page, has been scribbled out. Although the placement of hooks in its rhombs seems to be different from the other five schemes, Escher discovered that the geometric relationships between neighboring motifs here was the same as that of IV^B at the top of that column. In the scheme at the bottom of the page, each rhomb can travel horizontally to glide-reflect into an adjacent one of contrasting color and also can travel vertically to translate into one of the same color. In IV^B at the top of the page, rhombs glide-reflect vertically and translate horizontally to neighboring ones. Although the directions of the motions which relate adjacent rhombs in the two schemes are different, the motions themselves are the same. (Except for the exact shape of the rhombs, one scheme can be obtained from the other by a 90° rotation.) So the redundant scheme was noted as *gelijkwaardig* (equivalent) and scratched.

Escher's schematic description on the left page gives no visual information on the possibilities for a nongeometric shape for a motif in each system. On the right page, Escher shows regular division designs with asymmetric, congruent motifs, illustrating two of the schemes exhibited on the left page. The shape of the boundary of a single motif is only partially determined by the geometric motions for a given scheme: there are infinitely many artistic possibilities for portions of its outline. In both the upper and lower designs, Escher has labeled the endpoints of distinct portions of the boundary of a single motif and some of its adjacent copies with letters A, B, . . .

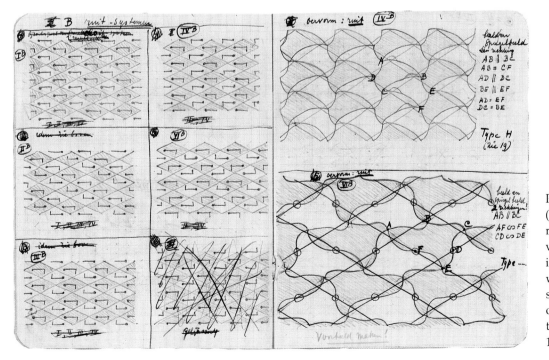

Pages in a copybook (with ''Theorie regelmatige vlakverdeeling I-O'' on its cover) from the winter of 1937–1938 show Escher working out his ''layman's theory.'' Pencil, 209 × 167 mm (page size).

In the upper design, first labeled Type H and later designated type IVB, his symbols ‖ and = do not mean "parallel" and "equal," as in standard geometric usage. Escher has assigned his own meaning to these symbols; if one associates sliding on tracks, the symbols are highly suggestive. Reading the sketch, we see that ‖ means "glide-reflect," and = means "translate." Two successive letters, such as AB, symbolize the portion of the boundary of a motif which joins point A to point B. The boundary which encloses a single motif and has points labeled consecutively A, B, C, D is characterized by the relationships: AB glide-reflects to BC and AD glide-reflects to DC. The relation of these portions of the boundary to those of the motif which adjoins below is noted by: AB translates into CF, AD translates into EF, and DC translates into BE. Escher also notes that the motif is in "one direction" ("één richting"), that is, there are no rotations, but the motif occurs in both direct and mirror image ("beeld en spiegelbeeld"). His numbered drawing 19 of birds (page 130), to which he refers, is a carefully drawn example of this type IVB with recognizable figures. This rough workbook sketch must have evoked that idea: Note his tentative suggestion of the head of a bird on some of the abstract motifs.

The lower design, labeled type VIB, has 2-fold rotation centers labeled with small circles; from this, his symbol **∽** in the list of boundary relations for a single labeled motif is clear. The characterizing relations are: AB glide-reflects to BC, AF half-turns into FE, CD half-turns into DE. Here Escher notes that in the design, the motif occurs in two directions (because of the 2-fold rotation), and in each direction, it occurs in both direct and mirror image. In red pencil he reminds himself, that for this pattern, he must "voorbeeld maken!" ("make an example"). For Escher, an example was an original design which obeyed not only the geometric constraints of one of his types but, in addition, consisted of recognizable figures, colored so as to fulfill the requirements that adjacent figures contrast and that colors are arranged compatibly with the symmetry of the design. Although his regular division drawing number 19 to illustrate the upper design of type IVB on this page was made in February 1938, it was not until July 1941 that he made an example, of snakes (page 144), to illustrate this type VIB.

The little copybooks Escher used were intended for young students; their covers feature Belgian boy scouts and the Red Cross. He filled their pages with sketches and ideas during the three years beginning in the winter of 1937–1938. These workbook pages are interspersed with trial ideas for abstract systems; one can see his theory developing and branching to consider other questions. In addition to exploring the possible systems of regular division of the plane with asymmetric motifs, he also investigated the possibilities with symmetric motifs. For him, this meant the motif had one or two mirror lines of reflection symmetry, like the letter M (one vertical mirror line) and the letter H (two mirror lines, one vertical, one horizontal). Although over the years he would make several regular division designs with symmetric motifs such as beetles and butterflies, he did not bother to record these investigations in the final version of his "Theorie." He had discovered that most designs with symmetric motifs required that the motifs have straight lines as portions of their boundaries; evidently in his view, this was not worth recording.

Recognition of individual motifs in a regular division of the plane was an unalterable requirement in Escher's theory, and this was achieved by color contrast of adjacent motifs. This consideration was an integral part of all his investigations. He also wanted to use a minimum number of colors in a regular division pattern to achieve this goal. Without realizing it, he engaged in pioneering research in a field that over twenty years later would be called by scientists "color symmetry." Realizing that some regular division designs required a minimum of three colors to conform to his coloring demands, he sought to find how such patterns could arise from simpler two-colored ones such as those shown on his copybook page. He developed a whole theory of "transitional systems," patterns of motifs which were derived through the alteration of part of the boundary of a motif in one of the simpler systems. Many of these transitional system patterns required a minimum of three colors. He also explored the ways in which a regular division of the plane with just one repeated motif could give rise to a design in which two different motifs could fill the plane, using the same geometric motions as the original design. The possible colorings of these two-motif designs were also explored.

By the winter of 1940–1941, Escher had filled out his theory to an extent that he decided to record his systematic findings carefully, all in a single notebook. In January 1941, he labeled the cover of a large notebook of squared paper, "Regelmatige Vlakerdeeling in asymmetrische congruente veelhoeken" ("Regular division of the plane with asymmetric congruent polygons") and, in it, set out his theory of "quadrilateral systems." A year and a half later, in October 1942, he added the results of his investigations into colored regular divisions of the plane based on what he called "triangle systems." Those designs have 3-fold and 6-fold rotations and are based on an underlying grid of equilateral triangles. In our next chapter, this notebook is reproduced in its entirety.

It is impossible to look at this notebook and not conclude that in this work, Escher was a research mathematician. Yet his poor performance as a mathematics student in school and his choice of the graphic arts, not science, as his profession left him feeling mathematically insecure, convinced that he was devoid of any ability to understand mathematics. In his acceptance speech for the Culture Prize of the city of Hilversum in 1965, he confessed, "At high school in Arnhem, I was extremely poor at arithmetic and algebra because I had, and still have, great difficulty with the abstractions of numbers and letters. When, later, in stereometry [solid geometry], an appeal was made to my imagination, it went a bit better, but in school I still never excelled in that subject. But our path through life can take strange turns." He seemed amazed that his interests had led him to cross the border into the domain of mathematics and that he felt an affinity for mathematicians. His son George, who is an engineer, perhaps better understands the reasons for this affinity.

Father had difficulty comprehending that the working of his mind was akin to that of a mathematician. He greatly enjoyed the interest in his work by mathematicians and scientists, who readily understood him as he spoke, in his pictures, a common language. Unfortunately, the specialized

language of mathematics hid from him the fact that mathematicians were struggling with the same concepts as he was.

Scientists, mathematicians and M. C. Escher approach some of their work in similar fashion. They select by intuition and experience a likely-looking set of rules which defines permissible events inside an abstract world. Then they proceed to explore in detail the consequences of applying these rules. If well chosen, the rules lead to exciting discoveries, theoretical developments and much rewarding work. [1986, p. 4]

Sources that came too late

Escher never was a follower of artistic trends, but he often felt isolated as he pursued his work with regular division. In *Regelmatige vlakverdeling*, he asks,

> If it counts as art, why has no artist—as far as I have been able to discover—ever occupied himself deeply with it? Why am I the only one captivated by it? I have never read anything about the subject by any artist, art critic or art historian; no encyclopedia of art history mentions it, no fellow-artist or predecessor has ever been seriously involved in it. There have been a few sporadic instances of products of decorative art that share the same roots, which I shall mention later and discuss, but these are rudimentary and embryonic. They do not arise from profound reflection and therefore do not penetrate to what I consider to be the essence of the matter.

There were artists whose work was precursor to Escher's regular divisions of the plane with recognizable figures. From about 1890 to 1905, the popular Art Nouveau, called *Jugendstil* in Germany, *Secessionsstil* in Austria, and *Nieuwe Kunst* in Holland, rejected the art of the Academy and gave attention to gracious and dashing decorative art which often took its inspiration from nature. In Vienna, one of the leading figures was Koloman Moser, an artist and teacher who was a founder of the Wiener Werkstätte (The Vienna Workshops), the school of decorative art which advocated this style. He produced many designs for wallpaper, tapestries, gift-wrapping paper, book endpaper, and fabric that were clever interlockings of stylized forms from nature: fish, birds, flowers, and leaves.

Although it seems reasonable to assume that Escher would have learned about the work of Koloman Moser as part of his studies at the Haarlem School, that seems not to have been the case. The form of study (reported by Escher in his essay on de Mesquita) was one of tutoring and apprenticeship in a particular chosen field of study; for Escher, this was the graphic arts, with de Mesquita as his primary mentor. De Mesquita was counted among those prominent in the Nieuwe Kunst movement, and Escher's student work reflects his experimentation with a variety of styles and techniques which can be found in the work of other Nieuwe Kunst artists, including R. N. Roland Holst, whose posters he greatly

admired. The book *Nieuwe Kunst,* by L. Gans, makes clear that the Dutch "New Art" was markedly different from that in France and Germany, and at least in the early stages of the movement, the English artists and designers (including Lewis F. Day and Walter Crane) seem to have had greater influence.

> In France decorative art is strongly influenced by literary Symbolism, the art of the Nabis and the Synthetists. In German decorative and applied art one also feels continuously the influence of the contemporary art of painting and drawing, particularly in the frequent use of female figures which in symbolic scenes must *mean* something. . . . In the field of Dutch applied art one cannot speak of such an influence of the art of painting. The painter's quest for sentimental imaginings and the craftsman's search for form exist side by side. The activities of the latter therefore, do not cease when about 1900 the art of painting has lost much of its strength. [p. 103]

Gans points out that while Art Nouveau was essentially defunct by 1905 in Belgium, France, Austria, and Germany, in Holland, the artists and designers born near or in the decade 1870–1880 gave fresh impetus to the movement: "together they allowed themselves, again, the liberty to search for principles of their own. . . . The inspired movement of these artists of the seventies has been greatly instrumental in determining that Art Nouveau in 1910 and even in the twenties is still apparent as an uncomplicated, sparkling, and cheerful style of applied art in the Netherlands." [pp. 104–105] De Mesquita (born 1868) was one of these artists of the seventies; a co-worker at 't Binnenhuis (The Interior) in 1900 and at De Woning (The Dwelling) in 1902, his experiments with batik fabric printing, woodcuts, and other graphic techniques continued throughout his years at the Haarlem School (1902–1926). His ideas would have had the greatest influence on Escher.

During Escher's years at Haarlem, the foremost avant-garde art movement was Constructivism, which in Holland was known as De Stijl (The Style), with Piet Mondrian as a leading proponent. Escher was no doubt aware of this new direction; there is strong geometric character in some of his student work. A few of his woodcuts show experiments with the faceting of cubism and one linoleum cut bears a strong resemblance to the composition with rectangular forms on the cover of the first issue of the magazine *De Stijl.* His interest in geometric form continued in more subtle ways than those advocated by Mondrian, whose carefully constructed geometric partitions achieved a precise balance of "unequal but equivalent oppositions" of form and color. Although Escher later also insisted on a balance of opposing forms of contrasting color, he strongly rejected abstract geometric shapes and insisted on recognizable forms even in his constructed worlds of fantasy.

Over and over again, in his articles, books, and lectures, Escher reported that he had searched for examples of regular division of the plane, but with the exception of the Islamic craftsmen and Japanese and Chinese pattern makers, who all limited themselves to purely geometric designs, he found none. Moreover, he openly invited the readers of art periodicals to inform him of any examples of art employing regular divi-

devoted to the theory of regular division of the plane, *Flächenschluss* (1963), by the German mathematicians Heinrich Heesch and Otto Kienzle. Although an article written in 1933 by Heesch had been on the list provided to Escher by Beer in 1937, that paper was highly theoretical and its diagrams (meant to be schematic) showed symmetric simple geometric figures—not what Escher was seeking. In 1932, Heesch, as a student of Andreas Speiser, had investigated and classified the possible shapes of tiles that could fill the plane in a regular manner, but this work was first published in his book in 1963.

Heesch had also methodically investigated what he called "reciprocal ornament"; these were regular divisions with two colors in which some of the symmetries of the pattern interchanged the colors. He had even seen some of his designs for wall tilings, fabric, and other items produced for exhibit at the 1937 Leipzig Fair. Like Escher, Heesch only considered asymmetric tiles in his classification; moreover, his schematic description of possible shapes to fill the plane was based on how the motions of translation, rotation, and glide-reflection of an individual tile related it to the tiles that surrounded it.

On June 20, 1963, Heesch sent Escher a lengthy letter, expressing admiration for the artist's work published in *Grafiek en tekeningen* and telling the story of his own investigations on regular division. He included a chart of his classification (see page 326) as a sample from the book and indicated that he would like to send the book to Escher; he mentioned that he also hoped to produce a future version of the material "in the language of the artist." Although Escher was then in a hospital recovering from yet another operation, he replied immediately. "The contents of your letter interested me very much," he wrote, but then added, "You are mistaken when you see in me an accomplished theoretical mathematician; however, I often deal with crystallography. I'm always crossing the border between mathematics and art." From Heesch's symbolic chart, Escher had decided that the book was far too hard for him to understand and in typical forthright fashion told Heesch that he would rather wait for the edition for the artist. Heesch sent him the book anyway; the edition in the language of the artist never materialized.

Heesch's classification system is one of several that we have noted in the Concordance at the back of this book. Since his characterization of asymmetric tiles that can fill the plane in a regular manner is, among all those that appear in the scientific literature, most similar to Escher's own, we have included his chart of classification.

Other experiments in regular division

At the same time Escher was developing his "layman's theory" of regular division of the plane, he also carried out extensive experiments in creating regular patterns in the plane using one or two squares containing simple line designs. In 1938 he carved two small square woodblocks, one the mirror image of the other, with a design of three straight bands crossing each other in an asymmetric manner and portions of bands at two of the corners. The carved bands touched each corner of the square

Design on carved square block and mirror image, 1938. Shown actual size.

and also touched the middle of the edges of the square; when the square block was printed in any of its positions to fill out a grid of squares, the contiguous images created seamless, rhythmic, plane-filling patterns.

For one carved block, Escher used the labels 1, 2, 3, 4 to indicate the four positions of its printed design made by repeatedly rotating it 90°; similarly for the second carved block, he labeled the four mirror images of these 1, 2, 3, 4. His scheme to create a regular all-over pattern using one or both of the carved blocks was to first choose a square arrangement of four of these numbers, such as

$$1 \quad 2$$
$$2 \quad 1$$

and then print a trial design of four adjoined copies of the block, according to the configuration dictated by the numbers. The larger square design was then to be repeated by translation (right and left, up and down) to fill out a page with a periodic pattern. Escher's copybook of 1938 shows several trial designs with their identifying number schemes.

Other trial designs printed with these carved blocks occur in several of Escher's little workbooks from 1938–1942. There are also several sketches of other designs for a single square and sketched trials of their repeating patterns; he returned to his experiments with combinatorial designs several times during these years. Using one or both of the blocks carved in 1938, he eventually made over thirty carefully printed patterns, each a square with nine repetitions of a design corresponding to a particular square array of four numbers—36 repetitions of a printing block. A very graphic explanation of a simple way to create similar printed patterns based on his father's method is given by George Escher in his article "Potato-Printing, A Game for Winter Evenings." [1986, pp. 9–11]

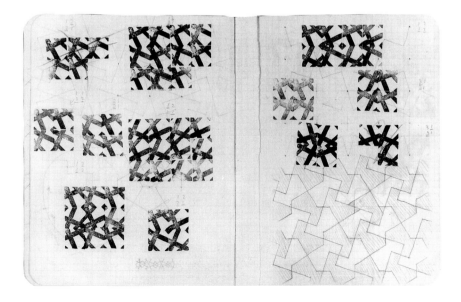

Trial designs printed by Escher in 1938 with his carved square blocks. The number array for each design is penciled next to it. A sketch that was the source for drawing 20 is also on the copybook page. 210 × 165 mm (one page).

Escher used two simple line designs in a square to determine the number of different designs possible using repeated arrays of four numbers; these date from 1942.

In addition to sketching simple patterns and hand-printing patterns in his workbooks with his little carved blocks, Escher experimented with decorated square tiles that he cut out of wood. He printed each tile with two different designs, one on the top face and the other on the bottom, one black and one red, and then hand-colored them with blue. Each design was carefully crafted to match on every side of the square; the edges of each tile were numbered 1, 2, 3, 4. With these, Escher could quickly arrange tiles into formation and view the result of a particular arrangement. His goal was similar to that achieved in his notebook on regular divisions with asymmetric polygons—to classify and enumerate all possible patterns created by a square tile according to his rules. This method of investigation was not only efficient, but also an excellent means to discover or verify by visual experiment his catalog of possible patterns.

In 1942, Escher collected some of his findings in a ring binder; its cardboard cover bears the title "Attempt at systematization and characterization of the number of possible arrangements of two types of square tiles, the one being the mirror image of the other." These notes show two systematic enumerations of the distinct patterns that could be created according to his numerical scheme described above, using a simple asymmetric line design in a square. One enumeration used just one line segment which joined the corner of a square to the midpoint of an opposite side, while the other used a v which connected the corner of the square to the midpoint of an adjacent side (see the illustration at left).

Using these simple motifs, Escher drew the designs that corresponded to repetitions of square arrays of four numbers and, in so doing, quickly discovered that different number schemes often gave rise to the same all-over pattern. For example, each of the four arrays

$$
\begin{array}{cccc}
1\ \ 1 & 1\ \ 1 & 1\ \ 2 & 2\ \ 1 \\
1\ \ 2 & 2\ \ 1 & 1\ \ 1 & 1\ \ 1
\end{array}
$$

yield the same all-over pattern when repeated, since each generates a pattern with alternating rows: . . . 1 1 1 1 1 1 . . . and . . . 1 2 1 2 1 2 1. . . . It might seem that Escher only needed to discover how many different square arrays of four numbers would lead to the same all-over

Printed and hand-colored wooden tiles, c. 1943. 22 × 22 mm (single tile). The numerical array for each design is given.

| 1 1 | 3 3 | 1 1 | 2 4 |
| 1 1 | 3 3 | 4 4 | 4 2 |

numerical pattern; this is what mathematicians call a purely combinatorial problem. But Escher's scheme of linking the numbers to the four positions assumed by a single marked square gave the problem geometric as well as combinatorial aspects. For example, the two arrays

$$
\begin{array}{cc} 1 \quad 1 & 1 \quad 2 \\ 2 \quad 2 & 1 \quad 2 \end{array}
$$

lead to all-over patterns of numbers which are related by a 90° rotation: one has rows of 1s and rows of 2s alternating while the other has columns of 1s and columns of 2s alternating. But the two corresponding geometric designs generated by one of Escher's marked squares are quite distinct: a 90° rotation of one of these designs does not change it into the other (see the illustration at right).

In addition, some completely different arrays of four numbers yield the same design because of the rotation symmetry which relates the four positions of a marked square. For example, the numbers 1 and 3 represent positions of a marked square that are 180° rotations of each other and the pair 2 and 4 are related in the same manner. Thus the two arrays

Two designs with Escher's second motif with their corresponding number arrays.

$$
\begin{array}{cc} 1 \quad 1 & 3 \quad 3 \\ 1 \quad 2 & 3 \quad 4 \end{array}
$$

generate exactly the same all-over pattern.

In each of his two enumerations with marked squares as shown in the illustration on page 46, upper left, Escher found that 23 distinct all-over patterns could be created according to his method using square arrangements of four numbers chosen from 1, 2, 3, 4; these patterns each used just one marked square in various positions. He catalogued 47 distinct patterns which used a marked square and its mirror image. For these, he chose two of the numbers for the square arrangement from 1, 2, 3, 4 and two from 1, 2, 3, 4. There were ten types when both choices were repeated numbers (e.g., 1, 1, 2, 2) and 37 types when both were different numbers (e.g., 1, 2, 2, 3).

In May 1942 Escher created printed designs with a new carved motif of straight bands meeting each other at right angles and tilted in a square. The designs illustrate each of his 23 distinct possible types of patterns requiring just one printing block. This motif divided the square block on which it was carved into six closed regions; after printing the designs, Escher added color to some of the regions following his usual rule—adjacent regions must be of contrasting color (see the illustration at right). In the patterns printed according to Escher's method described above, the light-colored areas formed enclosed regions with right-angled corners, and the dark-colored areas appeared as background. The all-over patterns showed black-outlined light-colored rectangles, zigzags, L and U shapes, marching in formation against a dark ground. Guided by more complex number schemes, Escher created a few other printed designs with this single carved block in addition to these illustra-

Design in square for printed patterns based on number arrays, May 1942. Shown actual size; coloring shown on one.

Designs on carved square blocks resemble portions of interlaced yarn, 1943. Each block is 2 × 2 cm.

tions; he also made some printed patterns using the block and its mirror image. His copybooks show that he attempted to link these patterns as well as his first printed patterns to the classification in his "layman's theory."

Escher's first printed designs in 1938 gave the appearance of overlapping continuous black bands; these no doubt suggested to him patterns of real ribbons or yarn, which are most often interlaced in intricate ways. In 1943, he carved two square woodblocks with different motifs and two more with their mirror images (four blocks in all). Each of these two blocks was based on a simple design of curves which (like his first carved motif) touched corners and centers of the edges of the square. This time, the carved bands were outlined and given shading to appear like yarn and showed over-under interlacing; the two carvings differed only in over-under crossings of the "yarn." Following the same method as before, Escher used these blocks to create several patterns. In these, single strands of "yarn" appear to be knitted or crocheted together. Some were hand-colored as well, giving the appearance of two or more strands of interlaced yarn of different colors.

Sometime later, Escher carved new square woodblocks based on his very first motif of straight bands; as with the "yarn" motif, the bands were now carved in outline, and showed the character of real ribbons overlaying one another. Four carved blocks were needed to capture the possibilities of over-under for the ribbons and each of the four blocks could be printed in four different positions; thus, there were sixteen distinct ways of printing a single blank square. Escher printed more than 30 interlaced patterns with these and hand-colored the printed designs so that ribbons are of a single continuous color and ribbons which interlace are different colors. Many of these colored printed patterns were exhibited together with a poster which explained how they were created using the number schemes.

Left: The geometric construction of the "ribbon" design. Shown actual size of carved block. Right: Designs of four carved "ribbon" blocks, each in four positions, with Escher's number labels.

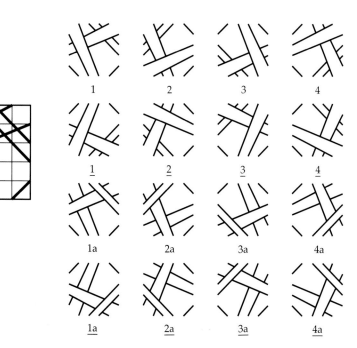

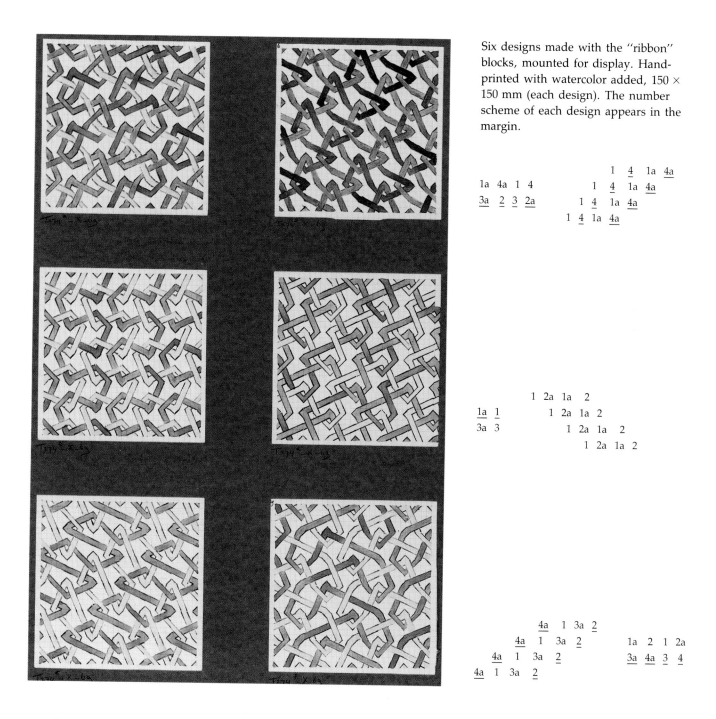

Six designs made with the "ribbon" blocks, mounted for display. Hand-printed with watercolor added, 150 × 150 mm (each design). The number scheme of each design appears in the margin.

```
                    1    4    1a   4a
1a  4a  1   4          1    4    1a   4a
3a   2  3  2a            1   4    1a   4a
                          1   4   1a   4a
```

```
              1  2a  1a   2
1a   1        1  2a  1a   2
3a   3          1  2a  1a   2
                  1  2a  1a   2
```

```
          4a   1  3a   2
        4a   1  3a   2              1a   2   1   2a
      4a   1  3a   2                3a   4a   3    4
   4a  1  3a   2
```

In 1943–1944, Escher carried out one other investigation of special tilings of the plane of a very different nature from the numerical method with square blocks. His copybooks from this period are filled with many trial ideas for designs in a 3:4:5 right triangle; the sketches on the pages shown on page 50 are typical. They clearly show his idea of having the curves in such a design meet the edges of the triangle in a regularly spaced manner; by carefully matching edges or portions of edges of the triangles, continuous flowing designs could be made. A ring binder

Some of Escher's trial sketches for designs in a 3:4:5 right triangle to print plane-filling patterns, 1944. Pencil, ink, 210 × 170 mm (one page).

dated July 1944 contains a collection noted as incomplete by Escher—19 examples of all-over patterns printed with a motif in a 3:4:5 right triangle block. Carved in image and mirror image, this motif is similar to some of his sketched trial designs.

Before creating printed designs with the carved triangular blocks, Escher investigated, in his usual methodical fashion, the various ways in which a right triangle could fill the plane in a "regular" manner, allowing both direct and mirror images. Each of the 19 pages of the 1944 ring binder shows a single printed all-over pattern containing 32 images from one or both of the carved triangular blocks; in the corner of each page is a small pencil drawing of the triangle tiling on which the printed pattern is based. Often Escher added a third color by hand to the printed black-and-white design.

Although the 19 patterns created by printing the triangular blocks are visually quite distinct, several of them are variations on the same geometric tiling. For example, if one begins with a tiling by strips of parallelograms diagonally bisected into triangles, in which all the edges of the triangles exactly match, then a new periodic pattern can be created by shifting parallel strips by the same amount, so that the parallelograms are uniformly staggered. Many of Escher's patterns are related in this manner; the first two are illustrated on the facing page along with their underlying triangle tilings. It is known that there are seven geometrically distinct periodic tilings of the plane by an arbitrary right triangle in which each triangle is surrounded in exactly the same way; Escher's collection of printed designs contains all of them.

Another ring binder dated August 1944 notes Escher's enumeration of distinct periodic tilings by copies of an arbitrary (i.e., general) triangle; 10 carefully drawn illustrations of tilings by the same triangle, with adjacent triangles colored in contrasting blue and gray, accompany the description of his findings. Here he tabulates four distinct types of tiling by an arbitrary triangle and links them to his "Theorie" classification.

One type shows half-turn centers at the midpoints of all three sides of each triangle, one has half-turn centers at the midpoints of two sides and a reflection in the third side of each triangle, and two types have a half-turn center at the midpoint of one side and glide-reflections in the directions of the other two sides of each triangle. His 10 different-looking tilings with the same triangle arose from the four types by considering all possible choices for the location of the half-turn centers. In this enumeration, Escher missed two other types of tilings by an arbitrary triangle; these are the ones obtained by uniformly shifting each of the infinite strips of parallelograms that occur in his first two types of triangle tilings. He had many examples of these missing types in his printed tilings based on right triangles; it is not clear why he omitted them for this more general case. (Information on various tilings of the plane by a single triangle can be found in the book *Tilings and Patterns,* by B. Grünbaum and G. C. Shephard.)

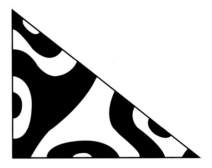

Design in a 3:4:5 right triangle to create plane-filling patterns based on triangle tilings.

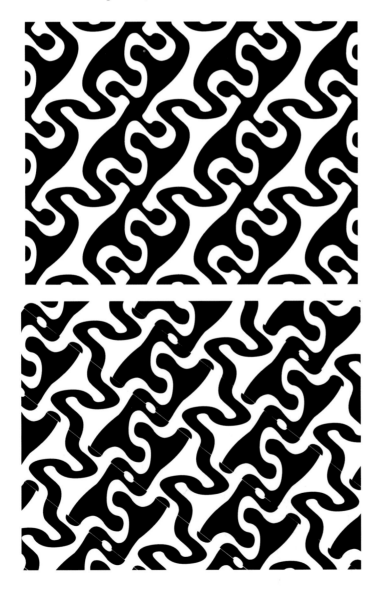

Illustrations of two of Escher's patterns, together with their related triangle tilings.

Design on carved hexagon-shaped block. Shown actual size.

Escher also carved a wood printing block shaped like a regular hexagon. It contained a symmetric design of crossed straight bands; the center of each side of the hexagon was touched by one band. Evidently he explored all-over patterns created by printing contiguous images of this motif in the familiar honeycomb pattern which fills the plane.

Escher engaged in a variety of other investigations of regular patterns in the plane in connection with designs for commissioned work as well as his own work. For example, he explored patterns with layered, or overlapping, motifs (for etched glass and for bank-note background; see drawings A3 and A6), moiré patterns, and line designs (for banknote background; see drawings A9, A10, and A11) and he also investigated patterns of entwined circles (see drawing A8 and pages 92–93). These latter designs were the basis for some periodic drawings; they also appear in postal-stamp designs as intertwined postal horns, and they form an intricate web in his last graphic work, *Ringsnakes*. These various investigations were each limited to specific design problems; he made no other systematic attempts at cataloging particular regular divisions of the plane.

CHAPTER 2

The 1941–1942 Notebooks

pared with that developed by mathematicians and crystallographers. The Concordance at the end of the book gives further comparative information of a more technical nature.

In addition to the theory notebook, Escher kept another notebook of the same size to collect finished regular division drawings with purely geometric motifs, as well as some geometric studies that were preparatory to making some regular division designs with special properties. Entitled "Regular Division with abstract motifs and geometric problems," its pages are reproduced here, following the notebook. It begins with 11 colored drawings of geometric regular divisions of the plane which are dated from September 1941 to October 1942. One of these is Escher's 1926 design for the majolica-tiled floors for the apartment and studio in Rome, together with a detailed scheme of the layout for the tiles.

Following the colored design numbered 11, there are two theorems, each a purely geometric claim about three particular lines in a polygon intersecting in a single point. These are no doubt Escher's own discovery; there are no references and no proofs. The second theorem makes an observation about the concurrency of the diagonals of a special hexagon that Escher had learned about in Haag's papers; those papers, however, make no mention of this property. Escher even wrote to ask his son George, then a student at the University in Delft, if he could prove the statement. George found a better construction of the hexagon, but could not prove his father's observation about the diagonals.

Two pages of carefully drawn designs follow; they are in two or three colors and display, in addition to kaleidoscopic symmetry, the property that the motifs diminish in size in a regular manner as they approach the center of the design. The last two pages are devoted to studies of interlaced circles based on an underlying square grid. Escher made several other color studies of interlaced circles based on an underlying grid of equilateral triangles; some that were inserted between the pages of this notebook are also reproduced.

The folio notebooks collection of regular division drawings with "recognizable" motifs is reproduced in Chapter 3.

[Notebook cover title]

Regular Division of the plane into asymmetric congruent polygons

I Quadrilateral Systems

MCE

I-1941

Ukkel

II "Triangle" systems

X-1942

Baarn

[Title page]

Regular Division of the plane into Asymmetric congruent polygons

I) based on *quadrilaterals* pp. 1–29

a) with a minimum of 2 contrasting colors and one motif

b) with a minimum of 3 contrasting colors and one motif
(transition from one system to another)

c) with a minimum of 2 contrasting colors and two motifs

II) based on *"triangles"*; i.e.
systems in which 3- or (and) 6-fold axes
occur

The fold-out overview Escher's overview diagram (next page) gives a succinct visual summary of his classification of 24 types of two-color tilings with one motif. His classification system for "regular divisions of the plane based on quadrilaterals" depends on two characteristics of such a tiling: the type of polygon in the underlying geometric lattice (letters A, B, C, D, E) and the geometric transformations that relate a single motif to its neighboring motifs (Roman numerals I through X). The letter A denotes an arbitrary parallelogram (that is, two sides and their enclosed angle may be chosen in any way); B any rhombus, C any rectangle, D a square, and E an isosceles right triangle. In the overview diagram, each individual polygon in a tiling represents a single motif whose area equals the area of the polygon. The geometric transformations which send a motif onto neighboring ones can be inferred from the markings inside the polygons and on their boundaries. Centers of half-turns (2-fold axes) are marked with small circles and centers of quarter-turns (4-fold axes) with small squares. The hook placed in each polygon keeps track of the direction and orientation (image or mirror image) of the motifs in a tiling. Escher's assumption that motifs are asymmetric necessitates such marking in a representation using polygons which possess additional symmetry. This hook used to mark the tiles is evidently Escher's own creation; none of the technical papers on B. G. Escher's list uses such a marking in tilings. Instead, small circles (or in one case, the symbol ♪), placed off-center inside a polygon tile, serve the purpose of Escher's hooks.

Summary chart, lower half of page 2 On this chart, Escher interprets the symbolic markings seen in his fold-out overview and outlines in words the geometric transformations that characterize each of the ten systems I to X. For each system, he notes the number and location of 2-fold and 4-fold centers of rotation on the boundary of any single motif in a tiling of that type, as well as the directions in which translations or glide-reflections move a single motif to an adjacent one. In each tiling, every polygon shares a common boundary with surrounding polygons of con-

Overview of 10 asymmetric polygon systems, based on 5 groups of quadrilaterals with a minimum of 2 contrasting colors and one motif

A Parallelogram	I^A	II^A	III^A						
B Rhombus	I^B	II^B	III^B	IV^B		VI^B			
C Rectangle	I^C	II^C	III^C		V^C		VII^C	VIII^C	
D Square	I^D	II^D	III^D	IV^D	V^D	VI^D	VII^D	VIII^D	IX^D
E Isosceles right triangle									X^E

trasting color and touches others of the same color at its corners. Translations and glide-reflections in a *transversal* direction move a motif to an adjacent one of contrasting color; the direction is parallel to a side of the quadrilateral that represents the motif. Those in a *diagonal (diametrale)* direction move a motif to one of the same color that touches a corner; the direction is parallel to a diagonal of the quadrilateral that represents the motif. Escher uses red lines to separate his ten systems into five groups; the geometric transformations constraining the patterns within each group are the same. His five "groups" correspond exactly to the five symmetry groups of periodic plane patterns that do not contain reflections or three-fold rotations. The association is as follows: I, *p1;* II, III, *p2;* IV, V, *pg;* VI, VII, VIII, *pgg;* IX, X, *p4.*

Transitional systems, pages 1–2 Here Escher briefly explains his method of relating the "minimum two-color" tilings in his ten systems to "minimum three-color" tilings. In all ten systems, an even number of motifs come together at any vertex, and so two colors suffice to distinguish adjacent motifs. New periodic tilings may be derived from these by a process of "transition," in which a piece of the boundary of each motif undergoes the same modification. The new tiling obtained in this manner has a single motif but requires three colors to distinguish adjacent motifs; Escher calls it a "transitional system." The geometric transformations which relate adjacent motifs in the new tiling are the same as those in the original tiling, but the placement of rotation centers and directions of translations and glide-reflections with respect to the boundary of the new motif are not the same as with respect to the original motif. Further modification of the motif (using the same process) can lead to another new tiling requiring only two colors to distinguish motifs; it is one of Escher's ten systems. In this manner, one may begin with a two-color tiling, create a transitional system requiring three colors, and end with another of the two-color systems. Escher labels the three-color transitional system obtained by this process with a hyphenated classification symbol, such as I^B-I^A, which identifies beginning and ending systems.

His schematic chart at the top of his page 1 (right page) shows the most common directions in which the transition process can take place. Since his five groups of system types correspond to five different symmetry groups of periodic tilings, and since the transition process preserves the symmetry group (in fact, uses the symmetries in the process), system types within any one group may be transformed to others in that group. However, it is impossible to begin with a system type in one group and end with a system type in a different group.

Examples of transitional systems, pages 3–18 Escher carefully records illustrations of the transition process for many pairs of system types in each of the five groups. Only on the first page of examples does he briefly explain how to follow the process in the picture. After that, except for a few special observations, words cease and pictures alone tell the story. In each demonstration, he outlines in red one polygon of the underlying geometric lattice of the two-color system.

On page 3, Escher carefully demonstrates the process of transition between two of the simplest systems, I^A, with underlying geometric lattices of parallelograms. In system I^A, translations parallel to the sides of the parallelograms move motifs to adjacent ones of contrasting color, while translations parallel to the diagonals of the parallelograms move motifs to ones of the same color that touch at a corner. The points labeled A, B, C, D are the same in his figures 1, 2, and 3; B and D are vertices of all three tilings. The transition process uses point A (which is on the boundary of a tile in figure 1) as a pivot point to transform the piece of the boundary which joins A to B into a new piece, which joins A to C. In figure 2, every motif in figure 1 has been modified in exactly the same way as described for the single motif; now three tiles meet at points B and D, and C is a new vertex of the tiling where three tiles also meet. The polygons in figure 2 have three pairs of parallel "sides," and are sometimes called par-hexagons. This I^A-I^A tiling requires three colors

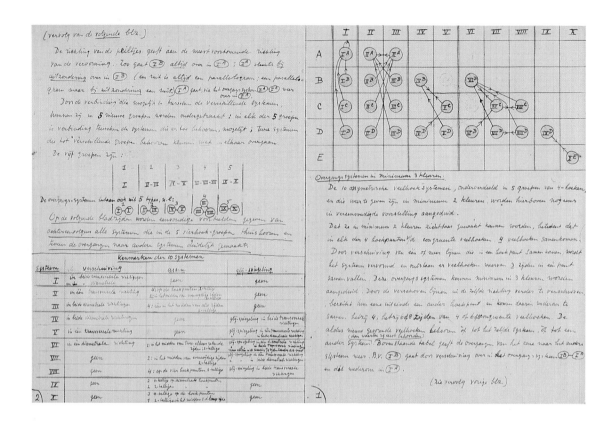

Transitional systems with a minimum of 3 colors.

[Escher's text begins on the right page and continues on the left page.]

The 10 asymmetric polygon systems, subdivided into 5 groups of quadrilaterals, which can be made with a minimum of 2 colors, are given once more above in a simplified representation.

That they can be made visible with a minimum of 2 colors means that at each of the 4 vertices of the congruent polygons, <u>4</u> polygons meet. By moving one or more lines that meet at a vertex, the system is transformed and there arise polygons of which <u>3</u> sides meet in a point. These transitional systems can be made visible with a minimum of 3 colors. By moving the shifted lines further in the same direction, their one end reaches another vertex in which again either 4 or 6 or 8 sides of 4 or 6 or 8 congruent polygons meet. The thus newly formed polygons belong either to the same system or to a system different from the one they first belonged to. The above table shows the transitions from one system to another. E.g., I^B changes by shifting into the transitional system I^B-I^A and this again into I^A.

(see continuation on previous page).

(continuation of the *next* page)

The direction of the arrows indicates the most common direction of the transformation. Thus, I^B *always* changes into I^A; I^A only *exceptionally* into I^B (a rhombus is *always* a parallelogram; a parallelogram only *exceptionally* a rhombus). I^A, via the transitional system I^A-I^A changes back into I^A. Because of the connections that are possible between the different systems, they can be classified into 5 new groups: in each of the 5 groups it is possible to connect the systems within a group; two systems that belong to different groups cannot change into one another. The five groups are:

1	2	3	4	5
I	II-III	IV-V	VI-VII-VIII	IX-X

The transitional systems also consist of 5 types, viz.:

1	2	3	4	5
I-I	II-III	IV-V	VI	IX-X
			VII—VIII	

[Translation of summary chart, lower half of page 2]

On the following pages simple examples are given successively of all systems that belong in the 5 quadrilateral groups, and also the transitions to other systems are made clear.

Characteristics of the 10 systems

system	[direction of] *translations*	[location of rotation] *axes*	[direction of] *glide-reflections*
I	in both transversal directions and in both diagonal directions	none	none
II	in one transversal direction	4: on the vertices, 2-fold 2: in the centers of parallel sides, 2-fold	none
III	in both diagonal directions	4: in the centers of all sides, 2-fold	none
IV	in both diagonal directions	none	glide-reflection in both transversal directions
V	in one transversal direction	none	glide-reflection in one transversal direction glide-reflection in both diagonal directions
VI	in one diagonal direction	2: in the centers of two adjacent sides; 2-fold	glide-reflection in one diagonal direction glide-reflection in both transversal directions but only in the direction of the sides without rotation point
VII	none	2: in the centers of parallel sides, 2-fold	glide-reflection in one transversal direction glide-reflection in both diagonal directions
VIII	none	4: on the four vertices, 2-fold	glide-reflection in both transversal directions
IX	none	2 4-fold ones on diagonal vertices 2 2-fold ones on diagonal vertices	none
X	none	3 4-fold ones on the vertices 1 2-fold one in the center of the hypoteneuse	none

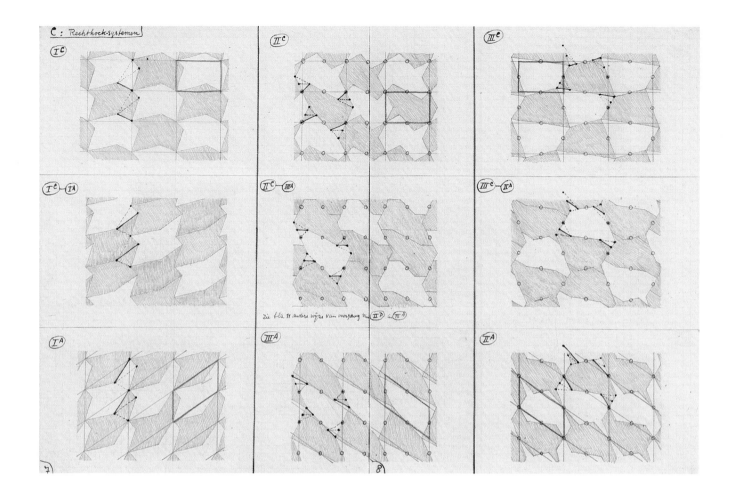

C: Rectangle systems

IC	IIC	IIIC
IC-IA	IIC-IIIA	IIIC-IIA
	see p. 11 for another way of transition from IID to IIIA	
IA	IIIA	IIA

Escher's transition process for systems IIA and IIIA is on page 4. Here, motifs are related to adjacent ones by half-turns or by translations. The two systems are distinguished by the position of half-turn centers on the boundary of each tile. In IIA, every vertex of a tile is a half-turn center, as well as the midpoints of two opposite sides, while in IIIA, midpoints of all four sides, but no vertices, are half-turn centers. At the top of the page, the same IIA tiling is shown twice. In the transition from IIA to IIIA on the left, the process explained on page 3 is applied to one piece of the boundary of a tile; this also modifies another piece related to

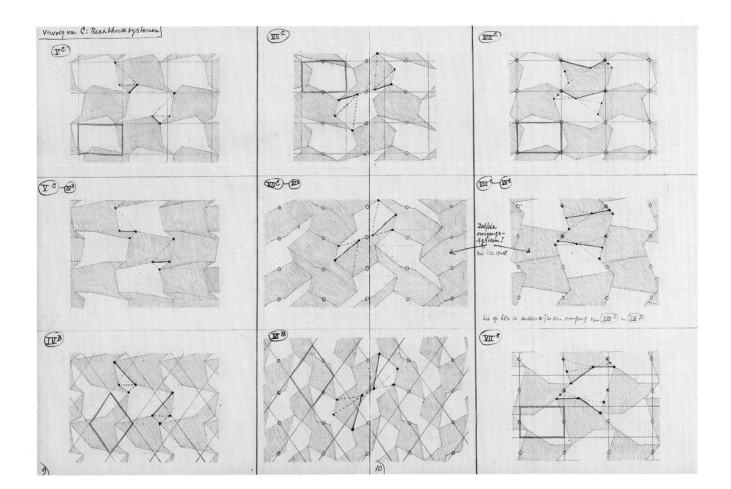

continuation of C: Rectangle systems

VC	VIIC	VIIIC	
VC-IVB	VIIC-VIB	same transitional system! see pp. 17–18	VIIIC-VIIC
		See p. 14 for another way of transition from VIIID to VIID	
IVB	VIB	VIIC	

this one by a half-turn. Each tile in the transitional tiling IIA-IIIA in the center left panel has half-turn centers at two vertices and at midpoints of three of its five sides. Continuing the transition process leads to a IIIA tiling with two special properties: The tiles have just three sides, each with a half-turn center, and the underlying parallelogram happens to be a rectangle. In the transition in the right column on page 4, Escher makes separate modifications on two opposite edges of the original tile; this leads to a transitional tiling IIA-IIIA in which each tile has six edges, four of which have half-turn centers at their midpoints. On this single

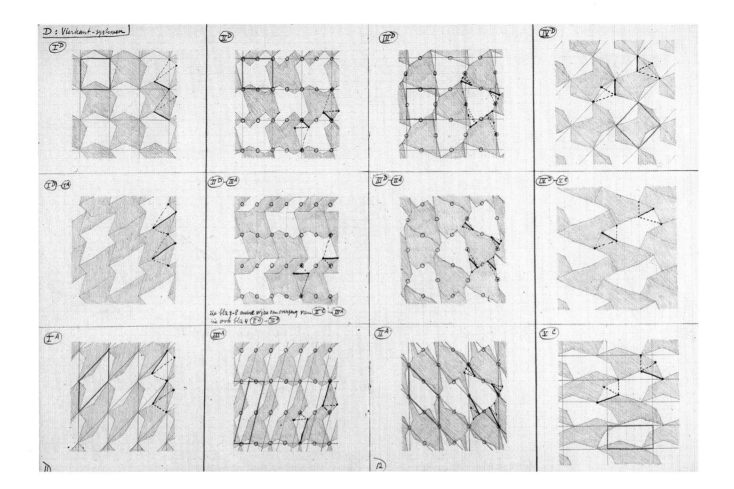

D: Square systems

I^D	II^D	III^D	IV^D
I^D-I^A	II^D-III^A	III^D-II^A	IV^D-V^C
	See pp. 7–8 for another way of transition from II^C to III^A see also p. 4 II^A-III^A		
I^A	III^A	II^A	V^C

page, Escher has an example of each of the five possible isohedral types of asymmetric tiles which can tile the plane using only half-turns [Schattschneider 1980]. Moreover, he shows how each can be obtained from any of the others by his transition process. Curiously, he never made an example with recognizable motifs of the transitional system II^A-III^A in the left column, in which each tile has five sides.

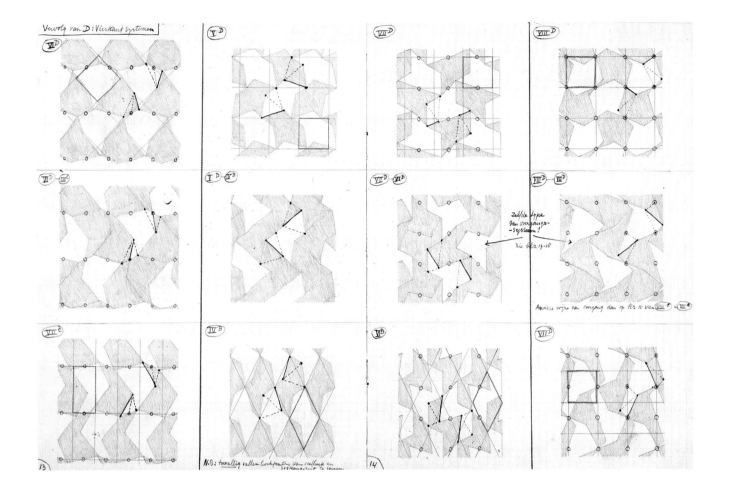

continuation of D: Square systems

VID	VD	VIID	VIIID
VID-VIIC	VD-IVB	VIID-VIB	same type of transitional system! see pp. 17–18 VIIID-VIID
			a different way of transition than that on p. 10 from VIIIC to VIIC
VIIC	IVB	VIB	VIID
	N.B. *by chance* the vertices of the polygon [motif] and system rhombus coincide.		

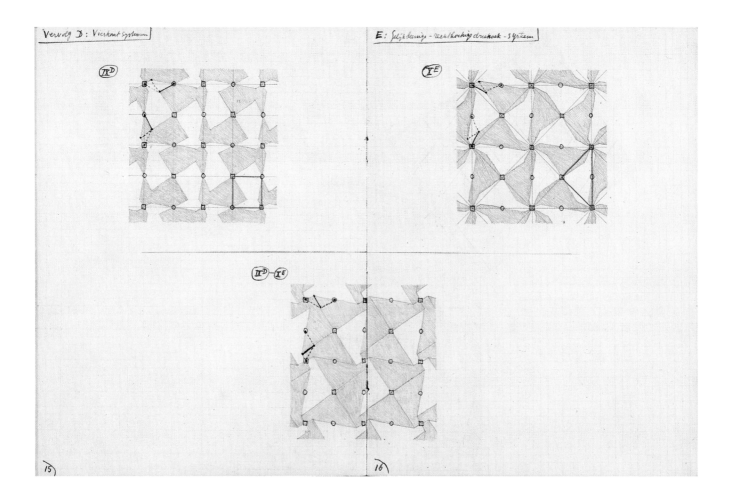

continuation of D: Square systems

IXD

E: Isosceles right triangle system

XE

IXD-XE

In the many demonstrations on his pages 3–18, Escher sometimes arrives at the same transitional system after modifying different two-color systems, and notes that fact. On page 17, he shows how to arrive at a single transitional system, beginning with any of the systems VI, VII, or VIII.

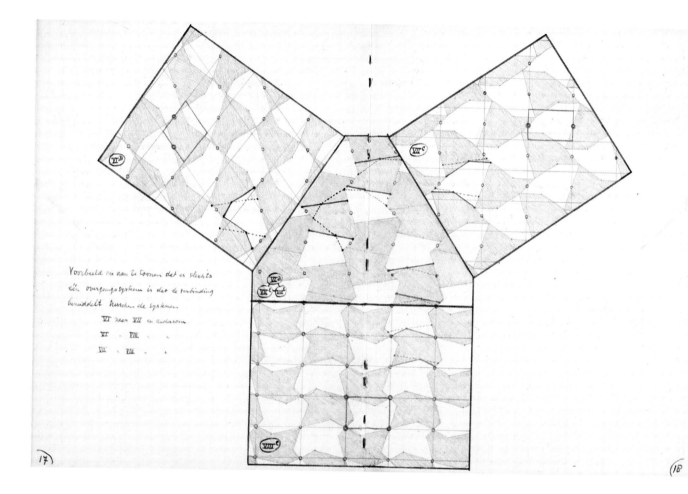

VIB VIIC

VIB
/ \
VIIC — VIIIC

Example to demonstrate that there is only
one transitional system which serves as the
connection between the systems

VIIIC

 VI to VII and the other way around
 VI to VIII and the other way around
 VII to VIII and the other way around

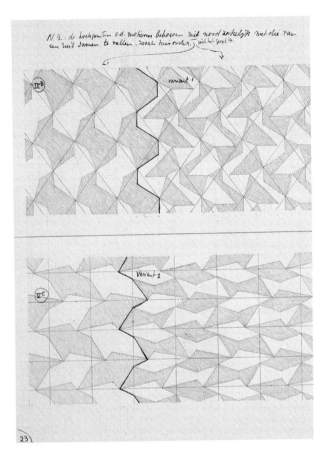

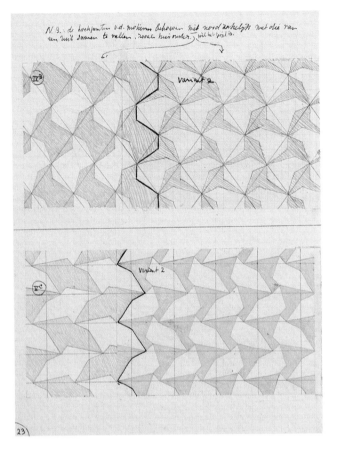

N.B. the vertices of the motifs need *not* coincide with those of a [system] rhombus, as is the case below.

IVB	variant 1
VC	variant 1

N.B. the vertices of the motifs need *not* coincide with those of a [system] rhombus, as is the case below.

IVB	variant 2
VC	variant 2

and Water, Day and Night). Andreas W. M. Dress has classified and cataloged all such tilings, naming them "regular *Heaven and Hell* patterns" [1986]. With one exception (VIB), Escher's examples of this type are variant 2 of two or more variants of splitting the same one-motif system. On some pages of the notebook, Escher pasted the variant 2 example as an overlay on top of variant 1. In these cases, we show a photograph of the whole notebook page with the variant 2 splitting and in a separate photograph show the variant 1 splitting that is covered by the overlay. In 1963, at the request of Carolina MacGillavry, Escher made a two-motif pattern missing from the notebook examples (see notes on drawing 115).

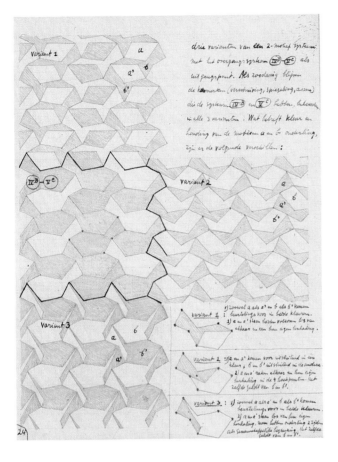

three variants of a 2-motif system
with the transitional system IVB-VC
as starting point. As such the characteristics
(translation, [glide-]reflection, [rotation]axes)
of the systems IVB and VC are preserved
in all 3 variants. With regard to color and
mutual position of the motifs a and b
there are the following differences:

variant 1:

1) both a and a' as well as b and b' occur
 alternately in both colors.
2) a and a' are both completely separate from each
 other and from their own repeats.

variant 2:

1) a and a' occur only in one color; b and b' only in
 the other [color].
2) a and a' touch each other and their own repeats
 at the 4 vertices.
 The same goes for b and b'.

variant 3:

1) both a and a' as well as b and b' occur
 alternately in both colors.
2) a and a' are separate from their own repeats,
 but share 2 sides as a common boundary.
 The same goes for b and b'

variant 1

IVB-VC variant 2

variant 3

VI^B	variant 2 (from VI^B as well as from VII^C)	VII^C	VI^B — VII^C	variant 1
VII^C	variant 2 (from VII^C as well as from VIII^C)	VIII^C	VIII^C	
VIII^C	same transitional variant as above.	VII^C		variant 2

VI^B variant 1

VII^C variant 1

IXD

XE

IXD-XE

In all Escher's other notebook examples of two-motif tilings, each motif occurs both in black and in white; color symmetries of the tiling can exchange any pair of congruent motifs of contrasting color. He gives 19 distinct examples of such tilings in the notebook; later he made other examples not in the notebook (for example, drawing 126). The classification of two-color, 2-isohedral tilings with color symmetries is an active area of mathematical research.

On pages 25–26, Escher shows splittings of the three systems VIB, VIIC, and VIIIC and their transitional system. He observes in three instances that two different one-motif systems lead to the same two-motif system. In his overlays, he indicates how the variant 2 examples can arise from either of two systems; in the bottom strip on page 25, his two-motif tiling which can be obtained from VIIIC or VIIC is geometrically the same as the variant 2 example in the middle of that page. On page 29, he summarizes his observations systematically in a single pictorial representation.

variant 1

variant 1	variant 2
variant 3	variant 4

VIIC-VIIIC

variant 2

variant 3

variant 4

Essay on use of regular division of the plane as surface decoration
Escher's insistence on living creatures as motifs posed unique problems not encountered with purely geometric decorative art. The position of the viewer relative to a decorated surface, as well as the familiarity of the view, are important for recognition and acceptability. His choice of motifs and of particular designs for use in murals, on ceilings, and even in graphic works was always guided by these principles. Chapter 4 contains some quoted passages from Escher's *Regelmatige vlakverdeling* on these and other concerns; see also the notes on drawing 91.

The Regular Division of the plane used in surface decoration.

The regular division of the plane can, for aesthetic purposes, be applied to decorate an arbitrary surface.

In the regular division of the plane the drawing surface is infinite in all directions, while a surface that is to be decorated in an aesthetic way a) is usually bounded on all sides, b) sometimes has a partial boundary (a cylindrical surface, for example) and c) can in just a few cases be called unbounded; a spherical surface, for example. A sphere has an ideal surface to which to apply the regular division of the plane.

When it comes to decorating a cylindrical surface, e.g. a vase, then a border must be found for the two edges that lie opposite each other, and the plane, infinitely extending in all directions becomes an infinitely extended band.

Usually, however, the surface to be decorated is bounded on all sides, namely in a rectangular way, so that an aesthetic rectangular border has to be found.

Since the regular division of the plane is based on the periodic repetition of one or more motifs, it lends itself particularly well to an application that is carried out in a technique in which repetition plays a logical role, e.g. stenciling; mosaics in all kinds of materials (terracotta, metal, wood); printed or woven fabrics.

When the form of the repeating motif, or motifs, is a purely geometrical one, then the question of whether the drawing surface is to be placed horizontally or vertically may be important from an aesthetic point of view, but from a logical point of view it does not matter: a mathematical figure can be viewed aesthetically from whatever side one looks at it.

[Next page]
Thus in the Moorish palaces in Spain and North Africa one often finds one and the same decoration, based on regular division of the plane and carried out in terracotta mosaic, serving both as floor covering and as wall covering, which is perfectly acceptable from a logical point of view.

However, the question of whether the representation is placed horizontally or vertically becomes more important when the motif on which the regular division of the plane is based, has the form of—or evokes in the spectator the association with—a living form occurring in nature, e.g. an animal or plant. Where an animal shape which serves as a regularly recurring motif is concerned, then we must in the first place distinguish the animals whose most characteristic shape or silhouette shows when seen from above (so in a vertical direction) from those seen from a side or from the front (so in a horizontal direction). A horse-silhouette is more characteristic when seen from a side than from above);* a characteristic horse-silhouette as a regularly recurring motif in a surface decoration is therefore more logical when applied to a vertical surface than to a horizontal surface, because one can look at the horizontal surface from all sides, and an "upside down horse" is an absurdity.

On the other hand, an animal of which the most characteristic silhouette shows when it is viewed from above, e.g. a lizard, lends itself as a motif to decorate both a vertical and a horizontal surface; from whatever side one looks at it, it always remains logically acceptable.

The decoration of the vertical surface, which in practice occurs more often than that of floor or ceiling, deserves still further consideration.

Of the systems for regular division of the plane, some are based only on [glide-]reflection and (or) translation, while in other systems rotation also occurs about axes that are perpendicular to the drawing surface. This distinction of 2 groups of systems is of special importance for application on a vertical surface.

*What's more, people *usually* look at it in a horizontal direction, since man and horse are about the same height.

[Right page]

When *no* rotation takes place (so only translation or (and) [glide-]reflection), then it is logically acceptable to use animal motifs whose most characteristic silhouette is the side-view (e.g. horse), or the front-view (e.g. person), and also those viewed from above (e.g. lizard). When a rotation *does* take place, then the only animal motifs which are logically acceptable are those which show their most characteristic image when seen from above. From this it follows that the systems without rotation are more important for decoration of vertical surfaces than those with rotation.

In the animal shapes appropriate for surface decoration another distinction can be made, viz. the animals that are found and which move only on the surface of the earth (most mammals) and those that do not need the surface of the earth as support (birds and fish). The latter group in general, both on the horizontal and on the vertical plane, lends itself better than the first group to surface decoration based on regular repetition.

The animals of the first group are not conceivable without a supporting surface, unless they are viewed from above, so that the supporting surface can be considered to be present without being visible in the drawing; the animals of the second group, however, gliding either in water or in the air, need in no case the suggestion of a supporting surface, because they are supported invisibly.

VIII-'61 I have in later years developed more clearly these reflections from 1941, for example, in the book "Regelmatige vlakverdeling." In particular the most fascinating aspect of play with repeating *recognizable* figures (motifs): the question: exchanging the function of "object" and "ground" is not yet mentioned here. This aspect became clear to me only in talks and correspondence with the ophthalmologist Dr. Wagenaar in Utrecht, in 1955.

II "Triangle" systems. (1942)

In this category are placed the systems in which 6-, 3-, and 2-fold axes can arise. They will be treated here as a separate group because their character, determined by the 6- and (or) 3-fold axes which always occur and which never exist in the quadrilateral systems, is completely different from the latter.

The name "triangle" system is given because the equilateral triangle (or 6 equilateral triangles which together form a regular hexagon, or 2 equilateral triangles which together form a rhombus) is instantly recognized.

In the "triangle" systems, translation and glide-reflection are completely absent. Their characteristics are defined solely by the [rotation] axes, and because of that, they are divided into two main groups A and B.
In system *A, only 3-fold axes* appear, arranged in the following way:

(a 3-fold axis is marked by the symbol △,

a 6-fold [axis] by the symbol ⊙,

a 2-fold [axis] by the symbol ⊙.)

In system *B, 6-, 3- and 2-fold axes* appear, arranged in the following way:

The systems with a central [rotation] axis are indicated as type C; although these type C systems are little used in the practice of regular division of the plane, they are mentioned here because they are the primal types from which all other ones spring. For example: from I A_3 type C_1 spring both I A_3 type 1 and I A_3 type 2, namely by connecting the central threefold point of rotation with points lying on the boundary of the motif. The two-motif systems in turn spring from the one-motif systems by division of the motif into two unequal parts that can be made visible in a minimum of two or in a minimum of more contrasting colors.

In the "triangle" systems the minimal number of colors is usually three, a consequence of the threefold axis that is never absent. We pay special attention to the types in a minimum of two colors because these are so important in practice. Only occasionally will types occur that cannot be made visible with fewer than 4 colors, e.g. II A_4 type 1.

Types with more than two motifs will not be dealt with here, as well as those in which more than 6 motifs meet at one vertex.

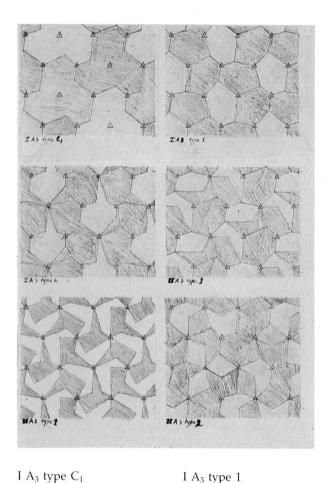

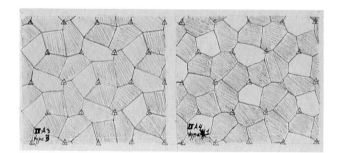

II A$_3$ type 3 II A$_4$ type 1

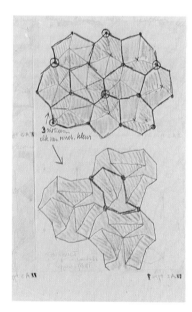

3 motifs
each of a different color

I A$_3$ type C$_1$ I A$_3$ type 1
I A$_3$ type 2 II A$_3$ type 1
II A$_2$ type 1 II A$_3$ type 2

Triangle systems Escher's explanation of the triangle systems is straight-forward and brief. His contention that translations and glide-reflections are entirely absent from such tilings must be read in his context: He assumes that motifs have no reflection symmetry and he considers only geometric transformations that move a motif to an adjacent one. Here there are no summary charts of characteristics of the various types; all information must be read from the visual examples. These are marked with the symbols for 2-, 3-, and 6-fold rotation axes that Escher no doubt saw in P. Niggli's 1924 article included on B. G. Escher's list; that article immediately follows Pólya's in the same journal. Each of Escher's examples is colored to meet his requirements for minimality and contrast and, in addition, each coloring is perfect, compatible with all symmetries of the design. By comparing the examples, his notation for individual types can be decoded. Each sequence of notation goes as follows: number of motifs (I or II), system (A or B), number of colors (2, 3, or 4), type

I B$_3$ type C$_1$	I B$_2$ type C$_1$
I B$_3$ type 1	I B$_3$ type C$_2$
I B$_3$ type 2	I B$_2$ type 1

II B$_2$ type 1	II B$_3$ type 1
II B$_2$ type 2	II B$_3$ type 2
	II B$_3$ type 3

(1, 2, 3, 4; that is, first, second, etc.).

It is interesting that for the triangle systems Escher recognizes motifs with central symmetry (type C). These were not considered in his quadrilateral systems with 2-fold and 4-fold rotations even though they are in Pólya's illustrations, which Escher copied. Every one of Escher's illustrations for triangle systems A and B is obtained by splitting the motif in a type-C tiling for that system. His exclusion of tilings in which 12 motifs meet at a vertex was probably due to the difficulty of realizing such an example with recognizable motifs. Such a two-motif tiling is easily obtained from his I A$_3$ type 2 example: Split the motif by joining its two vertices at which six motifs meet.

The loose sketch, which shows two different designs with three motifs was inserted in the notebook but not recorded on its pages; Escher decided not to pursue designs with more than two motifs.

(1)
triangle system
3 motifs
minimum 4 colors

(1) Baarn IX-'41

The abstract motif notebook On the cover of the abstract motif note-book, Escher wrote the title

Regular Division of the Plane
Abstract Motifs
Geometric Problems

Escher kept this notebook to record examples of tilings with purely geometric motifs as well as some of his observations about special geometric configurations, segregating them from his examples of regular division of the plane with ''recognizable'' motifs. (Those drawings are reproduced in Chapter 3.) Most of the 11 numbered watercolor designs are Moorish in flavor, and there is no question that Escher's collection of copied patterns was one source of ideas. These are, however, his own designs, arrived at by experimenting with shapes formed by line segments which connect certain points of simple grids of equilateral triangles or of squares. Escher has followed his coloring rules in all the designs; more information on their symmetry and coloring may be found in the Concordance.

(2)
System VII^C
VIII '44: Appears to be one of the ten arrangements in which an arbitrary triangle fills the plane (see "tiles")

(2) Baarn '41

construction of *improved* triangle (Abstract motifs no. 2)

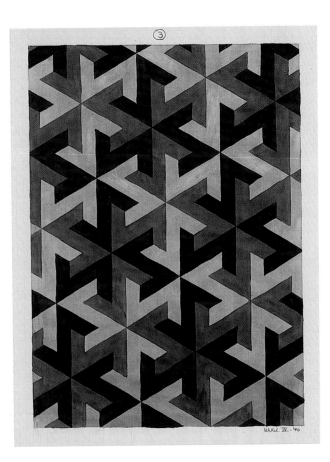

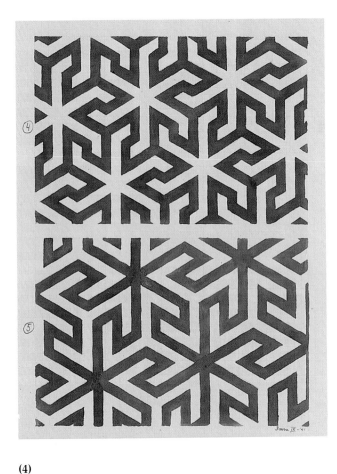

(3) Ukkel IV-'40 **(4)**

(5) Baarn IX-'41

(3)

triangle system
minimum 3 colors
one motif

Drawings 1, 3, 4, 5, 7, 8, and 9 are each based on a triangular grid; the 60° and 120° angles of the underlying lattice are clearly visible in the contours of the motifs in drawings 3, 4, and 5. In the other four patterns, one can discover the simplicity of the geometric structure of the design by connecting adjacent 3-fold rotation centers which form equilateral triangles. (In drawing 7, such triangles connect a 6-fold center to two adjacent 3-fold centers.) Drawing 1 is one of two designs with stars and diamonds that Escher created; a second was the source of a pattern of flowers and leaves (page 107). Drawings 4 and 5 can each be derived from the same line drawing of six-spoked pinwheels and can each be viewed as though etched in stucco or seen in raised brickwork, common

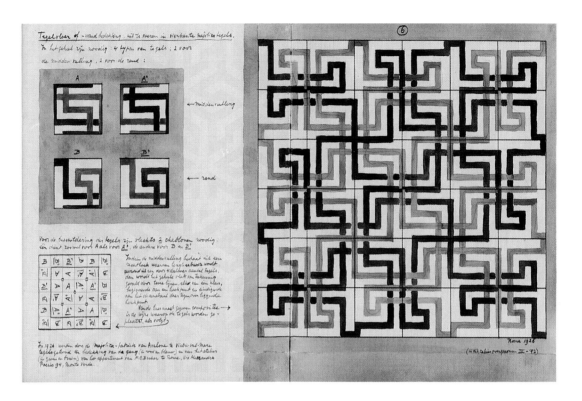

Tile floor or wall covering to be executed with square majolica tiles

(6)

Rome 1926
(copied in this notebook IV '42)

In total, 4 types of tiles are needed—2 for the center filling and two for the border:

A A′ ← center-filling
B B′ ← border

For the painting of the tiles, only 2 stencils are needed: one can serve for both A and A′, and the other for B and B′.

[diagram]

When the filled center portion is viewed as one rectangle whose length and width are each determined by a number of tiles which is divisible by 4, then the entire composition is filled by 2 lines, each of a single color, beginning in one corner and ending in the diagonally opposite corner.

For the composition shown facing here → the manner in which the tiles are to be placed is as follows ⇌

In 1926 the majolica factory of Avalone in Vietri-sul-Mare delivered tiles for the [floor] covering of the hallway (in red and blue) and of the studio (in green and brown) to the apartment of M. C. Escher in Rome, via Alessandro Poerio 94, Monte Verde.

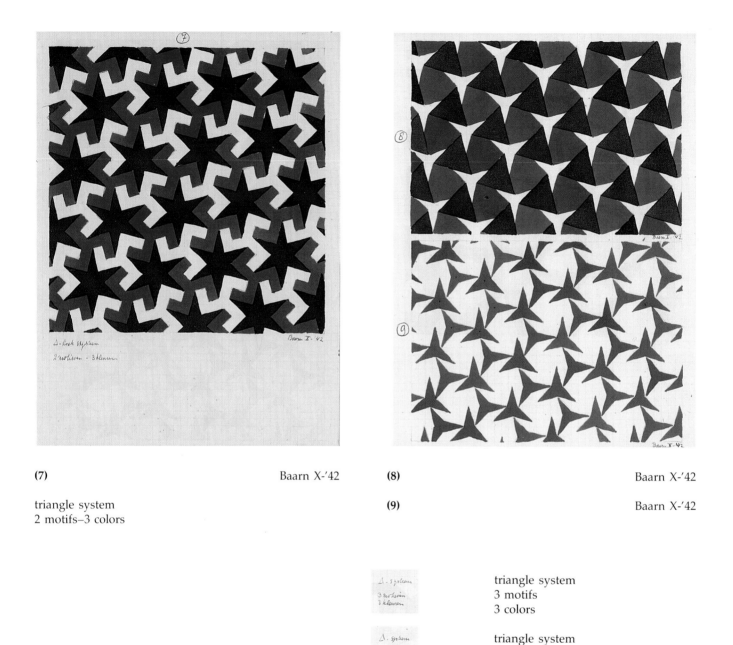

(7) Baarn X-'42 (8) Baarn X-'42

triangle system (9) Baarn X-'42
2 motifs–3 colors

triangle system
3 motifs
3 colors

triangle system
3 motifs
2 colors

in Moorish ornamentation. In drawing 4, the six-spoked motif is white (raised), outlined in black (shadow) and a kind of figure-ground reversal produces drawing 5, in which three-armed propellers are white, and six of them (outlined in black) rotate about a single point. Drawing 6, based on a square grid, is Escher's own design for floor tiles for the family apartment in Rome; similar interlaced meanders can be found in the Alhambra. Note that the path of the light-colored ribbon, which begins at the upper right, has been traced in pencil to its end at the lower left.

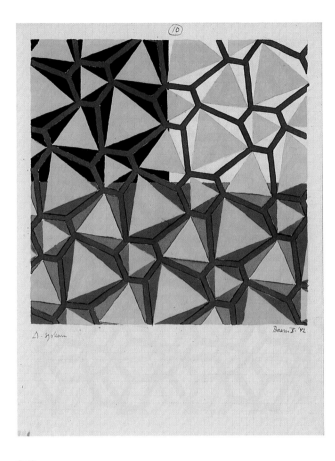

(10)
triangle system Baarn X-'42

(11)
triangle system Baarn X-'42

Drawings 2, 10, and 11 did not have a Moorish source, but were the result of Escher's own geometry investigations. On the page facing drawing 2, his sketch reveals how this design of right triangles can be obtained by overlaying two copies (one red and one blue) of the same tiling by rectangles. His selection of the single triangle for the tiling in drawing 2 is shown in heavy outline on the sketch. For the drawing, he constructed a special right triangle whose hypoteneuse and short leg are in golden ratio (see inset). This type of triangle tiling can be seen underlying Escher's design with lizards (drawing 33); he also proposed banknote background using the triangle with decorative motif (see drawing A7). His comment "see tiles" refers to his enumeration of tilings by a right triangle. To make drawings 10 and 11, Escher exploited properties of a special hexagon tiling described in a theorem (page 90).

Theorem

In an *arbitrary triangle*, one divides any side into 5 equal parts, a different side into 4 equal parts, and the remaining side into 3 equal parts. If one connects mutual points of division with each other and with the vertices, then 3 of the connecting lines intersect in a single point in such a manner that the connecting lines are divided into two parts by the point of intersection the ratio of which can be expressed by small whole numbers. In total, there are 17 cases of 3 concurrent lines. (See facing page.)

Group I: 2 cases: 3 lines begin at the 3 vertices.
Group II: 4 cases: 2 of the 3 lines begin at vertices.
Group III: 8 cases: 1 of the 3 lines begins at a vertex.
Group IV: 3 cases: no lines begin at a vertex.

[diagram] ← Note: the 3 intersection points of cases 4, 5, and 13 all lie on a single line and divide it into 4 equal parts.

(AB = BC = CD = DE)

This theorem was one outcome of Escher's experiments in 1944 to create continuous all-over patterns by repeatedly printing a design carved in a 3:4:5 right triangular block (see page 50). To create the design in the triangle, he divided the sides into three, four, and five units, corresponding to their lengths, and then connected three pairs of division points with line segments or with curves. His observation that triads of line segments were sometimes concurrent (intersected in a single point) evidently led to a systematic investigation of triads that connected such division points on the perimeter of an arbitrary triangle. His work-

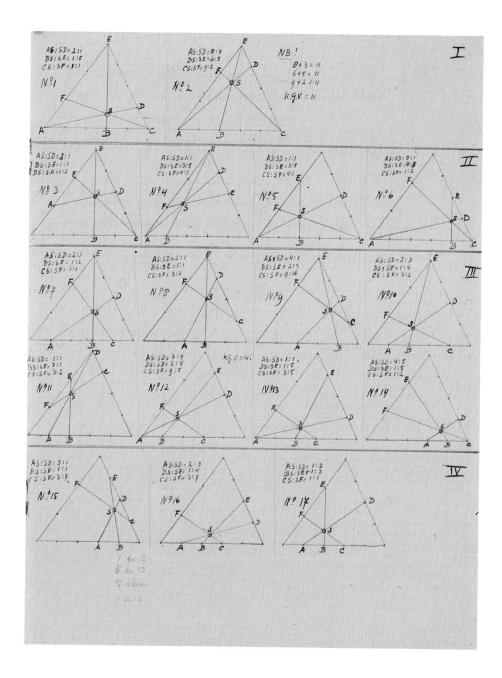

book with trial sketches for the carved design also contains his first enumeration of these 17 cases of concurrency of triads of lines. For Escher, visual verification sufficed as confirmation of this theorem; he lacked the knowledge for a traditional mathematical proof. Using a generalization of Ceva's Theorem [M. Klamkin and A. Liu 1991], A. Liu has verified that Escher found all possible cases of concurrency in which not all three lines have an endpoint at an interior division point on the same side of the triangle (all but cases 7, 10, 15, 16, and 17).

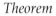

Theorem

From vertex A in an *equilateral triangle* ABC, one draws a line AF of arbitrary length and direction. (AF could, for example, be longer than AC and intersect BC.)

AD = AF; ∠FAD = 120°

BD = BE; ∠DBE = 120°

CE = CF; ∠ECF = 120°

(The plane is completely filled by congruent hexagons of the form ADBECF arranged as in the picture shown here [on the facing page].)

The diagonals AE, BF, and CD intersect in a single point S.

Escher discovered this theorem as he explored the properties of tilings with a special hexagon described in Haag's 1923 article (see page 29); that article says nothing about the concurrency of the diagonals of these hexagons. Escher's observation was correct, but he was unable to prove it. His son George pointed out a different way to construct the hexagon: Begin with any triangle (DEF in Escher's diagram) and construct outward on each of its three sides similar isosceles triangles with vertex angle 120° (at A, B, C). It can be proved that the diagonals of the hexagon ADBECF are concurrent for any chosen angle at A, B, C; when that angle is 60°, the result is known as Napoleon's theorem. Escher's tilings 10 and 11 in this notebook are carefully constructed using properties of his hexagon tiling shown here. In drawing 10, Escher forms new hexagons with inscribed equilateral triangles by joining the points S (at which the diagonals are concurrent) and corresponding vertices of three hexagons which meet at a 120° angle. In drawing 11, he overlays four copies of the hexagon tiling shown with the theorem; in each layer, the hexagons are outlined in a different color. In the web formed by the overlays, sides of hexagons of three different colors are concurrent at a surprising point: the center of the nine-point circle of triangle DEF. J. F. Rigby [1991] discusses Escher's theorem, provides proofs, and analyzes Escher's related tilings.

Regular division of the plane by similar figures of which size and contents rhythmically diminish in size, receding toward the center.

a. With 2 pairs of symmetry axes that intersect in the center. The axes in each pair are perpendicular, and the two pairs intersect each other at a 45° angle. ("square" system)

Similarity Designs These facing pages show five pairs of related designs, all having the kaleidoscopic symmetry of a quilt square. For convenience we refer to the numbers shown in the diagram at right. All the designs have four axes of reflection symmetry—the side bisectors and the diagonals of the square. These reflections are color preserving in designs 1, 2, 3, 4, and 5 and color exchanging in designs 1', 2' and 3'; they do not induce a uniform change of colors in 4' and 5'. All patterns are superimposed on themselves by a central similarity which shrinks (or enlarges) all motifs by a factor of 2, moving them toward or away from the center along the reflection axes. In designs 1, 1', 2, 2', 3, and 3' this similarity preserves colors; in 4, 4', 5, and 5' it induces a cyclic permutation of the colors. A spiral similarity, combining a 45° rotation with a central similarity which shrinks (or enlarges) the motifs by a factor of $\sqrt{2}$ also superimposes each pattern on itself. In design 2 this similarity preserves colors, while in 1 and 3 it interchanges colors; in 4 and 5 it induces a cyclic permutation of colors. This same similarity is color preserving in designs 1' and 3', while color exchanging in 2'; it does not induce a uniform change of colors in 4' and 5'.

		3	3'
1	2	4	4'
1'	2'	5	5'

Entwined circular rings

For each ring, the maximum thickness is taken.
The distance between centers [of the circles] is constant
in I^A, II^A, III^A, and IV^A.

A: Four-fold axes at each center point.

I^A
minimum 1 color

II^A maximum thickness

minimum 2 colors

III^A max. thickness

minimum 4 colors

IV^A max. thickness

minimum 8 colors

Escher undoubtedly saw interwoven circles in several Moorish designs; even when not visible, they are implicit in the geometric structure of most of those patterns. Several of the articles on Beer's 1937 list of references provided to Escher also show periodic patterns of packed circles and of intersecting circles. Escher probably intended a second careful display (to be called B) of interwoven circles based on a triangular grid; some of his loose sketches of these (shown on page 93) were inserted in the notebook.

From bottom to top it shows the metamorphosis from inorganic matter to birds. As the birds are completely developed and emerge on the surface they are liberated. We may also give an opposite interpretation: the birds flying in at random find places on the surface where they fit exactly. Thus the plane tiling is growing continuously. This corresponds to crystal growth. Clearly the birds do not know the symmetry group, but they recognize the vacancy where they fit in. [Engel, 1986, page 47]

The geometric grid crystallographers associate with a periodic design for the purposes of classification is not the same one Escher chose. In analyzing a periodic pattern, the crystallographer first identifies its translation lattice. This is a grid of congruent parallelograms which might have no special properties, or might be squares, rectangles, rhombuses, or fused equilateral triangles, depending on the pattern. This lattice is obtained by taking a single point in the pattern and finding all repetitions of that point which occur in exactly the same way. For example, in Escher's periodic drawing 7 of squirrels (page 121), one can choose an easily identifiable point such as the tip of the nose of a squirrel facing left; the translation lattice of this pattern consists of all of the points in the design which are tips of noses of squirrels facing left. (Here the coloring of the squirrels is not taken into account.) One can generate the same lattice by choosing any point in the pattern and applying to it all of the translations which leave the pattern invariant; the lattice is the array of images of the chosen point.

In the crystallographers' translation lattice, the parallelograms are called "unit cells"; they usually contain more than one asymmetric motif, whereas Escher's lattice polygons contain only one. The fractional part of their unit cell that would represent a single asymmetric motif in a periodic pattern is what mathematicians call a "fundamental domain." In Escher's drawing 7 of squirrels, two squirrels occupy a unit cell of the crystallographers' lattice; in this case, a fundamental domain is half a unit cell. Escher's own geometric grid can be seen in this design of squirrels; each of his parallelograms is equal in area to that of a single squirrel, and two of his parallelograms join to form the crystallographers' unit cell.

Escher's rule for the association of a particular geometric grid with each of his regular division drawings differs in another fundamental way from that of the scientists. Escher used the exact shape of the polygon in his underlying geometric grid to categorize an interlocking design of recognizable forms, whether or not the design displayed all the symmetries possessed by that grid. The crystallographic categorization of a periodic pattern depends purely on the symmetries of the pattern; the exact shape of a lattice unit is only secondary to these considerations.

We can use Escher's teaching example of five different regular divisions of the plane (page 35) to illustrate how his association of a geometric grid to a design differs from that of crystallographers. For Escher, all five designs in this example have the same underlying grid of squares, and each motif is equal in area to one square in that grid. For the crystallographer, these five patterns have translation lattices with unit cells of five different sizes and descriptions. Only in the first example, the pattern having just translation symmetry, does their lattice coincide with

Escher's. In this example, however, they would identify the lattice as a parallelogram lattice, rather than one of squares, because the pattern's symmetries are only those of a parallelogram grid. For the other four examples, a rectangular unit cell would consist of a block of two or four motifs, with one motif in each different direction (corresponding to Escher's different number labels). Only in the second pattern would the lattice be identified by a crystallographer as a square lattice: the 4-fold rotations in this design mandate that special shape for the unit cell. In each of the five patterns, a single one of Escher's motifs is a fundamental domain for the unit cell.

Escher's recognition of the exact shape of the polygons in his underlying grids was not just a layman's literal observation. Noting the exact shape was important for the design's practical uses. For example, patterns based on square grids can be easily translated into works whose components are manufactured as square tiles of porcelain or concrete.

In three major aspects, Escher's theory addressed questions that were ignored by the crystallographers and mathematicians:

the process of transition which changed the shape of the motif in a regular division of the plane but did not change the symmetries of the pattern;

the creation of patterns with two distinct motifs, beginning with a one-motif design; and

the coloring of the regular divisions of the plane in a systematic way.

His idea of linking different pattern types by the dynamic process of transition is one which has not yet been explicitly explored by scientists. His chart on page 1 of the notebook (page 60) shows his recognition that it was possible to move by the transition process between certain of his systems and impossible to move between others. Five groups were formed in which transition between systems was possible; this shows his fundamental understanding of categorization by symmetry groups. His five "groups" (separated by red lines on his chart of transitions) are the symmetry groups with crystallographic notation *p1, p2, pg, pgg,* and *p4*. These are exactly the symmetry groups with no reflections and with either no rotations, 2-fold rotations, or 2-fold and 4-fold rotations.

Escher's motivation for introducing the concept of transition was related to his concern for coloring his patterns so that no two adjacent motifs shared the same color. His classification of regular divisions of the plane with one motif, based on an underlying quadrilateral grid (as shown in his overview chart) only considered patterns in which an even number of polygons met at each vertex and hence could always be colored with two colors. He needed a way to categorize designs in which three motifs share portions of each other's boundary and meet at a common vertex; such designs require three colors to satisfy his coloring criterion. In order to relate such patterns to the systems requiring only two colors, he considered three-color patterns as "transitional," or halfway between, two of the two-color systems. The symmetries which related an individual motif in one of these transitional systems to those motifs which surrounded it were a selection or combination of those in the

related two-color systems. The notebook shows that he discovered that this categorization of three-color designs was not without ambiguity; he learned that he could arrive at the same transitional system taking different systems as starting points. (Note his remarks on notebook pages 7–14 and 17 for example.)

Escher's exploration of possible patterns with two different motifs created from a one-motif periodic pattern by splitting each motif into two noncongruent parts (pages 20–29 of the notebook) has only very recently been taken up by mathematicians. His desire to give visual expression to both real and philosophical contrasts, to juxtapose opposites, and to depict interlocked life forms no doubt spurred this investigation. It is interesting to note that although he was aware of the regular division of the plane with one motif based on an irregular hexagon with three pairs of parallel sides in which three motifs meet at each corner (type I^A-I^A on page 3 of his notebook, page 62), Escher never produced such an example for his collection of numbered regular division drawings, nor any other execution of this type. However, many of his works show two interlocked motifs obtained by splitting this one-motif transitional type; the design with two motifs, which he also labeled I^A-I^A, can be colored in two contrasting colors (page 22 of his notebook, page 71). The earliest of these are the drawings numbered 18, used in the graphic work *Day and Night*, and 22, used in *Sky and Water*, all created in 1938 (see pages 130 and 133).

Escher's inclusion of color, and particularly his consideration of the distribution of colors in his periodic drawings as an inseparable part of his theory, is the most significant original aspect of his research. At the time he was developing his theory, color was not recognized as having a role in the crystallographic theory of classification. The need to consider the coloring of periodic patterns with two colors and investigate symmetries which either preserved the coloring or interchanged the two colors was only widely recognized by crystallographers in the early 1950s; investigation and development of a theory of periodic patterns with three or more colors came even later.

*E*scher and the scientists on contrast and color

From the very beginning, Escher's theory of regular division incorporated the element of color contrast of adjacent motifs; to him, this was a natural and self evident constraint for all such patterns. Individual motifs had to be recognizable and should have equal value; motifs of one color should not dominate motifs of a contrasting color. To achieve both objectives, colors should have sufficient contrast and equal brightness. Much of his correspondence with manufacturers of materials for commissioned work shows his insistence on just the right contrast in tones of paint; he even refused to accept different degrees of shine in the glazes of black and white on tiles containing his designs.

In an essay entitled "Wit-grijs-zwart" ("White-gray-black"), published in 1951 in *De Grafische (The Graphic Arts)*, the newsletter of the

society of graphic artists to which he belonged, Escher wrote on contrast:

> Life is possible only if the senses can perceive contrasts. A "monotonal" organ sound that is held too long becomes unbearable for the ear, as does, for the eye, an extended solid-color wall surface or even a cloudless sky (when we are lying on our backs and see neither sun nor horizon). . . .
> Isn't it fascinating to realize that no image, no form, not even a shade or color "exists" on its own; that among everything that's visually observable we can refer only to relationships and to contrasts? If one quantity cannot be compared with another, then no quantity exists. There is no "black" on its own, or "white" either. They only manifest themselves together and by means of each other. We only assign them a value by comparing them with each other.

In the same essay, he addressed a basic issue in the graphic arts: where one should start when making a black-and-white representation.

> Isn't it really an utterly illogical way of acting to start from the one extreme at our disposal: the white paper? Wouldn't it be more valid, at least theoretically, to take the average between the two extremes [of black and white] as starting point: that is, paper in a shade of gray? . . . In fact, for a long time I formerly used gray borders, but I dropped what I consider a logical reasoning and capitulated to the present fashion of the white border, to my shame, I must confess.

In his 1958 book, *Regelmatige vlakverdeling*, Escher developed at length his thoughts on contrast. For him, "The beginning is gray," and from this must evolve recognizable forms in increasingly sharp contrast, until in stark black and white, either can serve as figure or ground. All the graphic plates of his book, at Escher's request, were printed with gray borders.

It was not a philosophical interest in contrast or in graphic representation which led crystallographers to take an interest in periodic patterns with two contrasting colors. The first investigations of such patterns may have been without specific applications in mind, but by the mid-1950s, scientists saw the possibility of using such colored patterns to encode additional information on physical attributes of the materials represented by the patterns, such as direction of spin, value of magnetic moment, or direction of parallelism. The Russian crystallographer A. V. Shubnikov and his students were the first to give extensive attention to periodic patterns with two colors and classify them according to symmetry groups. These groups comprise the geometric motions which superimpose such a pattern on itself so that the colors of all the motifs in the pattern remain unchanged or the colors of all motifs are interchanged (every black patch becomes white, and vice versa).

In order to distinguish between symmetries of a pattern which interchange colors and the traditional symmetries which disregard any coloring, Shubnikov and his colleagues introduced a term which was

translated into English as "antisymmetry." Antisymmetry was an unfortunate choice; it does not mean "against symmetry," as the prefix might suggest. Rather, it denoted an interchange of two colors induced by a symmetry, such as a reflection interchanging the negative of a photo with its positive. Those who introduced the term literally thought of a two-colored pattern as a double pattern (envision an infinitely large reversible damask), with one view of it showing on one side of a plane and another view of it showing (with colors interchanged) on the other side. An antisymmetry was a geometric motion that would superimpose the pattern on itself while simultaneously interchanging the two sides of the plane.

The literature of decorative art and fabric design had a much better term that might have been borrowed: "counterchange." Counterchange patterns show a repeating motif which occurs in each of two contrasting colors; one color of the motif can serve as figure, the other as ground. In 1936, H. J. Woods had published an article "Counterchange Symmetry in Plane Patterns" in the *Journal of the Textile Institute* (Manchester); this paper contains a systematic enumeration of the symmetries possible in two-color periodic patterns and illustrates each type with a black-white geometric design. Again, the work of an artisan had anticipated the investigations and results of the theoretical scientists. Woods found 46 types, and except for differing notation, his illustrations could have served as examples for exactly the same conclusions about possible types later enumerated by crystallographers and mathematicians. The book *Symmetries of Culture* by mathematician Donald Crowe and anthro-

[*Plane-filling motif with Reptiles*]. [1941]. Woodcut, 124 × 154 mm (cat. 324). A perfect example of a counterchange design: a 180° rotation about its center yields the same design, but with black and white interchanged. The half-turn is an antisymmetry of the design.

pologist Dorothy Washburn gives an extensive discussion of the 46 two-color symmetry groups, with numerous illustrations of two-color patterns chosen from various cultures, and includes Woods' patterns.

In the 1960s, investigations on the topic of symmetry in multicolored periodic patterns were undertaken by several scientists and mathematicians; as with any new research endeavor, there were many differing assumptions, approaches, theories, definitions, and notations for describing and classifying such patterns. The complexity of the mathematical analysis of such designs is far greater than that for those with just two colors. Several groups of symmetries of a multicolored periodic pattern play a role in their classification: the group of symmetries of the pattern, regarded as uncolored; the group of symmetries of the pattern which redistribute (permute) colors in an unambiguous way (for example, if a symmetry sends one white motif onto a red one, then it must send every white motif onto a red one); the group of symmetries which fix one selected color and permute other colors; the group of symmetries which fix all colors (each motif moves to another motif having the same color). The coloring of a periodic pattern that is most compatible with the symmetries of the uncolored pattern is one in which every symmetry of the uncolored pattern redistributes the colors in an unambiguous way (in mathematical language, every symmetry induces a permutation of the colors); such a coloring is currently termed a "perfect coloring." The surveys on color symmetry by R. L. E. Schwarzenberger [1984] and by M. Senechal [1988] give an overview of the history and basic results of mathematicians and crystallographers and contain extensive bibliographies.

In developing his "layman's theory" of regular division of the plane in which color and symmetry were inherently bound, Escher pursued his own interests, oblivious of whether or not they might be of any scientific value or importance. With regard to crystallographic considerations, he was ahead of his time. Escher, of course, never considered symmetry groups, nor looked at the question of coloring his patterns primarily from the viewpoint of symmetry. When he chose what for him was the logical underlying geometric grid for a periodic design based on quadrilaterals and insisted on contrasting colors for adjacent motifs, he essentially built in to his designs the element of two-color symmetry. In every type of design represented in his overview chart (page 58), each motif is related to an adjacent one of contrasting color by an antisymmetry and to a touching one of the same color by a color-preserving symmetry. All his periodic drawings of these types with a single motif are perfectly colored. Even in his theory of splitting single motifs to create two-motif periodic designs, he ensured the compatibility of coloring and the pattern's symmetries. Many of the two-motif designs assign each motif a single color, so every symmetry preserves color; when creating a two-motif design in which each motif appears in each of two colors, he used the symmetries of the original one-motif design to create the coloring of the derived design.

Escher never wrote down an explanation of how he decided on the distribution of colors in periodic designs with three or four colors. Again, a self-imposed constraint, that of using a minimum number of colors to ensure contrast of adjacent motifs, seems to have worked well

in all but one case to lead inevitably to perfect colorings. The one case was a periodic pattern which had 4-fold rotation symmetry and required at least three colors to guarantee contrast of adjacent motifs, his transitional system IX^D-X^E (pages 15–16 of his notebook). In this coloring, the 4-fold rotations which are symmetries of the uncolored pattern do not redistribute the three colors unambiguously.

Escher's first regular division drawing of this type was his number 3 (page 117), an early version of which he had created in 1936. His first version shows four colors and is perfectly colored; evidently when Escher later redrew the design in his folio/notebook he imposed his minimum coloring with just three colors. His lizard design, number 14 (page 127) is colored in the same manner, but his number 20 of fish (page 131), done just four months later, is perfectly colored using four colors. He notes on that design that it requires a minimum of three colors; evidently by then he had come to realize the need for four colors in order to have the coloring compatible with the design's symmetries. Quite possibly he decided to associate a different color with each of the four distinct aspects in which the motif appears in the design.

When Escher's work finally came to the attention of crystallographers, he had already investigated many possibilities for periodic designs with two, three, and even four colors and had produced a dazzling

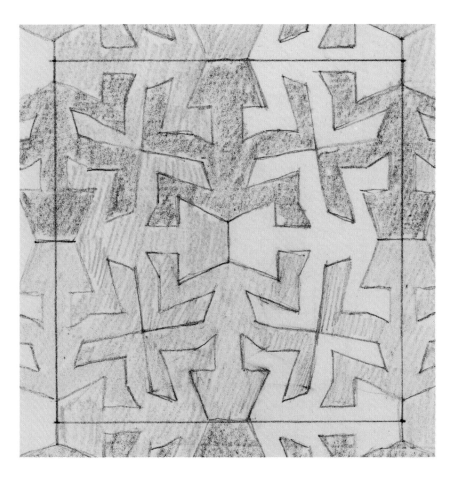

An early sketch for drawing 3 shows four colors. Pencil, colored pencil, 186 × 195 mm.

array of examples which included some color arrangements they had not yet discovered. The first crystallographer to give published recognition to Escher's periodic drawings was P. Terpstra, who in 1955 used Escher's drawing 67 of a horse and rider (page 169) as a frontispiece in his textbook *Introduction to the Space Groups*. But magazine articles, exhibitions, and published reviews of Escher's work had already caught the attention of mathematicians and scientists, first in Holland and then abroad. Carolina H. MacGillavry, professor of crystallography at the University in Amsterdam, recalls that after learning of a major exhibit of Escher's work at the Boymans Museum in Rotterdam (in 1952), she declared that "Escher is crystallography" and the whole laboratory staff had "work" to do: they all took the day off and attended the exhibit. The mathematician N. G. de Bruijn arranged for a major exhibit of Escher's work to be held at the Stedelijk Museum in Amsterdam during the 1954 International Congress of Mathematicians; hundreds of mathematicians saw Escher's periodic drawings and prints for the first time. Many became ardent fans of his work and even collectors of his prints; a few would later provide him ideas for use in his graphic work.

In 1959, Escher was visited by the crystallographers José (J. D. H.) and Gabrielle Donnay; they were especially interested in his work on antisymmetry and wanted him to give a lecture at the Congress of the International Union of Crystallography the following summer. Escher was both flattered and amused by this intense interest in his work and wrote to his son George,

> I had a nice visit from a professor from Baltimore and his wife, both ardent crystallographers, who insist I give a speech on my RV [regular division] in London next summer at an international gathering of crystal-gazers (or sym- and antisymmetrists. Antisymmetry involves using contrasting shades in a design of repeated motifs in space or on a plane. Russian scientists have been interested in this recently, and I myself have not been able to do without it since I started on the regular division of the plane, thirty years ago). When I told them my usual story about not knowing anything about mathematics, they answered: "You obviously know more about it than any of us." Just imagine!
>
> . . . I had noticed some time ago that old-fashioned crystallographers were quite perplexed by my contrasting shades: old Terpstra, for example, thinks you shouldn't talk in terms of "glide-reflection" if the color changes. And now the Russians say I'm right. As a complete layman in science, I've obviously never been troubled by over-rigid ideas, but I can easily imagine that those old scientific gentlemen find it difficult to let go of colorlessness (contours).

A couple of months later, Escher reported to George that "the nicest thing to have happened to me recently was a visit yesterday afternoon . . . from a lady, Professor MacGillavry, who . . . came with her sister-in-law, who was also somehow interested in divisions of the plane, and the two of them had their eyes glued to my prints from half past two till after half past five. What a pair of smart ladies! It's such a relief to have visitors at last who don't stare at my creatures uncomprehendingly, but who can chuckle with amusement at anything worth chuckling at." In

From theory to the periodic drawings

"How did he do it?" How did Escher discover or create those creeping, wriggling, soaring creatures that interlock in his work? Almost always he began with a geometric skeleton. His storehouses of geometric designs contained examples of majolica mosaics and stucco patterns he had sketched on site at the Alhambra, at La Mesquita, and at the cathedral in Ravello, the illustrations taken from the mathematical papers he had studied, a Japanese pattern book, a few miscellaneous other copied patterns, and, of course, the rich collection of tilings by polygons that he had produced as illustrations in his "Theorie" notebook. He drew the richest inspiration from a small handful of these; in his sketchbooks, he interprets them again and again.

The motif like a chevron with a tail that Escher copied in the Alhambra (page 17) was a direct source of ideas for drawings having the same symmetry (drawings 3 and 13, pages 117 and 126). It was also used as a schematic motif to represent fish and birds in concept sketches for graphic works. He included this design as an example of abstract regular division of the plane in his lecture illustration (page 32) and in Plate II for *Regelmatige vlakverdeling* noting there that this design "reminds me of 'something I know,' a hammer, a bird, a plane."

A design of plane-filling pentagons found in Haag's papers (page 28) fascinated Escher, perhaps because it can be derived in several different ways. One can begin with a simple grid of squares and place through the center of each square a skewed cross of two perpendicular lines that join opposite sides of the square, or one can superimpose two

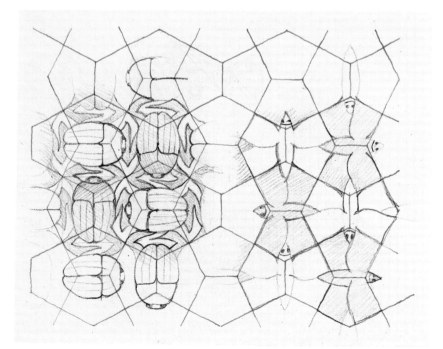

Scarabs and butterflies emerge from a grid of pentagons. Pencil, ink, 212 × 162 mm.

copies of a plane-filling pattern of congruent hexagons. This design of pentagons has 4-fold rotation symmetry and appears in sketchbook drawings as a skeleton for some early periodic drawings. It is prominent in later drawings in several variations (drawings 42, 131, 132, 133, 134, on pages 148 and 224–227). One of Escher's sketchbook pages shows two periodic designs, one of butterflies (his number 12), and one of scarabs (evidently never made as a numbered drawing), both emerging from this pentagon grid.

Escher used an altered square with a cross of perpendicular lines through its center to create designs with 4-fold rotation symmetry. The rudimentary beginnings of drawing 20 of fish suggested by this geometric tiling appear on a page in one of his early copybooks alongside experiments for his first printed designs based on number schemes (see page 45). He also used the geometric tiling in concept sketches for a print with those fish (page 271).

Escher had seen Moorish patterns with stars and other simple polygons and developed his own versions. Drawing 1 in his abstract-motif notebook is a colorful mosaic of stars, diamonds, and triangles. A variation of this design was the starting point for drawing 43 (page 149); Escher's preliminary sketch shows flowers and leaves emerging from the geometric shapes. Another design of stars and diamonds by Escher is closely related to the tiling by pentagons and was the basis for drawing 42 of shells and starfish (see notes on drawing 42).

A simple geometric design of kites alternately facing in opposite directions served as skeleton for many periodic drawings with glide-reflection symmetry. One can see on the left page of the copybook sketches shown on the next page, the rough geometric grid of kites, each kite split in two by a diagonal; this is a polygon tiling fitting

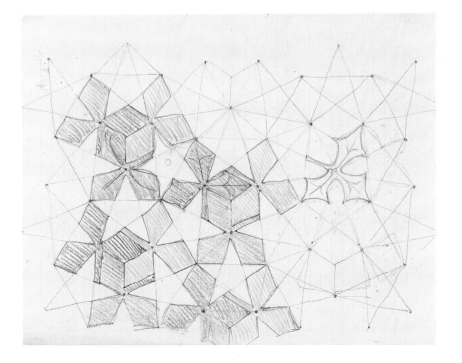

Stars and diamonds become flowers and leaves for folio drawing 43, 1942. Pencil, colored pencil, 274 × 216 mm.

Escher's two-motif system VI[B], variant 2 (see page 74). After roughly molding the figures of two interlocked fish to fit the geometric constraints of the system, he drew a careful final version on the facing page, which he then traced and repeated in regular division drawing 41 (page 147). The rhombus which is superimposed on the final motifs is the one of system VI[B], used to lay out the grid in the colored drawing; it is obtained from the underlying grid of rectangles, shown on the sketch on the left page, by connecting the midpoints of the sides of rectangles which contain part of the fish. Escher also used a regular division with kites in schematic layouts for graphic works; one example is his concept sketch for the woodcut *Horseman,* shown on page 242.

Escher's plane-filling by triangles, recorded in his abstract motif notebook (page 83), appears as a skeleton in his drawing 33 of lizards (page 141). This same triangle pattern is featured in his purely decorative design for bank-note background (page 232).

A generous collection of geometric sources from which to draw and a knowledge of the geometric rules which govern all periodic tilings of the plane provides a starting point and a set of basic directions, but the territory in which recognizable motifs are created is uncharted, and each venture is a new experience. Today computers can be programmed to apply geometric motions instantaneously to any squiggle or shape that is drawn on the screen—instant regular divisions of the plane. But the art of finding just the right squiggle, of seeing the possibilities for an imaginative creature in a rudimentary form is not programmable; it is a gift of special observation, ingenious imagination, and playful wit.

This most difficult to explain aspect of the creation of regular division motifs is best commented on by Escher, who in his explanation in *Regelmatige vlakverdeling,* invokes some advice by the master Leonardo:

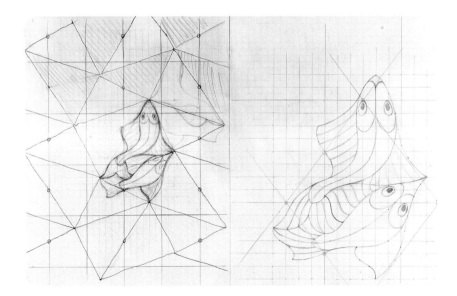

Development of the fish motifs for folio drawing 41, 1942. Pencil, ink, 210 × 165 mm (each page).

Imagination and inventiveness, not to mention tenacity, are indispensable for this work. These qualities come to us from somewhere "outside ourselves," but we can make ourselves open to them and encourage them and stimulate them in various ways. Among others, I found one suggestion in the writings of Leonardo da Vinci; here is the passage, translated as best I can:

"When you have to represent an image, observe some walls daubed with smudges, or built from stones of varying kinds. In them you will discover resemblances to a variety of mountainous landscapes, rivers, rocks, trees, vast plains and hills. You can also see battles and human figures, strange facial expressions, garments, and countless other things whose forms you can straighten and improve. These crumbling walls are like the peals of church bells in which you can hear any name or word you choose."

Leonardo's advice is useful for stimulating inventiveness and imagination in general. But experience has taught me that it is particularly valuable when designing regular plane fillings, since this is largely concerned with putting chaotic shapes in order and making abstract forms concrete.

Despite all this conscious personal effort, the artist still has the feeling that moving his pencil over the paper is a kind of magic art. It is not he who determines his shapes; rather, it seems as if the simple flat blot at which he painstakingly toils has a will (or unwillingness) of its own; that it is this blot which guides or hinders the movements of the drawing hand, as though the artist were a spiritualist medium. In fact, he feels quite amazed, dazed even, at what he sees appearing under his hand, and experiences a humble feeling of gratitude or resignation, depending on whether they behave willingly or reluctantly.

In 1938, as Escher embarked on making his regular divisions of the plane, he heeded Leonardo's advice quite literally; the wall of the washroom in the Eschers' rented house in Ukkel provided inspiration for a constant "work in progress." George Escher has amusing recollections of how his father could breathe life into formless blobs:

Father had an unusual inclination to recognize animal shapes in seemingly random patterns like clouds or wood grain, which served him well when developing his regular patterns of interlocking animals. . . . The wall in the small downstairs washroom was decorated with irregular swirls of green, yellow, red and brown, created by splashing paint of different colours on the wall and blending them by random movements of a brush. Father . . . would take a pencil and emphasize with a line here, a shade there, some portion of the wall pattern. . . . For us children that washroom became a special attraction because, as the months went by, the originally drab, uninteresting wall came alive with faces. Every few days a new one would appear, laughing, sad, grotesque or solemn and I remember how I would scan that wall on my visits to the toilet, hoping to discover some new personality. [1986, p. 7]

Sometimes the abstract polygon tilings Escher made in his notebook, intending only to show the relationship of motifs to each other, yielded vaguely recognizable forms. Escher's imagination and long practice in coaxing life into such shapes often produced striking results. The beautifully complex black-and-white design of birds and fish, drawing

126 (page 219), is not labeled by Escher as a representative of one of his systems. Rather, he simply notes that it has elements of systems IV and V. But look at his geometric drawing on page 23 of his notebook that illustrates system IVB, variant 1 (page 72). This drawing is not particularly suggestive of life forms, but after seeing the polished drawing 126, one can, with the clarity of hindsight, "see" what Escher must have seen. There are the rough forms of bird and fish, just waiting to be conjured into recognizability.

In 1947, in an article "Nederlandse grafici vertellen van hun werk" ("Graphic Artists of The Netherlands Speak of Their Work") in the magazine *Phoenix*, Escher described the process of creating a regular division drawing.

> One can divide a plane into geometric shapes according to certain systems; these forms can become infinitely varied and very complex and still meet the requirement of filling the plane with congruent forms in rhythmic repetition without leaving any 'void.' If one then tries to mold the form so as to evoke an association with something familiar to the viewer—an object, an animal, or whatever it might be—it becomes a compelling game in view of the infinite possibilities offered as well as the rigorous restrictions imposed by the rules. It is a painstaking process of groping and fumbling about. Sometimes not a single one of the patterns that appear at the end were consciously sought at the start. It dawns on you slowly. Then comes the moment you recognize it, when you suddenly realize—and here we shift from a general impression to a specific one—: it is a man on a horse! After this, he develops rapidly under the impact of certainty. At the end he stands out clear as crystal, obeying unshakable laws, clenched on all sides by his own mirror image. Note how each contour has a double function: a single line borders the mane as well as the belly of the horse; also the face of the rider as well as the neck of the animal are defined by one and the same line. See him riding through a landscape that is himself. He is alone by himself and yet he completely fills the entire two-dimensional world in which he lives.

Here, Escher cannot find words to describe any specific process of creating a motif, and without warning, he suddenly begins describing the creation of the motif in drawing 67 (page 169). Two pages from his copybooks testify that the development of the horseman was exactly as he describes it.

In the preface to the 1965 book by Carolina MacGillavry that reproduced 42 of his periodic drawings, Escher again spoke of his fascination and wonder in creating the creatures that populate them.

> They take little account of my critical opinion during their birth and I cannot exert much influence on the measure of their development. They are usually very difficult and obstinate creatures.
> The border line between two adjacent shapes having a double function, the act of tracing such a line is a complicated business. On either side of it, simultaneously, a recognizability takes shape. But the human eye and mind cannot be busy with two things at the same moment and so there must be a quick and continuous jumping from one side to the other. But this difficulty is perhaps the very moving-spring of my perseverance.

Sketches on a scrap show the emergence of the rough outline of a horseman. Pencil, ink, 105 × 156 mm.

Further refinements bring the horseman to life, ready for transfer into the folio notebook (drawing 67). Pencil, ink, 208 × 167 mm.

The folio notebooks of periodic drawings

During the years 1938 to 1941, while Escher was systematically exploring the possibilities for periodic designs and shaping his own "layman's theory," he produced colored designs of recognizable figures at a furious pace—over 40 in those four years. His small sketchbooks show him always working on ideas for several different motifs simultaneously. Often he abandoned the beginnings of a motif when part of a figure emerged and the rest refused to come into being. Some figures suggested by a geometric shape appeared almost instantaneously; others Escher labored over, refined in dozens of drawings, until finally, satisfied, he circled the final version or wrote "definitive" next to it.

Escher wrote the words "Regelmatige vlakverdeeling" ("Regular Division of the Plane") in the corner of the cover of a large notebook of squared paper, and into this he transferred and carefully colored the "definitive" version of each design that satisfied his criteria, numbering them as he did so. Over the years, he filled five of these folio notebooks with periodic drawings—137 numbered drawings in all—reproduced in this chapter. Escher numbered the drawings in the order he transferred them into these notebooks; in a few cases, his recorded dates of when the designs were created are not in strict chronological order. Escher never titled his drawings, and only referred to them by their numbers in his notes. He never bothered to copy into the folio notebooks several periodic designs he made especially for commissioned work or a print. Sketches of these are in his small copybooks and on loose sheets; some are reproduced here after the numbered drawings.

The individual pages of drawings were originally in notebooks with sewn binding; it is easy to see which edge of the page was at the center. The page facing each drawing was usually blank, and in a few cases Escher made notes on that page which referred to the drawing on the facing page. The first 50 drawings, contained in the first two folio notebooks, were on a left page, so Escher's comments are on the verso of the next numbered drawing. We show these comments as an inset with the reproduction of the numbered drawing to which they refer. Escher's definition of regular division of the plane, adapted from that of Haag's article, is on the verso of drawing number 1; thus it was the first entry that was seen when opening folio notebook I.

Escher's drawing 25 of lizards is the first in his folio notebook II; it can be seen in the lithograph *Reptiles*. The verso of this drawing, which was the first page in that notebook, was an inventory of the numbered drawings according to Escher's classification. No doubt this was a running record kept by Escher to follow the progress of his illustration of the various systems. This inventory is reproduced in the Concordance, on page 327.

Each of the drawings in the folio notebooks was begun in the same way: Escher first laid out the geometric grid of parallelograms, triangles, or other polygons which governed the way in which a motif was to be repeated in its interlocking design. For almost all his early designs, he labeled 2-fold centers with small circles, 4-fold centers with small squares, and 3-fold centers with small triangles. These penciled underly-

„Die regelmäszigen Planteilungen bestehen aus kongruenten, lückenlos aneinander ge- reihten (konvexen) Polygonen ; die Anordnung der Polygone um jedes einzelne ist die näm- liche wie um jedes andere."

„Die regelmäszigen Planteilungen und Punktsysteme". — F. Haag, Stuttgart Zeitschrift für krystallographie seite 478, Band 58, 1923

Escher's definition of regular division of the plane (adapted from a 1923 article by F. Haag) on the first page of his folio notebook I. "Regular divisions of the plane consist of congruent (convex) polygons joined together; the arrangement by which the polygons adjoin each other is the same throughout."

Reptiles. March 1943. Lithograph, 334 × 385 mm (cat. 327).

ing geometric grids and marked rotation centers can be seen in many of the finished periodic drawings. As Escher became more confident, the geometric underpinnings of the designs, which can still be seen in his sketchbooks, no longer appear in the carefully finished version in the folio notebooks.

Once Escher had arrived at a "definitive" motif, he would make a careful tracing from his sketchbook drawing, use this to transfer the design to fill one polygon of the grid on the notebook page, and then repeat it to fill the other polygons, always interlocking the motifs according to the appropriate geometric rules. For those designs based on a triangular grid, he used a portion of isometric drafting paper to assure geometric accuracy in rendering the definitive motif. He punched small holes like printer's registration marks at the three crucial rotation centers on the boundary of the motif; these three holes formed vertices of an equilateral triangle which could be repeated to fill the plane. His single butterfly motif of drawing 70 (page 172) is shown here drawn on isometric paper (next page); it is enclosed by a hexagon with punched holes at its vertices to ensure the accurate transfer and repetition of the butterfly as it filled out the beautiful design. Isometric paper was expensive, and Escher utilized every open space on a sheet; note on this sheet with the butterfly motif, the rough sketches and scraps of other designs, one of which is a design for bank-note background (page 232).

Finally, he added detail and color to the penciled design. Although his selection of colors for each design may have been somewhat arbitrary, his insistence on the proper contrast of colors guided his choice of hues and shades. He most often used watercolor, but also colored pen-

The butterfly motif for drawing 70 on isometric paper, with registration holes punched for accurate transfer. Pencil, ink, 360 × 235 mm.

cil, either alone or in combination with watercolor. He used india ink often for emphasis, outline, or detail; occasionally he used colored ink or gilt ink. Some artists and critics considered him a failure as a colorist, but the mathematicians and crystallographers marveled at the symmetric arrangement of colors in his designs.

Under each numbered colored drawing, Escher recorded the symmetry type of the design according to his classification scheme set out in the 1941–1942 notebook, together with the place and date of creation. Before he finalized his own system of classification, he gave short narrative descriptions of some of the important features of each design, such as the number of different motifs, the underlying geometric grid, whether the motifs appeared in both direct and mirror images, the way in which a motif was repeated, and the number of different directions (with respect to rotation) in which it faced. Beginning with drawing 34, he used the succinct labeling system of his "Theorie" notebook to characterize the symmetry of each drawing; he then went back and pasted over the earlier notations on each of the previous drawings with a patch of graph paper containing only the label of the appropriate notebook category.

Escher often cross-referenced drawings of the same system by writing on each "see," followed by the numbers of the others. He always noted when a motif in a drawing had bilateral symmetry and added an asterisk to the classification symbol when that local symmetry introduced global reflection symmetry into the drawing. He also noted a few instances where the motifs had bilateral symmetry and yet the pattern as a whole contained no reflection symmetry; he remarked in these cases that the motifs "apparently" have bilateral symmetry.

Escher considered the drawings a resource and referred to the folio notebooks as "storehouses" from which he could select a design to be used in a small vignette for an exhibition invitation or greeting card, to be incorporated as a key element in a large graphic work, or to be turned into a decorative design for a wall, ceiling, or column. For twenty years, as he filled his "storehouses," most of these drawings were known only to Escher.

A small selection of the drawings was shown along with related graphic prints in exhibitions and a few drawings were published in articles by art critics. In 1960, Escher's book *Grafiek en tekeningen* was published; it contained black-and-white photos of 13 of the regular division drawings. This was the first time that these drawings received wide publicity in Europe, England, and America. Most of the drawings bear the publisher's instructions to the photographer with regard to size and trim.

In 1960, after the great success of the exhibition of Escher's prints and periodic drawings at the Congress of the International Union of Crystallography in Cambridge, England, the Union commissioned Carolina H. MacGillavry to write a book to teach geology and crystallography students about symmetry and colored symmetry, using 42 of Escher's periodic drawings as instructive illustrations. Escher was delighted at the idea, and wrote to MacGillavry that he would consider such a book "a crowning of this work [on regular division of the plane], which I consider fundamentally more important than my graphic work, which is more addressed to a nonspecialized public."

Professor MacGillavry examined all Escher's numbered drawings, and selected an assortment that would best illustrate the crystallographic theory of colored periodic designs. She found many for which the coloring did not fit any of the categories on the crystallographers' list of color groups that was then current, but she also found that a few of the simplest examples of color groups were not represented and requested Escher to create new drawings to illustrate these types. At this time, Escher also improved several of the drawings chosen by MacGillavry; he added color and detail and, in some cases, completely redrew the design. Such drawings have two dates; the second states "improved April 1963." The book, entitled *Symmetry Aspects of M. C. Escher's Periodic Drawings* was published in 1965 under the auspices of the International Union of Crystallography. A set of color slides of Escher's work which included 11 of the periodic drawings was produced the next year by the Dutch company N. V. Filmfabriek Polygoon; Escher wrote the text for the pamphlet that accompanied the slides. Later books on Echer's work provide complete photo documentation of all his graphic work, but contain only a few of his periodic drawings.

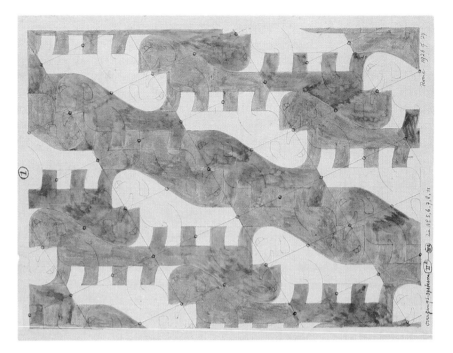

(1) transitional system II^A^-III^A^. See nos. 5, 6, 7, 8, 11 Rome 1926 or '27

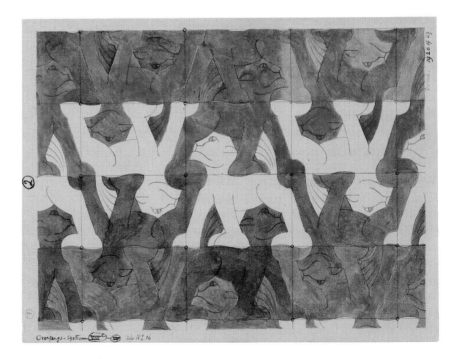

(2) transitional system VIII^C^-VII^C^. See no. 16 Rome 1926 or '27

Each drawing is reproduced here with Escher's annotations in English translation under the reproduction. Detailed notes on each drawing are contained in Chapter 5; these include its size, media used, selected publications in which it has been reproduced, how it was executed in finished work, notes on its symmetry or coloring, and remarks by Escher on the drawing taken from his articles and lectures. An index to the drawings and related work is on pages 346–347 and an index that lists the drawings by motifs is on page 345.

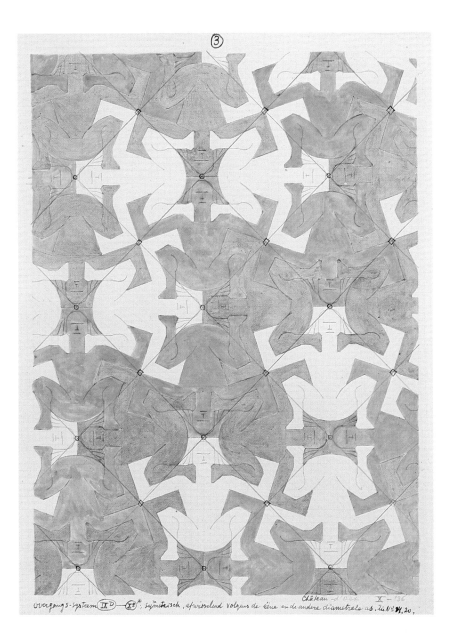

(3) transitional system IXD-XE*: symmetrical, alternately along one and then the other diagonal axis. See nos. 14, 20.

Château-d'Oex X-'36

source: Arabic motif in the Alhambra

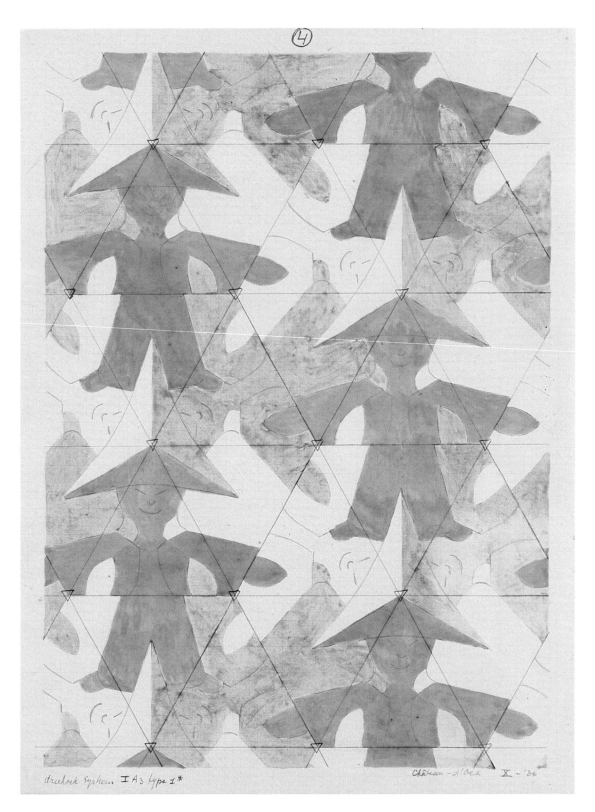

(4) triangle system I A$_3$ type 1* Château-d'Oex X-'36

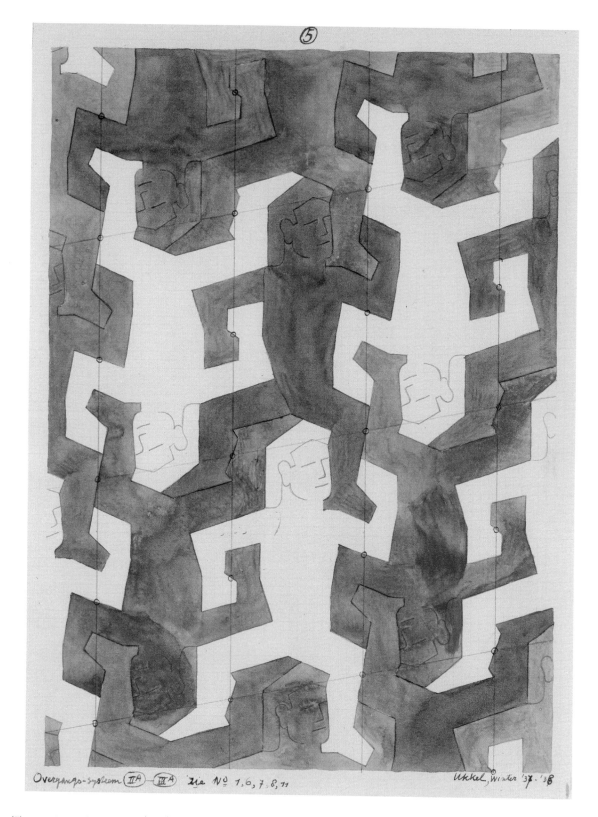

(5) transitional system II^A-III^A. See nos. 1, 6, 7, 8, 11

Ukkel Winter '37–'38

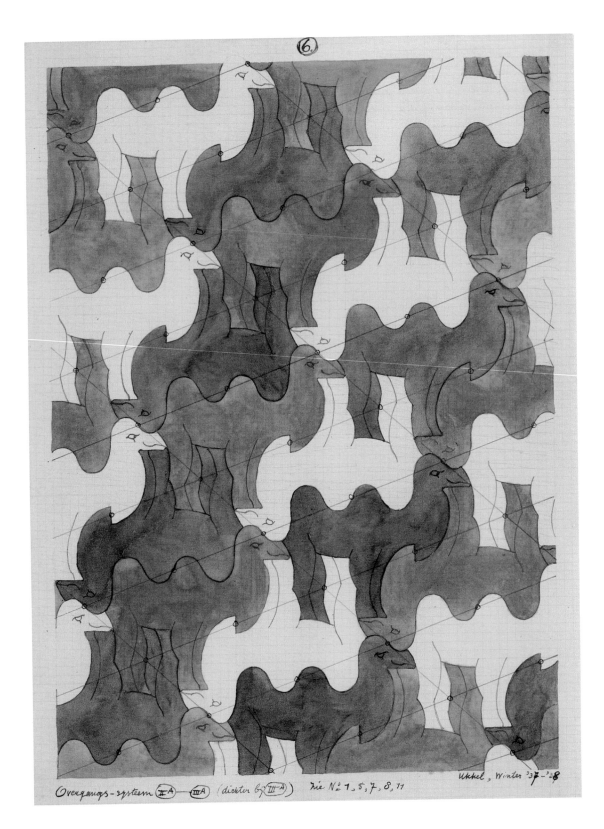

(6) transitional system II^A-III^A (closer to III^A). See nos. 1, 5, 7, 8, 11 Ukkel Winter '37–'38

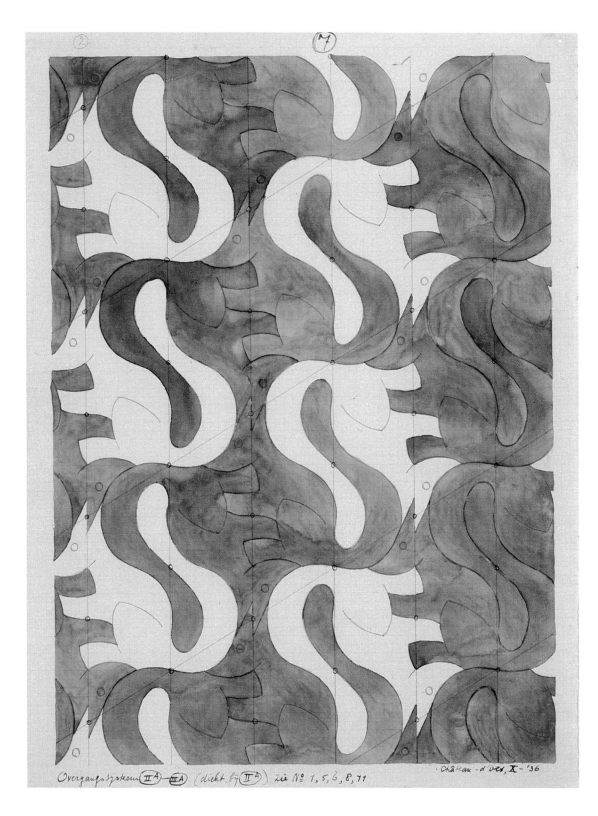

(7) transitional system II^A-III^A (close to II^A). See nos. 1, 5, 6, 8, 11 Château-d'Oex X-'36

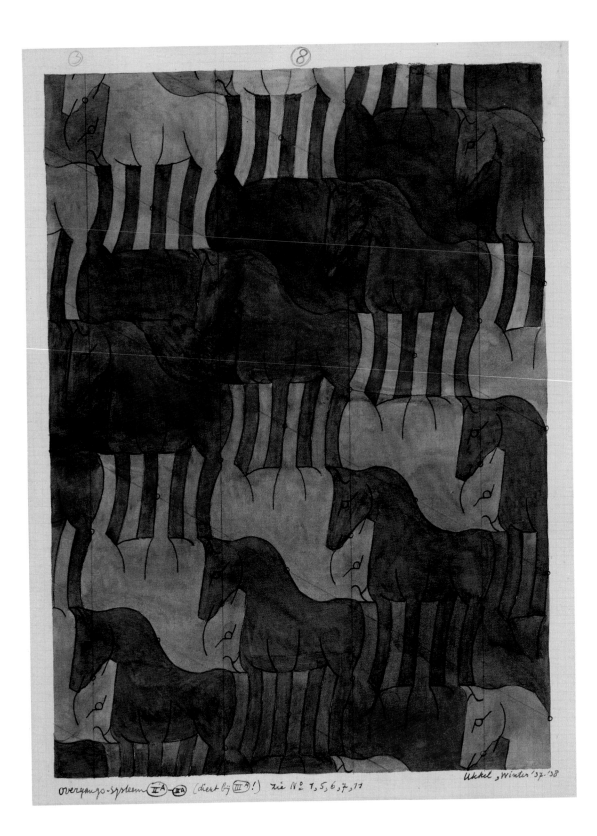

(8) transitional system II^A-III^A (Close to III^A!). See nos. 1, 5, 6, 7, 11 Ukkel Winter '37–'38

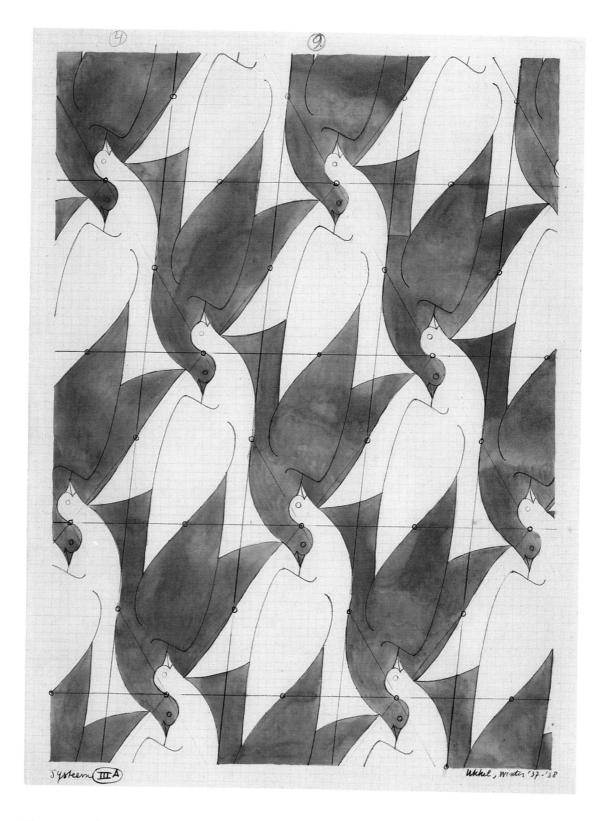

(9) system III^A

Ukkel Winter '37–'38

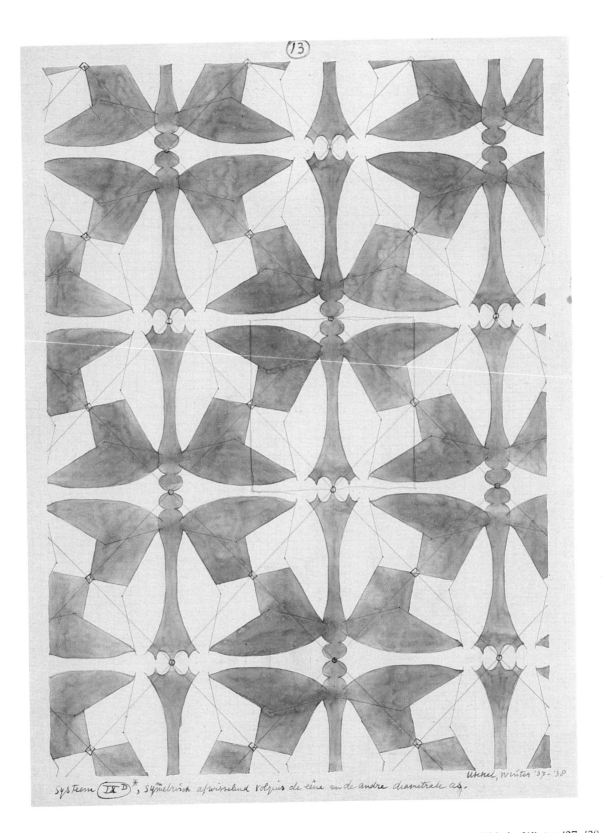

(13) system IX^D*, symmetrical alternately along one and then the other diagonal axis. Ukkel Winter '37–'38

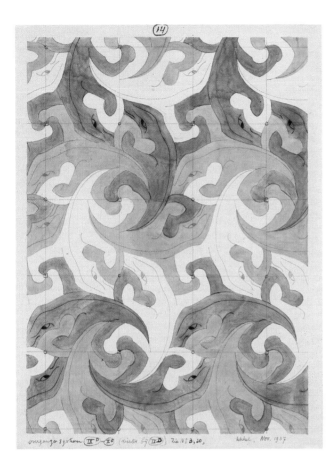

(14) transitional system IXD-XE. See nos. 3, 20
(closer to IXD)

Ukkel Nov. 1937

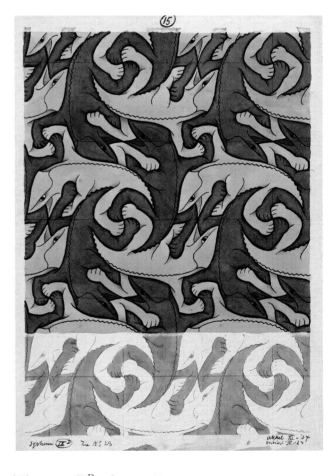

(15) system IXD. See no. 23

Ukkel XI-'37
improved IV-'63

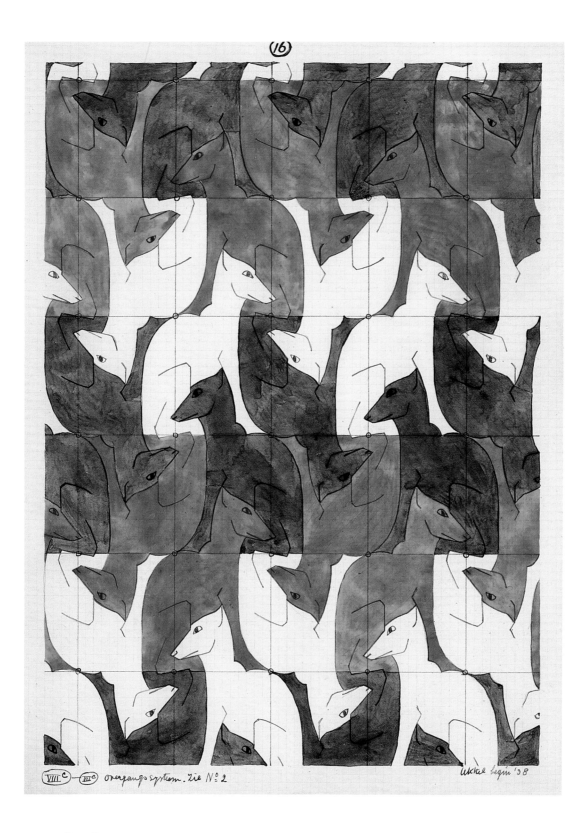

(16) VIII^C-VII^C transitional system. See no. 2 Ukkel beginning '38

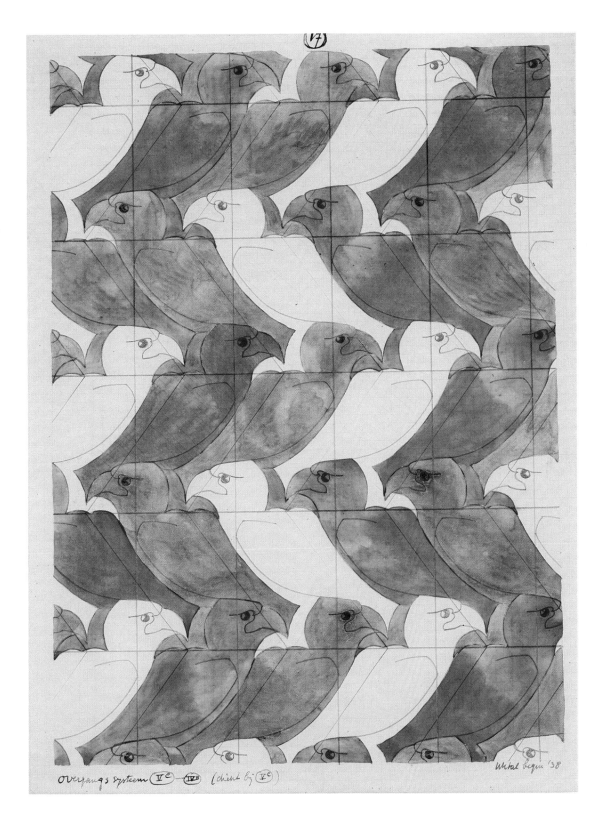

(17) transitional system V^C-IV^B (close to V^C) Ukkel beginning '38

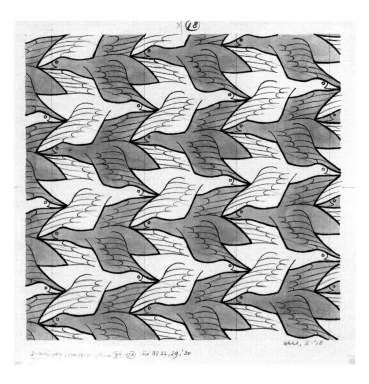

(18) *2 motifs:* transitional system I^A-I^A. See nos. 22, 29, 30

Ukkel II-'38

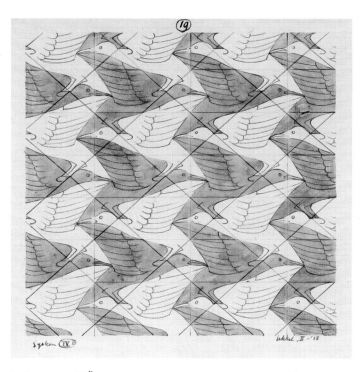

(19) system IV^B Ukkel II-'38

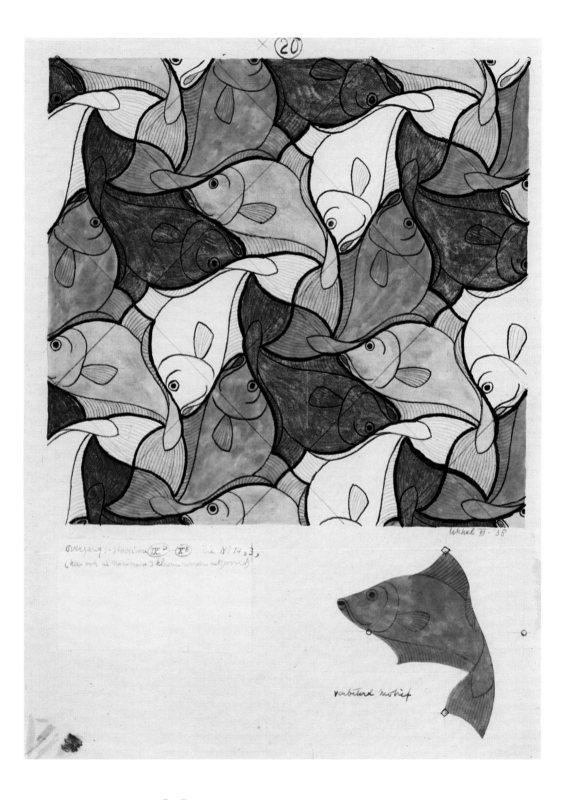

(20) transitional system IXD-XE. See nos. 14, 3 Ukkel III-'38
(can also be executed in a minimum of 3 colors)
[next to fish motif at lower right] improved motif

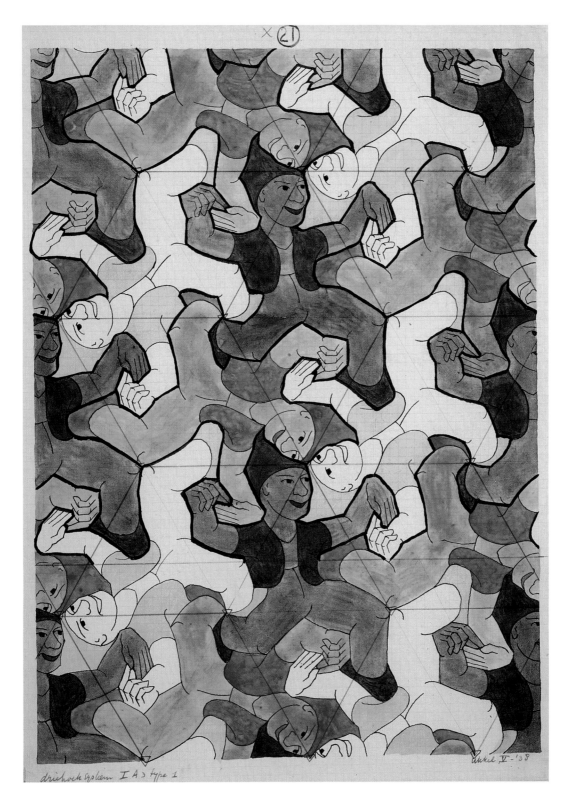

(21) triangle system I A₃ type I

Ukkel V-'38

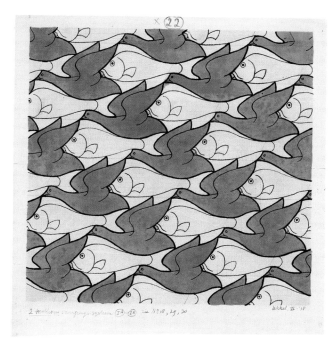

(22) *2 motifs:* transitional system IA-IA. See nos. 18, 29, 30
Ukkel VI-'38

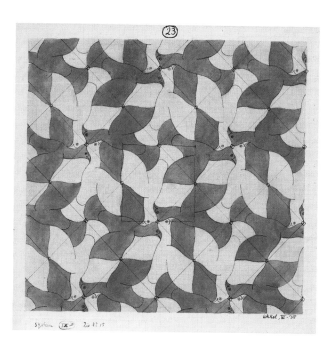

(23) system IXD. See no. 15 Ukkel VI-'38

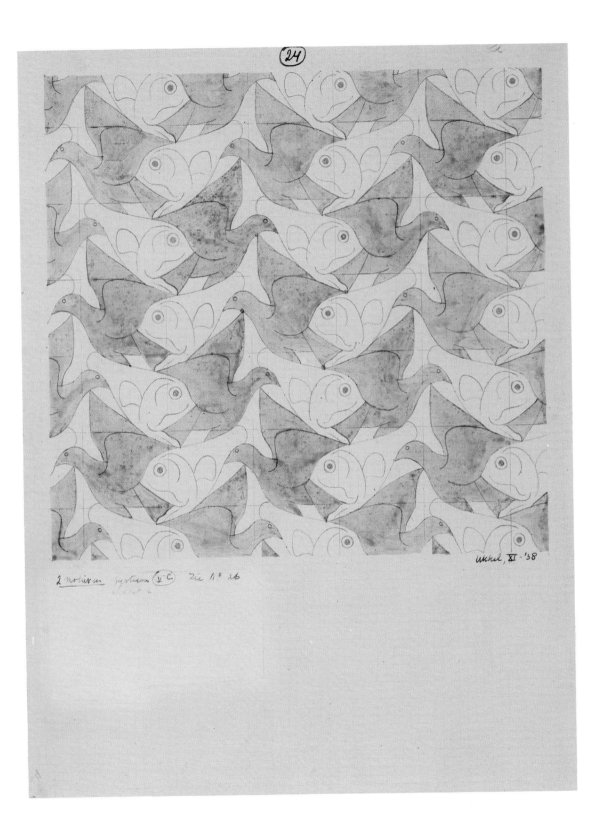

(24) *2 motifs* system V^C variant 2. See no. 26

Ukkel XI-'38

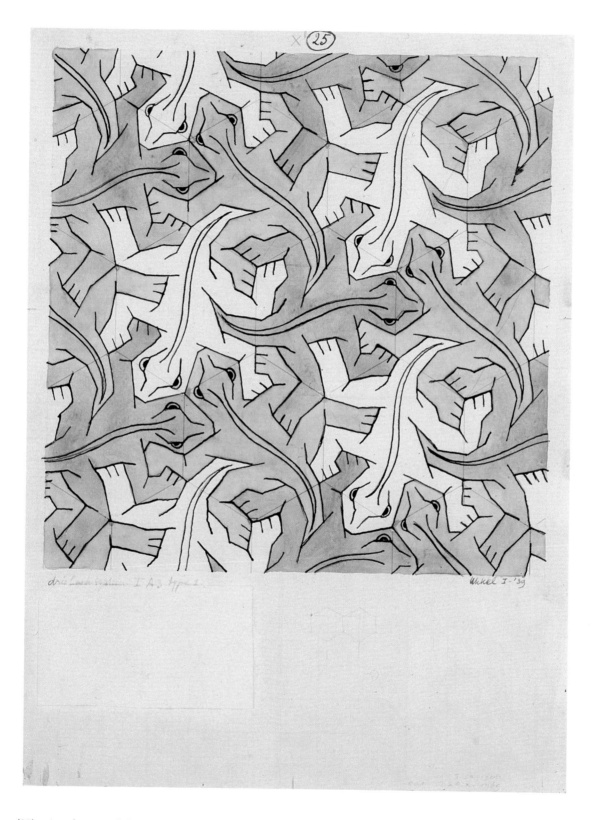

(25) triangle system I A$_3$ type I

Ukkel I-'39

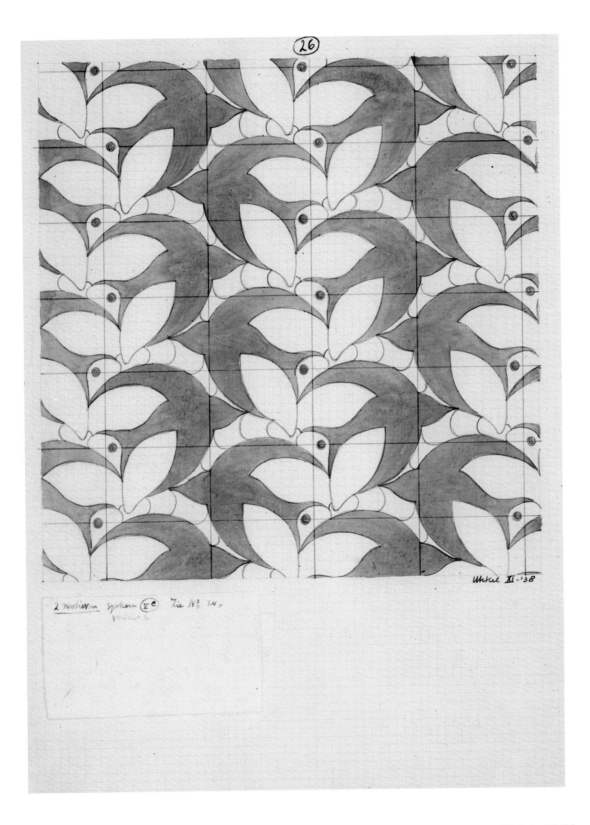

(26) *2 motifs* system VC variant 2. See no. 24

Ukkel XI-'38

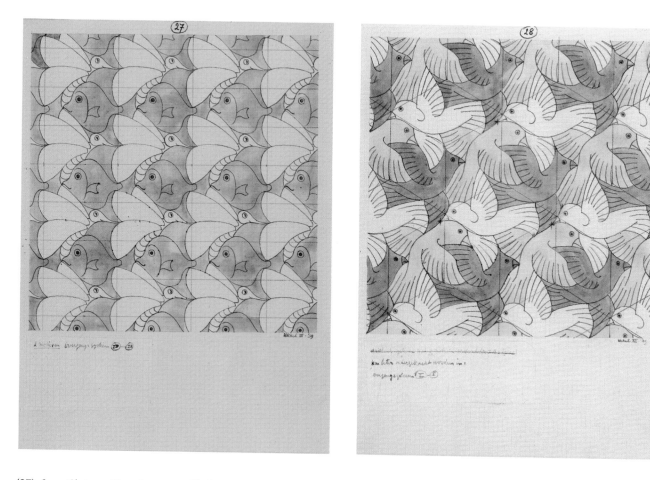

(27) *2 motifs* transitional system I^D-I^A Ukkel III-'39

(28)

~~triangle system with 3 motifs derived from I A₃ type 1~~
can be better classified as:
transitional system I-I Ukkel XI-'38

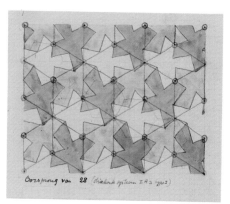

source of 28
(triangle system I A₃ type 1)

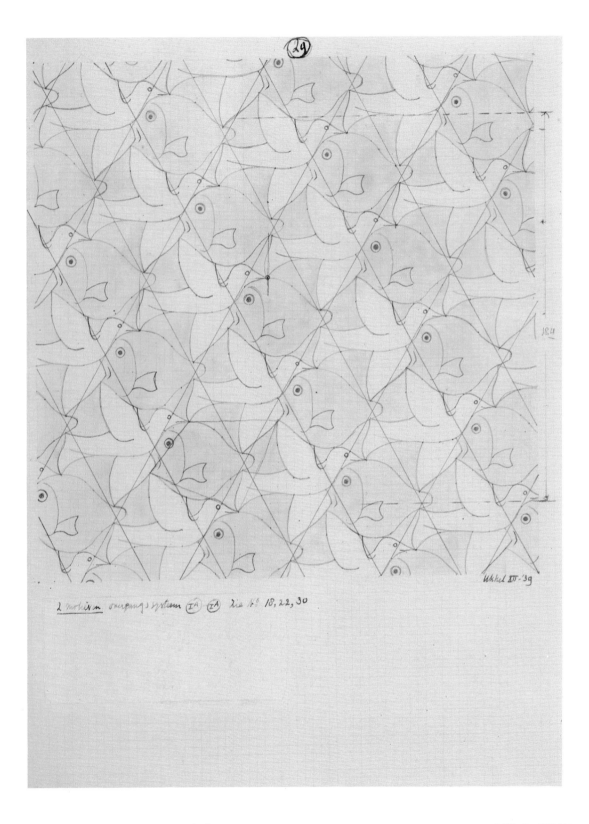

(29) *2 motif* transitional system I^A-I^A. See nos. 18, 22, 30

Ukkel XII-'39

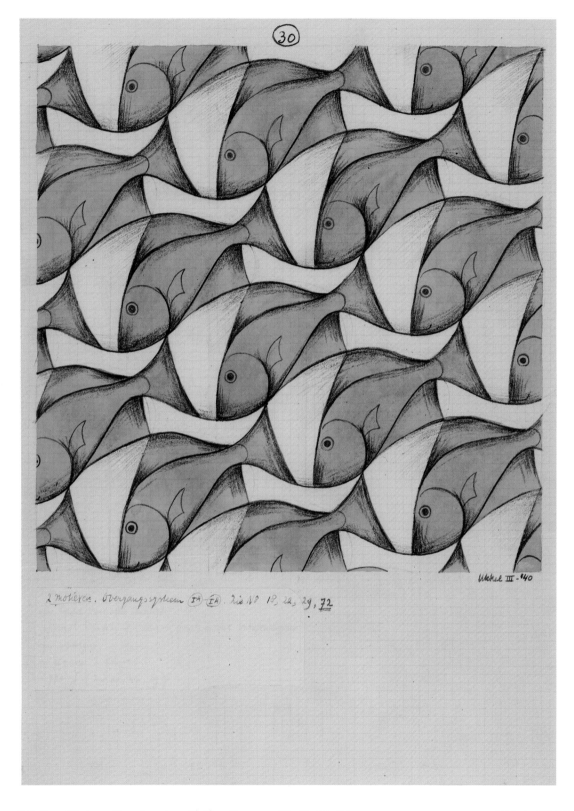

(30) *2 motifs* transitional system IA-IA. See nos. 18, 22, 29, <u>72</u> Ukkel III-'40

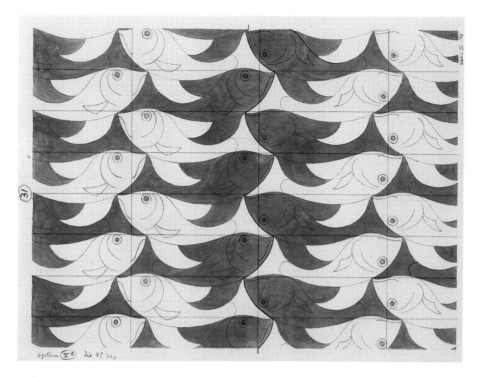

(31) system V^C. See no. 32 Ukkel IV-'40

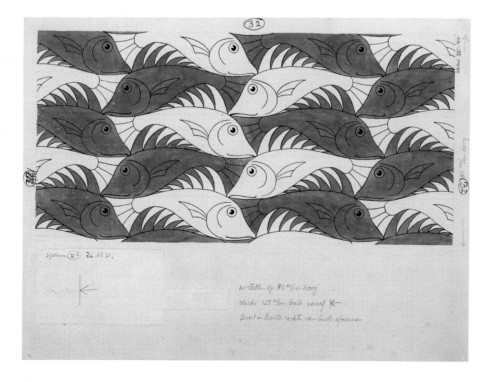

(32) system V^C. See no. 31 Ukkel IV-'40
[penciled instructions to photographer for *Grafiek en tekeningen*]

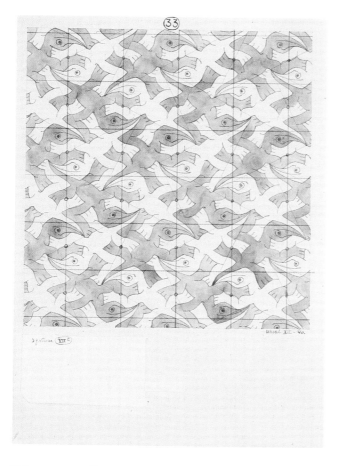

(33) system VII^C

Ukkel XII-'40

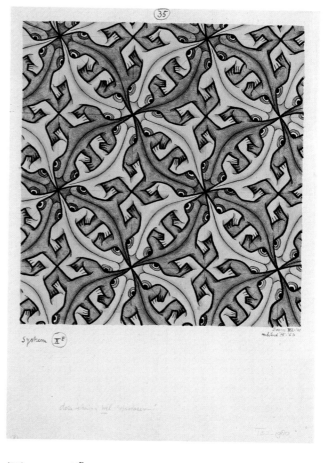

[*Drawings 34A, 34B, and 34 are on pages 142 and 143.*]

(35) system X^E
Do reproduce this drawing!

Baarn VII-'41
improved IV-'63

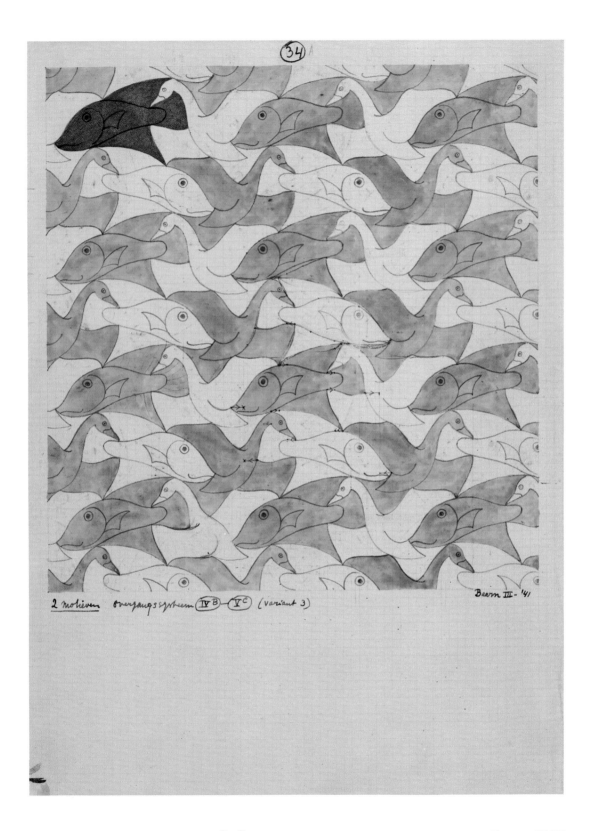

(34A) *2 motifs* transitional system IV^B-V^C (variant 3) Baarn III-'41

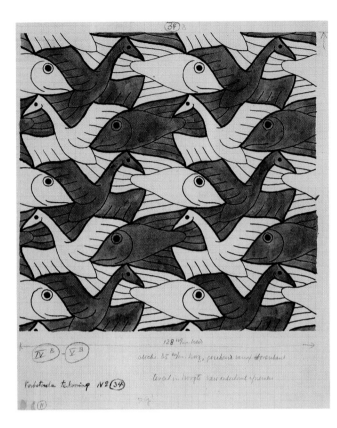

(34B) transitional system IV^B-V^B
improved drawing no. 34
[penciled instructions to photographer
for *Grafiek en tekeningen*]

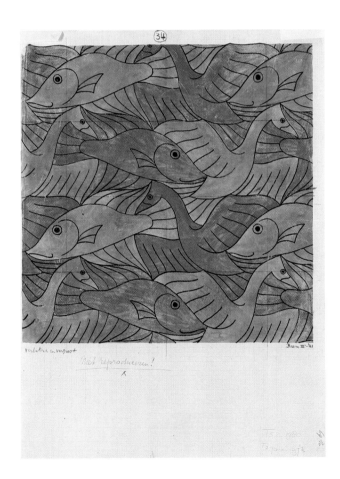

(34) improved and enlarged Baarn III-'41
Do *not* reproduce!

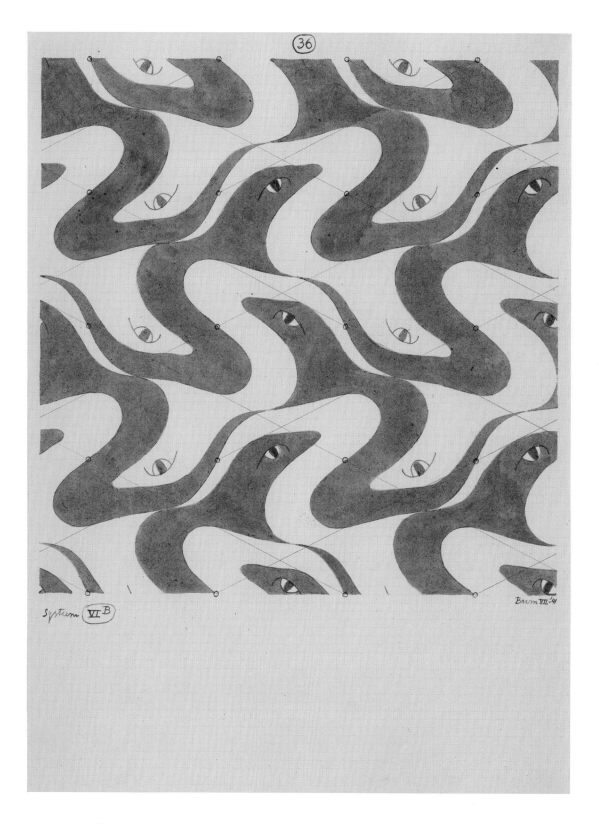

(36) system VIB Baarn VII-'41

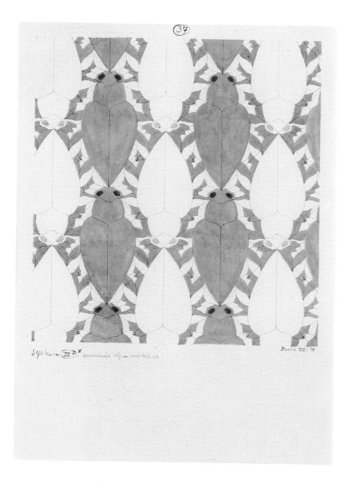

(37) system III^D*
symmetrical about vertical axis

Baarn VII-'41

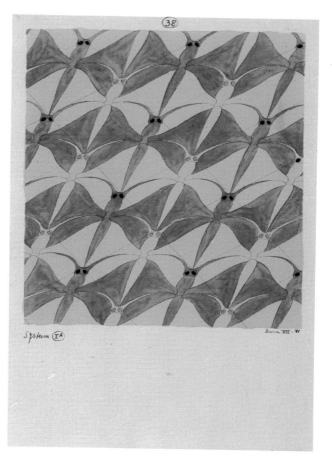

(38) system I^A

Baarn VII-'41

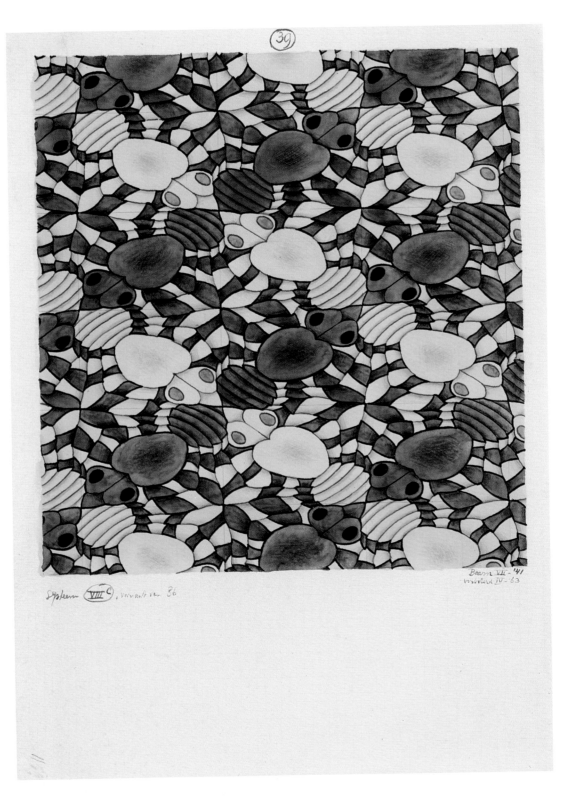

(39) system VIIIC, variant of 86

Baarn VII-'41
improved IV-'63

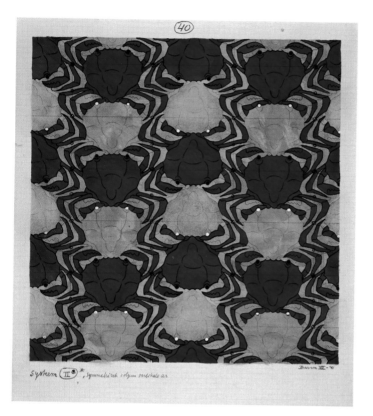

(40) system IIC* Baarn VII-'41
symmetrical about vertical axis

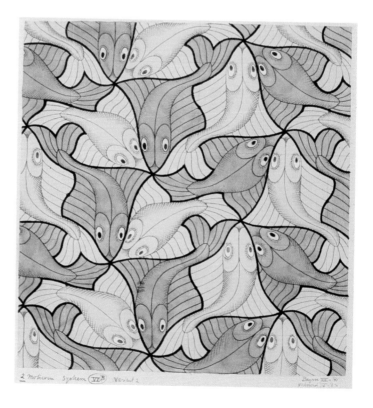

(41) 2̲ motifs system VIB variant 2 Baarn VII-'41
[*A mat obscures the number at the top.*] improved IV-'63

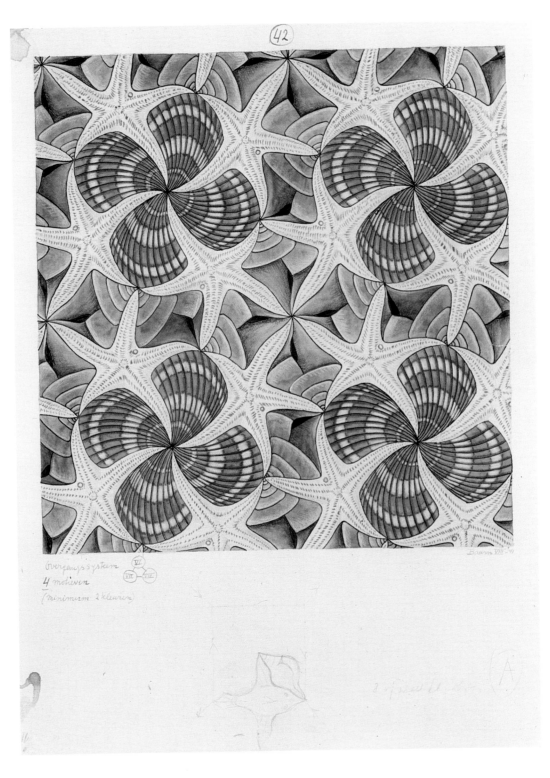

(42) transitional system VI

$\underline{4}$ motifs VII—VIII
(minimum 2 colors)

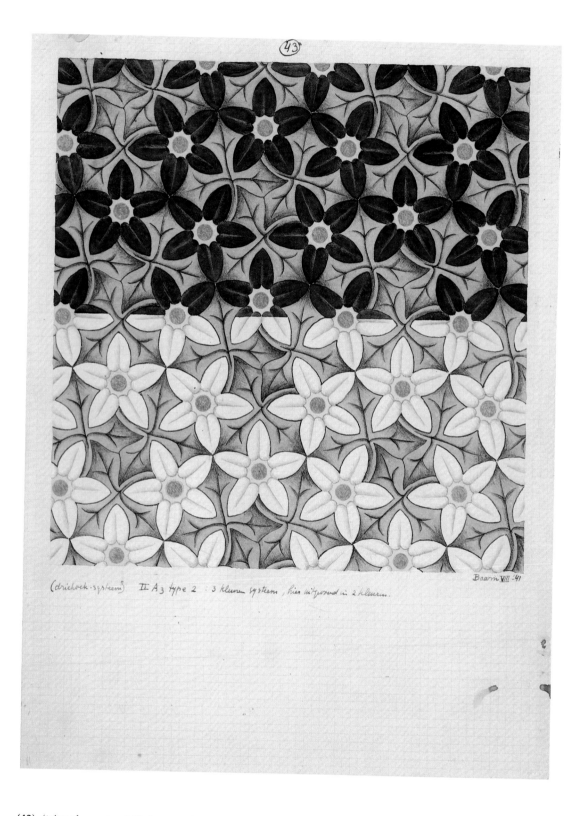

(43)

(driehoek-systeem) II A₃ type 2 : 3 kleuren systeem, hier uitgevoerd in 2 kleuren.

Baarn VIII-'41

(43) (triangle system) II A₃ type 2
3-color system; here executed in 2 colors

Baarn VIII-'41

(51) system III^C (exceptional case, see theory [notebook] p. 4)
one motif

Baarn VII-'42

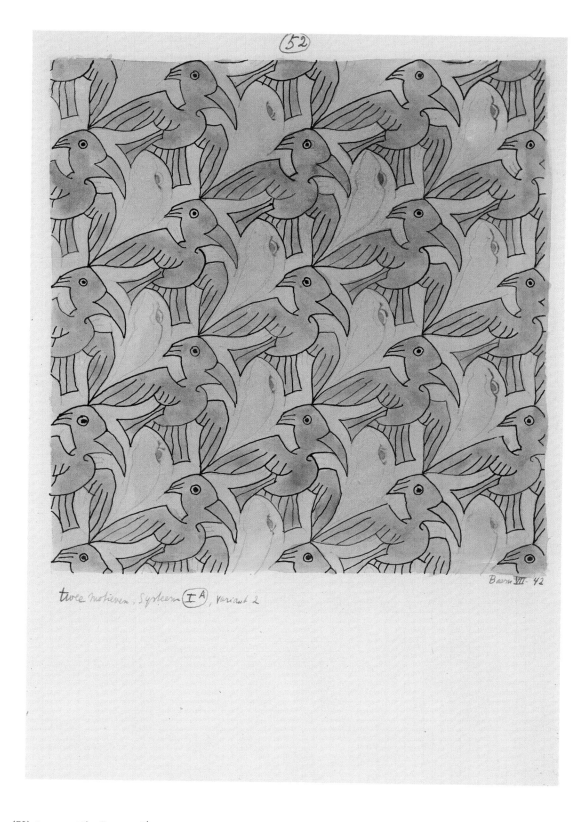

(52)

twee motieven, Systeem (IA), *variant 2*

Baarn VII-'42

(52) two motifs. System IA, variant 2

Baarn VII-'42

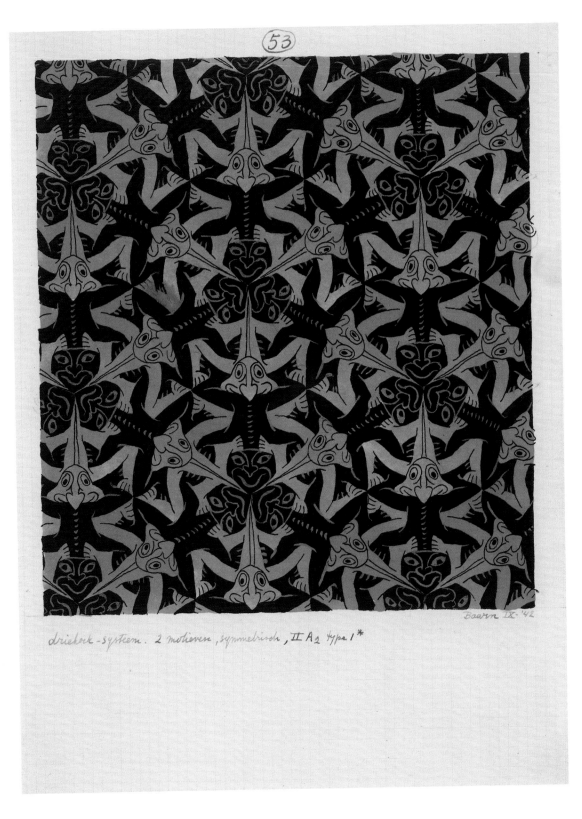

(53) triangle-system. 2 motifs, symmetrical, II A₂ type 1* Baarn IX-'42

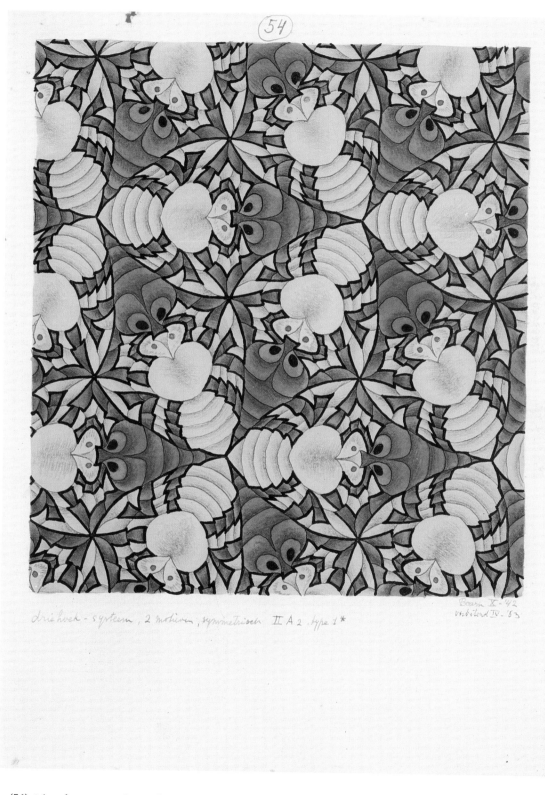

(54) triangle-system. 2 motifs, symmetrical, II A$_2$ type 1*

Baarn X-'42;
improved IV-'63

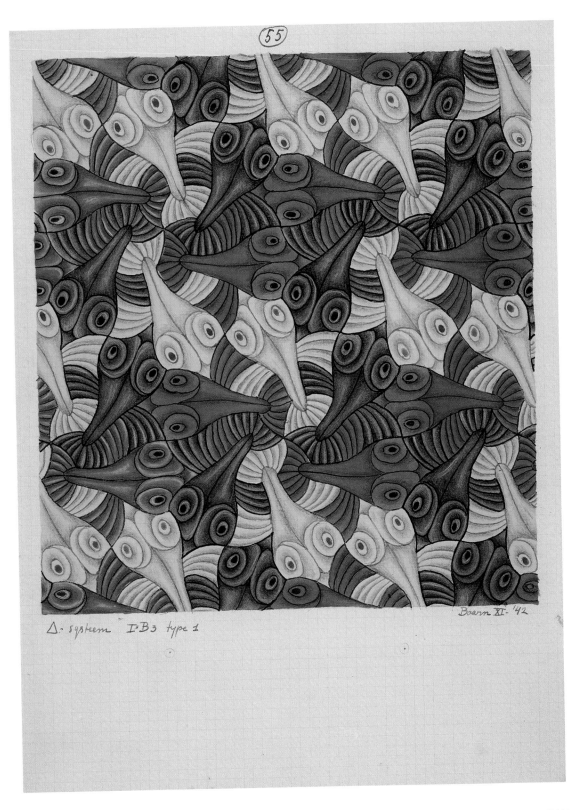

(55) triangle-system I B₃ type 1

Baarn XI-'42

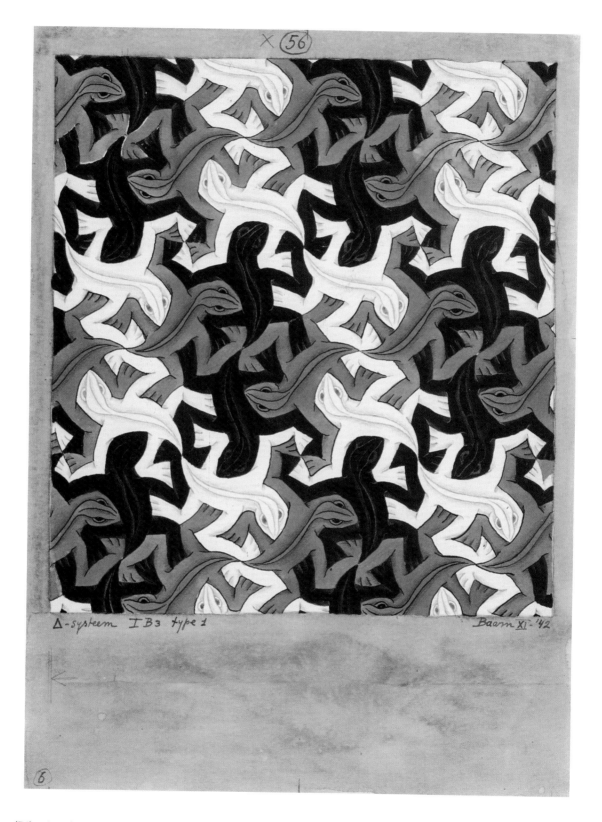

(56) triangle-system I B₃ type 1

Baarn XI-'42

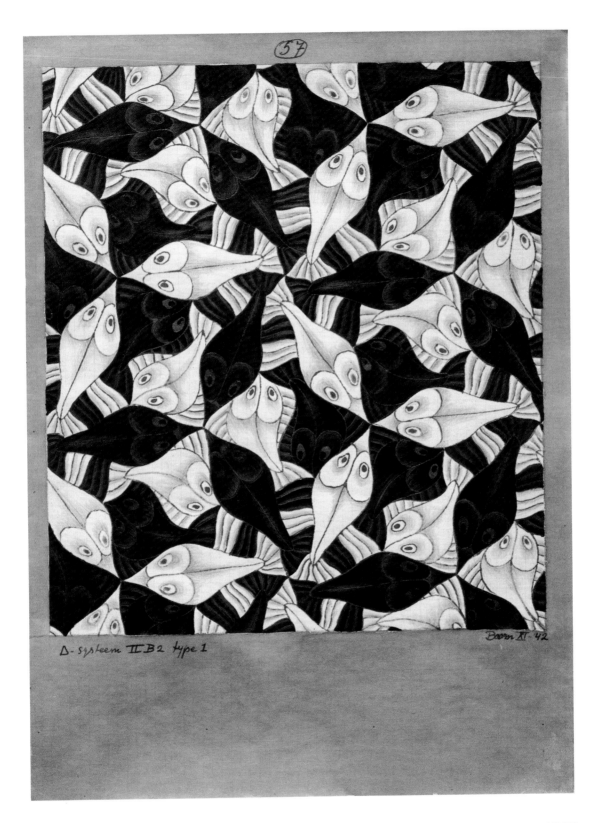

(57) triangle-system II B₂ type 1 Baarn XI-'42

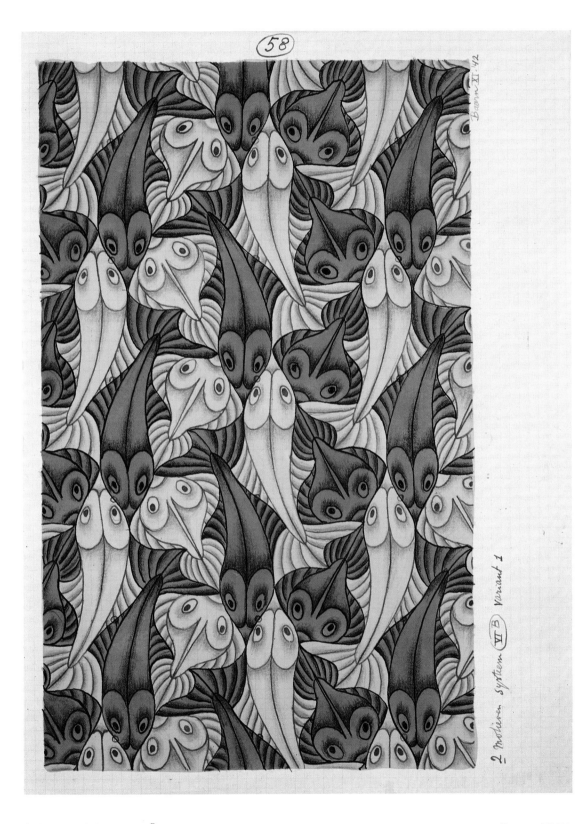

(58) <u>2</u> motifs system VI^B variant 1 Baarn XI-'42

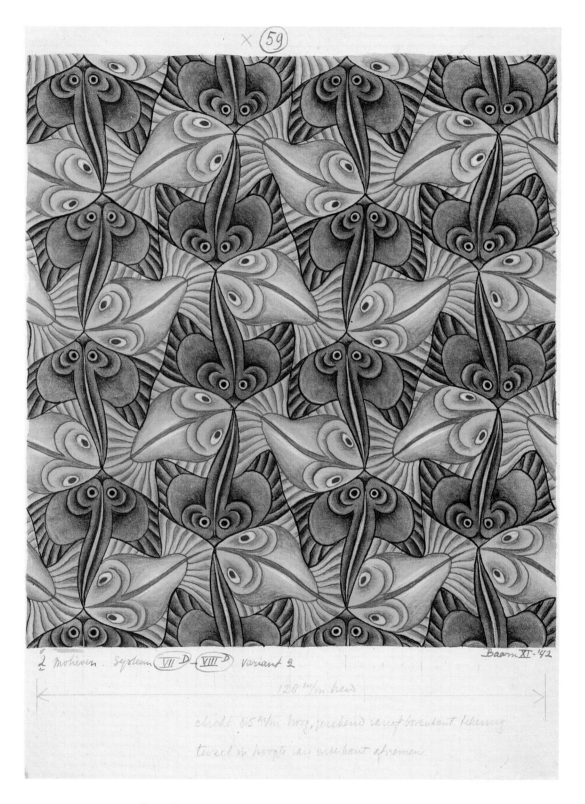

(59) 2 motifs. System VII^D-VIII^D variant 2 Baarn Baarn XI-'42
[penciled instructions to photographer for *Grafiek en tekeningen*]

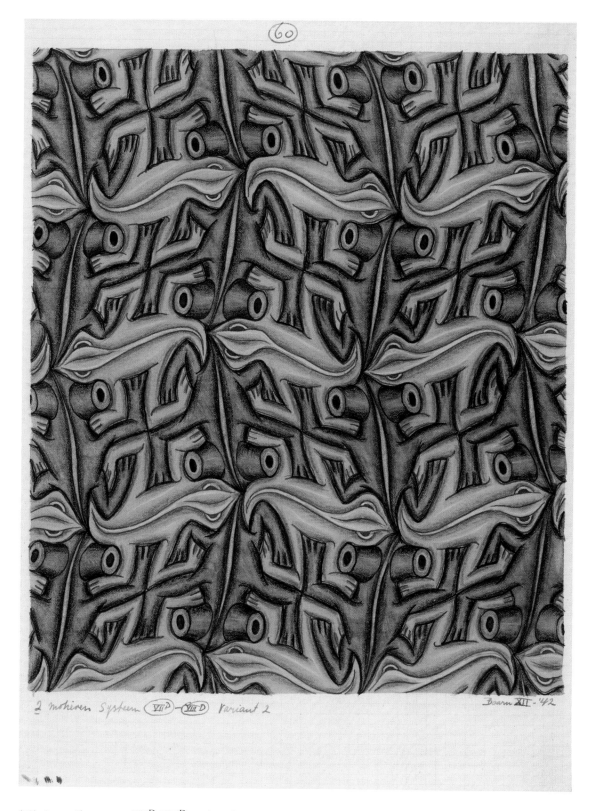

(60) $\underline{2}$ motifs system VIID-VIIID variant 2 Baarn XII-'42

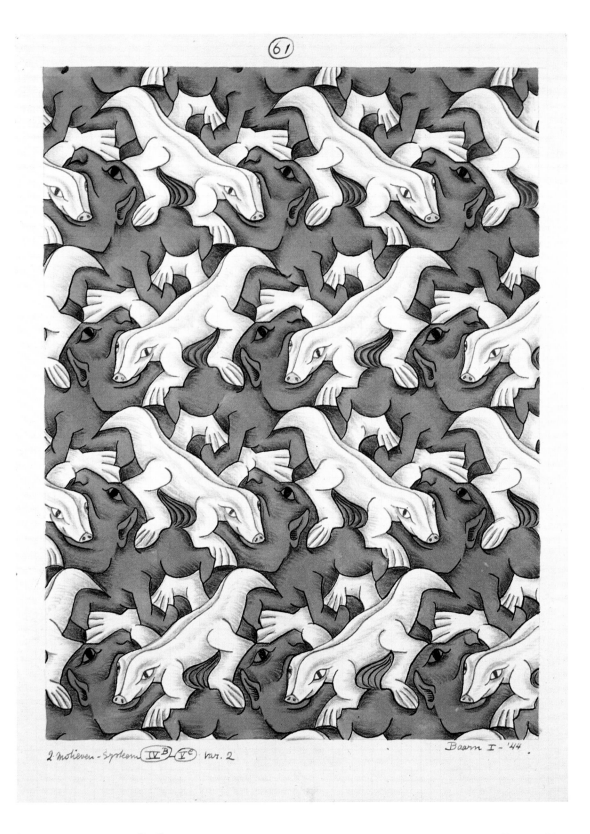

(61) 2 motifs system IV^B-V^C variant 2 Baarn I-'44

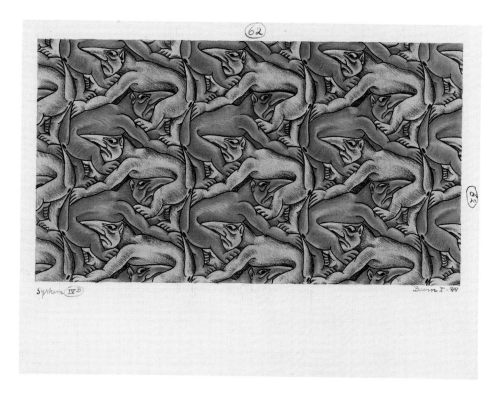

(62) system IV^B

Baarn I-'44

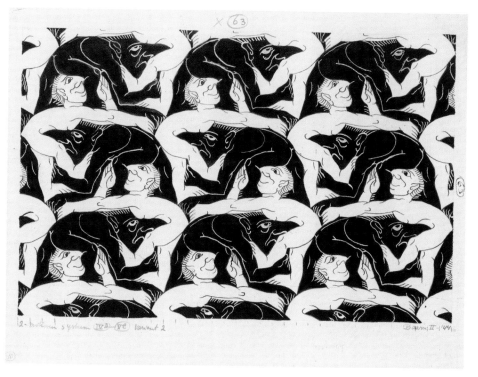

(63) 2 motifs system IV^B-V^C variant 2

Baarn II-'44

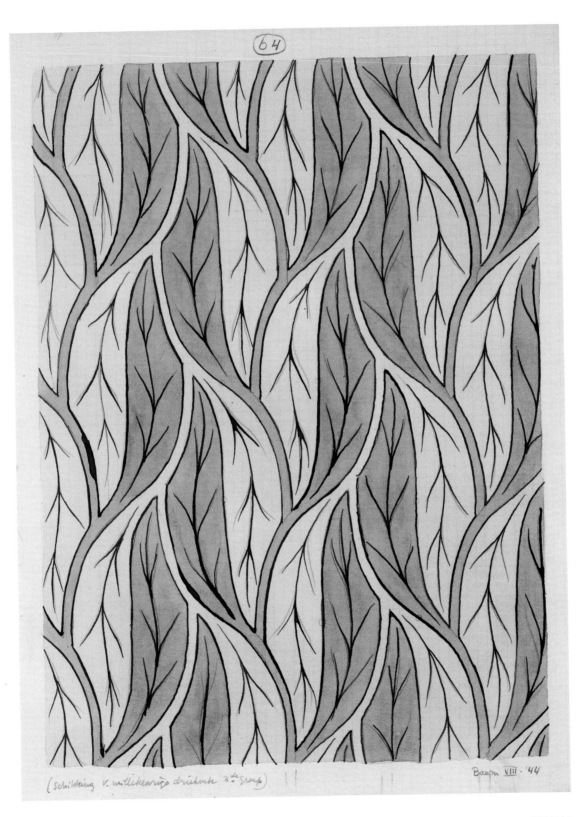

(64) (picture from arbitrary triangles, 3rd group) Baarn VIII-'44

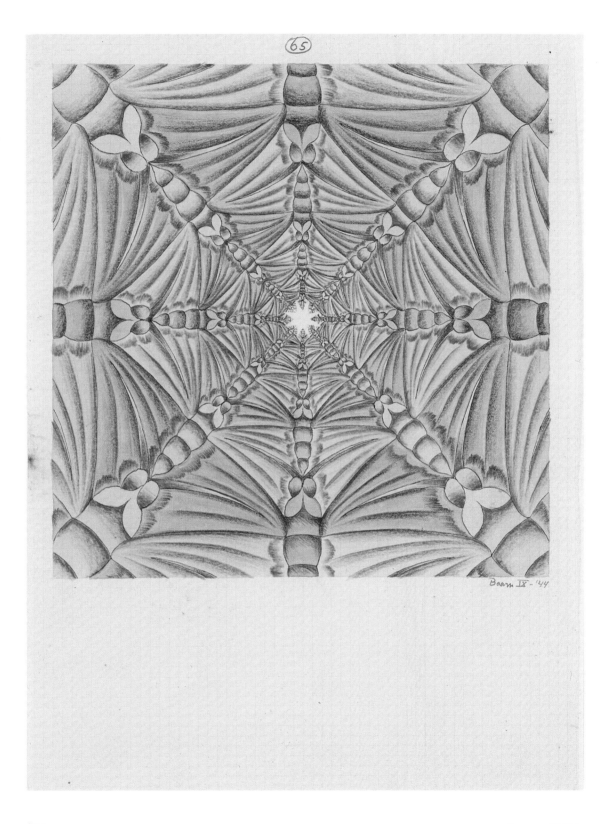

(65) Baarn IX-'44

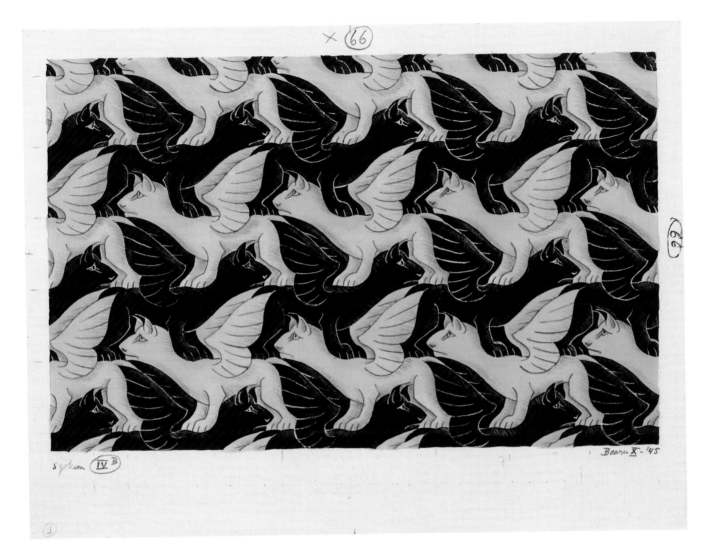

(66) system IVB Baarn X-'45

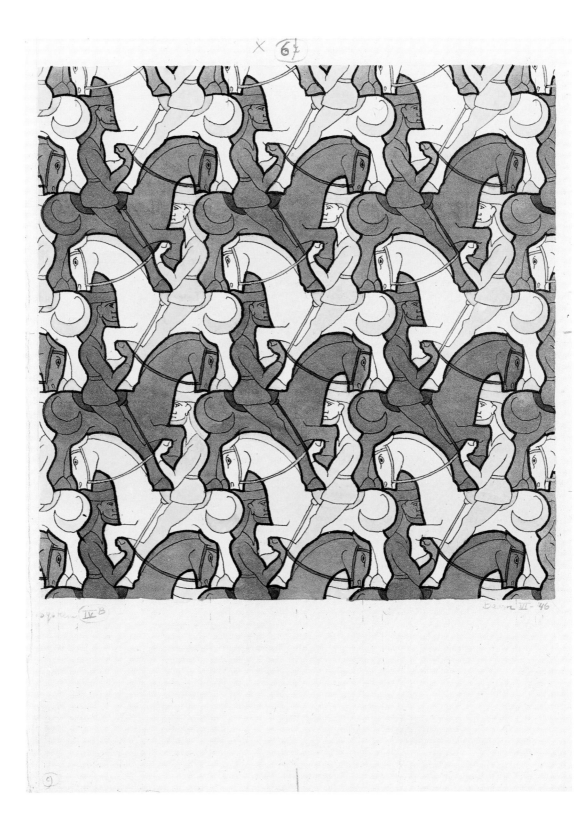

(67) system IV^B Baarn VI-'46

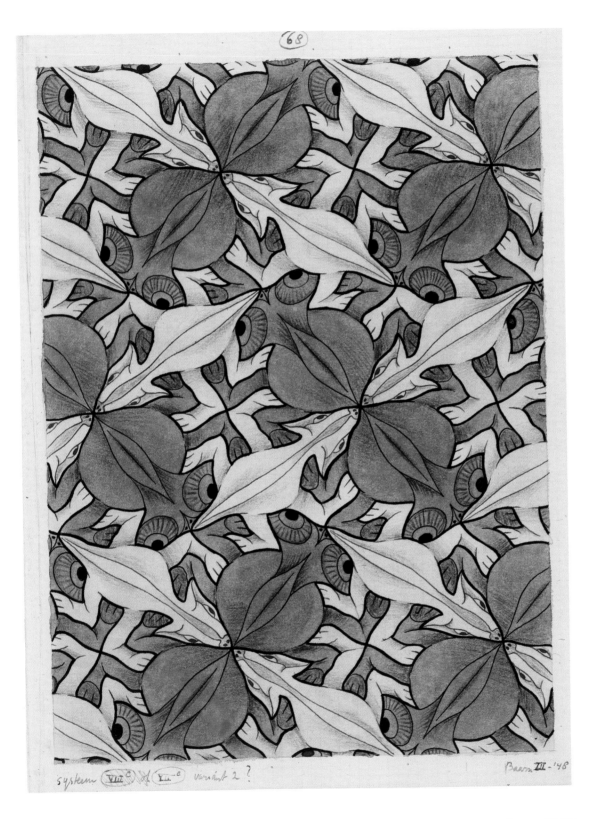

(68) system VIII^C or VII^C variant 2 ?

Baarn III-'48

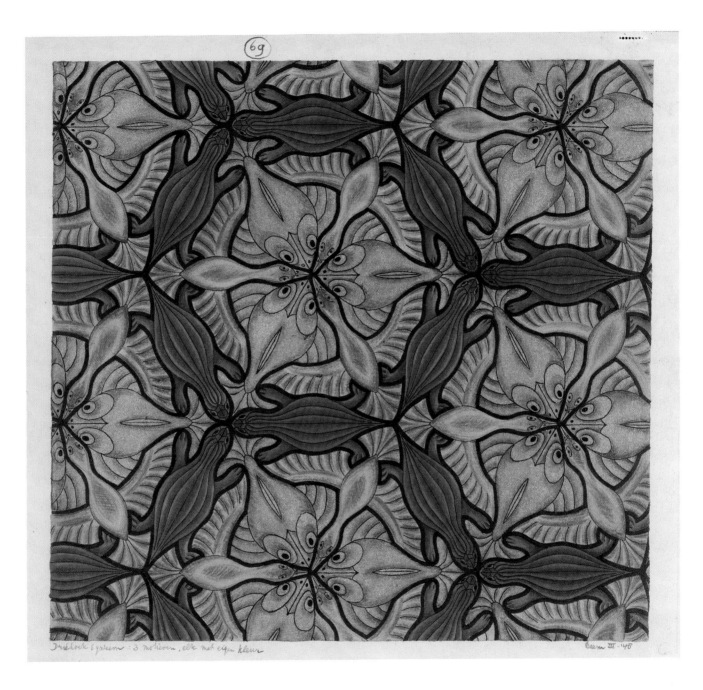

(69) triangle system: 3 motifs, each with one color

Baarn III-'48

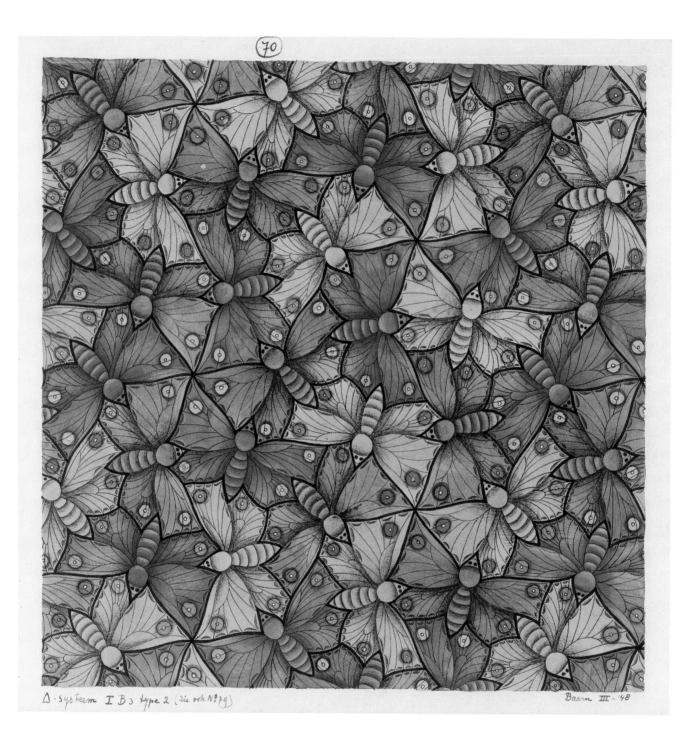

(70) triangle-system I B$_3$ type 2 (See also no. 79)

Baarn III-'48

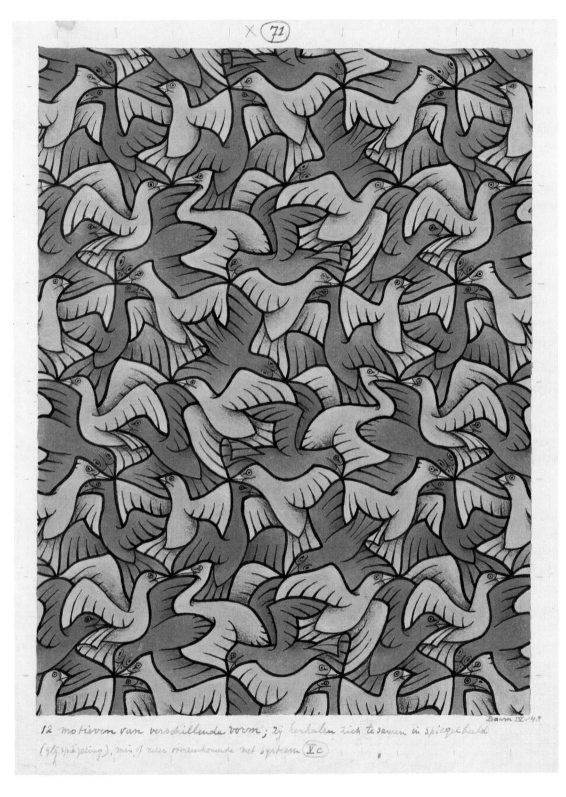

(71) 12 motifs of various forms; all are repeated in mirror image (glide-reflection), more or less according to system V^C.

Baarn IV-'48

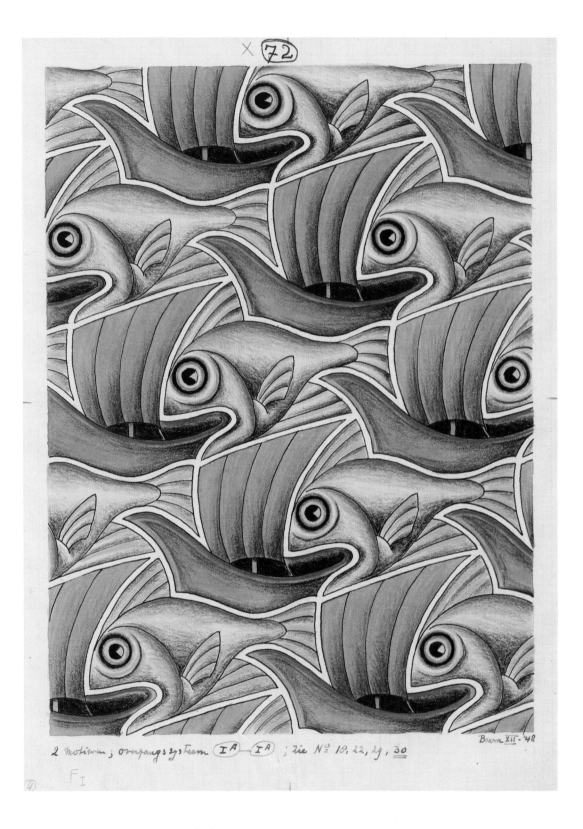

(72) 2 motifs; transitional system I^A-I^A; See nos. 18, 22, 29, <u>30</u> Baarn XII-'48

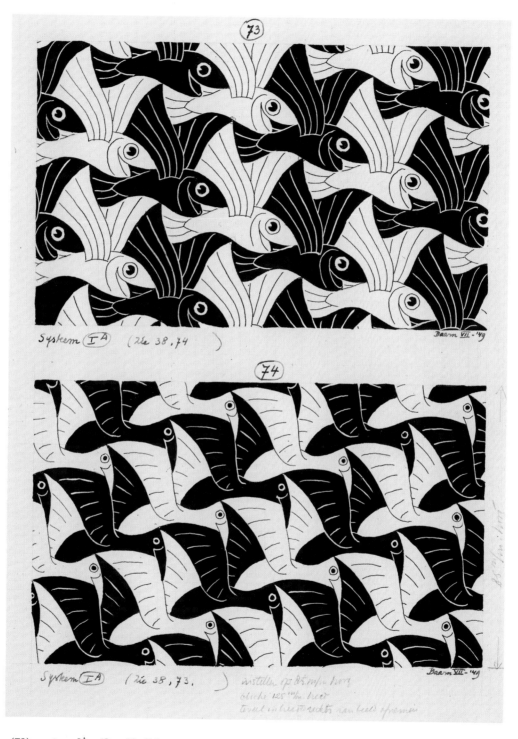

(73) system I[A] (See 38, 74) Baarn VII-'49

(74) system I[A] (See 38, 73)
[penciled instructions to photographer for *Grafiek en tekeningen*] Baarn VII-'49

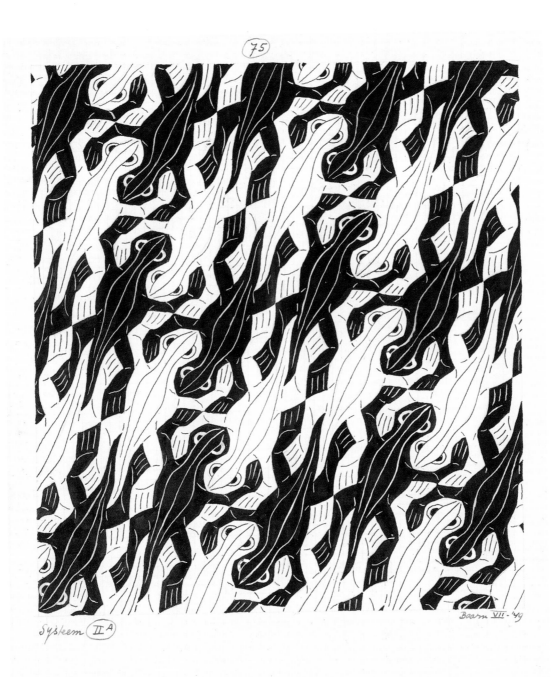

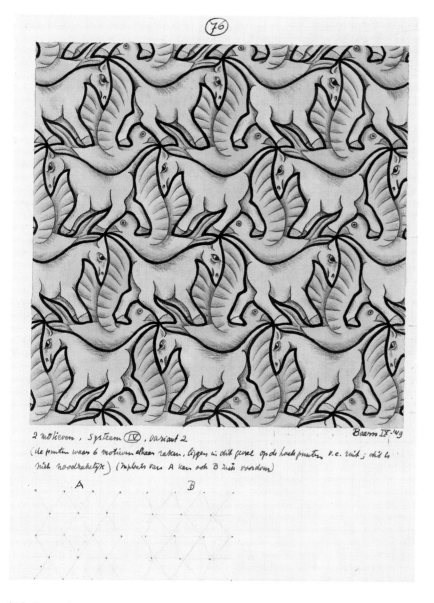

(76) 2 motifs, system IV, variant 2 Baarn IX-'49
(the points where 6 motifs come together lie in this case
at the vertices of a rhombus; this is not necessary)
(Instead of [the grid] A, [the grid] B can also arise)

(76a) 2 motifs, system I^A, variant 2

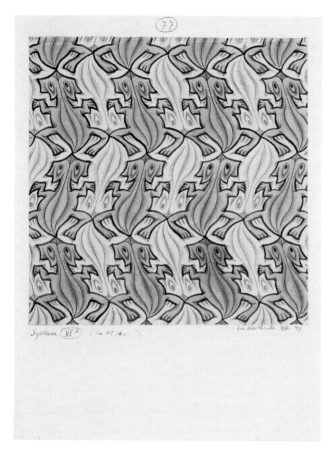

(77) system VI^B (see no. 36) Les Diablerets VIII-'49

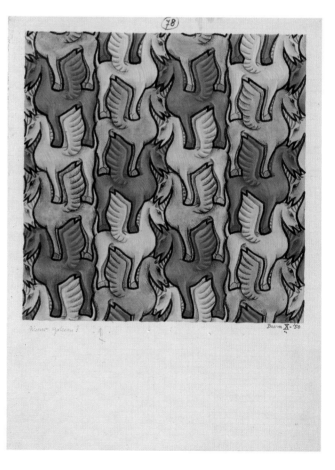

(78) new system? Baarn X-'50

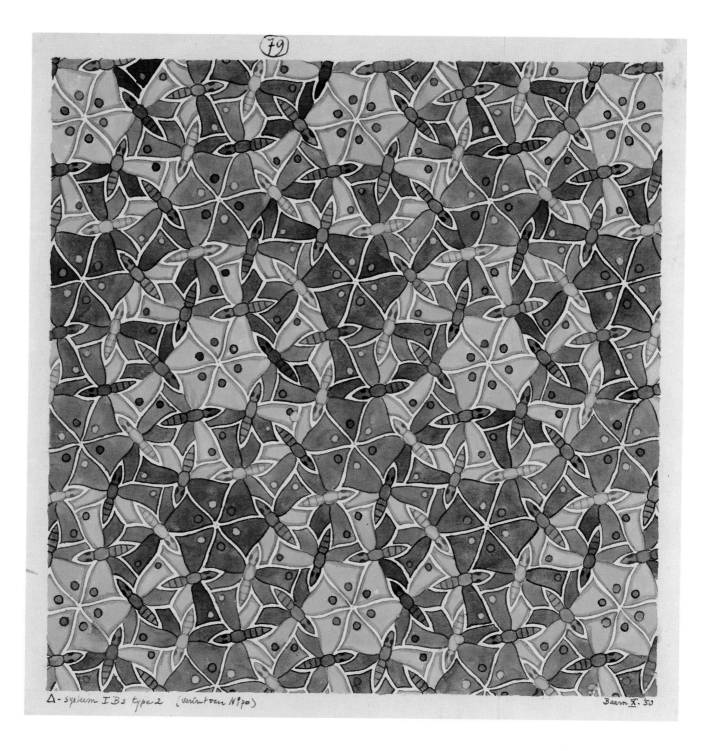

(79) triangle-system I B₃ type 2 (variant of no. 70)

Baarn X-'50

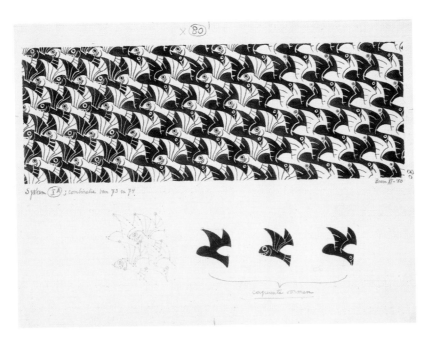

(80) system I^A; combination of 73 and 74 Baarn XI-'50
[under three motifs shown] *congruent forms*

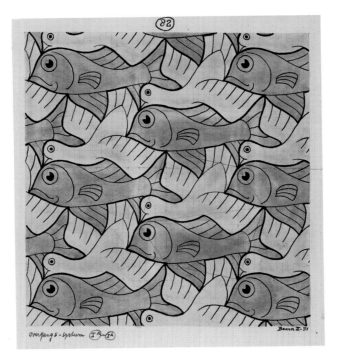

(82) transitional system I^A-I^A Baarn II-'51

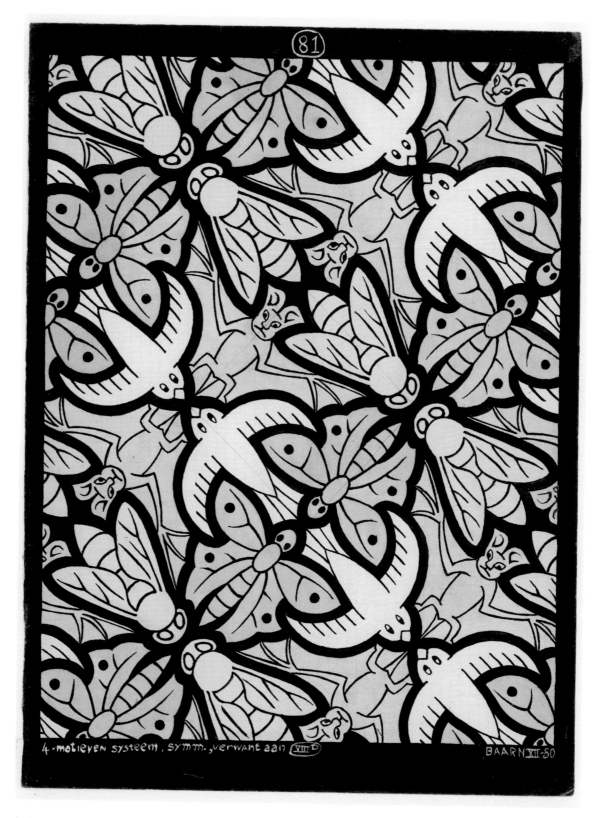

(81) 4-motifs system, symmetric, related to VIIID

Baarn XII-'50

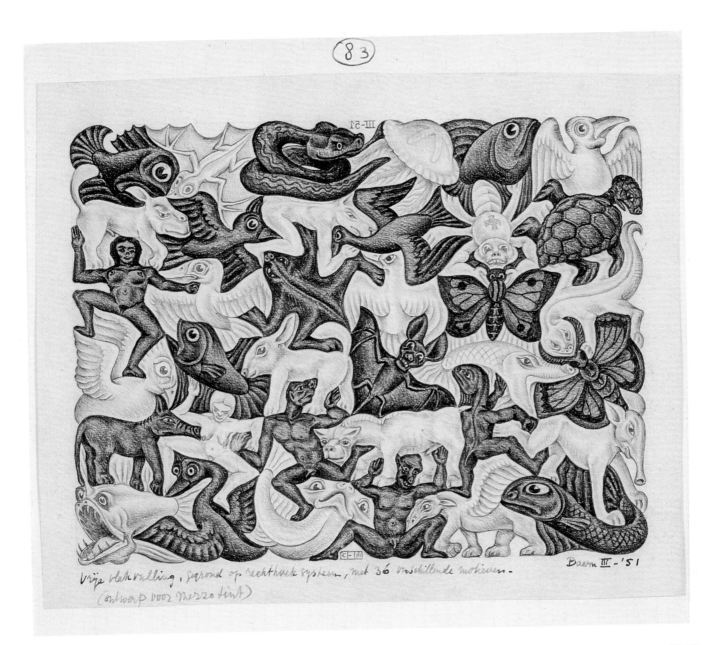

Baarn III-'51

(83)
Free plane-filling, based on rectangular system, with 36 different motifs.
(design for mezzotint)

(84) 2 motifs. Transitional system I^B-I^A Variant of no. 29. Baarn IV-'51
characterized solely by contour lines
[penciled instructions to photographer for *Grafiek en tekeningen*]

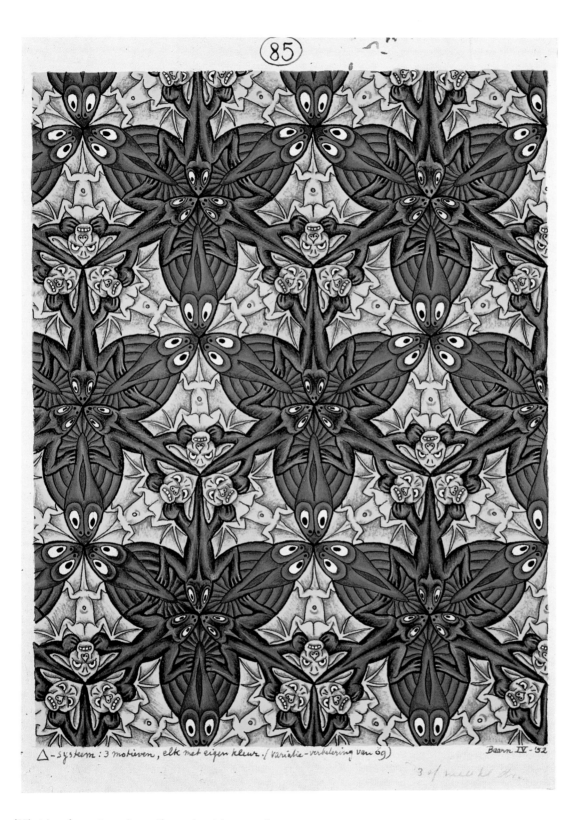

(85) triangle system: 3 motifs, each with one color.
(variation—improvement of 69)

Baarn IV-'52

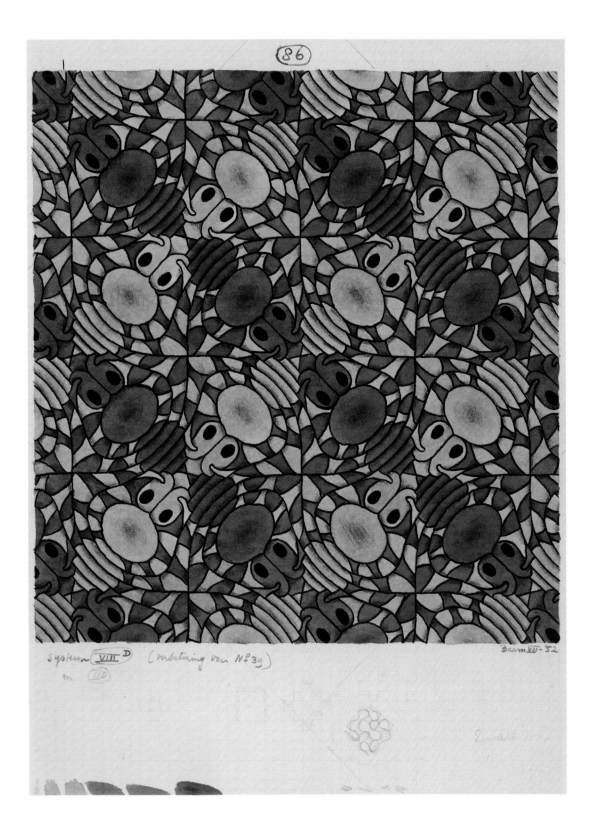

(86) system VIII^D and IX^D (improvement of no. 39) Baarn VII-'52

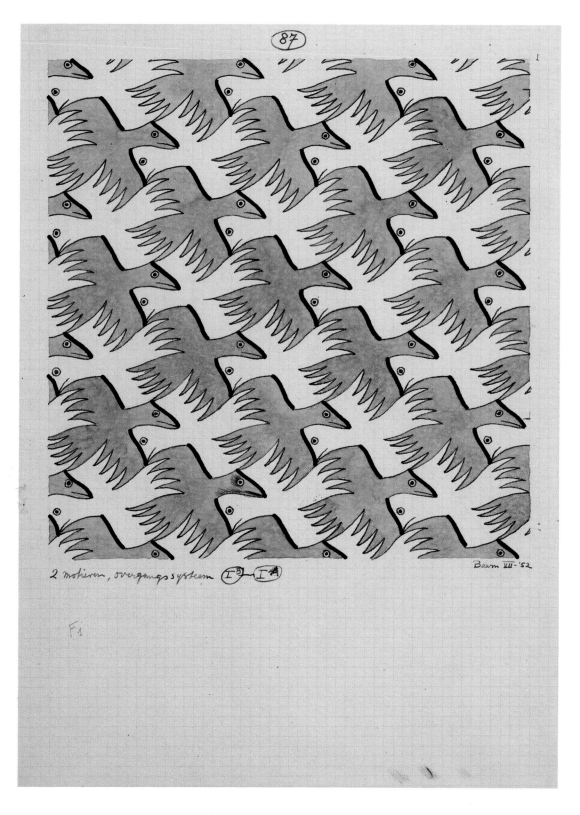

(87) 2 motifs, transitional system IB-IA Baarn VII-'52

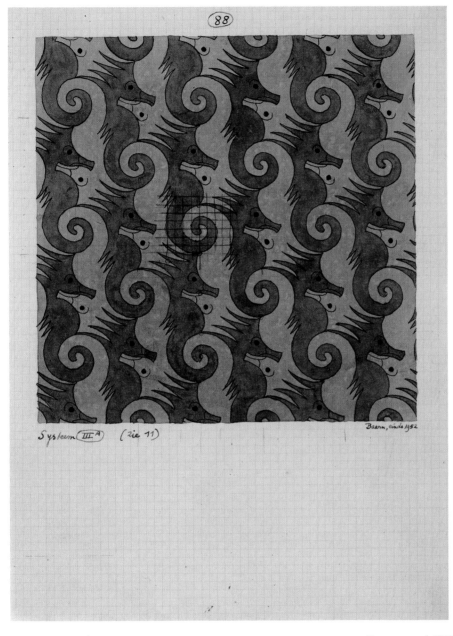

(88) system III^A (see 11) Baarn end 1952

[Verso of drawing 87; this triangle tiling is the geometric skeleton for drawing 88.]

(91) system I^B* as well as IV^B*
[penciled instructions to photographer for *Grafiek en tekeningen*]

Baarn IX-'53

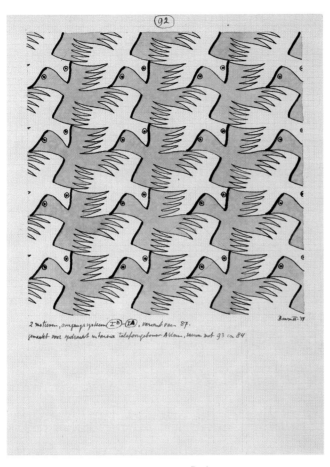

(92) 2 motifs, transitional system IB-IA Baarn II-'54
variant of 87
made for commissioned intarsia work,
telephone building Amsterdam, same
as 93 and 84.

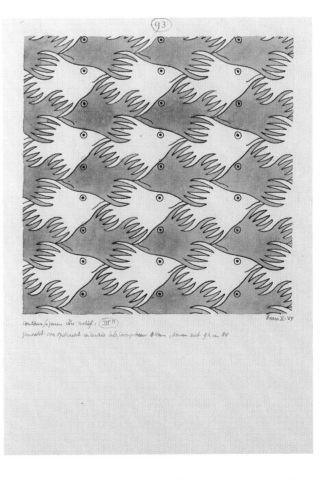

(93) contour figures one motif: IIIB Baarn II-'54
made for commissioned intarsia work,
telephone building Amsterdam, same
as 92 and 84.

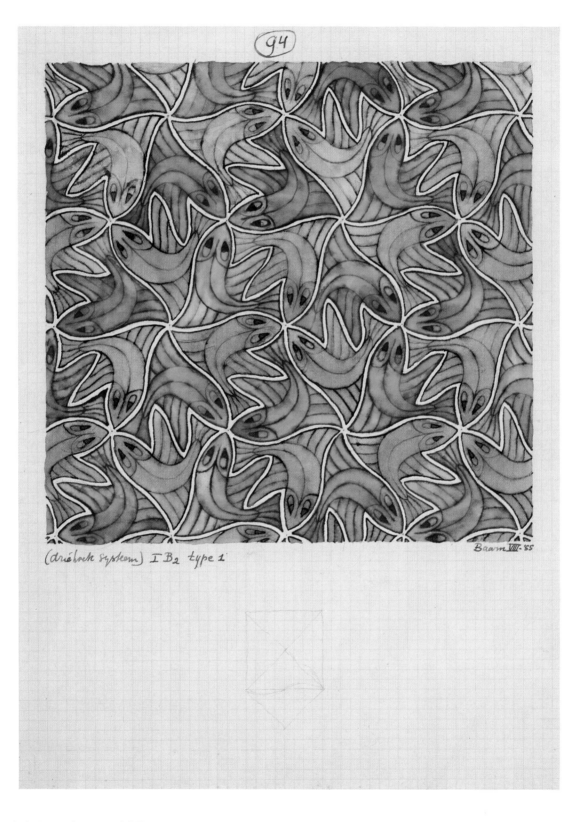

(94) (triangle system) I B_2 type 1 Baarn VIII-'55

(95) exceptional case of III^A: triangles,
see page 4 theory [notebook], bottom left.

Baarn VIII-'55

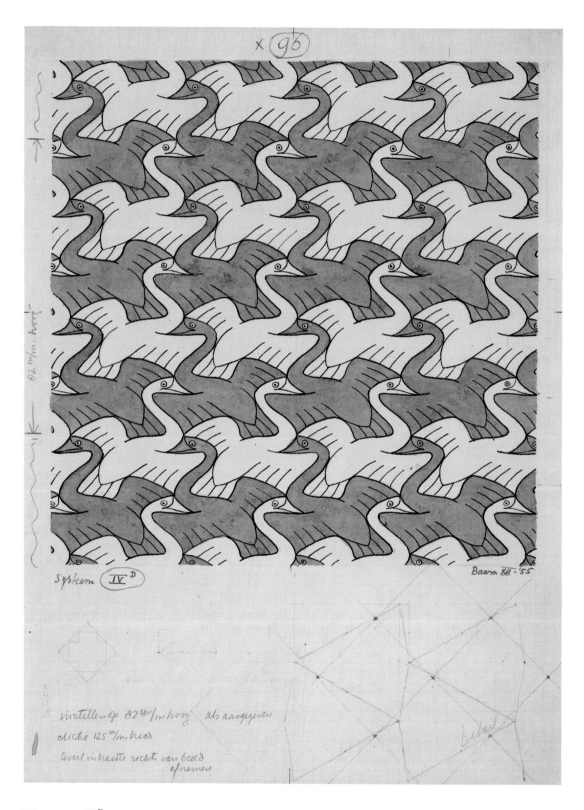

(96) system IVD
[penciled instructions to photographer for *Grafiek en tekeningen*]

Baarn XII-'55

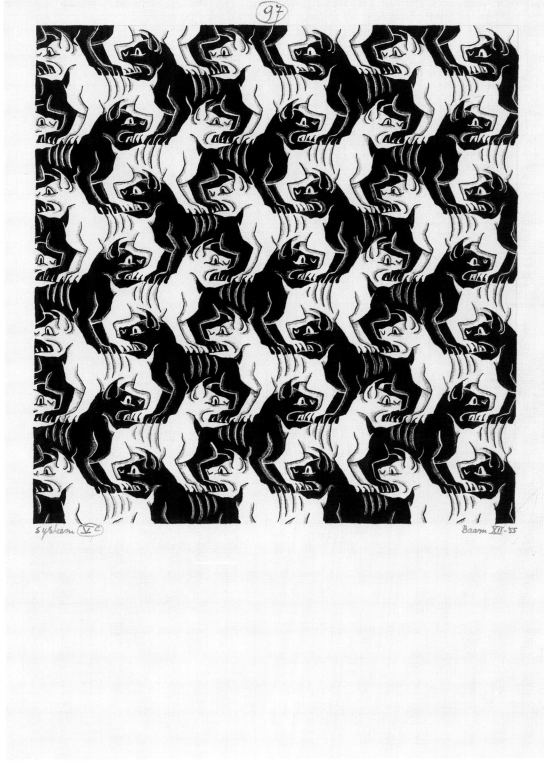

(97) system VC Baarn XII-'55

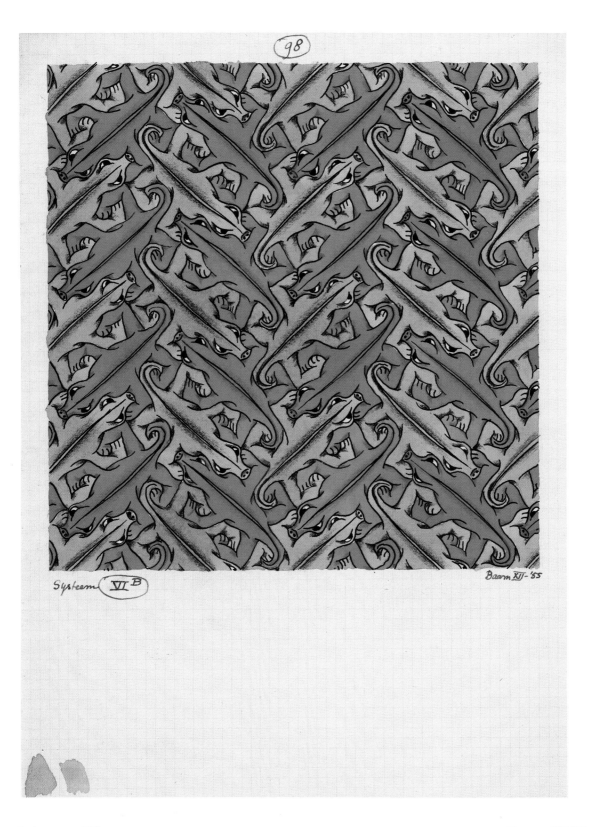

(98) system VI^B

Baarn XII-'55

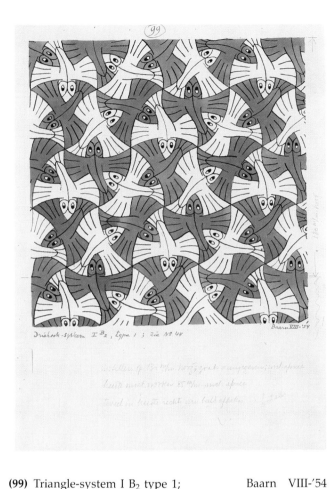

(99) Triangle-system I B$_2$ type 1; Baarn VIII-'54
see no. 44
[penciled instructions to
photographer for *Grafiek en tekeningen*]

(100) Triangle-system I B$_2$ type 1 Baarn VIII-'56
(for P.T.T.) [Postal, Telephone, and
Telegraph service]

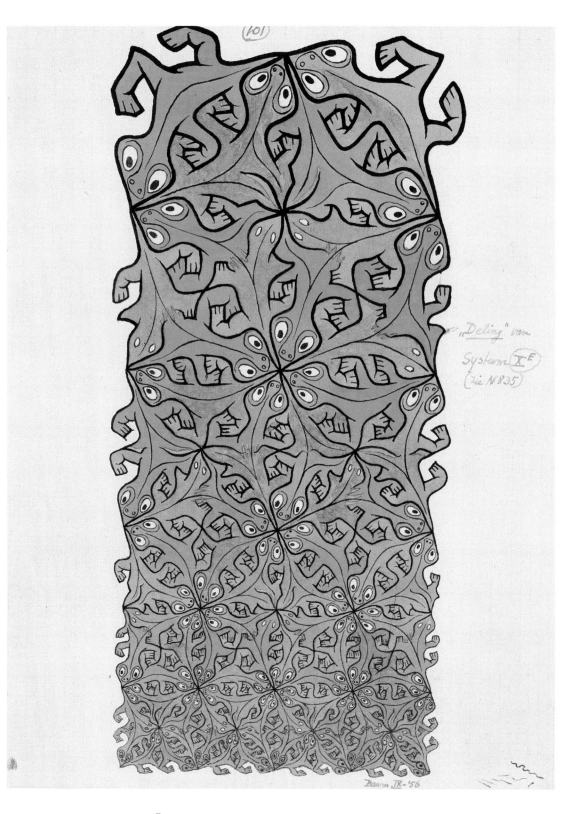

(101) *"Division"* of system XE (See no. 35) Baarn IX-'56

(102) system IV^B
[penciled instructions to photographer for *Grafiek en tekeningen*]
[at bottom of page] "Path of Life II"

Baarn III-'58

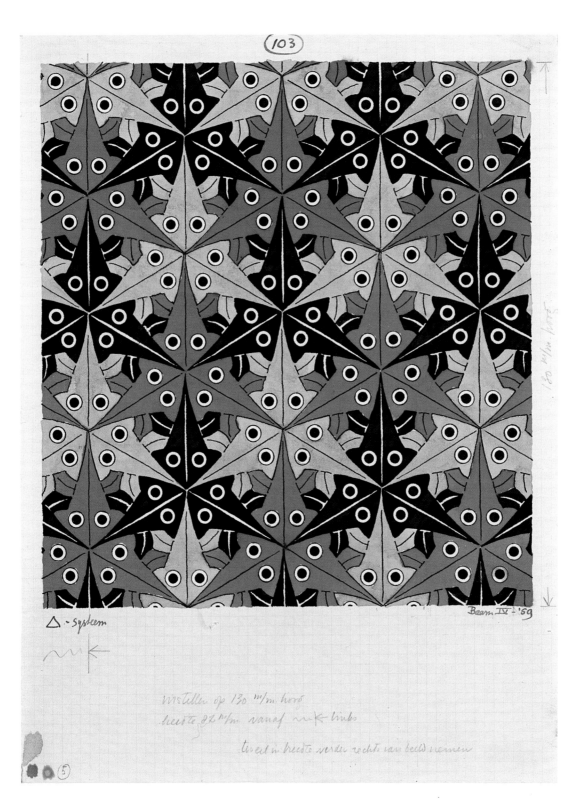

(103) triangle-system
[penciled instructions to photographer for *Grafiek en tekeningen*]

Baarn IV-'59

(104) system IX^D variant of 15 Baarn V-'59
[penciled instructions to photographer for *Grafiek en tekeningen*]

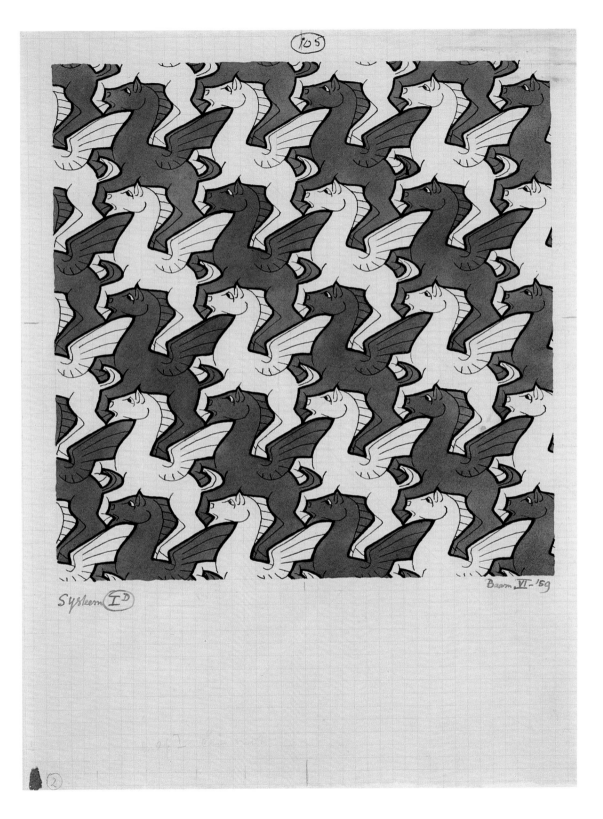

(105) system I^D

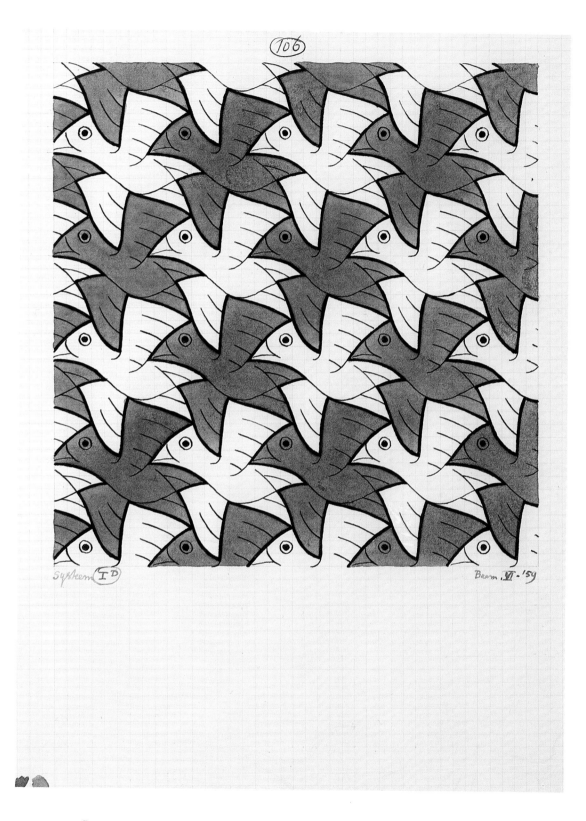

(106) system I^D

Baarn VI-'59

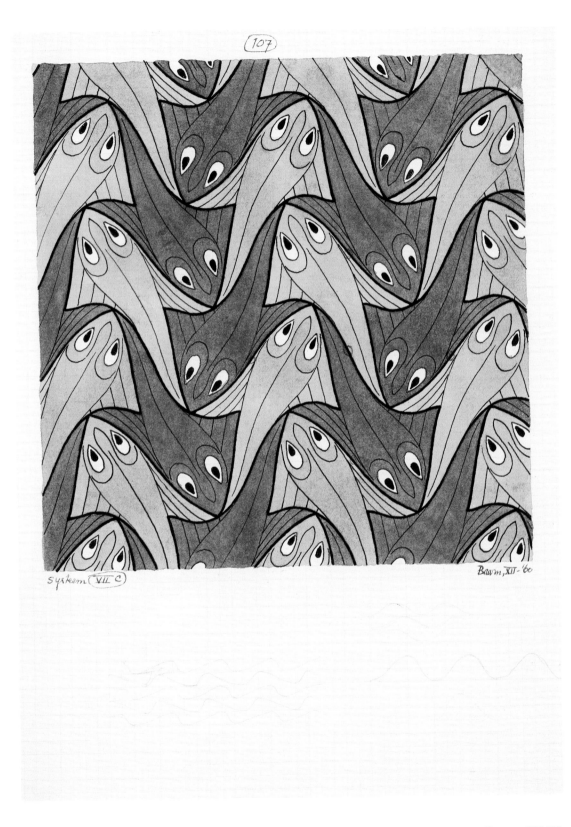

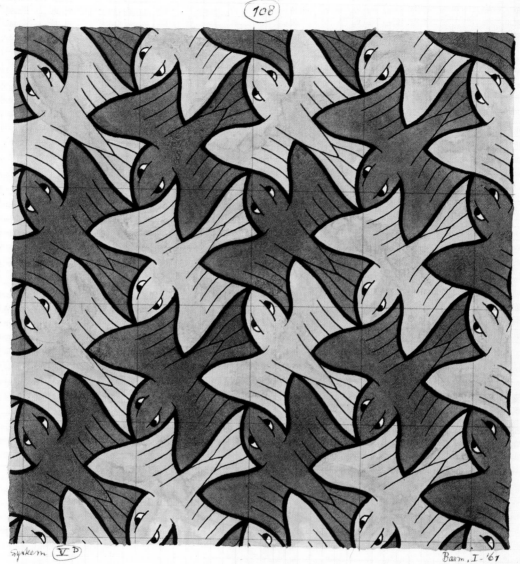

(108) system VD

Baarn I-'61

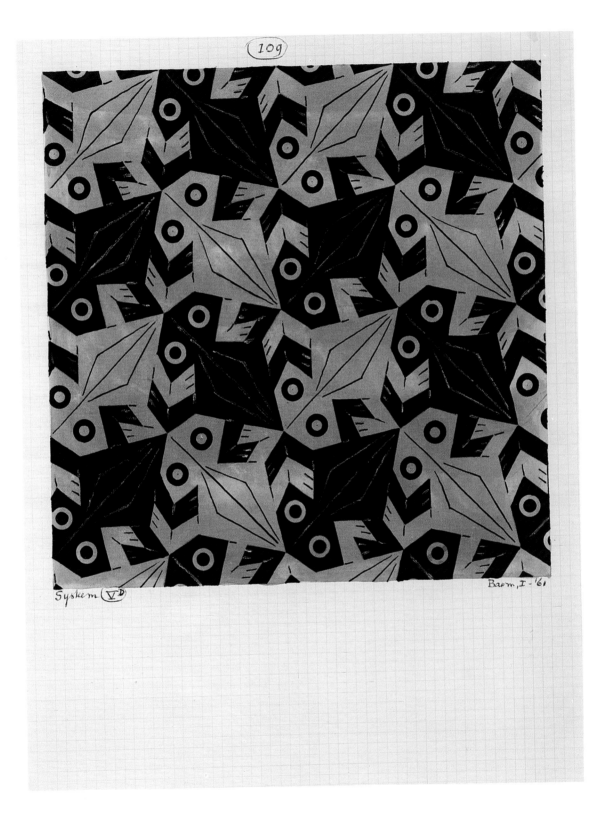

(109) system VD

Baarn I-'61

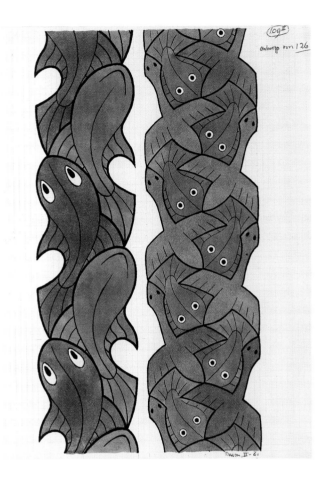

(109II) design for <u>126</u> Baarn II-'61

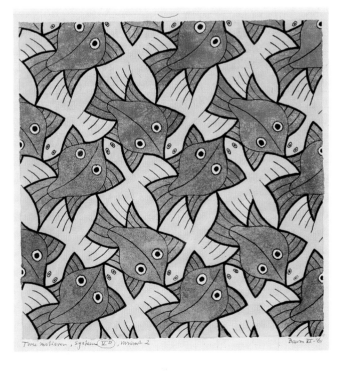

(110) two motifs system VD, variant 2 Baarn VI-'61
[A mat obscures the number at the top.]

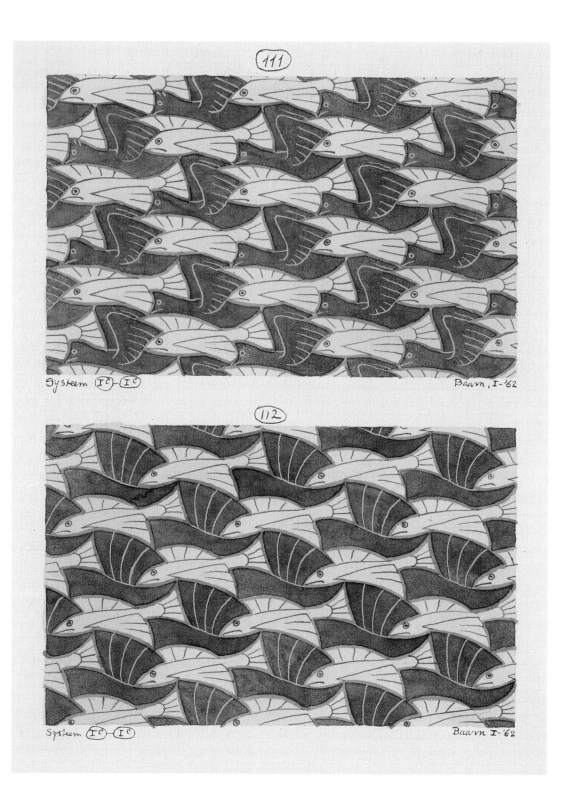

(111) system I^C-I^C Baarn I-'62

(112) system I^C-I^C Baarn I-'62

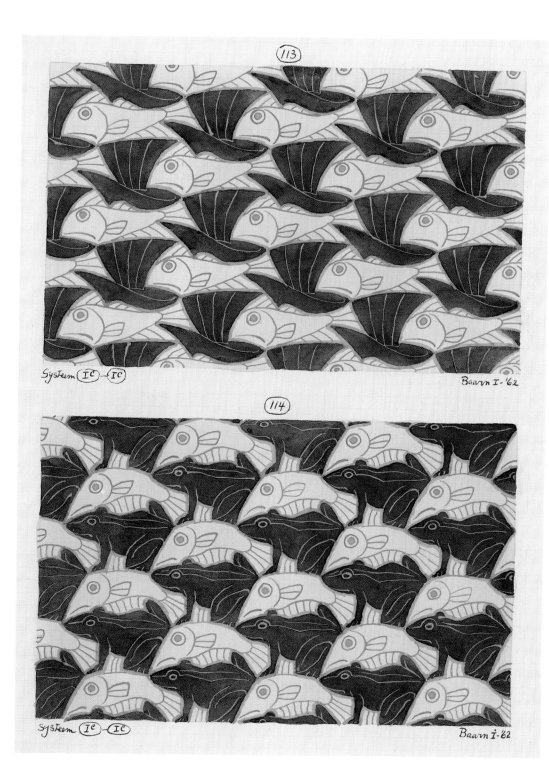

(113) system I^C-I^C Baarn I-'62

(114) system I^C-I^C Baarn I-'62

(115) System II^D, 2 motifs.

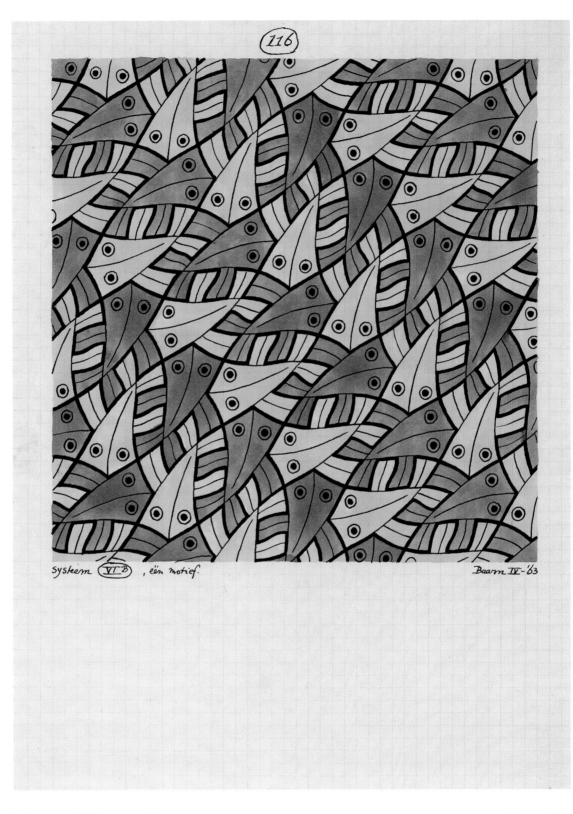

(116) system VI^B, one motif.

(116) system VI^B, one motif.

Baarn IV-'63

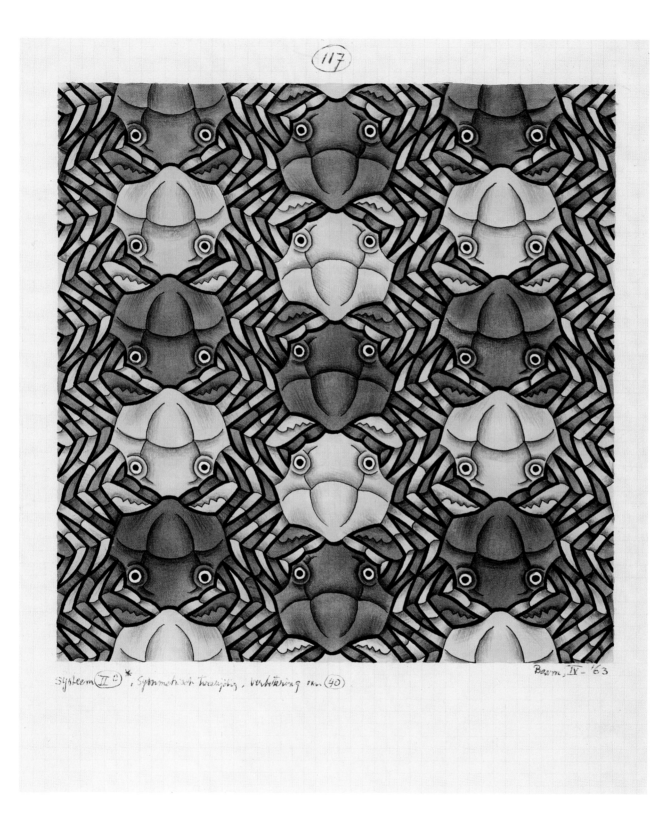

(117) system II^C*, symmetrically two-sided, improvement of 40

Baarn IV-'63

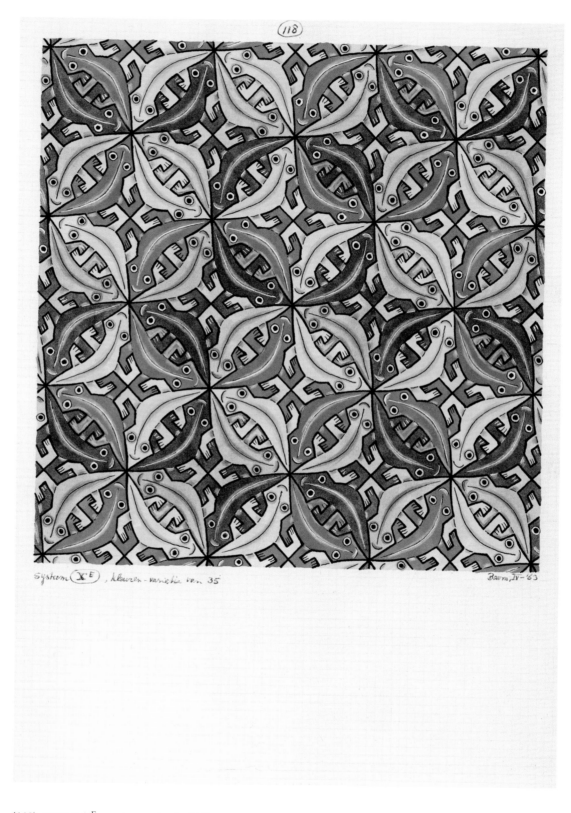

(118) system X^E, color variant of 35

Baarn IV-'63

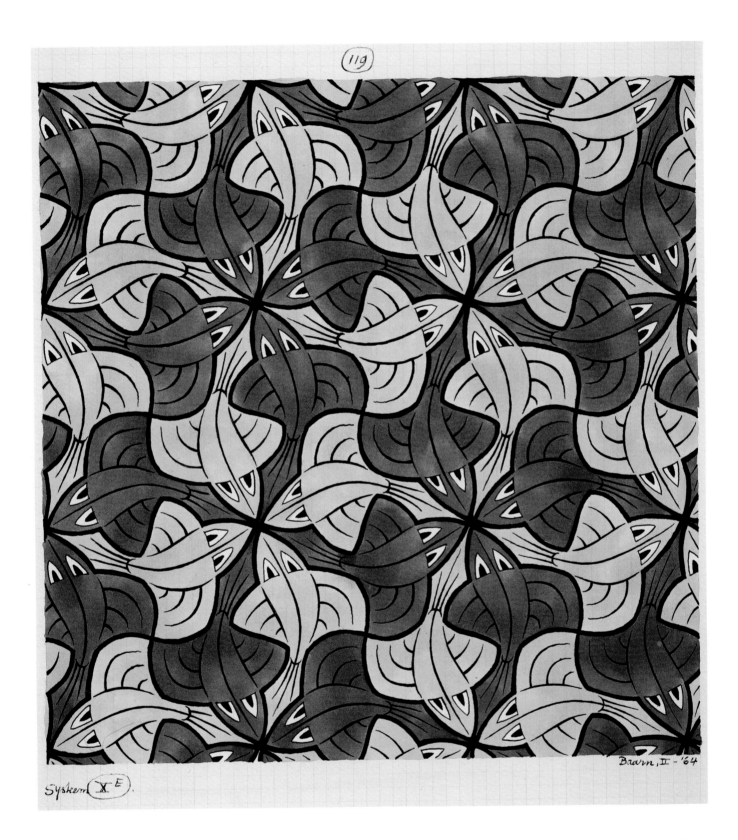

(119) system X^E

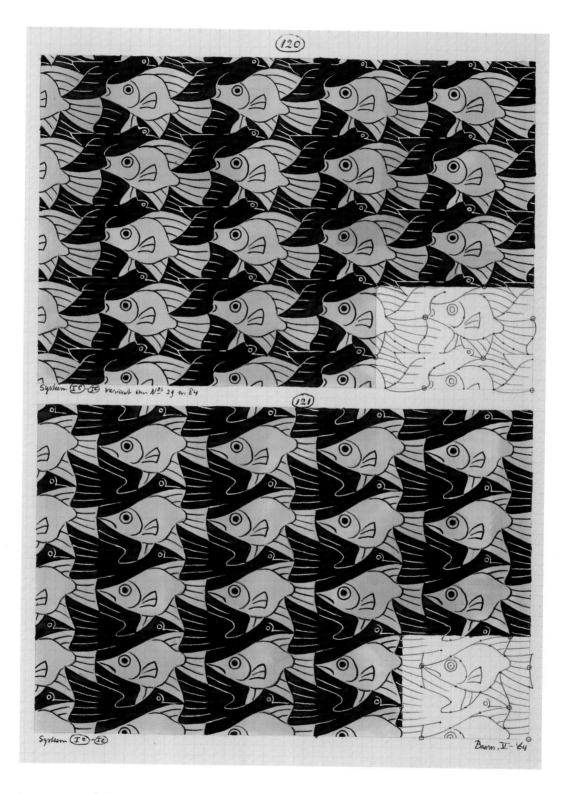

(120) system I^C-I^C variant of nos. 29 and 84

(121) system I^C-I^C

Baarn V-'64

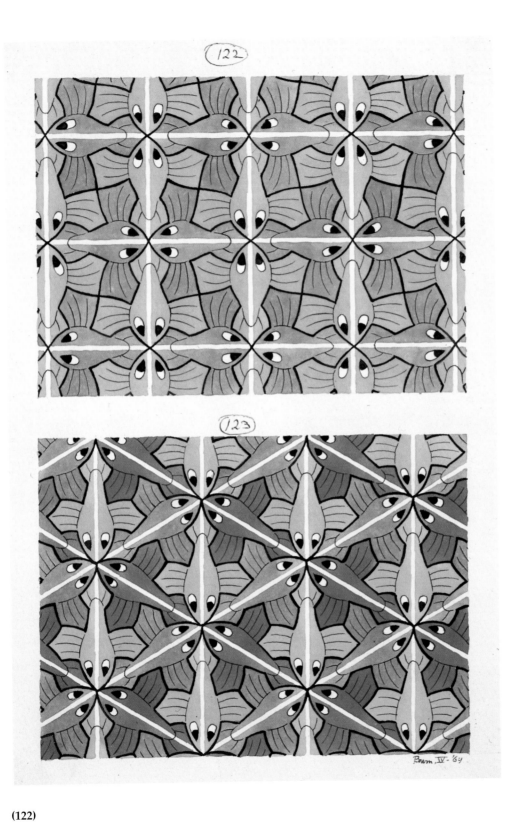

(122)

(123)

Baarn IV-'64

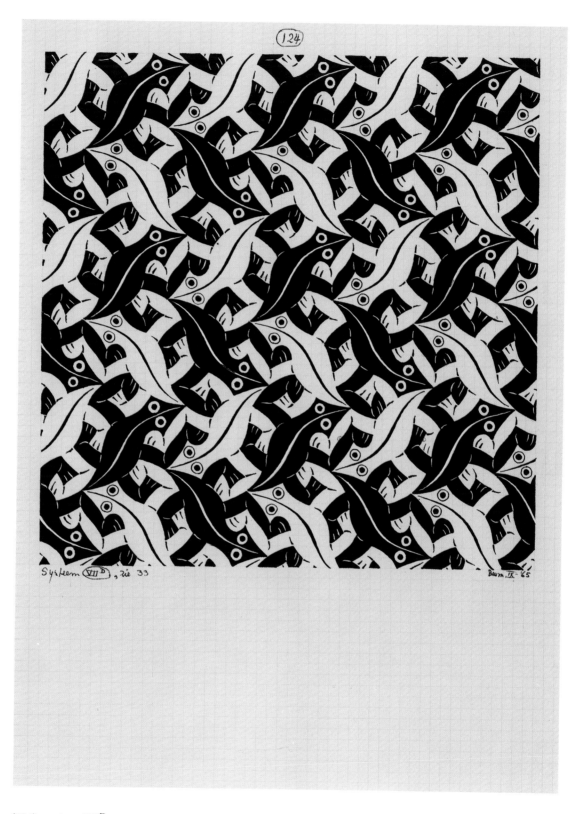

(124) system VII^D, see 33

Baarn IX-'65

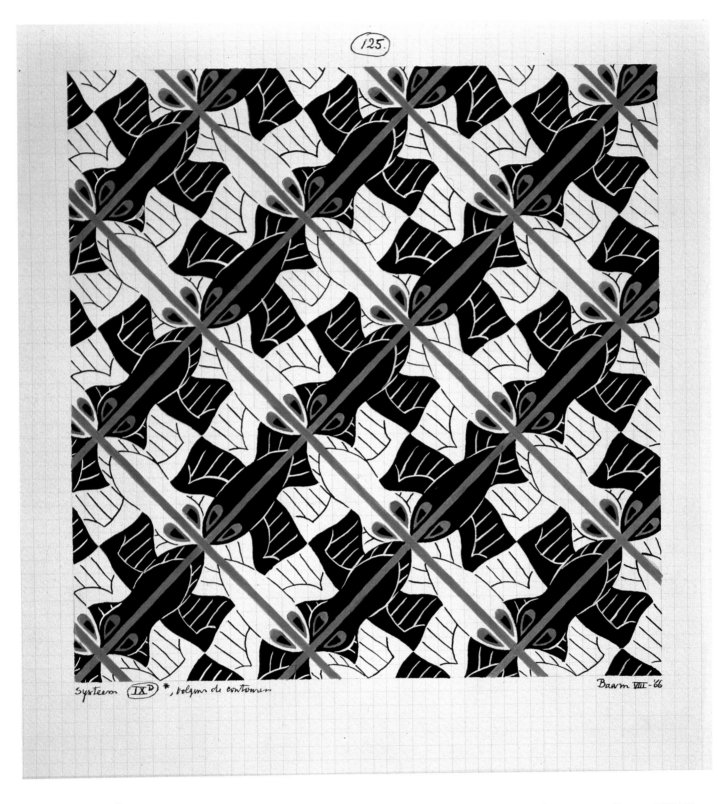

(125) system IX^D*, according to the contour
[at bottom left, not visible] preliminary study for "Path of Life III"

Baarn VIII-'66

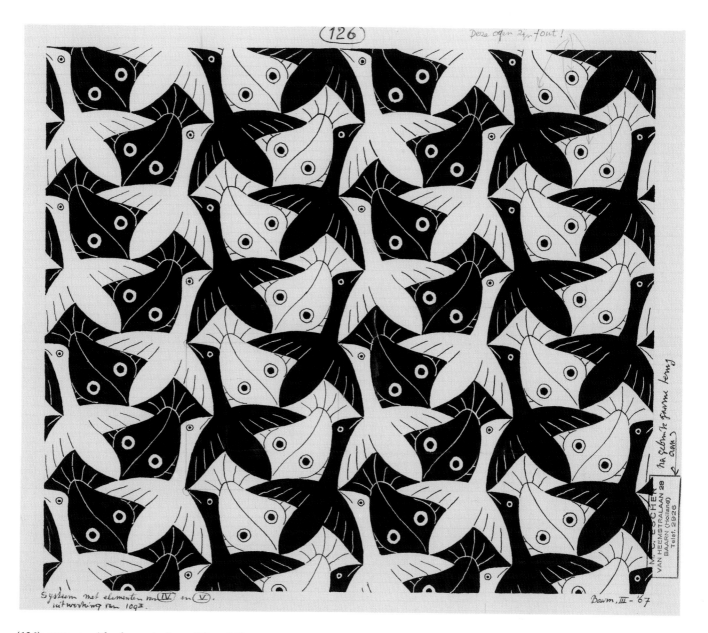

(126) system with elements from IV and V.
developed from 109^{II}.
[note at top, with arrows to fish's eyes] these eyes are a mistake!
[next to stamp with Escher's name and address] after using, please return to ⤺

Baarn III-'67

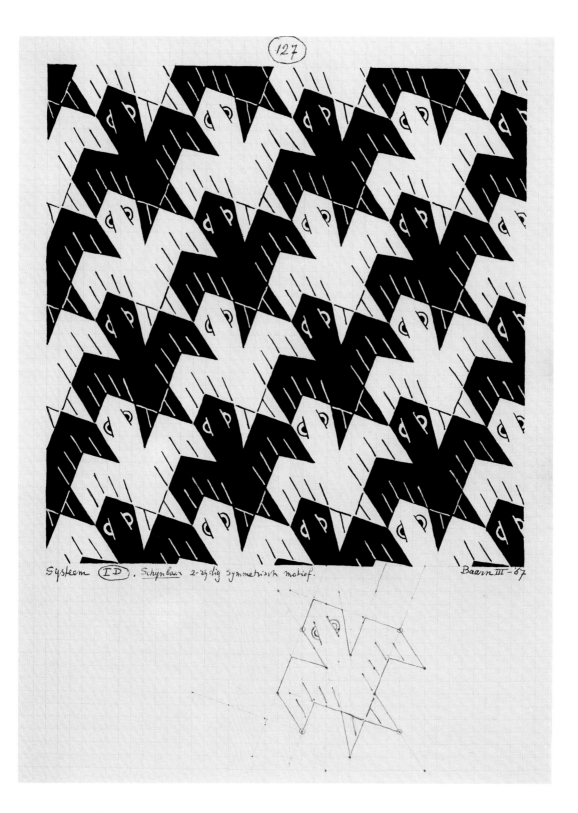

(127) system I^D

apparently 2-sided symmetric motif

Baarn III-'67

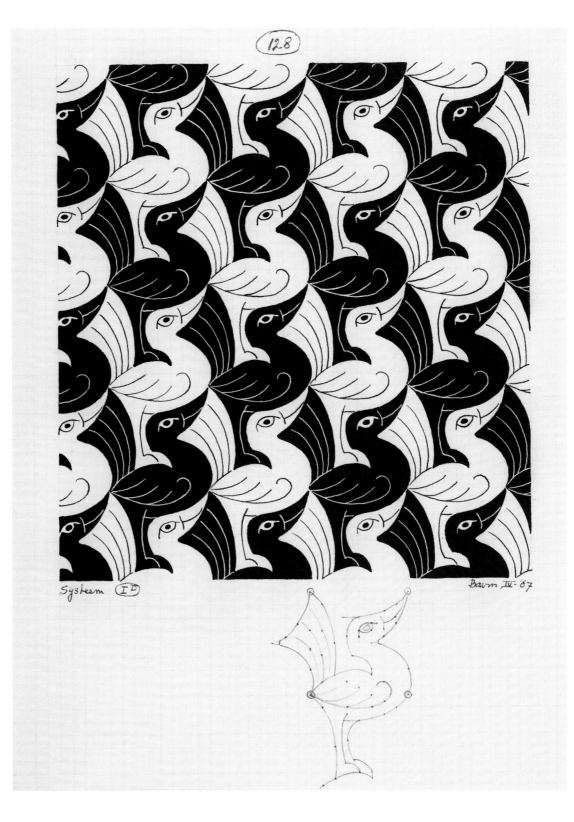

(128) system I^D

Baarn IV-'67

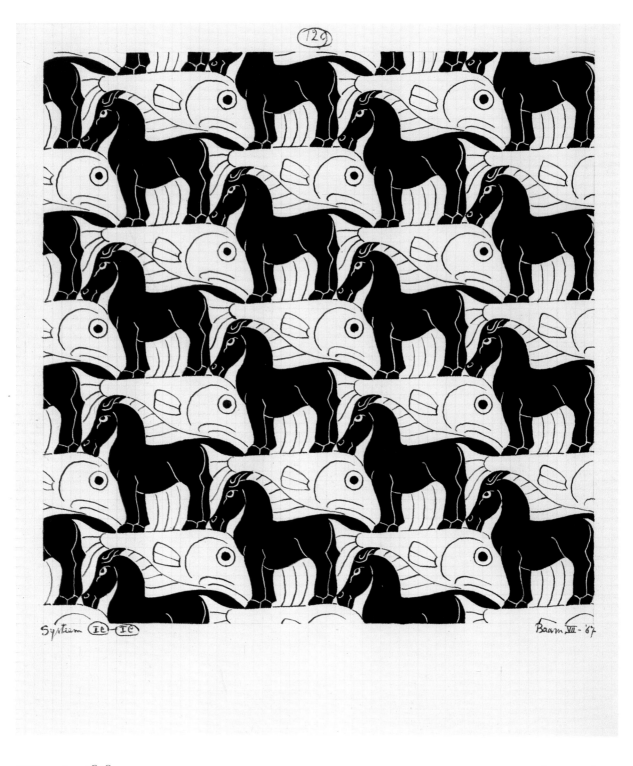

(129) system I^C-I^C Baarn VII-'67

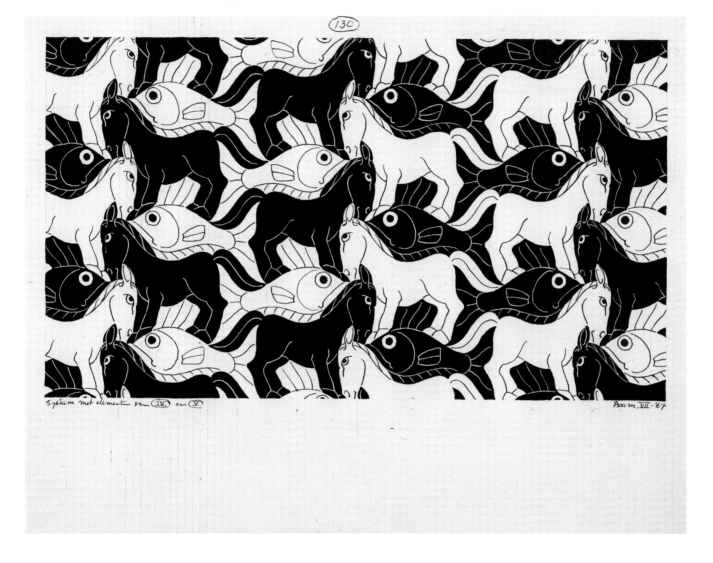

(130) system with elements from IV and V

Baarn VII-'67

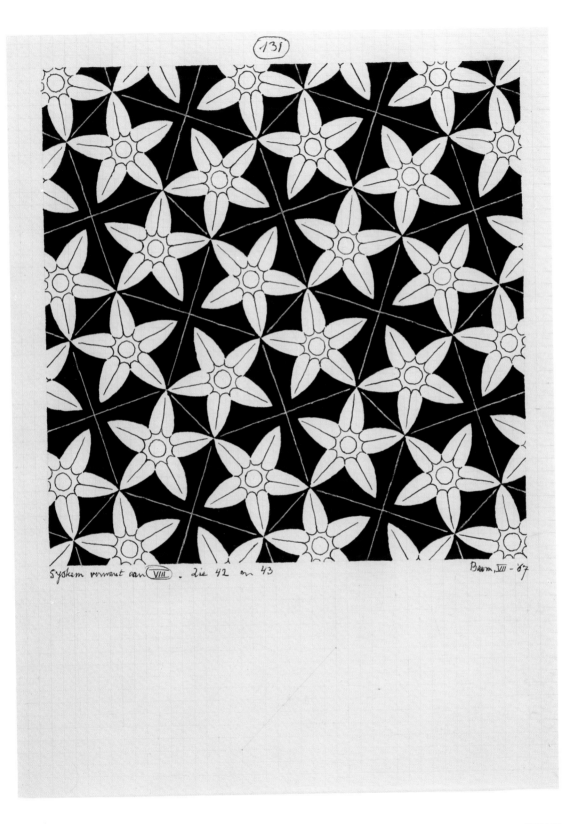

(131) system related to VIII. See 42 and 43 Baarn VII-'67

(132)

Baarn XII-'67

Baarn XII-'67

(134) Baarn XII-'67
[above stamp with Escher's name and address] after using, please return to:

design drawing
of tiles

eyes good

pillar A
2 types of tiles

pillar B
2 types of tiles

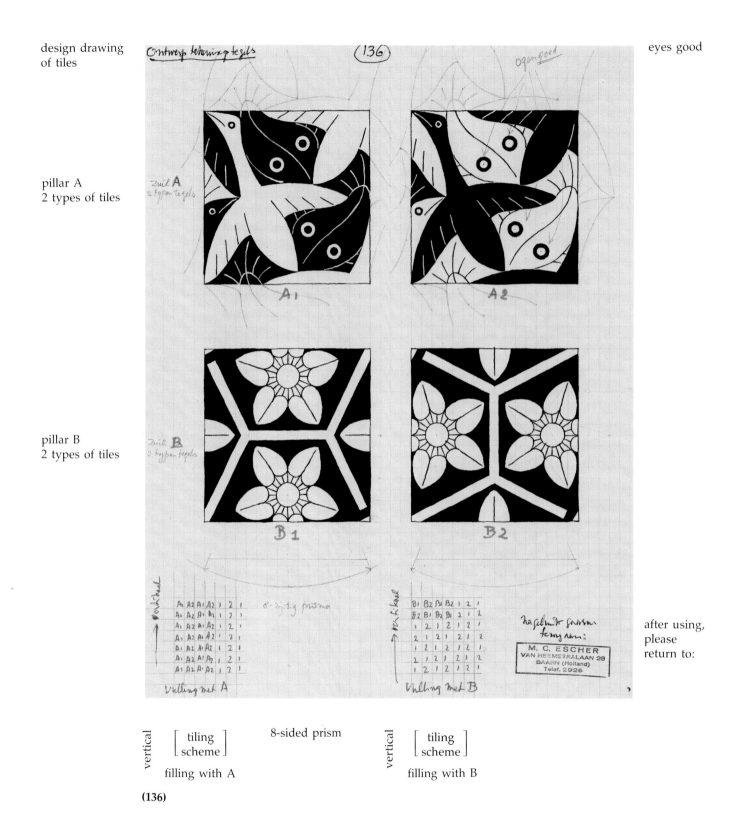

vertical $\begin{bmatrix} \text{tiling} \\ \text{scheme} \end{bmatrix}$ 8-sided prism vertical $\begin{bmatrix} \text{tiling} \\ \text{scheme} \end{bmatrix}$

filling with A filling with B

after using,
please
return to:

(136)

(137) Made following the system of Prof. R. Penrose's "jigsaw puzzle" Laren V-'71

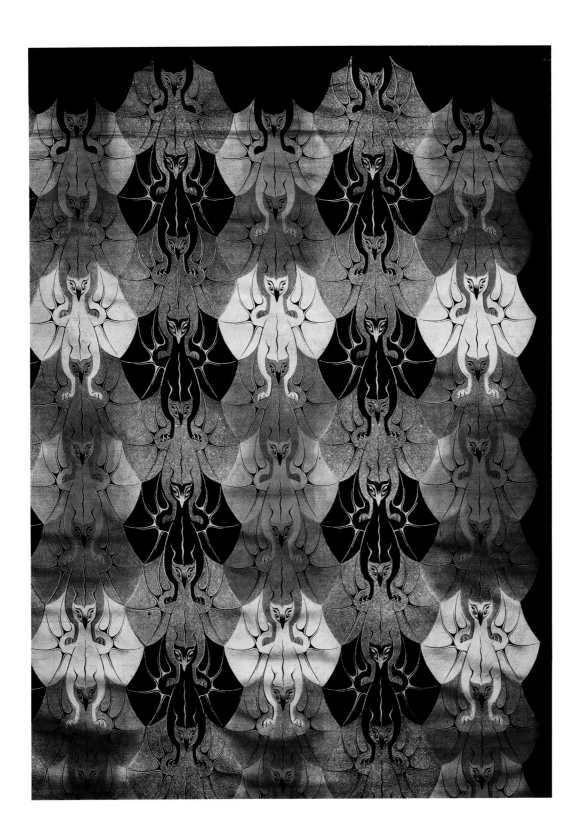

(A1) detail of hand-printed pattern on satin undated [circa 1926]

(A2) detail of regular division with birds Ukkel [1940]

(A3) regular division
with layered parallelograms Ukkel [1940]

(A4) regular division with leaves Baarn X-'50

(A5) details of 7 circular band designs Baarn X-'50

(A6) regular division with lattice Baarn X-'50

(A7) regular division with triangles Baarn [circa 1951]
containing decorative motif

(A8) regular division with entwined circles Baarn X-'50

(A9) regular patterns with curved lines Baarn 1953

(A10) regular pattern with curved lines Baarn I-'53

(A11) regular pattern with curved lines Baarn II-'53

(A12) regular division with the letter E Baarn [1953]

The periodic drawings as sources

Escher never regarded his periodic drawings as finished works of art. He looked on them as polished solutions to the exercises he posed in his early "Theorie" workbooks, responses to his reminders sprinkled in red throughout those pages: "voorbeeld maken!" More importantly, he used them as sources for ideas for prints and other works. Whenever they appeared in exhibits or published articles, they were referred to as preliminary, or working, drawings and, with few exceptions, were always linked to a finished graphic work.

Escher's graphic works after 1936 are easily distinguished from earlier ones; his son George notes in his essay "M. C. Escher at Work" how the difference is reflected in his own childhood memories.

> During the early days, in Rome and Switzerland, father's prints were seldom subjects of discussion. His work was then, for me, almost entirely a matter of sounds, smells and rituals. . . .
>
> Seldom was there anything striking enough in the subject of a print to capture my small boy's imagination and make me remember fifty years later. Then, when I was ten years old, a change occurred. Suddenly funny little men fitting closely together became of interest to me. There were explanations by father of repetitions by sliding, by reflection, by pivoting about axes. His work became more of a struggle, but there was a different enthusiasm than before, a need to communicate, to use us as sounding boards when talking about barely-understood problems. As time went by I became used to the strangest ideas. Although the actual making of a print never lost its charm, it was the intellectual content of a new work that from then on made the strongest impression.

In his introduction to *Grafiek en tekeningen,* Escher describes the sharp contrast between the driving force for his graphic work before and after 1936:

> I discovered that technical mastery was no longer my sole aim, for I was seized by another desire, the existence of which I had never suspected. Ideas took hold of me quite unrelated to graphic art, notions which so fascinated me that I felt driven to communicate them to others. This could not be achieved through words, for these thoughts were not literary ones, but mental images of a kind that can only be made comprehensible to others by translating them into visual images. Suddenly the method by which the images was to be rendered became less important than before. . . .
>
> When I compare the birth of a graphic sheet from my technique period with that of a print expressing a particular train of thought, then I realize that they are almost poles apart. In earlier years, I would often select from a pile of sketches one which seemed to me suitable for reproduction by a technique that at the moment held my special interest. But now it is from amongst those techniques which I have mastered (to some degree), that I choose the one which lends itself more than any other, to the expression of the particular idea I have in mind. . . .

The growth of a graphic image is now marked by two sharply defined phases. The process begins with the search for a visual form that will interpret as clearly as possible my train of thought. Usually a long time elapses before I decide that I have got it clear in my mind. But a mental image is something quite different from a visual image and no matter how hard we try, we never succeed in achieving completely that perfection which haunts the spirit: a perfection we can "see" with the inner eye. After a long series of attempts, at last—when I am just about at the end of my rope—I manage to cast my lovely dream into the imperfect visual mold of a detailed concept sketch. After this, to my welcome relief, there dawns the second phase: the making of the graphic print, during which the spirit can take its rest while the hands take over the task.

Escher's family was all too aware of these distinct stages in his work, as George vividly recalls:

The creation of a new print followed a recurrent pattern, the stages of which varied in length depending on father's enthusiasm or on the difficulties he was encountering. A new concept could take months, sometimes years of incubation before it led to a print. It could show up for the first time at breakfast, when father would start talking excitedly about a marvelous idea which had appeared crystal-clear when he had woken up in the middle of that night. After the initial enthusiasm we might not learn any more for several weeks, even months. . . .

Then the day would come when the new project was tackled seriously. Weeks followed in which his moods changed between irritated abstraction and relaxed discussion of some small problem, between restless pacing behind his closed door and sudden announcement that he had found some satisfying solution. During this period of gestation father demanded complete quiet and privacy. The studio door was closed to all visitors, including his family, and locked at night. . . .

Almost every day, to relieve tensions at the end of the afternoon he took a brisk walk through the beautiful old woods nearby, returning relaxed and ready for a cup of tea. . . .

One day the expectant atmosphere in the home would ease. The studio door opened, and we were invited to look at the new design, still on paper. It was discussed, explained, and sometimes taken into the living room to look at during the evening. In the weeks that followed one could sense the pleasure, the relaxation that went with the execution of the print, where use of hand and eye replaced mental concentration. From the studio emanated light-hearted whistling and the ritual sounds of woodcutting and printing. Our activities in the house took place against a background of the rhythmic swish of fine sandpaper smoothing pearwood, the tearing sound of gouges, the hiss of the inkroller or the heady smell of printing ink.

The end of the cycle, making the first print, gave father a mixture of joy and sadness. It was exciting and satisfying to lift the paper from the inked wood block for the first time, to see the finished print, crisp and immaculate, gradually appearing around the edge of the paper as it was carefully raised. But father had always a feeling of disappointment, of not having been able to depict adequately his thoughts. After all his efforts, how far short of the originally so lucid and misleading simple idea did this result fall! [1986, pp. 1–2]

Shield of the Swiss canton of Valais.

Although the ideas for most of Escher's graphic work after 1936 came from within, an outside source could plant the seed from which an idea could grow. Shortly after the war, during a mountain hike in Verbier, in the canton of Valais (Wallis) in Switzerland, Escher and his sons Jan and Arthur passed by a house where the cantonal flag of Valais was flying. He pointed out to them that the flag, which displays a perfect counterchange pattern of columns of red and white stars, had been the first seed for the idea of the print *Day and Night*, in the days when they lived in nearby Château-d'Oex. [G. Escher 1989]

Sometimes the idea for a print which used a regular division drawing seemed to be suggested by the characters themselves. In 1957, an article in *Openbaar kunstbezit (Public Art Collection)* by J. C. Ebbinge Wubben focused on the 1951 print *Predestination* and quoted Escher's explanation of its evolution from drawing 80:

> The idea for "Predestination" came to me simply and solely from the characters I conceived as the two animal motifs. If it appears strange that such simple figures are characters, it seems even more strange that they themselves create their character. I have such sensations all the time when I am working on designs for regular surface fillings. It seems it is not *I* who am doing the creating, but rather that the innocent flat patches over which I am slaving have their own will, and it is *they* which guide the movement of my hand as I draw.
>
> Thus it suddenly dawned on me that I was dealing with a cruel gluttonous fish and with a shy terrified bird which even in its embryonic state feels the teeth of its enemy at its neck. What else remained but for me to try to make the drama unfold itself in a clear manner?
>
> As the place for the climax forced upon me, I chose an open space in the foreground where the strip of images doubles on itself. In order that the attack could take place with primitive force, the birds and fish had first to be separated. So at the start a metamorphosis takes place, with the result that at the right end of the strip only fish are found, and at the left end only birds. Slowly both streams fade into the distance, but from each emerges one representative which simultaneously assumes a plastic form and becomes more distinctly characterized: one black devilish fish monster and one white innocent bird figure that is doomed to destruction. Since they fly toward each other, they must meet, but at this moment they pass by each other, the shy prey screaming loudly, escaping in the nick of time from the sharp teeth of the terrible attacker—but only for a moment as they both know. Inevitably they pursue the path that has been set for them. At each end of the print they pierce the perpendicular wall, double back in a sharp turn, break through the fence for a second time, and crash into each other in the "court" that has been prepared for them. There the drama unfolds itself; it is a sad case, but how can I help it? How I would have liked to see innocence triumph over evil; here it happens, to my regret, in just the opposite way. Let it be a consolation to us that in real life, fish are usually eaten by birds!

In this print, Escher depicts (with the added melodrama of a narrow escape) the logical outcome of a chase of predator and prey. Although his title *Predestination* reflects the irreversible roles the characters must play, it may also have satisfied his inclination to spoof gently an often pompously held concept.

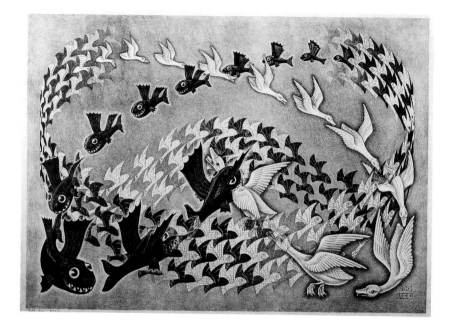

Predestination. January 1951. Lithograph, 294 × 422 mm (cat. 372).

Most of the ideas that Escher attempted to express in his graphic work after 1937 are broad concepts that one can observe, experience, and even feel, but which are impossible to capture fully in words. They are philosophical and perceptual observations that have, over the centuries, fascinated thinkers from diverse fields—poetry, art, philosophy, psychology, ecology, chemistry, physics, medicine, mathematics, His prints portray and even exploit the ambiguity with which humans must constantly struggle as they observe, represent, interpret and try to understand the world that surrounds them. How can I understand infinity? Is there a line between two and three dimensions? Is what I see "real?" What thoughts does a shape evoke? Does the shape of the background have its own identity? Can I understand or experience anything without knowing its opposite?

In 1965, Escher told an audience in Hilversum,

> The laws of the phenomena around us—order, regularity, cyclical repetitions, and renewal—have assumed greater and greater importance for me. The awareness of their presence gives me tranquility and support. I try to testify in my prints that we live in a beautiful, orderly world, and not in a formless chaos, as it so often seems.
>
> My subjects are often also playful. I cannot keep from having fun with our unassailable certainties. For instance, it is a pleasure to deliberately mix up two- and three-dimensionality, flat and spatial, and to poke fun at gravity. . . . It is satisfying to note that quite a few people enjoy this kind of playfulness and that they are not afraid to relativize their thought about rock-hard realities.

Although Escher used a variety of devices in his prints to awaken the viewer to see "reality" in a new light, fragments of periodic draw-

ings are a key component in about 60 of his prints. Most of these prints are reproduced in small scale in the next chapter; larger reproductions as well as more complete information on all Escher's graphic works may be found in the book *M. C. Escher: His Life and Complete Graphic Work.* It is rarely possible to "read" Escher's compositions in a single viewing; most observers discover something new each time they study a particular print.

Escher wanted his graphic works to be not only visual expressions of puzzling concepts, but puzzles themselves, and planned to reveal this in the title of the first book devoted to his graphic work. In 1958, as he chose the illustrations and wrote the accompanying text, he wrote to his son George,

> The title [of the book] probably will be "Speelse verzinsels" [Playful inventions]; the publisher won't hear of it, finds it not serious enough. But these two words lend themselves so well to making a letter puzzle that he will have to [give in]. I made a square of it, both Oey [an art colleague] and Terpstra are excited about it and I hope the bourgeois resistance of the Erven Tijl [the publishers] soon will be overcome.

Escher's letter puzzle intended for the title page, as well as a second one, "Amazing Images," likely designed for the British translation of the book, were never used. The stolid publisher prevailed, and the book was published in 1960 with the plain title *Grafiek en tekeningen* (which translates as *Graphic Work and Drawings*).

In a review of an exhibit of Escher's prints in 1946, W. Jos de Gruyter gave a succinct and accurate description of the unusual character of both the artist and his visions:

> This printmaker imperturbably goes his own way and reminds us of a modern alchemist, ingeniously and fanatically experimenting with his magic balls and magic mirrors, his magic animals and books, his magic mottos (*Verbum*) and magic ideas (*Cycle, Encounter*). A wonderfully obstinate figure, half artist, half thinker, philosopher, shaman, who in the form of graphic puzzles tries to bring nearer to us the hidden meaning of

Rejected letter puzzles made by Escher for the title of the book on his graphic work, 1959. Pencil, ink; "Speelse verzinsels" ("Playful Inventions") 55 × 55 mm; "Speelse verbazing" ("Playful Surprise") 50 × 50 mm; "Amazing Images" 106 × 106 mm.

life. . . . One must take him as he is: a clever and scrupulous researcher of all the possibilities of artistic expression in a terrain where art touches upon mathematics, physics, ornamentation, music and philosophy. A smart and entertaining, but also isolated and driven inhabitant.

Capturing infinity

Infinity—humans can only imagine it, never experience it. The concept permeates human thought, yet defies human understanding. It is invoked to answer otherwise unanswerable questions. In his book, *Against Infinity: A Cultural History of the Infinite,* Eli Maor describes many of the varied attempts by philosophers, scientists, and artists to define, to understand, and to use the concept of infinity. He devotes a chapter to Escher's work, calling him a "master of the infinite."

Mathematicians and scientists capture infinity in formulations which describe and measure. Escher sought to capture infinity in visual images. In 1959, in an essay, "Oneindigheidsbenaderingen" ("Approaches to Infinity"), he wrote,

Anyone who plunges into infinity, in both time and space, farther and farther without stopping, needs fixed points, mileposts as he flashes by, for otherwise his movement is indistinguishable from standing still. There must be stars past which he shoots, beacons by which he can measure the path he has travelled. He must mark off his universe into units of a certain length, into compartments which repeat one another in endless succession. Each time he crosses the border from one compartment to another, his clock ticks.

Anyone who wants to create a universe on a two-dimensional surface (he is somewhat deluding himself because in our three-dimensional world there cannot exist a reality of two dimensions nor of four) notices that time passes while he is working on his creation. But when he has finished and inspects what he has done, he then sees something that is static and timeless: in his depiction no clock ticks; there is only a flat, motionless expanse. . . .

The dynamic, steady ticking of the clock at the crossing of each border in our trip through space has grown mute, but we can replace it, in a static way, by the periodic repetition of congruent figures on our drawing plane, closed forms that border one another, determine each other's shape and fill the surface in every direction as far as we wish to go.

Regular division of the plane was, for Escher, a means to capture infinity. His challenge was to capture infinity in a "closed" composition; he could not accept the abrupt cutoff of the theoretically infinite repetition seen in the periodic drawings. His description of how his regular division drawing 67 of a horseman came into being (quoted on page 110) does not end with the creation of that working drawing. It continues:

The horseman has been born, but although his contour is closed, the plane in which he moves is limitless in all directions, and for this reason we can also work him as a fragment into a picture.

Concept sketches for the woodcut
Horseman, 1946. Pencil, colored pencil,
ink, 208 × 167 (each page).

Horseman. July 1946. Woodcut in red,
black and gray, printed from three
blocks, 239 × 449 mm (cat. 342).

What is done next is present him as a complete entity on a limited surface. Many solutions to this problem are possible and they are all poor. My chief goal was to show quite clearly that the congruent shapes moving in alternate rows to the left and to the right are indeed each other's mirror images. To achieve this I presented the two processions on one strip which, except in the center of the print, has a plastic appearance as if it were a woven fabric: the "pattern" on the front side is of the same color as the "background" on the reverse side, and vice versa. Thus the two processions now form a closed circuit. In the center where the three-dimensional illusion merges into a flat surface, they have obviously been integrated—become part of one single regular division of the plane.

Escher's concept sketches for the print clearly show his exploration of this central idea for presenting the processions of riders.

The device of a cycle, a closed loop, or a suggestion of a repeated procession of figures doubling back on each other are all used by Escher in several other graphic works which incorporate his periodic drawings as fragments. In these prints, he also mixes the illusion of three dimensions with two: the representation is in the plane, the regular division is in the plane, but the figures take on life, like the playing cards in *Alice in Wonderland*, and move about to complete their cycles. In *Regelmatige vlakverdeling* he explains,

When an element of plane division suggests to me the form of an animal, I immediately think of a volume. The "flat shape" irritates me—I feel as if I were shouting to my figures, "You are too fictitious for me; you just lie there static and frozen together; do something, come out of there and show me what you are capable of!"

So I make them come out of the plane. But do they really do that? On the contrary, I am deliberately inconsistent, suggesting plasticity in the plane by means of light and shadow. . . .

My objects, fictitiously brought to life, can now make their own way as independent plastic beings. If they want to, for example, they can eventually return to the plane and disappear into their place of origin. Such a cycle then constitutes a self-contained subject for a print. If the plane filling, which served as point of departure, consists of a repetition of two motifs of differing form and character, they can express their possible aggressive antagonism by destroying each other, or—if a more peaceful solution is preferred—they can become reconciled with each other in a fraternal embrace.

The prints alluded to by Escher in this explanation are *Reptiles* (page 113), *Predestination* (page 239), and *Encounter* (page 300). Other prints in which a cycle is prominent are *Cycle* (page 290), *Fish* (page 295), *Magic Mirror* (page 301) and *Swans* (page 310). An interesting puzzle for the viewer is to follow the path of the moving figures to discover whether such a cycle can exist and, if so, how it might be constructed or woven.

Regular division on three-dimensional surfaces Escher also used regular division to attempt to capture infinity by nongraphic means. In "Approaches to Infinity," he asks the question, "What has been achieved by the regular division of the plane in [drawing 25]?" He then answers his own question:

Not yet true infinity but nevertheless a fragment of it; a piece of "the universe of reptiles." If only the plane on which they fit into one another were infinitely large, then it would be possible to represent an infinite number of them. However, we aren't playing an intellectual game here; we are aware that we live in a material, three-dimensional reality, and we cannot possibly manufacture a plane that extends infinitely in all directions. What we can do, of course, is bend the piece of paper on which this world of reptiles is represented fragmentarily and make a paper cylinder in such a way that the animal figures on its surface continue to fit together without interruptions while the tube revolves around its lengthwise axis.

Escher wrapped a periodic design around a cylinder in commissioned designs for tiled columns for a school in The Hague and one in Baarn and for a painted concrete column for a provincial bureau in Haarlem. He wanted the columns for the school in The Hague to be instructive—one pattern having just translation symmetry, one having rotation symmetry, and one having glide-reflection symmetry—and he chose drawings 74, 96, and 104. He then had to find a new geometric grid for each design so the manufacturer, De Porceleyne Fles, could make just one square tile mold for each column. Escher enjoyed the challenge, and wrote to his son George in May 1959, "It's extraordinary what you can do with just a single square tile. The 'Fles' in Delft is quite amazed." In an article "Escher Designs on Surfaces," Marjorie Senechal discusses these columns and other surface coverings possible with Escher's designs.

The designs for the columns in the Baarn school, done in 1968, each required two different square tiles; the designs are drawings 126 and

Carved sphere with fish, 1940. Beechwood, stained in four colors, diameter 140 mm.

"Heaven and Hell" carved sphere, 1942. Maple, stained in two colors, diameter 235 mm.

Carved sphere with eight grotesques, 1943. Beechwood, stained in two colors, diameter 130 mm.

134. Further details on these tiled columns and on the painted column (pictured on page 260) can be found in Chapter 5.

Infinity is only partially captured in covering a cylindrical surface with a periodic design. In "Approaches to Infinity," Escher notes, "In this way, infinity is achieved in one direction, but not yet in all directions because we can no more make an infinitely long cylinder than we can make an infinitely extending plane."

He discovered that the sphere offered a more satisfying surface on which to capture infinity with only a finite number of congruent forms. In 1940, he carved the surface of a beechwood ball so that it was symmetrically covered with 12 identical fish in low relief. He stained the figures in four different colors, conforming to his rule that adjacent fish not share the same color. As a solution on a three-dimensional surface, *Sphere with Fish* is most satisfying: "When we turn the ball around in our hands, we see fish after fish appear, continuing into infinity."

The fish motif on Escher's carved sphere is very much like that in his periodic drawing 20, in which four fish spin around pivot points at the tips of their dorsal fins and tails. On the sphere, three carved fish rotate about each of these same pivot points. Escher does not say how the design on his carved ball was derived. However, many years later, when he gave instructions to a Japanese netsuke carver to make a small replica in ivory, he noted on a photo of his wooden ball that the 3-fold rotation points at which fish come together are the corners of a cube inscribed in the sphere. Indeed, if a square grid is superimposed on drawing 20 by connecting its 4-fold rotation points and the flat pattern of a cube is cut out from this grid, the folded-up cube has a continuous pattern of 12 fish covering its faces, arranged in the same manner as those on Escher's carved sphere.

During the war years, when Escher found the mental concentration for his graphic work difficult, he carved two other wooden balls, making regular divisions on their spherical surfaces. In 1942, he adapted his angel and devil motifs of drawing 45 to the surface of a large maple ball and stained the devil motifs for contrast. In a letter to the American collector C. V. S. Roosevelt in 1962, he described the ball: "It has two poles and an equator. One pole represents 'heaven,' with only white angels on a black background, which I carved much deeper than the angel figures. The other pole shows 'hell,' with only black devils on a deeply carved white background. At the equator both angels and devils are visible and equivalent, carved at the same sphere-level."

In 1943, Escher carved a softball-size beechwood ball with eight grotesques—two different pairs of interlocked figures alternating light and dark, each pair appearing twice. One pair of these figures is similar to the motifs of drawing 53, made the previous year.

He carved a maple sphere with reptile motifs in 1949, commissioned by a friend who was a collector. The carved design is not derived directly from any of Escher's periodic drawings, but was evidently designed directly on the ball. The symmetry of the design is exactly the same as that of the fish ball; it has 12 identical lizards covering its surface, stained in four colors.

For a brief period in the spring of 1952, Escher experimented with covering the surfaces of polyhedra with regular division designs. He

Carved sphere with reptiles, 1949. Maple, stained in four colors, diameter approx. 18 cm. (Drawing, 1990.)

Regular dodecahedron with turtles, 1952. Cardboard construction with pencil, colored pencil, ink, diameter 87 mm.

wanted the 12 pentagon faces of a regular dodecahedron to show a repeated animal motif and made a cardboard model on which he drew a design of interlocked turtles. He was very dissatisfied, however, because the shells and heads of the turtles were bent in an impossibly unnatural way by the corners and edges of the polyhedron.

He considered his second attempt, which adapted his periodic drawing 85 to the faces of a cardboard rhombic dodecahedron, more successful on several counts. Each diamond-shaped face is occupied by roughly one whole motif, and the animal parts that extend to adjoining faces are ones that can believably bend in that manner. There are three motifs (lizard, fish and bat) which represent the three elements of life—earth, water, and air. Each animal motif has its own color, and in the total design which covers the surface of the cardboard model, each of the three colors forms a closed circuit of four diamonds around the form.

Eleven years later, Escher eagerly accepted an invitation from Roosevelt to provide a new design for a carved sphere to be executed in ivory by the Japanese netsuke carver Masatoshi. He had hoped to make the sphere himself, but knew he no longer had the time or energy. He chose his three-element design and, to guide the ivory carver, drew the design on a plastic ball and provided a line drawing of one of the eight spherical triangles that repeat to fill the sphere's surface. The number of motifs and their arrangement on his earlier cardboard rhombic dodecahedron and on this sphere are exactly the same; on the sphere, each circuit of four identical animal motifs forms a great circle, and these three great circles are mutually perpendicular.

Escher's interest in polyhedra extended to compound polyhedra and star polyhedra as well; he studied photos of models in the classic book *Vielecke und Vielfläche* by M. Brückner as well as drawings of these

Rhombic dodecahedron with "three elements" (bat, fish, lizard), 1952. Cardboard construction with pencil, colored pencil, ink, diameter 100 mm.

Plastic ball with Escher's sketch of the surface design "three elements" to guide Masatoshi's carving of an ivory ball. The motifs on the ivory ball for Escher were colored in the same manner, but Escher later removed the color.

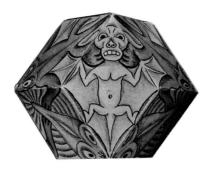

forms by Leonardo da Vinci; he also constructed several cardboard models. The idea for a puzzle was probably born as he studied the star polyhedron called a "stellated dodecahedron" which he featured in his 1950 lithograph *Order and Chaos*. In 1952, as he made preliminary drawings for the lithograph *Gravity*, he restudied the form closely; this time he viewed it as 12 intersecting five-pointed stars (pentagrams). He then invented a puzzle of 12 intertwined identical starfish shapes and rendered it in heavy paper, in rubber tubing, and in rubber.

Escher once expressed the hope to make a clear glass sphere etched with a surface design of regular division, to be illuminated from the inside, so that the perfect continuous symmetry of the repeated motifs could be viewed as a whole. Such a sphere was never made. However, inspired by the starfish puzzle, he made a beautiful stellated dodecahedron of clear plexiglass with a starfish engraved on the inside of each of its 12 pentagram faces.

In 1958, guided by the compound polyhedron of five interlocked tetrahedra which he found illustrated in Brückner's book, Escher carved a maple ball in deep relief. He transformed the stark angles and flat faces of the polyhedron into softer, curved petals of flowers, but retained the symmetry of the polyhedron.

One decorated polyhedron designed by Escher was manufactured; in 1963, the Verblifa company commissioned him to design an unusual candy tin to celebrate the company's seventy-fifth anniversary. Escher chose the form of an icosahedron, with 20 triangular faces. His surface design has elements from his periodic drawing 42, but is not directly based on that plane filling. Each triangular face of the tin box has exactly the same design and the 5-fold symmetry of the polyhedral form produces a starfish at each vertex (see page 295).

Puzzle of twelve entwined starfish, 1952. Rubber, diameter 123 mm.

Carved polyhedron (compound of five tetrahedra) with flowers, 1958. Maple, diameter 160 mm.

Drawing with Escher's identification: "5 regular tetrahedra whose 20 vertices are those of a regular dodecahedron. (found in table IX, no. 11, 'Vielecke und Vielfläche,' Dr. Max Brückner, Leipzig, B. G. Teubner, 1900.)" Pencil, colored pencil, ink, 234 × 317 mm.

Central similarity

Spiral similarity

Two similarity transformations used by Escher in his prints. A central similarity scales all figures uniformly (scale k) and moves them along lines which emanate from the center O, so that their new distance to O is k times the old distance. In the illustration, the motifs shrink by almost half as they move toward O; $k = 3/5$. A spiral similarity is a two-step transformation: a rotation about a center O, followed by a central similarity with respect to O. In the illustration, the large moth rotates 45° and then shrinks and moves inward; the scale is $k = 1/\sqrt{2}$.

Prints with motifs of diminishing size Capturing infinity on the surface of a sphere or polyhedron did not satisfy Escher the graphic artist. He wanted to capture infinity in the plane, and not "cheat" by counting the same motif over and over. He abandoned the constraint of working only with repetitions of congruent figures and employed instead the repetition of figures of the same shape, but diminishing size.

A geometric transformation of a figure in the plane which simply scales the figure—enlarging or shrinking its size, but retaining its exact shape—is called a "similarity." Spiral paths of similar figures can be created by rotating a motif about a pivot point while simultaneously shrinking it and then repeating the transformation again and again. Other geometric transformations can scale the size of a figure while distorting its shape only slightly. Projections are related to our own visual perception of objects viewed at a distance or from different positions— the figure's shape is perceived as unchanged. Other less familiar geometric transformations also scale figures with only a slight distortion of shape: transformations of figures in a noneuclidean hyperbolic plane (contained entirely within the confines of a circle) repeat a motif as a slightly distorted similar figure which grows infinitely small as it approaches the edge of that circular world. By use of these various geometric transformations, Escher could create "plane fillings" with a theoretically infinite number of "same-shaped" figures, the actual number of images limited only by the physical bounds of hand, eye, and carving tools. Such compositions could capture infinity through endless rhythmic repetition of a motif within the borders of a graphic print.

One way to achieve a design with an infinite number of similar figures is to wrap a periodic drawing with congruent motifs around a cylinder and then project the design back onto the flat surface of a plane. This is not done by unrolling the pattern covering the cylinder's surface, but rather by depicting in the plane an unusual view of the rolled pattern. Envision Escher's drawing 102 rolled up with the design continuously covering the *inside* of an infinitely long cylinder, so that the horizontal glide axes for the rows of alternating black and white ray fish form circles that wrap around the cylinder's surface and are spaced at equal intervals; then the translation axes of the pattern will run parallel to the cylinder's axis. If the cylinder is tilted so that a viewer can peer directly down its infinite hollow, then those parallel lines will appear to converge to a point, and those stacked circles will be seen as a nest of concentric circles, forever diminishing in size to the same center point.

Escher's *Path of Life I* is a stylized depiction of this view of his drawing 102; his motifs do not diminish with the increasing rapidity characteristic in one-point perspective. Instead, he uses a central similarity to produce a geometric progression; the motifs shrink in size by almost one-half each time they move inward from one concentric circle to the next. In this print, as well as others which use this geometric device, Escher distorted the outermost motifs to provide an aesthetic frame for the composition. Other prints that can be viewed in this way are *Fish* (page 322), *Path of Life II* (page 311) and *Path of Life III* (page 316).

In all three of the *Path of Life* prints, but especially in *Path of Life III*, streams of motifs of the same color appear to follow spiral paths. This last design is derived from drawing 125. In the print, the red-outlined

squares of the drawing appear distorted and packed like the seedhead of a sunflower. When a pattern (such as drawing 102 or 125) is rolled in the manner described above (with the glide axes forming circles), the diagonal head-to-tail streams of motifs become helices, twisting around the inside of the cylinder like stripes on a barber's pole. The helices are then transformed into spiral paths when projected through the hollow of the cylinder onto a distant plane.

In several other works, Escher transformed the parallel rows of interlocked motifs which move in opposite directions in a plane periodic design into spiraling streams. In addition to depicting infinity, these works are a visual metaphor for birth–life–death: motifs in one stream are born in the eye of a whorl (birth–life) and increase in size as they spiral outward, while adjacent motifs of contrasting color spiral in the opposite direction, diminish in size as they are drawn into a vortex, and eventually disappear (death). In 1957, Escher made a pair of such designs representing life-passage for wall murals in the funeral building at the third public cemetery in Utrecht (see drawing A13 and its notes).

While working on the life-passage designs, Escher also completed the graphic work *Whirlpools,* which is a double spiral. In this print, each fish is born in the eye of a whirlpool, follows a coiled path outward while growing in size, then follows a spiral path in the opposite direction toward the vortex of the second whirlpool, until disappearing into

Path of Life I. March 1958. Woodcut in red and black, printed from two blocks, 410 × 410 mm (cat. 424).

its funnel. Escher carved only one block to print the colors in this wood-cut; the figures printed in one color are identical to those in the contrast-ing color. By rotating the block 180°, the second spiral of fish neatly interlocks with the first; the carved date and initials MCE appear at the top and bottom of the print. A few months after completing the painting of the large wall murals at the funeral building in Utrecht, Escher pro-duced the print *Sphere Surface with Fish* in which he transformed parallel streams of fish in the plane into paths of fish which spiral from pole to pole around a globe (see drawing A14 and its notes).

In all these prints, the motifs diminish in size as they follow a path to a single point in the interior of the composition. Escher sought in vain to depict an opposite progression, to have the motifs increase endlessly in number from the center outward while decreasing in size, to ap-proach an infinite number of points on the boundary of an enclosed region.

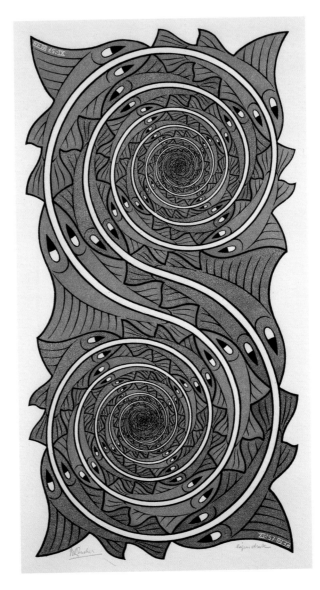

Whirlpools. November 1957. Wood engraving and woodcut, second state in red, gray, and black, printed from two blocks, 438 × 235 mm (cat. 423).

In 1958, in almost a replay of his discovery in 1937 of the power of geometric rules from the mathematical articles by Pólya and Haag, Escher seized the visual information in a geometric diagram in a mathematical article by H. S. M. Coxeter. The diagram showed a tiling of black and white curved triangles inside a circle—it was an illustration of a tiling of the hyperbolic plane—and it offered Escher a solution to his problem. Coxeter had sent Escher a reprint of this 1957 paper to thank him for permission to reproduce two of his periodic drawings as illustrations. Several months later, Coxeter received an enthusiastic letter from Escher which began, "Did I ever thank you for sending me (more than half a year ago) 'A Symposium on Symmetry'? I was so pleased with this booklet and proud of the two reproductions of my plane patterns! Though the text of your article on 'Crystal Symmetry and Its Generalizations' is much too learned for a simple, self-made plane pattern-man like me, some of the text-illustrations and especially figure 7, page 11, gave me quite a shock."

Escher spent a great deal of time figuring out the "rules" of such a hyperbolic tessellation from the diagram; Coxeter's "hocus pocus text" gave him no help. He was able to construct the intersecting circular arcs and "scaffolding" necessary to create his own version of a hyperbolic tiling, *Circle Limit I* (page 316), which he sent to Coxeter. In the next two years, he produced three other such designs; two of them use motifs from his numbered periodic drawings. *Circle Limit III* uses drawings 122 and 123 and *Circle Limit IV* (page 296) uses drawing 45. Two articles by Coxeter, "The Non-Euclidean Symmetry of Escher's Picture 'Circle Limit III'" and "Angels and Devils," tell more of the story of his correspondence with Escher about these prints, and also provide careful mathematical analyses of them. Coxeter's book [1969, p. 285] and his 1979 article reproduce the hyperbolic tessellation of triangles which "shocked" Escher.

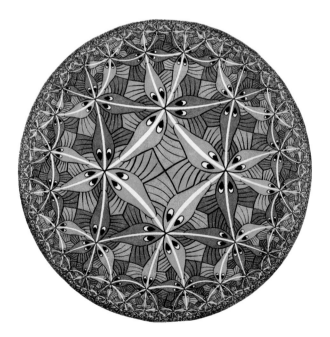

Circle Limit III. December 1959. Woodcut, second state, in yellow, green, blue, brown, and black, printed from five blocks, diameter 415 mm (cat. 434).

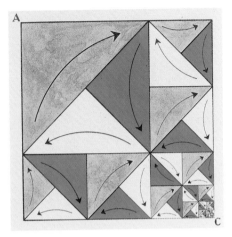

Escher's lecture illustration to show the geometric scheme of *Smaller and Smaller*. This corresponds to one quarter of the square print, with C at the center.

Escher devised other highly original methods of capturing infinity in graphic works; his prints *Division, Fish and Scales, Smaller and Smaller* (two versions), and *Square Limit* are examples. Although each work displays a logical progression of repetition (or creation) of figures, these designs do not use geometric transformations, at least in the traditional mathematical sense of that phrase. In fact, in these works Escher seems to have anticipated yet other fields of inquiry which have only recently been recognized as important areas for research by mathematicians and scientists.

In *Division*, lizards emerge from lizards; the suggestion that this splitting (familiar in living cells) can continue forever depicts an infinite process (see drawings 35 and 101 and their notes). In *Fish and Scales* (page 321), rows of small fish serve as scales for larger fish, or, reading it the opposite way, large fish shed scales which become small fish—again, an infinite process of creation through splitting or amalgamation. The two versions of *Smaller and Smaller* as well as *Square Limit* use well-defined algorithms for division. In *Regelmatige vlakverdeling*, Escher describes his line limit version of *Smaller and Smaller* (page 294) as an example of "a dynamic action . . . a halving or a doubling, a diminution or an enlargement, a division or a multiplication depending on whether the print is read from the top downwards or from the base upwards. Whichever description we choose, it is a fact that 'something happens' in a vertical direction." This description of the print is accompanied by a geometric diagram of right triangles to illustrate the division algorithm; in the print, the triangles are replaced by lizards.

Escher created a similar geometric diagram of triangles as a lecture illustration to show the division algorithm used in his central limit version of *Smaller and Smaller*. The algorithm for the diagram is this: to produce smaller triangles adjacent to a given right triangle, reflect the triangle across its hypotenuse and split the image into two congruent right triangles. (This shows, by the way, that the two newly created triangles are scaled by $1/\sqrt{2}$; Escher's "halving" refers to area, not scale.) A far more complex algorithm is needed for Escher's lizards to occupy the diminishing triangular spaces successively. Starting at an outer corner, each large lizard must be turned (pivoted about the point where it touches elbows with two other lizards), shrunk to fit the smaller adjacent compartment, and then turned over (reflected) to bend in the right direction. This transformation of a single motif into a smaller neighboring motif is completely local; none of these transformations are symmetries of the print as a whole.

Escher's *Square Limit* (page 315) was created in 1964, four years after completing his Circle Limit prints. It uses an adaptation of the same splitting algorithms just described, but now motifs multiply and diminish in size as they approach all four sides of the square frame of the print. Escher sent one of his first prints of *Square Limit* to Coxeter with a colored diagram which clearly reveals the algorithmic nature of the geometric scheme of the print (see notes on drawing 119). Tilings which can be produced by such algorithms are today called "self-similar" tilings and are the subject of mathematical research.

Although one can envision and describe how a single motif can be transformed into a multiplicity of different-sized similar figures which

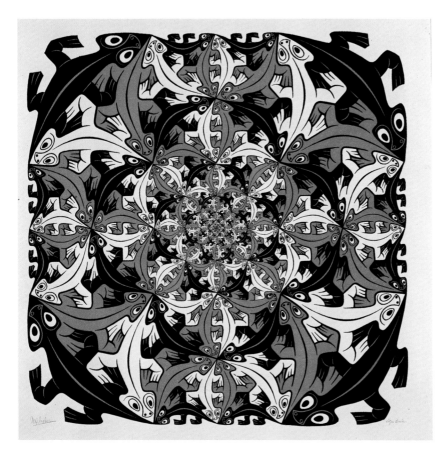

Smaller and Smaller. October 1956. Wood engraving and woodcut in black and red, printed from four blocks, 380 × 380 mm (cat. 413).

fill a region, the realization of each imagined transformation was an enormously painstaking task for Escher. The mathematical accuracy of his hand-drawn and then hand-carved woodblock designs was the result of careful planning and patient work, preceded by numerous trial sketches and choices of coloring schemes. For each print with rotation symmetry, he carved only that portion of the design which could generate the whole through repeated printing and changing the color of the printing ink.

Escher's letter to Coxeter in 1964 which accompanied his print *Square Limit* explained the ardous printing process: ''I fear that the subject won't be very interesting, seen from your mathematical point of view, because it's really simple as a flat filling. None the less it was a headaching job to find an adequate method to realise the subject in the simplest possible way.'' He then indicated how he made the print in three colors (one being the white of the paper) with only two woodblocks: he printed each woodblock four times and alternated the color printed by a single block as it was rotated 90° about the center of the print. Escher also employed the technical power of strong magnifying lenses to stretch to the limit the skill of his hands and capabilities of his carving tools. In *Regelmatige vlakverdeling* he reports on carving the block for the print *Smaller and Smaller:*

The material I chose was a block of the best quality of palmwood available and on this I engraved a series of increasingly smaller animal figures, starting at the edges and working toward the center. As I approached the middle, increasingly higher demands were made on the steadiness of my hand, the keenness of my eyesight, the sharpness of my burin, and the quality of my material. By the time my little picture surface had been reduced to a square centimeter, I needed a system of three magnifying glasses placed on top of one another in order to see clearly enough what I was doing. The smallest figure still recognizable as a complete animal form—with head, tail, and four legs—had a total length of about two millimeters. During this extremely minute work—minute for me at least, but what is our Western skill compared with the proficiency of the Eastern artisan—I discovered once again that the human hand is capable of executing extremely small and yet completely controlled movements, on the condition that the eye sees sufficiently clearly what the hand is doing.

Escher found in the canons of J. S. Bach an expression of his own desire to capture infinity; he wrote in 1961 to the art historian E. H. Gombrich, "It may be that the canon is near to my (anti)symmetric plane-filling mania. Bach played with repetition, superposition, inversion, mirroring, acceleration and slowing down of his themes in a way which is, in many regards comparable with my translation and glide-mirroring of my 'themes' of recognizable figures. And that's perhaps why I love his music particularly." The music was also an inspiration; he closed his essay in *Regelmatige vlakverdeling* with a testimony to the influence of Bach's music on his work.

His reasonableness, his mathematical arrangement, and the severity of his rules probably play an important role, but not a direct one. It is an influence based on feelings that takes place, at least as far as my conscious perceptions while hearing his music are concerned. . . . A vague feeling of expectation and suddenly emerging hope sometimes manifests itself during a concert, in the middle of a period of sterility. Longing for creativity precedes the urge to create and this is the first spark that sets in motion the mechanism of making images. Thus my periods of slackening, mental emptiness, and listlessness call for the music of Bach as a tonic to stimulate my longing for creativity.

*M*etaphor and metamorphosis

Metamorphosis, that process in nature that turns larva to butterfly or tadpole to frog, is a rich metaphor to describe any gradual change from one state to another sharply contrasting one. Escher found that metamorphosis is not only a metaphor, but also a visual device to draw attention to the ambiguities of human perception and attempts to categorize.

In his first review of Escher's work in 1938, "Nieuw werk van M. C. Escher" ("New Work by M. C. Escher"), s'-Gravesande commented,

I do not know whether Escher is familiar with the following words of Diderot in the dialogue *Le rêve d'Alembert,* but they could serve as a motto for his latest graphic work, which was born of one thought: "Tout animal est plus ou moins homme; tout minéral est plus ou moins plante; toute plante est plus ou moins animal. Il y n'est rien de précis en nature." ("Every animal is more or less human; every mineral is more or less plant, every plant is more or less animal. There is nothing precise in nature.")

The art critic was referring to the first five prints that Escher made beginning in May 1937—*Metamorphosis I, Development I, Day and Night, Cycle,* and *Sky and Water I.* Each of these prints contains a metamorphosis, yet each transformation serves a different function. From each, several other prints followed and gave further expression, variation, and refinement to the possibilities suggested by metamorphosis.

Picture stories *Metamorphosis I* (page 19) was Escher's first attempt at telling a picture story in which one scene leads to the next by a subtle metamorphosis of forms. In his 1940 article in *De vrije bladen,* 's-Gravesande reported that Escher was very dissatisfied with the composition because he felt that there was no "logical" train of thought or story line that would connect a Chinese boy with a tower on the Amalfi coast. For that reason, Escher did not exhibit this particular print.

Thoughts, loosely associating in a stream of consciousness and occupying idle moments in daydreams or in relaxation before sleep are familiar to everyone. Sometimes young campers spin a yarn in the dark of a cabin, piecing together the story as it bounces from bunk to bunk, with no predictable end. In an article "Spel van vormen en denkbeelden" ("Play of forms and ideas"), J. R. Kist relates Escher's recollection of how he would evoke a panorama of images:

> I played a similar game when I was ten years old, at night in bed before falling asleep: the association of thoughts. As my starting and finishing points I took two completely arbitrary concepts, and these I had to try to relate in a logical way. For example: How do I get from a tram conductor to a kitchen chair? Tram conductor—a tram pulled by horses—rails—through the whole city—'til the end—near the forest—with many trees—from wood—someone sawing planks—someone making furniture—a kitchen chair. It only becomes difficult when one wants to convey such a stream of thought in the form of an image. I only found out how to do so some thirty years later.

In this last sentence, Escher was referring to the monumental visual display of thought association in his 1939–1940 *Metamorphosis II,* which defied not only conventions of composition, but even the most liberal conventions of size. The woodcut was printed from 16 blocks, on three separate but contiguous panels, each 19.5 centimeters high. Its total length is 4 meters. In order to see the whole print, the viewer is forced to travel its length. The picture story, beginning with a letter puzzle of the word "metamorphose," weaves together fragments of five of Escher's drawings (numbers 15, 25, 27, 28, and 29). *Metamorphosis II* is also a closed cycle of thought associations; its end returns to its beginning. On

at least one occasion it was mounted and exhibited on the surface of a cylinder around which the viewer could walk. It is interesting to note, as did 's-Gravesande in the 1940 *De vrije bladen* article, that Escher incorporates into this picture story the same town on the Amalfi coast that he showed in his 1937 *Metamorphosis*. This time, the town is part of a logical transition of images and provides the link between stacked cubes and a chess game. Escher described this print to 's-Gravesande as a "surrogate for a film" and expressed a desire to realize his "metamorphosis and thought association mania in an animated cartoon." In his lectures, Escher showed this print in a sequence of six slides, two at a time, side-by-side. That was the closest approximation to continuous scanning that could be arranged with projected slides. (Escher's lecture description of this picture story is given on pages 257 and 258).

In 1967, a commission by the PTT (the Dutch Postal Service) provided Escher the unusual opportunity to enlarge his previous work. The large post office on the Kerkplein in The Hague was being renovated, and he was asked to design a new version of *Metaphorphosis II* for a mural for its main customer service room. In September 1967, during the negotiations with the PTT, he wrote about it to his friend Gerd Arnzt. He explained that a print of *Metamorphosis II*, hung in a conference room, had for years served as a source of diversion for the director of the PTT during dull meetings, and he "figures a bunch of bored people in lines can be kept amused by something like that."

The first plan was to enlarge the print 10 times, but these dimensions did not fit the wall, which was 2.4 meters high and 45 meters long. Negotiations led to the final plan:

> I will execute this all in a woodcut of the same size [as the 1939–1940 print], ±19.5 cm high. So I get a strip 7 m long which has to be ready before 1 Jan. '68. After that they will have in hand from me one complete print which they will enlarge photographically to a band breadth of 1.10 m. The length will be ±42 m. Under my supervision, one (or two) skilled housepainters will paint this thing on linen . . .
>
> It is a nice work. They pay me well and at the same time I can work for myself because I still retain the right to sell the woodcut to people who are eager to buy. Apparently there are always nuts who are nuts enough to buy such a streamer of 7 m.
>
> The only thing that scares me is my strength. I hope not to get sick before I'm finished with it.
>
> It is not so easy as it may appear to expand a "closed" design of 4 m by 3 m more. It is a strange feeling also after 28 years to glue a second part to the first. Around 1940 my inventiveness certainly was greater than now. Shall I succeed in reaching the same level? (if you can speak of a level at all). One advantage, of course, is that after 28 years I have a vast collection of periodic drawings at my disposal which I did not have in 1940.

The commission challenged Escher with a multiple puzzle: first how to create "openings" in his picture association of twenty-eight years before and then, for each pair of pictures now divided by a gap, how to bridge that gap with new pictures in a continuing metamorphosis of images. Escher wove fragments of six additional periodic drawings into his 1939–1940 serial; he already had four of these (numbers 76a, 100,

112, and 113) in his folio collection and he created two new ones (numbers 129 and 131). The woodcut print of the design was delivered on time to the PTT, but the painting of the mural (begun by one young painter who was joined by a second after a short time) took much longer than anticipated; it was finally completed in February 1969. Escher was pleased with the exacting care of the painters in translating his 7-meter-long print to a monumental work six times that size. Kist's 1968 article about the mural, written shortly after it was unveiled, described how the picture story could engage the imagination of young and old alike: "All these animals and objects, these changing foregrounds and backgrounds, form a logical and enthralling play of interpenetrating images, each of which can be recognized as easily by children as by the pensioners who come to pick up their checks."

In June, 1968, when barely half the mural was painted, Escher gave a lecture at the opening of a retrospective exhibition of his work in the Haags Gemeentemuseum, celebrating his seventieth birthday. He wrote to Roosevelt about preparations for the lecture; the museum had agreed to make a continuous strip of film of the new *Metamorphosis III* so it could be shown as an uninterrupted story by slowly pulling the filmstrip past the lens of a projector. Unfortunately, that plan was never realized. Later that same year, a movie was made for Canadian television about Escher's work; in it, the viewer is shown the continuous stream of images in *Metamorphosis III* as though the camera were slowly scanning the print. Actually, the print (owned by Roosevelt, and mounted on linen as a continuous streamer) was slowly pulled in front of the lens of a fixed movie camera, so the same effect that Escher had planned for his lecture was recreated in much larger scale.

Four years earlier, in 1964, Escher was to have given a lecture at M.I.T. in Cambridge, Massachusetts, but emergency surgery forced its cancellation. Arthur Loeb, the Harvard professor who arranged the visit, did show the slides and deliver a lecture based on Escher's text, both of which had been sent by George Escher from Canada. The typewritten text of Escher's lecture, in English, contains his own reading of his 1939–1940 *Metamorphosis II*, and it is especially interesting to follow that description while scanning the reproduction here of his seamless 1968 *Metamorphosis III* in which he has lengthened the story by the insertion of additional "chapters." In reading the description of the earlier picture story while viewing the later version, one can judge Escher's success in weaving new episodes into his earlier stream of images. Here is the lecture text of Escher's description of the 1939–1940 *Metamorphosis II* (the hyphenation is Escher's):

It's a picture-story, consisting of many successive stages of transformation. The word "Metamorphose" itself serves as a point of departure. Placed horizontally and vertically in the plane, with the letters O and M as points of intersection, the words gradually transform into a mosaic of black and white squares, which, in turn, develop into reptiles. If a comparison with music is allowed, one might say that, up to here, the melody was written in two-quarter measure. Now the rhythm changes: bluish elements are added to the white and black and it turns into a three-quarter measure. By and by each figure simplifies into a regular hexagon. At this

Metamorphosis III. 1967–1968. Woodcut, in black, green, and reddish brown, printed from 33 blocks on 6 combined sheets, 192 × 6800 mm (cat. 446).

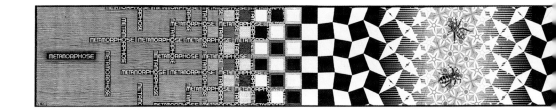

point an association of ideas occurs: hexagons are reminiscent of the cells of a honeycomb, and no sooner has this thought occurred, than a bee-larva begins to stir in every cell. In a flash every adult larva has developed into a mature bee, and soon these insects fly out into space.

The life-span of my bees is short, for their black silhouettes soon merge to serve another function, namely: to provide a background for white fishes. These also, in turn, merge in[to] each-other and the inters-pacings take-on the shape of black birds. Then, in the distance, against a white background, appear little red bird-silhouettes. Constantly gaining in size, their contours soon touch those of their black fellow-birds. What then remains of the white, also takes a bird-shape, so that three bird-motifs, each with its own specific form and colour, now entirely fill the surface in a rhythmic pattern.

Again simplification follows: each bird is transformed into a rhomb and this gives rise to a second association of ideas: a hexagon made up of three rhombs, gives a plastic effect: appears perspectively as a cube.

From cube to house is but one step and from the houses a town builds up. It's a typical little town of southern Italy, on the Mediterranean, with, as commonly seen on the Amalfi-coast, a Saracen tower, standing in the water and linked to the shore by a bridge.

Now emerges the third association of ideas: town and sea are left behind and interest is now centred on the tower: the rook, and the other pieces on a chessboard.

Meanwhile the strip of paper, on which "Metamorphose" is portrayed, has grown some 12 feet long. It's time to finish the story and this opportunity is offered by the chess-board, by the white and black squares, which at the start emerged from the letters and which now return to that same word "Metamorphose."

In 1962, Escher created a picture story of metamorphosis in a vertical manner. His design for a column for the Provinciale Waterstaat en Planologische Dienst (Provincial Bureau of Water Management and Planning) in Haarlem evokes many associations with water: frog—fish—boat—flying fish—bird. Repetitions of each motif continuously encircle the column, while in an upward transition, each frog metamorphoses through four stages and emerges as a bird. From the four periodic drawings (111, 112, 113, 114) he created for this commissioned work, Escher later chose the two of interlocked boats and fish to integrate into *Metamorphosis III.* Whether moving horizontally or vertically, his fish and boats seem to transform effortlessly into each other. (See page 260.)

Development of form and contrast *Development I* (page 30), as its title suggests, depicts a developmental metamorphosis from flat gray

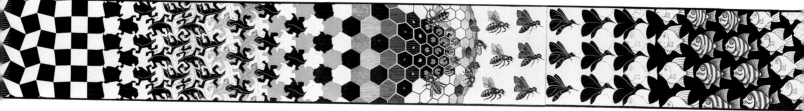

squares to sharply defined lizards in starkly contrasting black and white. This print was the first of several that served to declare in visual metaphor Escher's strongly held opinions on graphic technique and regular divisions of the plane. He gives a picture lesson on the subject in *Plate I* in *Regelmatige vlakverdeling* (page 305). Here contiguous panels of the print, numbered in sequence, form a meander of 12 episodes in a gradual transition: neutral gray plane—geometric checkerboard—silhouetted motif—contrasting interlocked identical birds—contrasting birds and flying fish with identical contour. In his accompanying essay, he describes the general process of making one of his regular divisions of the plane. Form is developed through the evolution of contour and given individuality through contrast. Further individuality is provided through the addition of internal detail—contours alone, like silhouettes, may have multiple interpretations. The birds and fish with the same contour that evolve in *Plate I* are almost the same ones that play out the drama of predator and prey in *Predestination* (page 239).

Other periodic drawings show Escher's creation of two motifs from a single contour, for example, drawings 31 and 125. Sometimes symmetry present in a periodic drawing was lost when he altered some internal detail of the interlocked forms in order to integrate them as a fragment in a graphic work. Compare, for example, drawing 51 which has half-turn symmetry, with the corresponding portion of the print *Verbum* (see notes on drawing 51).

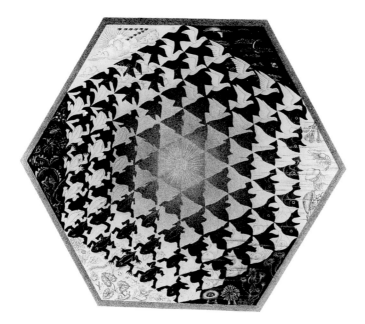

Verbum. July 1942. Lithograph, 332 × 386 mm (cat. 326).

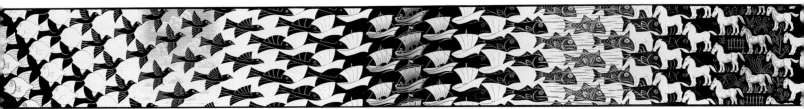

Metamorphosis III (continued)

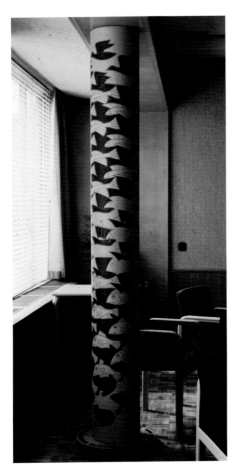

Metamorphosis on column, Provinciale Waterstaat en Planologische Dienst (Provincial Bureau of Water Management and Planning), Haarlem, March 1962. Painted concrete, diameter 30 cm, height 250 cm (approx.).

In *Regelmatige vlakverdeling*, Escher refers to his lithograph *Verbum* ("In the beginning was the Word") as another example of the use of development of form and contrast. "One can even make it into a story of creation. Out of a misty gray vagueness, primitive shapes can loom up that slowly develop into animal figures in gradually more contrasting shades—creatures of the earth, water, and air which in the final stage of their development stand out against the background of the element in which they live." This print integrates six different periodic drawings, numbers 47 to 52, each of which shows two interlocked animal motifs; each motif is created by altering the three sides of an equilateral triangle. Escher's choice of an isometric grid of equilateral triangles as the skeleton for the design, rather than the more familiar square grid, was the perfect way to depict the creatures of land, sea, and sky inextricably locked in their mutual existence. Such a grid forms rings of concentric hexagons with lines radiating in six different directions from its center and is even suggestive of the polar grid of latitude and longitude which maps our globe.

The development from formlessness to a flat geometric framework to plastic, interlocked forms to live creatures which escape to freedom seen in *Verbum* occurs in other prints: *Development II* (page 291), *Butterflies* (page 302), and *Liberation* (page 95). Escher also used this dynamic process to provide transition from one picture thought to another in his long *Metamorphosis* prints of 1939–1940 and 1968.

The mystery of dimension Although Escher's first two prints using regular division of the plane (*Metamorphosis I* and *Development I*) each contain a metamorphosis from flat to spatial, in the third print *Day and Night* this metamorphosis of dimension is especially startling. Here the scene of flat squares of Dutch farmland is familiar and believable, and the formations of geese flying across the sky is also familiar and believable. Only when the viewer realizes that the flat patches of earth have metamorphosed into "live," flying geese is the impossibility of the scene (as well as the subtlety of Escher) apparent.

Escher was fascinated with the perception of space and dimension; through his prints, he wished to jolt viewers into questioning the "reality" of their perceptions. In a lecture "Het onmogelijke" ("The Impossible") in 1963, he spoke of the mystery of space and his motive for deliberately creating impossible mixings of two and three dimensions in his prints.

> We do not know space. We do not see it, we do not hear it, we do not feel it. We are standing in the middle of it, we ourselves are part of it, but

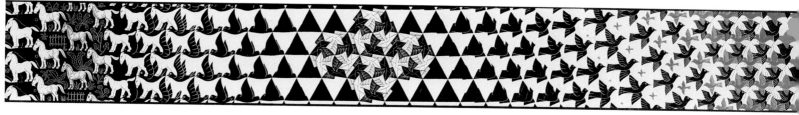

we know *nothing* about it. I can measure the distance between that tree and myself, but when I say, "three meters," that number reveals nothing of the mystery. I see only boundaries, markings; I do not see space itself. The prickling on my skin caused by the wind blowing about my head is not space; when I feel an object with my hands, it is not the spatial object itself. Space remains inscrutable, a miracle.

So the reality around us should already be unexplainable and mysterious enough! But no, we are not satisfied with it and persist in playing with stories and images in order to escape it. . . .

Whoever wants to *portray* something that does *not* exist has to obey certain rules. Those rules are more or less the same as for the teller of fairy tales: he must produce contrasts; he must cause a shock. . . .

Day and Night. February 1938. Woodcut in black and gray, printed from two blocks, 391 × 677 mm (cat. 303).

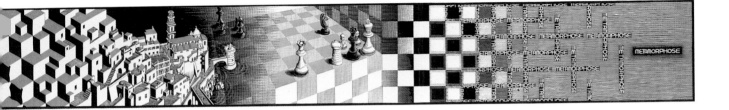

Metamorphosis III (continued)

The element of mystery to which he wants to call attention must be surrounded and veiled by perfectly ordinary everyday occurences that are recognizable to everyone. That environment, which is true to nature and acceptable to every superficial observer, is indispensable for causing the desired shock. . . .

Profundity is not at all necessary, but a kind of humor and self-mockery is a must, at least for the person who makes the representations.

In each of his prints that weave part of a regular division drawing into a composite scene of "real" objects or views, Escher follows the rules outlined in his lecture. In these works, metamorphosis is a means to join those "acceptable" individual parts of a composition to create an impossible whole. His print *Cycle* (page 290), which shows a fragment of drawing 21, is another early example; here a "live" running figure dissolves into a flat patch in a paving, which in turn changes shape and becomes a part of what appears to be stacked cubes. However, perception of this formation is ambiguous; these parts of the three-dimensional configuration may also be interpreted as diamonds in the flat pavement on the terrace of the building from which the running figure emerges. Here, Escher's visual metaphor does not show the cycle, but suggests it, and the viewer must put together the pieces of his puzzle. Other prints which mix "reality" and fantasy and point to the ambiguities in perception of space and dimension are *Magic Mirror* (page 301), *Encounter* (page 300), and *Reptiles* (page 113).

The dynamic tension between figure and ground In *Sky and Water I* as well as *Sky and Water II* (page 291) Escher uses metamorphosis to turn figure into ground and in so doing creates a powerful metaphor for the inseparability of life from the life-supporting elements, air and water. At the center of each print is a fragment of a flat regular division of the plane (drawing 22 and drawing 24); here the motifs define each other and have equal individual existence. But then moving upward, the dark birds gain life and fly away and the fish forms dissolve into sky, while moving downward, the white fish sink into the depths and swim and the bird forms melt into the dark water.

In creating interlocking motifs with a single contour line defining adjacent figures and contrasting colors providing individual definition, Escher entered the domain of perception of figure and ground. He called his regular division drawings "backgroundless," asserting that each motif was an object, that there was no ground. In 1953, he corresponded with an ophthalmologist, J. W. Wagenaar, about the differences in their respective views on the subject of the equivalence of black-and-white

motifs in a plane filling. In referring to the regular division in the center of the print *Sky and Water I* Escher wrote, "I consider the boundary between, for example, a white fish and a black bird as a contour line with a double function so to speak, defining the form of both fish and bird at the same time: on the left side of this line is a fish, on the right a bird; both are equal and at the same time object. The background is reduced to zero, to an ideal line." Wagenaar explained that from the theory of perception, this was impossible; in his reply, Escher agreed with the doctor's critique.

In *Regelmatige vlakverdeling,* Escher addressed at length the subject of perception of figure and ground, both in the text and in graphic plates. With Wagenaar's permission, he quoted from the ophthalmologist's 1953 letter:

In my opinion you [Escher] do not in fact create pictures without a background. They are compositions in which background and figure change functions alternately; there is a constant competition between them and it is actually not even possible to go on seeing one of the elements as figure for very long. Irresistibly the elements initially functioning as background present themselves cyclically as figure. Just as, for example, someone who holds a red glass in front of one eye and a green glass in front of the other does not see the world as either red or green but con-

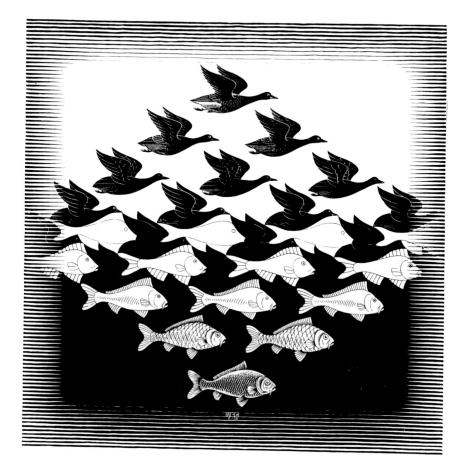

Sky and Water I. June 1938. Woodcut, 435 × 439 mm (cat. 306).

stantly changes from one to the other and back again (as least if both eyes have equal strength and one is not distinctly dominant!), so in your compositions there is no visual static balance but a dynamic balance, in which, however, there is a relationship between figure and ground at every stage. A static balance is possible only if one sees the whole configuration as a pattern, and thus frees oneself from the notions of "bird" and "fish."

In *Regelmatige vlakverdeling*, four of Escher's six plates are visual lessons in the art of perception of a single shape first as figure, then as an equal part of a counterchange pattern, and then as ground. (See plates II, III, IV, and V, on pages 288, 302, and 310). The transformation is made with a minimum of actual change in the figures; most of the transformation takes place in the mind of the viewer as the print is scanned. It is achieved by two devices: the addition (or deletion) of a bit of internal detail to the silhouetted figures, and the gradual separation of figures from a tightly packed formation of flat congruent shapes to individual figures against a blank background. Escher describes these plates as having three stages: the beginning and end stages are opposites (like a positive and a negative image) of each other; one has a white object on a black ground and the other has a black object on a white ground. The middle stage between the first and last stages is the real, pure division of the plane in which both elements are equivalent.

In his essay he also points out that the transition of motifs from figure to ground is an important device in linking episodes in the long *Metamorphosis* prints; he illustrates this technique by referring to one panel in which insects are transformed into birds (see pages 259 and 260). "At first the black insect silhouettes approach one another. At the point where they touch, their white background has become fish-shaped. By interchanging figure and ground, white fish are subsequently swimming against a black background. The fish thus function more or less as catalysts. Their form changes hardly at all, but their position with respect to one another does change; their 'battle array' is modified. When they are reunited, their interspaces appear to have become bird-shaped."

Dynamic balance of opposites The titles of many of Escher's prints reveal his fascination with contrasts, opposing forces and duality. The prints are visual metaphors for their titles. He found that his regular divisions with two interlocked motifs possessed a "dynamic balance among the motifs themselves," which provided a unique way to give expression to these ideas. He wrote in *Regelmatige vlakverdeling,*

> This most fascinating aspect of the division of the plane . . . has led to the creation of many prints. Here the representation of all kinds of opposites comes to the fore. Isn't it obvious for one to arrive at a subject such as *Day and Night* as a result of the double function possessed by both the white and the black motifs? It is night when the white, as object, stands out against the black as a background; day when the black figures are set off against the white as ground. Likewise, the idea of a duality such as *Sky and Water* can be manifested as an image by taking as a point of departure a plane filling of birds and fish: the birds are water with respect to the fish,

and the fish are air with regard to the birds. Even heaven and hell may be symbolized in a similar fashion by an interplay of angels and devils.

(See *Circle Limit IV,* page 296 and the carved sphere with angels and devils, page 244.)

In each of the prints referred to by Escher, its duality is achieved through the double function of each of the motifs. At one place in the composition, one motif assumes the role of figure while the other is ground, and at another place in the print, the roles of the motifs are reversed.

The dynamic tension between figure and ground when each motif can assume either role (as Wagenaar explained to Escher) is most dramatically depicted in the print *Sun and Moon.* Based on Escher's drawing 71, this print is literally two scenes in one; only the viewer, through directed observation, can sort them out. There is no metamorphosis of images here; the scene of light colored birds against a deep blue starry night sky must be blinked away and the eyes refocused in order to see the second (simultaneous) scene of dark birds against a brilliant gold sun. If one tries to see the composition as a whole, only a flat pattern of birds is evident; neither background, that of sun or of moon, is seen as a backdrop for a lively flock of birds.

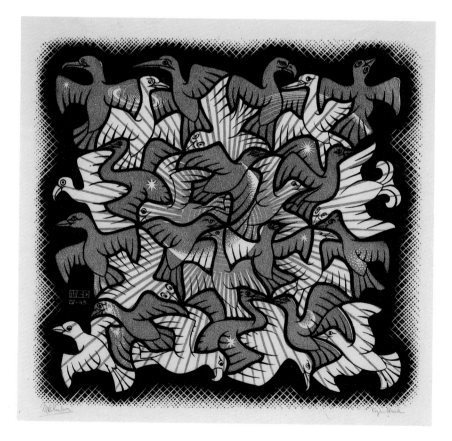

Sun and Moon. April 1948. Woodcut in blue, red, gold, and black, printed from four blocks, 251 × 270 mm (cat. 357).

*E*scher's decorative use of regular division of the plane

The most traditional use of regular division of the plane is as decorative, or applied, art. Something in the human spirit craves embellishment of the buildings and instruments of daily life; every culture in every era has left its stamp though its decorative art. Escher was moved by the decorative art he found in palaces, mosques, and cathedrals; something in him responded to the designs and spurred his quest to learn more about regular division. He also was acquainted with the work of the Nieuwe Kunst artists who emphasized the role of decorative art. Among these were R. N. Roland Holst and Samuel Jessurun de Mesquita; de Mesquita was well-known for his batik fabric designs, and Roland Holst for his murals for buildings in Amsterdam.

In each of his 1940 articles about Escher's work, the art critic 's-Gravesande pointed out that Escher's experiments with regular division were admirably suited to practical application: to damasks, carpets, and murals. The critic was instrumental in seeing that application realized; he introduced Escher to H. T. Zwiers, one of the architects engaged for the building of the new Leiden Town Hall. In 1940, Escher received his first important commission for public work: he was asked to design decorative wall panels and a clock face for the council chamber, a wall panel for the mayor's office, and etched glass windows for book cabinets in the town clerk's office in the Leiden Town Hall.

The panels were to be executed in wood intarsia, and although this might have seemed strange to his colleagues in graphic art, Escher welcomed the commission. In 1941, he replied to the question "How did you as a graphic artist come to make designs for wall decorations?" in an article in *De Delver* with that question as its title. "I could make do with the following answer, 'I did not come to it as a graphic artist.' My designs for wall decorations have no point of contact with my graphic work up to the end of 1937. They are indeed related to most of the graphic work I have done since that date, but they did not develop, as was the case before 1937, from a great interest in the graphic arts as such, for example, the woodcut technique."

He then explains to his readers his almost life-long fascination with regular division of the plane, his personal journey to understanding the laws which govern such designs, and his various ways of using regular division in graphic prints and on curved surfaces. He makes clear that now graphic technique is used to serve as a vehicle of expression for his ideas and subject matter rather than the other way around. His explanation concludes:

> I dared to make another "metamorphosis" [*Metamorphosis II*] executed in a series of woodcuts which, when printed contiguously, form a print 4 meters long. Did I thus violate the art of printmaking? I can truthfully say that I did not make this long print roll with the primary aim of emphasizing graphic technique; rather, I used graphic technique to serve my own special purpose. That I seized with both hands the opportunity offered to me to design panels executed in the wood intarsia technique proves to

what extent, as far as my present work is concerned, I feel liberated from the graphic arts simply for the sake of graphic arts. Of the designs I created, the one reproduced here [design for panel with fish] is that in which I was given the greatest degree of freedom by the people who commissioned the work and consequently in this work I could most truly bear witness to my interest in the regular division of the plane.

The design referred to by Escher in his interview is one of a pair that are mirror images of each other. The panels, based on drawing 32, show arched fish leaping rhythmically, and provide a playful note in the formal paneled meeting room for the mayor and alderman. Escher's sketchbooks show he originally intended each row of fish to perform a U-turn at the panel's edge to swim in the opposite direction in the next row. Although this idea was either vetoed or abandoned for the final execution of the panels, he later carried it out successfully in a hand-printed design of fish on fabric.

In contrast with the fish panels, regular division appears only in brief fragments in Escher's two other intarsia panels in the Leiden Stadhuis. The large wall clock shows a design with birds. Here small silhouettes are tightly packed to encircle the clock face; the birds at the outer edge of this dense formation are those in Escher's drawing 23. But this regular division is broken as birds, growing in size and detail, burst from the regular formation to fly outward to two opposite corners of the panel, or home in to the flock from the two other directions. The design

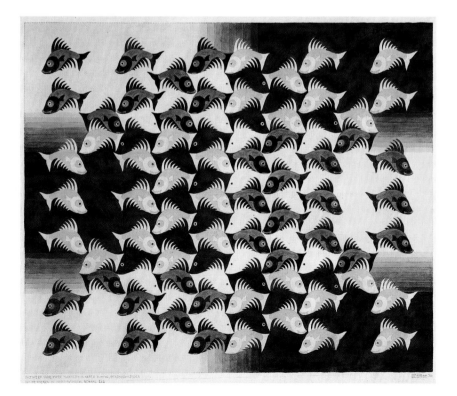

Design drawing for intarsia wood panels with fish for Leiden Stadhuis, July 1940. Watercolor and gouache, 548 × 665 mm, scale 1:2.

Intarsia panel with clock, conference room for the mayor and aldermen in the *raadzaal* (council hall), Leiden Stadhuis, 1940. Elm root veneer, teak veneer, and maple, 115 × 151 cm.

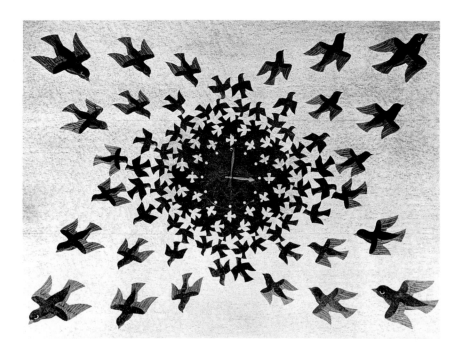

suggests two ideas simultaneously: rays bursting from the sun, which constantly marks time, and the universal epigram "time flies."

Escher's birds in the clock panel also appear in the large intarsia panel which is a focal point on one wall in the mayor's office. Their flight path leads the viewer through the intricately detailed picture which depicts the growth of the city of Leiden. At two points, flight paths cross, and birds traveling in each of the four directions briefly interlock. Here the figures not only lose their freedom, but appear unnaturally distorted in order to fill roughly the same contour, but face in four different directions. (See drawing A2 and its notes.)

Escher's purely geometric design for glass panes for book cabinet doors (shown in drawing A3) overlaid two layers of evenly spaced parallelograms, with each layer in a different orientation. The designs were etched (perhaps sandblasted) in the glass, and the layering of the shapes created a complex textured symmetric design from just one simple shape. Escher was also commissioned to design a large intarsia panel for the Leiden Town Hall which was never executed. As with his other large panel, a stream of motifs (this time fish and birds) leads the viewer's eye through the work, and where the paths of the motifs cross, fish and birds interlock as in drawing 34.

The 1940 commission led to several others over the years; public buildings in several cities in Holland contain Escher's unique designs executed in a variety of imaginative techniques. Several of these were described earlier: tiled columns at two schools, a painted column at a provincial ministry, murals in a funeral building, and the monumental mural at the post office in The Hague. In addition to these, Escher made designs for the facades of two buildings: a porcelain tile tableau of birds and fish commissioned for a private house in Amsterdam (based on drawing 82), and a design of prancing Pegasus executed in concrete tiles

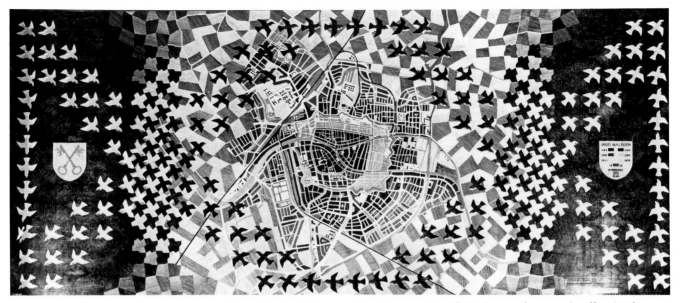

Intarsia panel, mayor's office in the *raadzaal* (council hall), Leiden Stadhuis, 1940. Satinwood root veneer and light wood species, 112 × 266 cm.

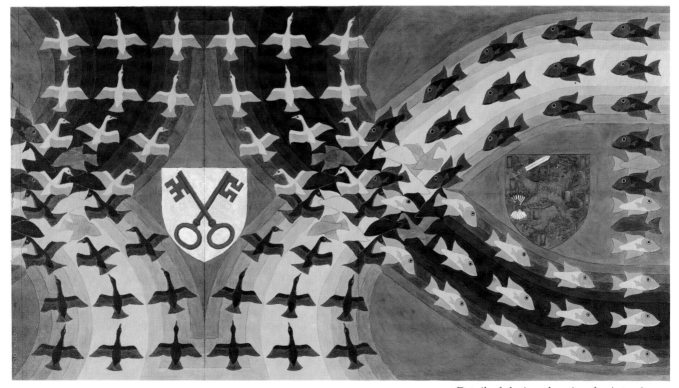

Detail of design drawing for intarsia wood panel for Leiden Stadhuis (unexecuted), 1940. Watercolor and gouache, 502 × 1298 mm.

for a school in The Hague (based on drawing 105). In 1954 he made three designs for cabinet doors for an office in a postal building in Amsterdam; they were executed in wood intarsia in pairs, image and mirror image, for six cabinets (drawings 84, 92 and 93).

Escher also designed two unique ceilings: one in 1951 for the Philips Company in Eindhoven and one in 1962 for the office of the Secretary-General of the Dutch Ministry of Agriculture and Fisheries in The Hague. The second one was painted on a large panel of stretched vellum and shows birds and fish (see notes on drawing 110). The Demonstration Laboratory for the Philips Company was an exhibit center housed in their original 1891 factory building to show modern lighting engineering; Escher's ceiling was its showpiece. In it, four creatures of the air interlock (drawing 81), separate, and repeat while growing smaller. The hung ceiling was made of large square wooden panels painted battleship gray, with the outlines of the motifs cut out of the panels and colored lucite with the interior details of bat, bee, bird and butterfly inserted. (The faint outline of these square panels can be seen in Escher's design drawing for the ceiling.) The panels were back-lit so that the flying forms glowed in the dark ceiling.

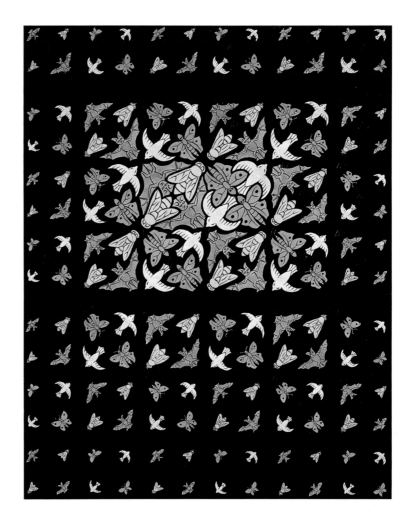

Design drawing for ceiling for Demonstration Laboratory, Philips Company, Eindhoven, 1951. Pencil, watercolor, india ink.

Escher found many other decorative uses for his designs. In December 1942, he returned to the technique of his very first regular division prints and hand-printed a decorative design of lizards on fabric. Based on drawing 56, the printed lizards fill out a large circle of turquoise satin and thus emphasize the rotational symmetry of the design.

While Escher worked on ideas for the Leiden Town Hall commission he also developed his periodic design with fish that became drawing 20 and made concept-sketches for a print based on this design. He could now move away from his earlier static wallpaper style of decorative design and allow his motifs both movement and freedom. After 1940, perhaps in 1942, he made a print of the fish on white silk, using four colors. The swirl of fish, packed pinwheel-like at the center of the print, has a rotating rhythm and also a liveliness as the fish seem to spin out of their tight formation.

Escher designed another decorative print of fish in 1943 and hand-printed it in several different versions on silk. He envisioned this design as two colored ribbons weaving continuously, one the warp and one the woof. In the print, the ribbons take on life as streams of two different fish. One printed design glows with gold and black fish on red silk; in

Hand-printed design of reptiles on satin, December 1942. Gold and black on turquoise, diameter 690 mm.

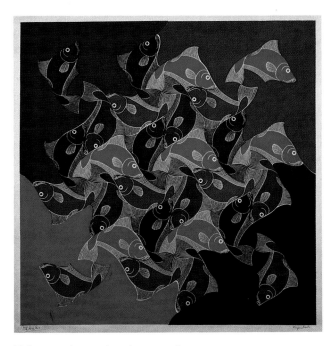

Fish, woodcut printed on textile, c. 1942. Green, blue, red, and black, 420 × 420 mm.

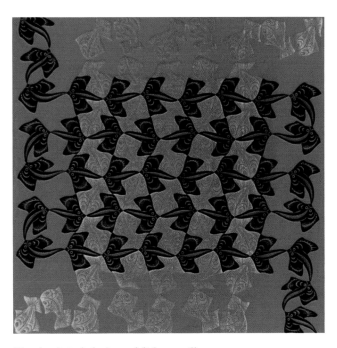

Hand-printed design of fish on silk, 1943. Gold and black on red, 450 × 450 mm.

In all the commissioned work for others, Escher insisted on doing the work himself whenever possible. For printing his own graphic work, and even for his correspondence and record-keeping, he refused to hire any helpers. Only his lithography was entrusted to a skilled lithographer of the "old school." Escher printed his wood blocks with extreme care, in the traditional Japanese way: carefully rubbing the paper against the inked block with a little bone spoon.

Escher's exacting standards were the cause of much frustration and negotiation with those who were necessarily involved in the manufacture of materials or final execution of his commissioned works. Colors had to be exactly the right shade; there had to be a precise balance of contrast. The realities of the fading of desired colors or of the impossibility of technical demands sometimes meant compromise, but usually Escher held out for his precise requirements. He painted the column with the metamorphosis design in Haarlem and the murals in Utrecht himself, but his health did not permit him to paint the vellum ceiling in The Hague nor the mural in the post office in The Hague. He was pleased with the care taken by painters of these designs. He was quite displeased, however, with the imprecise tiling of the three columns in the school in The Hague and tried without success to have them redone with proper precision. The bank note commission may have been the most trying of all: over a three year period he tried to balance his vision and ideas for the bank notes with the demands of a committee which held its own firm ideas concerning appropriate content and presentation. In his book, Bolten notes, "If one had been a bit less timid regarding what Escher's work contained that seemed somewhat unusual to people in those years between 1950 and 1960, then The Netherlands would be enriched with a number of interesting and intelligently conceived bank notes." [p. 169]

*T*he use of Escher's work on regular division by others

Escher's prints, born from a desire to give visual expression to *his* thoughts, seemed to take on a life of their own and speak to others in ways he could never have imagined. His drawings and graphic works became visual metaphors for *their* theories and served as lessons to illustrate concepts that he never in his wildest dreams conceived. In his essay "Escher: Science and Fiction," C. H. A. Broos gives an excellent overview of the variety of interpretations and uses that others have made of Escher's work. As Broos noted, the most frequently used and most widely interpreted of Escher's works are drawing 67 for *Horseman* and the prints *Sky and Water, Day and Night,* and *Verbum.*

The earliest and still most common use of Escher's periodic drawings by others is to provide interesting and challenging examples of regular division of the plane. The numbered drawings are viewed by others as paradigms of plane color symmetry, to be studied and used by generations of students and their teachers. The regularity of his tilings (which classifies them as tile-transitive, or isohedral) makes them espe-

cially appropriate as illustrations in teaching plane symmetry and, in particular, in showing how to analyze and create periodic designs by using the geometric transformations of translation, rotation, reflection, and glide-reflection.

His brother Beer was the first teacher of crystallography to see Escher's unique drawings and realize their potential as illustrations in teaching symmetry; he hoped to write a book on regular plane filling and have Escher do the illustrations. Unfortunately, the project never materialized. In 1959, Escher invited P. Terpstra, director of the Crystallographic Institute in Groningen, to write a short essay for *Grafiek en tekeningen* to explain the mathematical basis of symmetry in periodic drawings. The essay "Iets over de wiskundige achtergrond van regelmatige vlakverdelingen" ("Some Mathematical Background of Regular Division of the Plane"), appeared at the front of the book. It was written from the viewpoint of symmetry groups, and Escher privately expressed his opinion that it was too technical. Even though Escher tried to persuade the British and American publishers of translations of the book to keep the essay, it was issued as a separate pamphlet by Oldbourne (London), and completely excised by the American publishers. (The enlarged 1966 edition of *Grafiek en tekeningen* omits Terpstra's essay; Escher notes MacGillavry's book published the previous year.)

When crystallographers began to investigate two-color and multicolor symmetry they were especially struck by Escher's portrayal of their idea of color-changing symmetries. Terpstra's essay for *Grafiek en tekeningen* reveals his difficulty with the idea of symmetries changing colors. In his analysis of Escher's drawing 67 of horsemen, after identifying the glide-reflection symmetries of that pattern, he writes "It should be noted here that in our analysis we have neglected the difference between white and black [the colors of the reproduction of the drawing]. It is self evident that white cannot be converted to black by a mathematical reflection. In the strictly mathematical sense, therefore, our plate has no glide reflection[s]. . . ."

When the crystallographer A. V. Shubnikov received a copy of *Grafiek en tekeningen* as a gift from Terpstra in early 1960, his response to the reproductions of Escher's work was enthusiastic. Shubnikov and his students were a major force in making black-white symmetry (antisymmetry) an integral part of the crystallographic analysis of periodic patterns. Rather than explain away the color-reversing symmetries in Escher's patterns, he seized them for his theory. Shubnikov's message to Terpstra was in turn transmitted to Escher: "Escher's pictures are for me particularly interesting because they display the best possible illustration of the theory of 'antisymmetry.' The illustration on the cover shows, for example, the existence of antisymmetry axes of the second order in the given 2-dimensional symmetry group."

The enthusiasm for Escher's work by crystallographers and mathematicians was evident in increased correspondence, visits by several individuals to his Baarn studio throughout the 1960s, exhibits and invited lectures at major international congresses, and the 1965 publication of *Symmetry Aspects of M. C. Escher's Periodic Drawings*. This book, a collaboration between Escher and MacGillavry, was a late realization of the kind of project that had been proposed by Beer in 1948. By now, the

Escher's book *Grafiek en tekeningen* with his cover design, J. J. Tijl, Zwolle, 1960 (first printing November 1959). Screened fabric cover; book size 26 × 26 cm.

added element of color was part of the crystallographer's symmetry analysis of Escher's drawings, and his work, through this publication, took on added scientific significance.

After the publication of Escher's book in 1960 and MacGillavry's in 1965, Escher continually received requests for permission to use his drawings as illustrations in books and articles about symmetry. Mathematicians, chemists, physicists, crystallographers, and others all wanted to use these drawings to teach about symmetry for the reason given by MacGillavry in the introduction to her book: "These patterns are complicated enough to illustrate clearly the basic concepts of translation and other symmetry, which are so often obscured in the clumsy arrays of little circles, pretending to be atoms, drawn on blackboards. . . ." Escher gladly gave permission for the use of his work in this way and never charged a fee for its reproduction in noncommercial educational publications. Several publications which use Escher's work in this way are listed in the bibliography.

The truth of the well-worn saying "A picture is worth a thousand words" was demonstrated over and over as others saw in Escher's work an eloquent and succinct expression of abstract scientific concepts, complicated processes in nature, human relations, and interaction with the environment. We have selected several different areas to illustrate some of the visual messages that Escher's work conveys.

Crystallography In his article "Teaching Symmetry," L. Glasser uses Escher's drawing 43, which has 3-fold rotational symmetry but contains flowers with 5-fold symmetry, to draw an analogy: "it is a common occurrence that full molecular symmetry is not utilized in the packing in the crystal." He sees in the print *Development I* (page 30) a demonstration of a "point defect, such as an impurity atom (or cluster of atoms)" in a crystal; the print illustrates how "the disturbance of the defect spreads beyond its immediate boundaries, its influence decreasing with distance from the defect center." Drawing 80 is described as "a representation of interdiffusion of two kinds of particles crystallizing in similar ways with similar lattice dimensions. The center portion also represents a mixed crystal." Finally, he sees the print *Sky and Water* as "a description of epitaxial growth of one kind of crystal on another of an entirely different kind."

Physics In 1957, the horsemen of Escher's drawing 67 marched endlessly around the cover of the slim book *Elementary Particles: A Short History of Some Discoveries in Atomic Physics*, by the Nobel-prize-winning physist C. N. Yang. For him, this drawing was the perfect illustration of a new kind of antisymmetry in atomic physics: an operation that would "*combine* the operation of switching matter and antimatter with a mirror reflection." He noted that in the drawing, "the picture is not identical to its mirror image. But if one switches the white and black colors of the mirror image [the colors in the reproduction of the picture], then identity is restored."

Another physist, J. H. de Boer, found in the two *Sky and Water* prints the visualization of a fundamental question in the structure of matter. In the book *Reactivity of Solids*, he discusses the mechanism of many reactions of solids at the atomic level and notes "The question which of the two, atoms or vacancies, is the most important in crystals, is well-demonstrated by the Dutch artist M. C. Escher."

Biology Escher's periodic drawings and metamorphosis prints provide analogies for morphogenesis and close packing observed in molecular biology. In his essay "Symmetry in Protein Structure and Function," E. P. Whitehead notes, "Symmetry and close fitting of the animals . . . constrained M. Escher in the design of the individual units. The artist is not free in such a system to create just the design he might like. In the same way, . . . the combined constraints of symmetry and close packing in a protein oligomer do not allow the ligand binding site to have the exact shape the ligand molecule would ideally like to fit into. Another point, the animals in many of Escher's designs *cannot do anything* that involves changing the shape of their outline. . . . [without] breaking up the whole structure. So will a ligand if it binds to a symmetrical protein; the oligomers will fly apart, disassociate. . . ."

Mathematics In his essay "The Mathematical Implications of Escher's Prints," H. S. M. Coxeter gives G. H. Hardy's memorable definition of "real mathematics": it has "a very high degree of *unexpectedness*, combined with *inevitability* and *economy*." This definition describes Escher's work equally well; indeed, hardly a print that Escher made after 1937

can be seen as not having mathematical implications. D. J. Lewis, in his introduction to his abstract algebra text, sees another analogy of Escher's work with mathematics. "Although symmetry plays a dominant role in much of Mr. Escher's art and the eye quickly adjusts to expect certain patterns to continue, one is often surprised and pleased by the discovery that everything is not symmetrical: there can be symmetry in the large but not in the small and vice versa. Similarly in mathematics one often encounters certain patterns that suggest formalizing a mathematical system, only to discover on further examination that some really striking results are not covered by the system. . . . Like Mr. Escher's prints, the most beautiful results often entail a systematic approach combined with some ingenious *ad hoc* argument."

The rich mathematical content of Escher's prints is amply demonstrated by Coxeter in his essay as he discusses the variety of mathematical objects depicted and geometric transformations used by Escher in his graphic works. In his book *The Magic Mirror of M. C. Escher*, B. Ernst gives the mathematical details of Escher's intricate planning that preceded the execution of several prints. E. Maor celebrates Escher's work in *To Infinity and Beyond:* "It is Escher's ability to portray abstract mathematical ideas in terms of concrete, recognizable objects that is perhaps his greatest genius." Many of Escher's visual metaphors concern fundamental abstract mathematical concepts—symmetry, infinity, dimension, duality, topological transformation, convexity, reflection, surfaces, "impossible objects," self-reference, self-similarity—and that is perhaps why his images captivate so many mathematicians.

Mathematicians also find Escher's periodic drawings a rich source for new inquiry. Several articles in the collection *M. C. Escher: Art and Science* (which was the outgrowth of an international congress on Escher held in Rome in 1985) show how Escher's drawings pose mathematical questions for which no answers are yet known. In his article "Mathematical Challenges in Escher's Geometry," B. Grünbaum notes that the bird motif in drawing 127 is almost symmetric (and is easily made perfectly symmetric), yet the tiling has no reflection symmetry, and no other tiling by this symmetric motif will have reflection symmetry. He asks the natural question: what other such "hypersymmetric" tiles exist? Escher's drawings and even more so, his "layman's theory" provide collective evidence of many unexplored questions about plane tilings and beg mathematicians to examine their ingrained assumptions about the methods of analysis and creation of colored plane tilings.

Escher's colored drawings can be used to give visual expression to abstract concepts of group theory; the groups are the color symmetry groups of the drawings. M. Senechal's 1988 article "The Algebraic Escher" gives an excellent outline of how, by "reading" the drawings, one can literally "see" the meaning of the following concepts: generators of a group, noncommutative composition of group elements, subgroups, conjugate subgroups, cosets, permutation representations and group extensions.

Evolution Escher's print *Verbum* (page 259) appears at the end of the essay "Chemical Evolution," which was the 1961 Cordon lecture by the Nobel-prize-winning chemist Melvin Calvin. He concludes, "When life is mea-

sured in terms of the fraction of the total number of atoms involved in living processes, it is not very large. However, the effects of life are more far-reaching. The surface of the earth has been completely transformed by the evolution of living matter, and it is being changed even more by one of the more recent forms of this living matter—man." He then refers to Escher's print, noting that it "struck me as representing, in artistic form, the essence of what I had been thinking about the nature of evolution and living processes. The gradual merging of the figures, one to another, and the transformations which eventually became apparent, seem to me to represent the essence not only of life but of the whole universe."

Vision/perception In his correspondence with Escher, J. W. Wagenaar explained the impossibility of seeing both object and ground simultaneously and the inability to simultaneously interpret each with equal importance. He examined the practical implications of this phenomenon in 1952 in an article "The Importance of the Relationship 'Figure and Ground' in Fast Traffic," using Escher's prints *Sky and Water* and *Day and Night* as illustrations. "Generally an object-sensation has as a 'figure' a certain pregnance in relation to the 'ground,' whereby the image in our consciousness possesses a certain stability. . . . At that point where the 'figure' and 'ground' reach a certain geometric equilibrium, the psychological equilibrium is lost, i.e., the certainty of our orientation disappears through a cycle change of the 'Gestalten' in the subjective visual field." Drawing attention to the center interlocking portions of Escher's two prints, he notes, "Although viewed aesthetically a striking rhythmic equilibrium is reached, one sees . . . a continuous competition, as soon as we no longer give our attention to the elegant game of black and white, the physiological contrast, but to the image of bird and fish, the psychological contrast. Through this a situation of confusion and uncertainty arises." He then uses this analysis to explain why automobile drivers may be disoriented in fast traffic, especially at dusk, when "there is a contest between positive and negative 'road-image' through decrease of day contrast on the one hand . . . and heightening effect of headlights on the other. The 'figure and ground'-relation loses significance—the certainty of one's orientation diminishes."

Group analytic psychotherapy In 1968, M. L. J. (Jane) Abercrombie presented several of Escher's prints as visual analogues of the group process in a slide lecture. One analogy applies to many of Escher's prints: "The group situation is one of people sitting within four walls, but the walls only arbitrarily delimit it from other situations extending far beyond. The shadows of the world outside also belong to it. The members come together for a brief time; something new has happened, like, but also not like, many other events. The thoughts they express, each according to his own kind, soon lose their discreteness and dissolve in the common experience." Later she interprets three prints, beginning with *Sky and Water:* "These designs picture the closely interlocking relationships which are established in a group, and the way the participants draw apart, reestablish their own contours, and become individuals again as they leave it." In *Metamorphosis II,* "a simple pattern of black and

white gives rise to a continuous series of changing figures which arise from each other by association of ideas, just as in discussion in a group, ideas take form, become more complicated and then more simple again, evolving others in an everlasting series of transformations." The lithograph *Liberation* "seems to illustrate how in the very process of transforming, clarifying identifying and emancipating, the group disappears, for the aim of group analytic psychotherapy is to make the group redundant."

Art/illusion In "How to Read a Painting," published in *The Saturday Evening Post* in 1961, E. H. Gombrich introduces Escher as "a contemporary artist whose prints are meditations on image reading." Beginning with *Day and Night,* Gombrich reproduces and carefully examines three of Escher's prints: "It is indeed doubtful how much the critics would approve of his ingenious exercises in applied geometry and psychology. But to the explorer of the prose of representation, his nightmarish conundrums are invaluable." The imperceptible switch from figure to ground that is demanded as the viewer "reads" *Day and Night* is easily discovered, but "it is impossible to keep both readings stable in one's mind. The day reading drives out the night from the middle of the sheet, the night reading turns the black birds of the same area into neutral ground. Which forms we isolate for identification depends on where we arrive from."

Other prints by Escher reinforce his point: "Their complexity is far from whimsical. It reveals the hidden complexity of all picture reading. We . . . believe that we take in the picture more or less at one glance and recognize the motif. Our experience with Escher's contradictions shows that this view is mistaken. Reading a picture is a piecemeal affair that starts with random shots and gradually adjusts to the coherence of the work. There is a clear limit to the visual information we can process through any given glance."

Logic/artificial intelligence In 1980, an improbable tome was a bestseller and winner of the Pulitzer prize for nonfiction. In his book *Gödel, Escher, Bach: An Eternal Golden Braid,* Douglas Hofstadter used the work of that unlikely trio—logician, artist, and musician—to explain and illustrate several concepts in artificial intelligence. The book, in emulating Escher's work, weaves the fantasy of Alice in Wonderland dialogues through the exposition on the roles and rules of logical strings. Thirty-six of Escher's prints and drawings are reproduced to provide analogies for Hofstadter's many demonstrations of the logic and "thought" of computer "intelligence."

One central concept is what Hofstadter calls a "strange loop"; this "phenomenon occurs whenever, by moving upwards (or downwards) through the levels of some hierarchical system, we unexpectedly find ourselves right back where we started. To my mind, the most beautiful and powerful visual realizations of this notion of Strange Loops exist in the work of the Dutch graphic artist M. C. Escher." [p. 10] "Implicit in the concept of Strange Loops is the concept of infinity, since what else is a loop but a way of representing an endless process in a finite way? . . . Several such patterns can be seen in Escher's

famous print *Metamorphosis*. It is a little like the 'Endlessly Rising Canon' [of Bach]: wandering further and further from its starting point, it suddenly is back." [p. 15]

Later the author discusses figure-ground recognition in new context: "A *cursively drawable* figure is one whose ground is merely an accidental by-product of the drawing act. A *recursive* figure is one whose ground can be seen as a figure in its own right . . . the figure is 'twice cursive'" [p. 67]; he offers Escher's drawing 71 as a masterly example.

When the characters Achilles and the tortoise find themselves trapped in Escher's print *Reptiles* (page 113), they escape by simply noting that "the little lizards have learned to climb UP when they want to get out of the two-dimensional sketchbook world." [p. 125] The print *Fish and Scales* is used to illustrate the central idea of recursion: "Escher took the idea of an object's parts being copies of the object itself." [p. 146] Drawing 117 of crabs is entitled "Crab Canon" by Hofstadter, and it serves simultaneously as an illustration of that musical form and a visual play on words. He notes (through the tortoise) "I fully appreciate the beauty and ingenuity with which he [Escher] made one single theme mesh with itself going both backwards and forwards." [p. 199]

Decorative illustration/design The most pervasive use of Escher's work has been to provide attractive and provocative designs to embellish otherwise ordinary products: book jackets, occasional illustrations in texts, calendars, engagement books, printed and woven fabrics, posters, record jackets, gift wrap, tee shirts, and the like. These uses have been both authorized and unauthorized, sometimes tasteful and often appalling, frameable reproductions and trashy kitsch. Texts from every scientific discipline and in almost every country have (usually with permission) reproduced Escher's work primarily for decorative purposes, to enliven covers and brighten interiors of chapters heavy with theory and formulas. In the late sixties, the American hippies made Escher (unwillingly and without permission) their own; they freely interpreted his work in garish fluorescent-color posters. His work was wildly popular with college students, and reproductions of his prints (both pirated and authorized) were ubiquitous on campuses throughout the United States. During the last years of Escher's life, much time and effort was spent by the Escher Foundation trying to stem the tide of unauthorized use of Escher's work.

Reproductions of Escher's work inspired others to create their own. In the last ten years of his life, Escher received several samples of original tilings created by teachers and students; these were often sent as holiday greetings. Although the designs paled in comparison to his, he always sent gracious acknowledgments to the senders, happy that his work had awakened others' interest in regular division of the plane. At least one professor of design, W. S. Huff, found inspiration in Escher's continuous deformations of interlocked motifs in his metamorphosis works, and explored various possibilities for these with his students. Some of this work is reported in the article, "Parquet Deformations: Patterns of Tiles That Shift Gradually in One Dimension" by Douglas Hofstadter.

Escher's work has also provided ideas for commercial application, especially in the fields of graphic art and design. For example, Jonathan

Seals Two, Jonathan Talbot, 1973.
Original lithograph, 292 × 228 mm.
(© 1973 Jonathan Talbot)

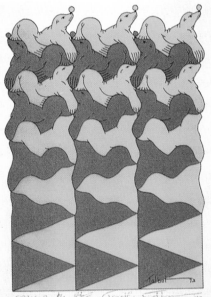

Ecuadoran rug, 1989. Hand-woven
wool and synthetic fibers, approx.
100 × 70 cm.

Talbot, an American graphic artist, used several of Escher's devices to
turn colorful pennants into performing seals in his design for a circus
poster. Illustrators and designers have found Escher's prints a source of
ideas for cartoons, magazine covers, posters, and advertisements.

Fabric designs, both printed and woven, have been based on Es-
cher's work; one design which is based on his print *Sky and Water* and
which he approved, is a batik print on cotton. The fabric is still in pro-
duction and has been used to make a variety of items, including cloth-
ing, pillows, and tote bags. Since the early 1970s, rugs handwoven by
Ecuadoran Indians have often shown interpretations of Escher's draw-
ing 96 of swans; they can be purchased in tiny villages in Ecuador as well
as through the fund-raising catalogs of philanthropic organizations. The
"traditional South American Indian design" (a catalog description) was
evidently introduced to the Indian weavers by a Peace Corps worker
who was an Escher fan.

Escher's designs have been used to cover continuously the surface
of several polyhedra, including "kaleidocycles" in which a closed ring of
linked tetrahedra can be turned endlessly through a central hole. When
the author discovered these forms in collaboration with graphic designer
Wallace Walker in 1974, their continuous surface decoration was a natu-
ral next step; at that time the author was unaware of Escher's own exper-
iments in surface decoration of polyhedra with his periodic designs.

The wide variety of uses of Escher's work by others attests to his
genius in capturing ideas in images. His struggles to realize his visions
graphically have been mirrored by others' struggles as they grope for
words which can only inadequately express their ideas. His images pro-
vide a resource for the creative illustration of their thoughts and an
inspiration for their own attempts at visual expression.

Notes on the Drawings

ESCHER NO. 1 [DOGLIKE "LION"]

Drawn at Rome, 1926–1927
India ink, pencil, watercolor
335 × 247 mm (image);
359 × 270 mm (sheet)
Escher system IIA-IIIA;
 Symmetry group *p2*

Published in *World* (plate 22) and in
 Magic Mirror.

Related work: Hand-printed designs on
 silk using two individual blocks. Gold
 and silver ink on black satin (page 11)
 and gold and silver ink on red satin,
 707 × 1013 mm (fabric).

On the drawing, Escher refers to drawings
5, 6, 7, 8, and 11, which are all the same
type as this. In this first attempt at inter-
locked repeated motifs, Escher was disap-
pointed with the crudeness of the animal
and the fact that half the motifs were un-
naturally upside down. The two prints on
fabric show experiments with coloring the
design in a systematic manner. The draw-
ing as well as the print on black are per-
fectly colored in three colors while the print
on red is not. In fact, on the latter, motifs of
the same color are adjacent; this violates
Escher's coloring rule that he formulated
later.

See notes, no. 1.

ESCHER NO. 2 [LION]

Drawn at Rome, 1926–1927
Pencil, ink, watercolor
248 × 330 mm (image);
270 × 352 mm (sheet)
Escher system VIIIC-VIIC;
 Symmetry group *pgg*

Published in *World* (plate 23).

Related work: Hand-printed designs on
 silk using four individual blocks. Red,
 gold, and dark blue on ivory silk (page
 11) and black, gold, and silver on
 turquoise satin, 746 × 982 mm (fabric).

On the drawing, Escher refers to drawing
16, which is the same system. The lion
motif in drawing 2 (which was made in
1937) is different from that in the earlier
prints on fabric: now hind paws are sole to
sole, and the mouth is closed (see Table 3,
page 330). Although the drawing is per-
fectly colored in three colors, each of the
fabric prints uses four colors, counting the
color of the fabric. The print on turquoise
uses black only for motifs at the border but,
even in the interior, is not perfectly col-
ored. The print on ivory is perfectly col-
ored.

ESCHER NO. 3 [WEIGHTLIFTER]

Drawn at Château-d'Oex, October 1936
Pencil, watercolor
331 × 243 mm (image);
357 × 272 mm (sheet)
Escher system IXD-XE*;
 Symmetry group *p4g*

Published in *World* (plate 93) and *Life and
 Work*, p. 54.

Escher notes that this weightlifter design
had as its source a majolica tiling from the
Alhambra, (see his sketch on page 17). His
preliminary drawing on tracing paper
(page 18) shows clearly how the designs are
related; there he superimposes centers of
rotation and axes of reflection of both de-
signs. Escher notes on the polished folio
drawing that the motif is symmetrical; axes
of reflection alternate on the diagonals of
the squares of his underlying grid. He uses
a systematic arrangement of three colors
that is compatible with all symmetries of
the design except its 4-fold rotations. Al-
though drawing 3 is not perfectly colored,
an earlier study shows a perfect coloring
with four colors (page 102).

See notes, no. 2.

ESCHER NO. 4 [CHINESE BOY]

Drawn at Château-d'Oex, October 1936
India ink, pencil, watercolor
331 × 243 mm (image);
358 × 270 mm (sheet)
Escher triangle system I A$_3$ type 1*;
 Symmetry group *p31m*

Published in *World* (plate 98) and in *Art
 and Science*

Related graphic work: *Metamorphsis I,*
 May 1937 (cat. 298).

Escher's sketchbooks show that he devel-
oped this design from a geometric tiling
etched in stucco in the Alhambra, (see his
sketch on page 17). The motif of three ar-
rows meeting like a tripod may have sug-
gested to him the pointed hat and stiffly
spread arms and legs of the paperdoll-like
figure.

See notes, no. 4.

ESCHER NO. 5 [STRONGMAN]

Drawn at Ukkel, Winter 1937–1938
Pencil, ink, watercolor
333 × 243 mm (image);
360 × 270 mm (sheet)
Escher system IIA-IIIA;
 Symmetry group *p2*

On the drawing, Escher refers to drawings
numbered 1, 6, 7, 8, and 11, which, like
this, have motifs related to adjoining ones
by half-turns or translations. All six draw-
ings are examples of his system IIA-IIIA,
shown at the center of the right column on
his notebook page 4 (page 62). The outline
of each motif (in this case, a single strong-
man) can be divided into six pieces; the di-
viding points are the places where three
motifs meet. Two pieces of the outline are
exactly the same and match by a translation

(in drawing 5, these pieces delineate the strongman's head, part of his left arm and, simultaneously, most of his left leg), while the four other pieces are centrosymmetric and match themselves by a half-turn about their center points. This is one example of a tile which satisfies the "Conway Criterion" (it is Heesch type TCCTCC); details on such tiles can be found in the article "Will It Tile? Try the Conway Criterion!" by the author.

ESCHER NO. 6 [CAMEL]
Drawn at Ukkel, Winter 1937–1938
Pencil, ink, watercolor
333 × 243 mm (image);
360 × 270 mm (sheet)
Escher system IIA-IIIA;
 Symmetry group $p2$

On the drawing, Escher refers to drawings numbered 1, 5, 7, 8, and 11, which are all the same type. (Our comments on drawing 5 about the outline of the motif and its relation to adjacent motifs also apply to this drawing.) Escher's note that this example is closer to his system IIIA is likely a mistake in recording; his underlying grid of parallelograms with marked half-turn centers is his system IIA.

ESCHER NO. 7 [SQUIRREL]
Drawn at Château-d'Oex, October 1936
Pencil, watercolor
332 × 243 mm (image);
358 × 270 mm (sheet)
Escher system IIA-IIIA;
 Symmetry group $p2$
Published in *World* (plate 92).

On the drawing, Escher refers to drawings numbered 1, 5, 6, 8, and 11, which are all the same type. (Our comments on drawing 5 about the outline of the motif and its relation to adjacent motifs also apply to this drawing.) He also notes this design is close to his system IIA; the underlying parallelogram grid with circled half-turn centers corresponds to that for his system IIA.

ESCHER NO. 8 [HORSE]
Drawn at Ukkel, Winter 1937–1938
Pencil, watercolor
343 × 243 mm (image);
360 × 270 mm (sheet)
Escher system IIA-IIIA;
 Symmetry group $p2$

On the drawing, Escher refers to drawings numbered 1, 5, 6, 7, and 11, which are all the same type. (Our comments on drawing 5 about the outline of the motif and its relation to adjacent motifs also apply to this drawing.) He notes (with an exclamation point) that this design is close to his system IIIA; that underlying grid of parallelograms with circled half-turn centers is lightly visible. Escher never used these six related drawings in any finished work, and his remarks in his notebook (page 77) about the choice of motif for regular divisions with rotation symmetry suggests why: an upside-down horse is absurd from any viewpoint.

ESCHER NO. 9 [BIRD]
Drawn at Ukkel, Winter 1937–1938
Pencil, ink, watercolor
343 × 243 mm (image);
360 × 270 mm (sheet)

Escher system IIIA; Symmetry group $p2$

This is Escher's first periodic drawing using only two colors; here every bird is related to an adjacent one of a different color by a half-turn. The outline of each bird is made up of four graceful S-shaped curves, their centers marked by small circles. The design was never executed (birds do not fly upside down), but his later motif of a sea horse (drawing 88), also outlined by four centrosymmetric curves, was used in a design for table linen.

ESCHER NO. 10 [FISH]
Drawn at Ukkel, Winter 1937–1938
India ink, pencil, watercolor
332 × 243 mm (image);
359 × 270 mm (sheet)
Escher system VIIC-VIB;
 Symmetry group pgg

The cameo holding two nestled fish which half-turn into each other can pack the wavy horizontal rows facing either left or right. Escher's early sketches show the cameos all facing in one direction, a design with just half-turn symmetry (see lower diagram). In the final folio drawing, he chose to alternate the direction in which the cameos face from row to row and thus added glide-reflection symmetry to the design. Depending on the packing of the cameos, the outline of the motif can be classified in two different ways (see Table 1 in the Concordance, under pgg and $p2$).

ESCHER NO. 11 [SEA HORSE]
Drawn at Ukkel, Winter 1937–1938
Pencil, ink, watercolor
333 × 243 mm (image);
360 × 270 mm (sheet)
Escher system IIA-IIIA;
 Symmetry group $p2$

On the drawing, Escher refers to drawings numbered 1, 5, 6, 7, and 8, which are all the same type. (Our comments on drawing 5 about the outline of the motif and its relation to adjacent motifs also apply to this drawing.) Here, he succeeds in finding a motif for which upside down is a natural position in which to be viewed. About fifteen years later, he revised the motif (drawing 88) so that it could be executed in a two-color design for table linen.

ESCHER NO. 12 [BUTTERFLY]
Drawn at Ukkel, Winter 1937–1938.
Pencil, ink, watercolor
333 × 244 mm (image);
360 × 270 mm (sheet)
Escher system IXD*; Symmetry group $p4g$

See notes, no. 10.

See notes, no. 12.

II, *Regelmatige vlakverdeling;* see notes, no. 13.

Related work: Design for bank-note background, June 1951. Rendered in India ink, with motif called a bee by Escher (unexecuted), 103 × 123 mm (image), 112 × 139 mm (sheet).

A copybook sketch reveals how Escher "saw" butterflies in a Moorish pattern based on circular arcs. He clipped out a small lune-shaped piece from the convex edges and added it to the concave edges

See notes, no. 12.

(see diagram). He also found (probably after seeing Haag's paper) that a grid of pentagons could serve as a geometric source for this same design (page 106). Although in silhouette the butterfly pattern retains all the symmetries of its Islamic source, internal detail on the motifs destroys the pattern's global symmetry. While each butterfly has mirror symmetry, overlapping wings destroy the reflection symmetry of the pattern and the wing markings of dots destroy all rotation symmetry. The wing dots are placed systematically, however, following the diagonals of the underlying square grid. In the design for bank-note background (above) Escher transforms the butterfly into a bee by heavily veining the wings.

ESCHER NO. 13 [DRAGONFLY]
Drawn at Ukkel, Winter 1937–1938
India ink, pencil, watercolor
332 × 243 mm (image);
359 × 269 mm (sheet)

Escher system IX^{D^*}; Symmetry group *p4g*

Related graphic work: Plate II, *Regelmatige vlakverdeling,* June 1957. Woodcut in red, 240 × 180 mm (cat. 417).

Other related work: Design for tablecloth for van Dissel, c. 1953 (unexecuted).
 Design for bank-note background, June 1951 (unexecuted).

Escher's sketchbook shows this dragonfly design had as its source the Moorish tessel-

See notes, no. 13.

lation which he exhibits as vignette C in the same plate from *Regelmatige vlakverdeling* that shows a panel with the dragonflies. The penciled square at the center of the drawing contains exactly one blue and one white dragonfly (in pieces); Escher may have sketched it to identify a single square that could fill out this design using only translations and half-turns. In his design for bank-note background (not shown), the outline of the motif (see sketch) differs slightly from that in the numbered drawing and shows the veining of the insect's wings, which is reminiscent of his 1936 print *Dragonfly* (cat. 281).

ESCHER NO. 14 [LIZARD]

Drawn at Ukkel, November 1937
India ink, pencil, watercolor
333 × 243 mm (image);
359 × 270 mm (sheet)
Escher system IXD-XE;
 Symmetry group *p4*

This lizard as well as the two-color version in drawing 15 were Escher's first reptile motifs in a plane filling. On this drawing, Escher refers to drawings 3 and 20, which are the same type, and notes this design is closer to his system IXD, for which the corresponding square grid is shown. Escher's coloring uses the minimal three colors, following his notebook diagram for this system (page 68); since this coloring is not compatible with the 4-fold rotations of the tiling, the design is not perfectly colored.

ESCHER NO. 15 [LIZARD]

Drawn at Ukkel, original November 1937, improved April 1963
Ink, watercolor
330 × 245 mm (image);
360 × 270 mm (sheet)
Escher system IXD; Symmetry group *p4*
Published in *Periodic Drawings* (plate 24) and *Art and Science*.
Related graphic work: *Development I*, November 1937 (cat. 300).
 Metamorphosis II and *III*, 1939–1940 and 1967–1968 (cat. 320 and 446).

A small change in the outline of the motif in drawing 14 transforms that lizard to this one. Escher shrinks the boundary where two lizard knees meet and creates a design which can be colored with only two colors. *Development I*, his first graphic work to exhibit his mastery of the underlying geometry of regular division of the plane, was

sent with a warm note of appreciation to Pólya. In *Metamorphosis II*, these lizards are the first creatures to appear in the picture story; they evolve out of checkerboard squares in a manner similar to that seen in *Development I*. The original drawing 15 was enhanced and recolored in 1963 for publication in *Periodic Drawings*.

ESCHER NO. 16 [GREYHOUND]

Drawn at Ukkel, beginning 1938
Pencil, ink, watercolor
333 × 243 mm (image);
360 × 270 mm (sheet)
Escher system VIIIC-VIIC;
 Symmetry group *pgg*

On this drawing, Escher refers to drawing 2, which is an example of the same transitional system. The outline of this greyhound is the same isohedral type as the lion motif which occurs in Escher's fabric print of c. 1926 (page 11), but is not the same type as the lion in drawing 2 (see Table 3 in the Concordance, page 330). However, this drawing and drawing 2 are colored in the same manner and have the same color symmetry group.

ESCHER NO. 17 [EAGLE]

Drawn at Ukkel, beginning 1938
Pencil, watercolor
333 × 242 mm (image);
360 × 270 mm (sheet)
Escher system VC-IVB;
 Symmetry group *pg*

This design was the first that Escher made having only glide-reflection and translation symmetry. It took repeated efforts to bring it to life, beginning with Pólya's illustration labeled D$_1$gg (see page 23). Details can be found in an article by the author [1987]. The idea for the motif may have come from an earlier work: in 1922, Escher made a signboard and a woodcut vignette of an eagle for a welfare organization (cat. 92).

ESCHER NO. 18 [TWO BIRDS]

Drawn at Ukkel, February 1938
India ink, pencil, watercolor
228 × 243 mm (image);
358 × 268 mm (sheet)
Escher system IA-IA; Symmetry group *p1*
Published in *Periodic Drawings* (plate 28), *World* (plate 101), *Magic Mirror* and *Escher on Escher*. Published on the cover

See notes, no. 18.

of *Scientific American*, April 1961, with several colors added to the dark birds by the publisher.
Related graphic work: *Day and Night*, February 1938 (cat. 303).

On this drawing, Escher refers to drawings 22, 29, and 30, all patterns of two interlocked motifs created by splitting an irregular hexagon having three pairs of parallel sides with a curve that joins a pair of opposite vertices (type IA-IA on page 22 of his notebook). The dark birds and light birds fly in opposite directions, and appear to be mirror images of each other, related by a glide-reflection. They are not, however! Even the editor of *Scientific American* was fooled by its apparent symmetry. In a letter to the editor, April 7, 1961, Escher wrote, "In the cover description on page 4 it is said that the spaces between the coloured birds are filled with white birds of the *identical* shape. That isn't true, for two reasons. First: as they fly in the opposite direction, a superficial spectator could conclude that they are mirror-reflections of the coloured birds. In that case they would be 'similar' but not 'identical.' Secondly they are not even similar; they are 'different'!: e.g. the coloured bird-tails go 'up,' the white ones 'down.'"

Escher's woodcut *Day and Night* in which a fragment of this drawing appears is without doubt the most popular print he ever made. When making 40 new impressions in 1969 he wrote to Gerd Arnzt that

he had already produced almost 600 prints of it in the thirty years since he carved the blocks.

ESCHER NO. 19 [BIRD]

Drawn at Ukkel, February 1938
Pencil, watercolor
230 × 245 mm (image);
360 × 270 mm (sheet)

Escher system IVB; Symmetry group *pg*

This design has true glide-reflection symmetry which is falsely apparent in drawing 18. Escher's superimposed rhombus grid corresponds to his system IVB; the almost triangular shape of the birds and their arrangement corresponds to a familiar tiling of the plane by isosceles triangles.

ESCHER NO. 20 [FISH]

Drawn at Ukkel, March 1938
India ink, pencil, watercolor, gold paint
229 × 243 mm (image);
358 × 268 mm (sheet)

Escher system IXD-XE;
Symmetry group *p4*

Published in *Periodic Dawings* (plate 37), *Art and Science,* and *Escher on Escher.*

Related work: Woodcut in four colors on silk, ca. 1942. Surface design for carved beechwood sphere with 12 identical fish, 1940.

On this drawing, Escher refers to earlier drawings 14 and 3, also of his system IXD-XE. He notes that this design, like those, may be executed in a minimum of three colors, but chooses to use four in an arrangement compatible with all of the symmetries of the design. His print on fabric emphasizes its 4-fold color symmetry and shows each quadrant of the square a different color. G. Shephard [1986, 1988] exhibits several perfect colorings of the design, including Escher's. Escher derived this fish design from a geometric pattern; an early rough sketch in a copybook (page 45) gives the hint of a single fish with the placement of one eye and modification for the mouth. In October, 1938, he sketched the fish pattern in drawing 20 with an accompanying couplet for a friend:

Hengelaars-droom
Zoo vol van visschen is de vliet,

Dat men het water niet meer ziet.
(Angler's dream
The brook is so full of fish
One can no longer see the water.)

ESCHER NO. 21 [IMP]

Drawn at Ukkel, May 1938
Pencil, ink, watercolor
332 × 242 mm (image);
358 × 270 mm (sheet)

Escher triangle system I A$_3$ type I; Symmetry group *p3*

Published in *World* (plate 103), *Magic Mirror, Art and Science,* and *Escher on Escher.*

Related graphic work: *Cycle,* May 1938. Lithograph, 475 × 279 mm (cat. 305).

It is quite likely that Escher derived this design of a running figure from the geometric tiling labeled C$_3$ found in Pólya's 1924 article (see page 25). Escher's lithograph *Cycle* is his first print to explicitly suggest a cycle of repetition. In the print the pattern of rhombus shapes is interpreted both as a flat terrace paving and as a three-dimensional stacking of boxes. Escher's transition from this geometric pattern to the running figure is similar to that in *Metamorphosis I,* made six months earlier.

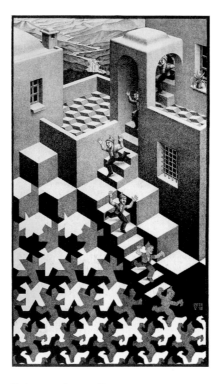

Cycle; see notes, no. 21.

ESCHER NO. 22 [BIRD/FISH]

Drawn at Ukkel, June 1938
India ink, colored pencil, watercolor
228 × 243 mm (image);
358 × 270 mm (sheet)

Escher system IA-IA; Symmetry group *p1*

Published in *World* (plate 105), *Art and Science,* and *Escher on Escher.*

Related graphic work: *Sky and Water I,* June 1938 (cat. 306).

This drawing was made after drawing 23, whose impression can be seen in the paper (both are dated June 1938). Escher relates this drawing to numbers 18, 29, and 30; all are derived by splitting a single motif (see comments on drawing 18). This is his first pair of interlocked motifs to suggest contrasting (yet interdependent) worlds. The graceful forms and the perfect balance of *Sky and Water I* may account for its wide appeal and interpretation. The idea for the print may have come from an earlier work: in 1926, Escher depicted sky and water together with their inhabitants in a "split screen" woodcut, *The Fifth Day of Creation* (cat. 108).

ESCHER NO. 23 [BIRD]

Drawn at Ukkel, June 1938
Pencil, ink, watercolor
228 × 244 mm (image);
360 × 270 mm (sheet)

Escher system IXD;
Symmetry group *p4*

Related work: Intarsia panel for clock for the conference room of the mayor and aldermen in the *raadzaal* (council hall), Leiden Stadhuis (Leiden Town Hall), 1940.

On this drawing, Escher refers to drawing 15, where lizards squirming in 4-fold rotation in a tightly packed mass seems natural. In contrast, these birds rotate unnaturally about pivot points on head and tail. In the clock panel (page 268), Escher encircles the clock face with just a single layer of these tightly packed motifs. From this mass the flock explodes with action—birds homing in and flying out. The single square outlined in pencil at the center of the drawing contains one white and one orange bird (in pieces) and can generate the design with only translations and half-turns. It may have been used to lay out the inner ring of birds on the clock face.

ESCHER NO. 24 [FISH/BIRD]

Drawn at Ukkel, November 1938
Pencil, ink, watercolor
228 × 244 mm (image);
360 × 270 mm (sheet)

Escher system VC variant 2;
Symmetry group *pg*

Related graphic work: *Sky and Water II*,
December 1938. Woodcut, 623 ×
407 mm (cat. 308).

This is Escher's first design with two motifs in two colors in which each motif occurs in two different aspects. Although all birds are blue and all fish white, adjacent birds face in opposite directions, and adjacent fish likewise. The woodcut *Sky and Water II* amplifies the lively action of the motifs which dive and fly toward the four corners of a rectangle. Its composition exhibits a perfect, yet dynamic, balance in comparison with the serene static balance of *Sky and Water I*.

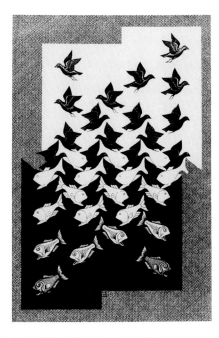

Sky and Water II, see notes, no. 24.

ESCHER NO. 25 [LIZARD]

Drawn at Ukkel, January 1939
India ink, pencil, watercolor
245 × 245 mm (image);
359 × 268 mm (sheet)

Escher triangle system I A$_3$ type I;
Symmetry group *p3*

Published in 1941 in an article by Escher in *De delver*, *Periodic Drawings* (plate 38), *World* (colorplate II and plate 119),

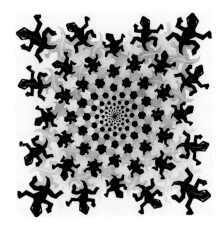

Development II, see notes, no. 25.

Magic Mirror, Art and Science, and *Escher on Escher*.

Related graphic work: *Development II*, February 1939 (cat. 310 and 310A). Woodcut in brown, gray-green, and black, printed from three blocks, 455 × 455 mm.
 Metamorphosis II and III, 1939–1940 and 1967–1968 (cat. 320 and 446).
 Reptiles, March 1943 (cat. 327).

Escher chose this drawing to be the first to appear in an article on his work on regular division of the plane and featured it in its "natural state" in the lithograph *Reptiles*. Apparently he added the regular hexagons in pencil on drawing 25 after the drawing was made, likely as he planned *Development II* or the panel of *Metamorphosis II* in which these lizards metamorphose into packed regular hexagons (page 259). In *Metamorphosis II*, these lizards provide a transition from squares to hexagons; they first link with the lizards in drawing 15 and then evolve into a honeycomb. An irregular hexagon is formed by joining the points on the boundary of a single lizard where three lizards meet; it is the type described in Escher's theorem in his abstract motif notebook (page 90).
 Development II is Escher's first attempt at a "smaller and smaller" regular division of the plane. It can be viewed as a spiral print, but more easily seen as concentric rings of diminishing radius, each ring packed with 24 adjoined hexagons colored cyclically with three colors. The hexagons metamorphose into lizards as the rings increase outward; the square frame of the print captures the largest lizards at its corners. An earlier version of this woodcut (cat. 310A) shows 5-fold symmetry; Escher only carved one block and never printed it.

ESCHER NO. 26 [BIRD/BUG]

Drawn at Ukkel, November 1938
Pencil, watercolor
245 × 245 mm (image);
360 × 270 mm (sheet)

Escher system VC variant 2;
Symmetry group *pg*

On this drawing, Escher refers to drawing 24, which is the same system and was made in the same month. In the other drawing the shape and position of the motifs strongly suggest a design for a graphic work, but this regular division with bird and bug does not readily lend itself to graphic interpretation.

ESCHER NO. 27 [INSECT/FISH]

Drawn at Ukkel, March 1939
Pencil, watercolor
245 × 245 mm (image);
360 × 270 mm (sheet)

Escher system ID-IA; Symmetry group *p1*

Related graphic work: *Metamorphosis II and III*, 1939–1940 and 1967–1968 (cat. 320 and 446).

Here insect and fish, traveling in opposite directions, face each other. Escher frequently used two interlocked contrasting figures for figure-ground reversal and metamorphosis in his serial picture stories. In *Metamorphosis II* the figures of drawing 27 provide an intermediate stage in the transition from insect to bird (see drawing 29 and pages 259–260). The shapes of the motifs and the way in which they pack are closely related to those in drawings 120 and 121 and also in the lower portion of Escher's 1949 design for the tapestry made by the weavers de Cneudt.

ESCHER NO. 28 [THREE BIRDS]

Drawn at Ukkel, November 1938
Pencil, watercolor
245 × 245 mm (image);
360 × 270 mm (sheet)

Escher system I-I;
Symmetry group *p1*

Related graphic work: *Metamorphosis II and III*, 1939–1940 and 1967–1968 (cat. 320 and 446).

This is Escher's first regular division of the plane with three different motifs. It was created to solve a specific problem in *Metamorphosis II*: how to make a transition from flying birds (in a parallelogram grid) to stacked cubes (in a hexagonal grid). Escher

notes he began with a tiling by congruent rhombuses in which three fill out a regular hexagon; he then modified each rhombus to a bird shape. The three different birds occupy the same area as one hexagon and can fill the plane by translations. Birds of a single type all face the same way and are regularly spaced, so the desired left-to-right transition in the print is smoothly accomplished. In both *Metamorphosis II* and *III*, Escher used four individual blocks to hand-print the little birds that fly between the black birds of drawing 29 as they home into position in the flock of drawing 28 (see page 261).

ESCHER NO. 29 [BIRD/FISH]

Drawn at Ukkel, December 1939
Pencil, watercolor
245 × 245 mm (image);
360 × 270 mm (sheet)

Escher system I^A-I^A;
 Symmetry group *p1*

Related graphic work: *Metamorphosis II and III*, 1939–1940 and 1967–1968 (cat. 320 and 446).

On this drawing, Escher refers to drawings 18, 22, and 30; all are two-motif designs of type I^A-I^A. In *Metamorphosis II*, it is through the shifting and gradual separation of the fish in drawing 27 that Escher provides the transition from that plane filling to this one. The diagonal array of birds from this drawing then fly in to become part of the flock in drawing 28. In *Metamorphosis III*, these birds emerge from a triangular grid, and the fish shapes between them are barely discernible (see page 261). The shapes of motifs in drawing 29 are similar to those in drawing 120 and those at the top of the tapestry designed in 1949 by Escher for the weavers Ed. de Cneudt (wool, 3000 × 1230 mm; at the Arnhem Gemeentemuseum).

ESCHER NO. 30 [FISH/BOAT]

Drawn at Ukkel, March 1940
Colored pencil
245 × 245 mm (image);
360 × 270 mm (sheet)

Escher system I^A-I^A; Symmetry group *p1*

On this drawing, Escher refers to drawings 18, 22, 29, and 72; this last reference was added many years later (when Escher did not often note others of the same system on his drawings), probably because the subject matter was the same. Although drawing 30

was not executed in any finished work, drawing 72 (as well as drawings 112 and 113) with boat/fish motifs were.

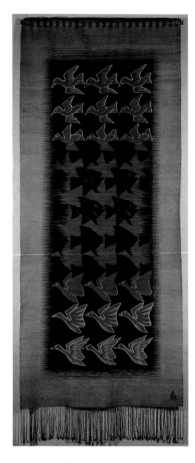

See notes, no. 29.

ESCHER NO. 31 [FISH]

Drawn at Ukkel, April 1940
Pencil, watercolor
338 × 245 mm (image);
270 × 360 mm (sheet)

Escher system V^C; Symmetry group *pg*

On this drawing, Escher refers to drawing 32, which shows congruent fish swimming back and forth in horizontal rows. In silhouette, the motifs in drawing 31 are congruent and behave the same way. But Escher adds internal detail (eye, mouth, and gill) in one way on the left side of the drawing and in another on the right; whichever way the drawing is viewed, the fish on the left are right side up while the fish on the right are upside down. With internal detail taken into account, the fish on the left and those on the right become distinct motifs.

ESCHER NO. 32 [FISH]

Drawn at Ukkel, April 1940
Ink, watercolor
162 × 335 mm (image);
270 × 360 mm (sheet)

Escher system V^C;
 Symmetry group *pg*

Published in *Graphic Work*.

Related graphic work: *Fish*, 1963.
 Woodcut, 109 × 109 mm (cat. 442).

Other related work: Two decorative intarsia wood panels (mirror images of each other) for the conference room of the mayor and aldermen in the *raadzaal* (council hall), Leiden Stadhuis (Leiden Town Hall), 1940.

Escher seized the opportunity to use regular division of the plane in his first commission for a public building, a design for decorative panels. The fish in the panels are more arched than those in drawing 32 and appear to leap playfully. Escher's preliminary sketch for Plate III to exhibit glide-reflection in *Regelmatige vlakverdeling* shows a design based on drawing 32. However, his final choice was to use drawings 57 and 97 in Plates III and IV. His woodcut vignette *Fish* made in 1963, also based on this drawing (the fish have fewer fins), is printed from the original block in *De tekens van de dierenriem (The Signs of the Zodiac)*, by Pam G. Reuter, and represents Pisces.

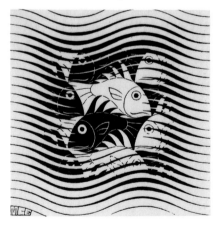

Fish; see notes, no. 32.

ESCHER NO. 33 [LIZARD]

Drawn at Ukkel, December 1940
Pencil, watercolor
246 × 246 mm (image);
360 × 267 mm (sheet)

Escher system VII^C; Symmetry group *pgg*

In addition to the rectangular grid of his system VII^C, one can see in this drawing

the penciled tiling of triangles from drawing 2 in Escher's abstract motif notebook. The geometric relationships in the triangle tiling are the same as those for the tiling by lizards. Each beaked lizard fits a triangle; lizard and triangle have exactly the same vertices (points where four motifs touch each other) and half-turn centers on their boundaries.

ESCHER NO. 34A [BIRD/FISH]
Drawn at Baarn, March 1941
Pencil, ink, watercolor
258 × 240 mm (image);
360 × 270 mm (sheet)
Escher system IVB-VC variant 3;
 Symmetry group *pg*
Related graphic work: *Two Intersecting Planes,* January 1952 (cat. 377).

Other related work: Design for intarsia panel, Leiden Stadhuis (Leiden Town Hall), c. 1940 (unexecuted).

Escher made three different drawings of this design; this one appears to be the first. It shows some arrows which indicate alteration of portions of the tile boundary—compare the silhouette of these motifs with those in drawings 34B or 34. Escher also notes a different system type on drawing 34B.

Two Intersecting Planes, January 1952. Woodcut in green, brown and black, printed from three blocks, 224 × 310 mm. See notes, nos. 34A, 34B, and 34.

ESCHER NO. 34B [BIRD/FISH]
Drawn at Baarn, March 1941
Ink, watercolor
215 × 220 mm (image);
280 × 237 mm (sheet)
Escher system IVB-VB;
 Symmetry group *pg*
Published in *Graphic Work* and *Periodic Drawings* (plate 32).

Related graphic work: *Two Intersecting Planes,* January 1952 (cat. 377).

Other related work: Design for intarsia panel, Leiden Stadhuis (Leiden Town Hall), c. 1940 (unexecuted).

This is likely the second version of this design made by Escher; on it he notes "improved drawing no. 34." It was probably redone for publication in *Grafiek en tekeningen.* In *Two Intersecting Planes,* Escher presents the birds and fish of one color as a layer cut out of a sheet of wood; the two differently colored layers pass through each other at an oblique angle. Either plane of motifs can serve as figure, while the other serves as ground.

ESCHER NO. 34 [BIRD/FISH]
Drawn at Baarn, March 1941
India ink, watercolor, pencil, gold paint
248 × 252 mm (image);
360 × 267 mm (sheet)
Escher system not given;
 Symmetry group *pg*
Related graphic work: *Two Intersecting Planes,* January 1952 (cat. 377).

Other related work: Design for intarsia panel, Leiden Stadhuis (Leiden Town Hall), c. 1940 (unexecuted).

This drawing is on the verso of drawing 35 and is likely Escher's third version of drawing 34A; he notes it is "improved and enlarged. Do *not* reproduce!" This last comment might be one of frustration if he redrew the design for *Periodic Drawings* only to find that it would not reproduce well in black and white. That book reproduces drawing 34B, the same version as the one published in *Graphic Work.*

ESCHER NO. 35 [LIZARD]
Drawn at Baarn, July 1941; improved April 1963
India ink, colored pencil, opaque white
248 × 241 mm (image);
359 × 268 mm (sheet)
Escher system XE; Symmetry group *p4*
Published in *Periodic Drawings* (plate 25).

Related graphic work: [*Plane-filling motif with reptiles*], 1941 (cat. 324).
 Division, July 1956 (cat. 411).
 Smaller and Smaller, October 1956 (cat. 413)
 Plate VI, *Regelmatige vlakverdeling,* June 1957. Woodcut in red, 240 × 180 mm (cat. 421).

Escher notes "Do reproduce this drawing!"; he is likely referring to his instruction written on drawing 34, which is on the verso of this drawing. This design is colored with the minimum two colors; in 1963, Escher created a four-color version of

a similar design in drawing 118. His 1941 vignette (page 100) is his only print to show the motifs exactly as in drawing 35. In 1956, he created *Division* and folio drawing 101 which begin with this plane filling, but from these lizards, new ones emerge through splitting and fusing. It is not a totally predictable process, but one which presents an orderly division of the plane. In the two *Smaller and Smaller* prints, Escher distorts the lizards to conform to an algorithmic filling of a square or rectangle with triangles. His diagram to show the underlying geometry of *Smaller and Smaller* in Plate VI (right) displays the algorithm.

VI, *Regelmatige vlakverdeling;* see notes, no. 35.

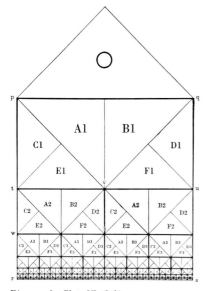

Diagram for Plate VI, (left).

ESCHER NO. 36 [SNAKE]

Drawn at Baarn, July 1941
Pencil, watercolor
251 × 251 mm (image);
360 × 270 mm (sheet)

Escher system VIB; Symmetry group *pgg*

In 1941, as Escher was finalizing his "layman's theory," he made a concentrated effort to find examples of motifs for systems he had not yet illustrated. This drawing was his first example of system VIB; neither this nor any other single-motif examples of this system were ever used in a finished work. The sinuous snake in this drawing shows how far from the edges of the underlying rhombus grid the boundary of a motif may stretch. In 1931, Escher depicted an open-mouthed snake entwined around a tree in an illustration for *De vreeselijke avonturen van Scholastica* (cat. 197).

ESCHER NO. 37 [BEETLE]

Drawn at Baarn, July 1941
Colored ink, pencil, watercolor
248 × 239 mm (image);
359 × 267 mm (sheet)

Escher system IIID*; Symmetry group *pmg*

In his careful observation of nature, Escher sketched small creatures, especially insects, including beetles. This is his first beetle motif in a periodic drawing. Here dark beetles and light beetles crawl up and down in opposite directions; adjacent dark and light beetles can exchange places by pivoting 180° about a point where their legs touch (marked by small circles).

ESCHER NO. 38 [DRAGONFLY]

Drawn at Baarn, July 1941
Pencil, ink, watercolor
244 × 240 mm (image);
360 × 270 mm (sheet)

Escher system IA; Symmetry group *p1*

This is geometrically the simplest of all periodic tilings and the very first system in Escher's overview chart for his theory notebook. Motifs are made by altering two adjacent edges of a parallelogram and then translating copies of the new edges to the opposite sides. Perhaps because it was so simple, Escher made no folio example of this system IA with just one motif until his inventory in 1941 showed it was missing. Here the dragonfly is purposely asymmetric, so the drawing has only translation symmetry.

ESCHER NO. 39 [BUG]

Drawn at Baarn, July 1941; improved
 April 1963
India ink, colored ink, colored pencil,
 watercolor
247 × 240 mm (image);
359 × 266 mm (sheet)

Escher system VIIIC; Symmetry group *pgg*
Published in *Periodic Drawings* (plate 22).

Escher notes on this drawing that it is a variant of drawing 86. In fact, if one stretches the rectangle into which the bug in this drawing is squeezed so that it becomes a

square, this design is transformed into the one in drawing 86. Drawing 39 was made in 1941 to provide a folio example of system VIIIC, which Escher had not yet illustrated. It was improved for publication in *Periodic Drawings*.

ESCHER NO. 40 [CRAB]

Drawn at [Baarn], July 1941
Pencil, ink, watercolor
244 × 242 mm (image);
270 × 360 mm (sheet)

Escher system IIC*; Symmetry group *pmg*

At first glance, this drawing bears a strong resemblance to drawing 37 of beetles, and indeed, it has the same plane symmetry group. A comparison of the two illustrates how classification by plane symmetry group alone misses important information about the design's construction and coloring. Here the crabs, like the beetles, march up and down in opposite directions. But the crabs actually interlock in vertical columns, whereas the beetles in vertical columns merely touch each other at a single point. The crabs in vertical columns are colored alternately light and dark, whereas all the beetles in a single vertical column are the same color. On either side, each crab is touched (at half-turn centers) by two crabs of the same color and two of contrasting color, whereas each beetle is touched at half-turn centers on its boundary by four beetles of contrasting color. Escher redrew

this design (as drawing 117) for publication in *Periodic Drawings*.

ESCHER NO. 41 [TWO FISH]

Drawn at Baarn, July 1941; improved
 April 1963
Pencil, ink, watercolor
244 × 240 mm (image);
360 × 270 mm (sheet)

Escher system VI^B variant 2;
 Symmetry group *pgg*

Published in *Periodic Drawings* (plate 21)
 and *Art and Science.*

Related graphic work: *Fish,* October 1941.
 Woodcut in three tones of gray-green,
 printed from three blocks, 507 ×
 384 mm (cat. 323).

Graceful S curves outline the two inter-
locked fish motifs in this design and the
half-turn symmetry of their wavy contours
is repeated several times on both a local
and a global scale in Escher's woodcut *Fish*.
In the drawing, each species of fish occurs
in four different aspects, and Escher uses
this to create a dynamic ballet of motion in
the print. One species of fish traces out
three separate sinuous closed curves while
the second species of fish forms two
schools, one of dark fish traveling clock-
wise and the other of light fish traveling
counterclockwise, each tracing circular
paths that weave through the paths of the
other fish.

ESCHER NO. 42 [SHELLS AND STARFISH]

Drawn at Baarn, August 1941
India ink, colored ink, colored pencil,
 watercolor
244 × 239 mm (image);
359 × 268 mm (sheet)

Escher system $\begin{matrix} \text{VI} \\ \text{VII} - \text{VIII} \end{matrix}$
Symmetry group *p4*

Published in *Periodic Drawings* (plate 13)
 and *Art and Science.*

Related work: Similar starfish and shells
 (but not interlocking) decorate a tin
 icosahedron box designed for the
 Verblifa Co., 1963, diameter 170 mm.

Escher developed this design from a geo-
metric pattern of stars and diamond shapes
based on a square grid. Our diagram (right)
based on his copybook sketches shows
how he "saw" the shell and starfish of
drawing 42 as well as the leaves and flow-
ers of drawings 131 to 134 in the geometric
pattern. The pattern can be generated from

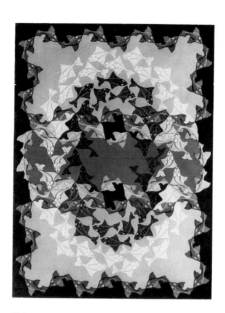

Fish; see notes, no. 41.

a single square containing a few intersect-
ing lines (see diagram). By outlining each
individual star, one obtains the grid of con-
gruent pentagons that appear in the later
drawings. Escher chose a natural mul-
ticoloring for the shells and starfish but
notes the design needs a minimum of two
colors—if all starfish are light, then all
other shells can be one contrasting color.
The interior detail of the brown snail shells
must be ignored if the points where four
clam shells meet is to be a center of 4-fold
rotation for the design. Several of Escher's
earlier prints display shells; he also chose a
clam shell and a snail for his later detailed
mezzotint made in 1949 (cat. 362). In 1952,
he entwined starfish figures in a puzzle and
also engraved them on the faces of a clear
Plexiglas stellated dodecahedron. A contin-
uous surface design for a regular dodecahe-
dron, based on drawing 42, was made by
the author [1977].

Verblifa tin. See notes, no. 42.

ESCHER NO. 43 [FLOWERS/LEAVES]

Drawn at Baarn, August 1941
Pencil, ink, watercolor
245 × 243 mm (image);
360 × 270 mm (sheet)

Escher triangle system II A₃ type 2;
 Symmetry group *p3*

Published in *Periodic Drawings* (plate 7).

Escher developed this design from a pat-
tern of stars and diamonds (see page 107);
drawing 1 in his abstract motif notebook
shows a similar pattern. The stars in the
design on which this drawing is based just
touch at their tips and thus enclose hexa-
gons, while the stars in the abstract motif
drawing overlap their edges and so enclose
triangles. Escher notes on drawing 43 that
it is a three-color system, but rendered
there in two colors. His development
sketch shows three interlocking "sham-
rocks" distinguished by three colors while
stars are left uncolored.

ESCHER NO. 44 [BIRD]

Drawn at Baarn, December 1941
Ink, watercolor
248 × 244 mm (image);
360 × 270 mm (sheet)

Escher triangle system I B₂ type 1;
 Symmetry group *p6*

Published in *Periodic Drawings* (plate 27).

Related work: Design for bank-note
 watermark, *f* 100, *Christiaan Huygens,*
 1950 (unexecuted).

This is Escher's first periodic drawing with
6-fold symmetry; he was particularly
pleased to discover this triangle system in
which the motifs could be colored with just
two colors. His abstract motif in triangle
system I B₂ type I in his theory notebook
(page 81, lower right) is suggestive of a bird
and may have led to the motif in drawing
44. The contour of Escher's bird motif can
also be interpreted as a flying fish; he
makes this interpretation in drawing 99,
and notes drawing 44 as a cross-reference.

See notes, no. 42.

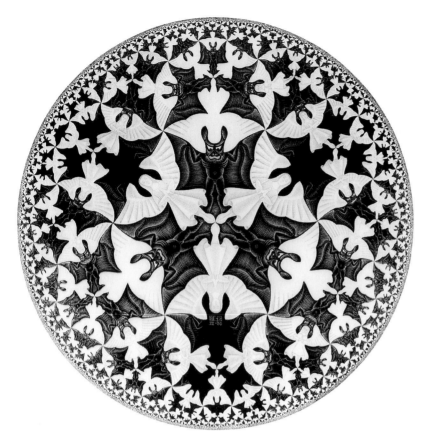

Circle Limit IV; see notes, no. 45.

Escher notes the motifs here are "apparently symmetrical." The fused pair of fish with backbones aligned can be made perfectly symmetrical and still interlock in Escher's manner, so that the mirror symmetry of the motifs is not a symmetry of the tiling. But the "symmetrized" fish are not hypersymmetric (see page 341). Each motif in Escher's tiling occurs in four different aspects but each species of fish occurs in just one color.

ESCHER NO. 47 [TWO BIRDS]
Drawn at Baarn, July 1942
Ink, watercolor
175 × 223 mm (image);
360 × 270 mm (sheet)
Escher system I^A variant 2;
Symmetry group *p1*
Related graphic work: *Verbum*, July 1942 (cat. 326).
[*Plane-filling motif with birds*], April 1949. Wood engraving, 115 × 208 mm (cat. 361 and 361A).
Other related work: Book cover design for *Regelmatige vlakverdeling*, 1958.
Design for wall covering, [Leiden Stadhuis], c. 1940. Watercolor and gouache, 700 × 700 mm (drawing); repeat 380 × 535 mm (unexecuted).

This design of birds is one of two regular divisions on the same folio page; both were created for use in the complex lithograph *Verbum*. Although the design has just translation symmetry, Escher used an isometric grid, in which each bird occupies one triangle and a contrasting pair fills a parallelogram. In *Verbum*, these birds provide the transition from flight against sunrise to flight against night sky at the top of the print. A vignette of six of these birds, alternating white and black around a single point, was used on an invitation to an exhibition in 1949; this hexagon-shaped block can be printed contiguously to create a plane filling. The cover of *Regelmatige vlakverdeling* was literally wrapped with this plane filling. Escher's design for wallpaper based on this drawing portrays the birds' flight both in the day and at night—a contrast emphasized in *Verbum* as well as in his earlier *Day and Night*. The flock of 12 different birds in drawing 71 contains the two in drawing 47. Escher's idea for *Sun and Moon* may have grown out of his executions of drawing 47.

ESCHER NO. 45 [ANGEL-DEVIL]
Drawn at Baarn, Christmas 1941
India ink, colored pencil, opaque white
245 × 239 mm (image);
359 × 270 mm (sheet)
Escher system X^{E*};
Symmetry group *p4g*
Published in *Periodic Drawings* (plate 6), *World* (plate 244), *Magic Mirror, Art and Science*, and *Escher on Escher*.
Related graphic work: *Circle Limit IV*, July 1960. Woodcut in black and ocher, printed from two blocks, diameter 416 mm (cat. 436).
Other related work: Surface design for carved maple sphere with 12 angel-devil pairs, 1942.

Although this design has two distinct motifs—angel and devil—Escher classifies it as though it was the one-motif system X^E in the overview chart in his theory notebook (page 58). It fits this category if two allowances are made: black triangles are replaced by devils and white ones by angels and the 4-fold center where two white and two black triangles meet are reduced to 2-fold centers. He remarks the motifs are symmetric about one diagonal of the square in system X^E. (The two-motif system could easily be obtained by splitting the single motifs in system X^E, but Escher's notebook does not show this.) In both his woodcut *Circle Limit IV* and on his carved sphere, Escher emphasized the duality of the figures by alternating their roles as figure and ground. Drawing 45 is Escher's only regular division to be interpreted as a surface filling on three different "planes"—Euclidean, hyperbolic, and spherical; H. S. M. Coxeter [1981] discusses all three designs.

ESCHER NO. 46 [TWO FISH]
Drawn at Baarn, May 1942
India ink, colored pencil, watercolor
289 × 255 mm (image);
359 × 270 mm (sheet)
Escher system VII^C-$VIII^C$ variant 2;
Symmetry group *pgg*

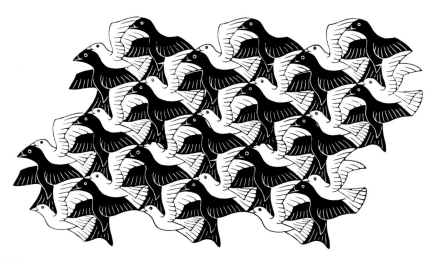

Birds; see notes, no. 47.

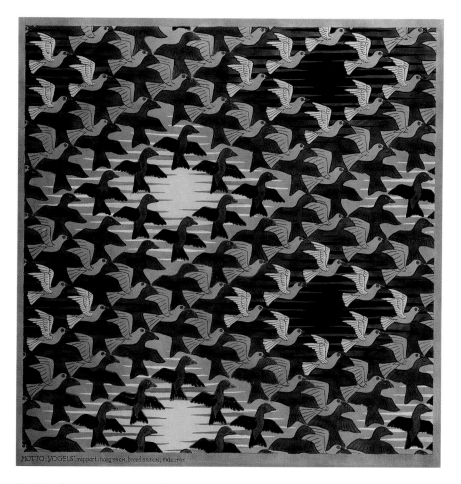

"Birds" wallpaper; see notes, no. 47.

ESCHER NO. 48 [BIRD/FISH]

Drawn at Baarn, July 1942
Ink, watercolor
175 × 223 mm (image);
360 × 270 mm (sheet)

Escher system I^A variant 2;
 Symmetry group *p1*

Related graphic work: *Verbum,* 1942 (cat.
 326).

On the same folio page as drawing 47, this
design was created specifically for use in
the lithograph *Verbum.* These interlocked
motifs provide the transition from bird to
fish (air to water) at the right side of the
print.

ESCHER NO. 49 [TWO FISH]

Drawn at Baarn, July 1942
Ink, watercolor
175 × 223 mm (image);
360 × 270 mm (sheet)

Escher system I^A variant 2;
 Symmetry group *p1*

Related graphic work: *Verbum,* 1942 (cat.
 326).

On the same folio page as drawing 50, this
design was created specifically for use in
the lithograph *Verbum.* These interlocked
motifs provide the transition from fish in
daylit water to fish in inky depths (at the
right side of the print).

ESCHER NO. 50 [FISH/FROG]

Drawn at Baarn, July 1942
Ink, watercolor
175 × 223 mm (image);
360 × 270 mm (sheet)

Escher system I^A variant 2;
 Symmetry group *p1*

Related graphic work: *Verbum,* 1942 (cat.
 326).
 Fish and Frogs, October 1949. Wood
 engraving, 81 × 71 mm (cat. 364).

On the same folio page as drawing 49, this
design was created specifically for use in
the lithograph *Verbum.* There interlocked
motifs provide the transition from fish to
frog (water to earth) at the bottom of the
print. Escher made a small wood engraving
based on this design for an exhibition invi-
tation in which he shows the fish more
playful and adds some acrobatic minnows.

His own playfulness reverses the usual depiction of earth and water; here water is above and earth below.

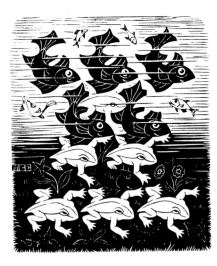

Fish and Frogs; see notes, no. 50.

ESCHER NO. 51 [FROG]

Drawn at Baarn, July 1942
Ink, watercolor
205 × 205 mm (image);
305 × 230 mm (sheet)

Escher system IIIC; Symmetry group $p2$

Related graphic work: *Verbum,* 1942 (cat. 326).

In drawing 51, there is a single frog motif. All dark frogs are right side up while light ones are upside down; interlocked dark and light frogs can exchange places by pivoting 180° about centers on their outlines. Escher notes on the drawing that it is an exceptional case of his system IIIC and refers to page 4 of his notebook; the motif is outlined by just three centrosymmetric curves which replace the edges of a triangle. In using this drawing in *Verbum,* Escher changes the internal detail of the light-colored frogs by repositioning the eyes and mouth; these new frog motifs are now right side up and crawl up while the dark frogs crawl down. These contrasting frogs provide the transition from earth in daylight to earth at night (at the left side of the print).

ESCHER NO. 52 [FROG/BIRD]

Drawn at Baarn, July 1942
Ink, watercolor
205 × 208 mm (image);
305 × 230 mm (sheet)

Escher system IA variant 2;
Symmetry group $p1$

Related graphic work: *Verbum,* 1942 (cat. 326).

This design was created specifically for use in the lithograph *Verbum.* These interlocked motifs provide the transition from frog to bird (earth to air) at the left side of the print.

ESCHER NO. 53 [TWO CLOWNS]

Drawn at Baarn, September 1942
Ink, watercolor
220 × 203 mm (image);
305 × 230 mm (sheet)

Escher triangle system II A$_2$ type 1*;
Symmetry group $p31m$

Published in *Art and Science.*

Related work: A pair of figures similar to these appear in the surface design for a carved beechwood sphere with grotesques, 1943.

This is the first of several folio drawings Escher made to provide examples of his various triangle systems recorded in his "Theorie" notebook in October 1942. This two-motif system is in two colors, with each motif a single color. Escher notes the motifs are symmetric (and his asterisk records that fact symbolically); indeed, the backbones of the acrobats clearly delineate the triangular grid of reflection axes which underlies the design.

ESCHER NO. 54 [TWO INSECTS]

Drawn at Baarn, October 1942; improved April 1963
India ink, colored ink, colored pencil, watercolor
220 × 206 mm (image);
304 × 218 mm (sheet)

Escher triangle system II A$_2$ type 1*;
Symmetry group $p31m$

Published in *Periodic Drawings* (plate 8).

This design of embracing insects is the same type as that in drawing 53, but the underlying triangular grid of reflection axes is invisible here. The design's dominant geometric feature is the swirl of circular arcs which outline the bodies of the red bugs and give the overall impression of overlapping circles. This design has the same symmetry group as the one labeled D$_3^0$ in Pólya's article (page 23); perhaps Pólya's fleur-de-lis and his adjacent pattern D$_6$ of intersecting circles suggested to

Escher the idea for the outline of his two inseparable insects.

ESCHER NO. 55 [FISH]

Drawn at Baarn, November 1942
Ink, watercolor
220 × 205 mm (image);
305 × 230 mm (sheet)

Escher triangle system I B$_3$ type 1;
Symmetry group $p6$

Related work: Design for bank-note background, ƒ 100, *Christiaan Huygens,* 1950 (unexecuted).

In this design, six identical fish swirl about a point where their tails touch; they are colored cyclically red-blue-yellow. Escher's sketch for bank-note background using this regular division replaces some of the six-fold swirls of fish with a six-petaled flower. In fact, the pattern created by the outlines of the six-fold swirls (Escher's triangle system I B$_3$ type C$_1$) can be easily interpreted as one of flowers (see sketch).

See notes, no. 55.

ESCHER NO. 56 [LIZARD]

Drawn at Baarn, November 1942
India ink, gold ink, colored pencil, poster paint
220 × 207 mm (image);
304 × 229 mm (sheet)

Escher triangle system I B$_3$ type 1;
Symmetry group $p6$

Published in *Graphic Work, Periodic Drawings* (cover and plate 39), *Art and Science,* and *Escher on Escher.*

Related work: Hand-printed circular design in gold and black on turquoise silk, December 1942.

Although this lizard obeys the same geometric constraints as the fish in drawing 55, Escher succeeds in making the little creature seem absolutely natural in its role of filling the plane. The rotation centers are

less obvious in this design, and the underlying triangular grid is invisible. Escher carved two small woodblocks to print the design on silk: one to print the lizards in black and in gold and the other to print the internal detail on the lizards whose color is the turquoise of the silk. In 1968, Escher's Christmas greeting card reproduced a color photograph of drawing 56.

ESCHER NO. 57 [TWO FISH]
Drawn at Baarn, November 1942
Ink, watercolor
225 × 205 mm (image);
305 × 230 mm (sheet)
Escher triangle system II B$_2$ type 1;
Symmetry group $p6$

Variations of these two fish motifs appear in several of Escher's drawings made in 1942; as a pair, they seem to be easily molded to fit the geometric contraints of various systems. The abstract polygon tiling in Escher's notebook which illustrates the triangle system II B$_2$ type 1 (top left of page 81) shows shapes that are strongly suggestive of these fish.

ESCHER NO. 58 [TWO FISH]
Drawn at Baarn, November 1942
Watercolor, ink
280 × 178 mm (image);
305 × 230 mm (sheet)
Escher system VIB variant 1;
Symmetry group pgg

Related graphic work: [*New Year's greeting card, Eugène & Willy Strens, 1956*], October 1952. Woodcut in green and blue, printed from two blocks, with letterpress in gray, 155 × 135 mm (cat. 385).

This design has the same symmetry group as that of drawing 46, but there are marked differences in the designs (note they are different Escher systems). In this design, one fish is arched while the other is symmetric and each species swims up and down in an orderly stream. Each species occurs in four different aspects but here two aspects (mirror images of each other) are red and two are gold. In using this design for a New Year's greeting card, Escher turns it 45° so the fish travel diagonally. Although he distorts the motifs somewhat to fit the square frame of the card, he retains the half-turn center of symmetry in the graphic design. The card is one of a series representing the four elements and depicts water.

ESCHER NO. 59 [TWO FISH]
Drawn at Baarn, November 1942
India ink, colored pencil, watercolor
237 × 220 mm (image);
304 × 227 mm (sheet)
Escher system VIID-VIIID variant 2;
Symmetry group pgg
Published in *Graphic Work, Periodic Drawings* (plate 11), and *Art and Science.*
Related work: Hand-printed designs on silk, 1943. Black and gold on red (page 271); green and gold on ivory, 336 × 336 mm (version shown).

Escher preferred to have his fish motifs swim in continuous streams and was successful in aligning their paths in one direction in drawing 58. In drawing 59 he weaves two streams of fish traveling in perpendicular directions, one serving as warp and the other as woof, to create a seamless fabric. His concept sketches for two applications of the drawing show that he conceived of these streams of fish as ribbons. One application (that was not executed) was to wrap these ribbons of fish around the framework of a cube in a preliminary sketch for *Cube with Ribbons* (cat. 415).

A second application was a lyrical decorative design hand-printed on silk in which the pure regular division of drawing 59 appears as a tightly woven center rectangle. Escher made "weavings" of several sizes: the print on red is 6 × 6 (columns of six goldfish and rows of six ray fish form the rectangle); he also made 4 × 4 and 8 × 4 versions. To print these designs, he carved 16 individual small wooden blocks,

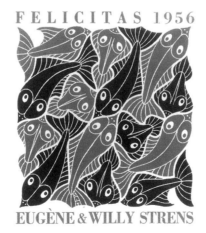

FELICITAS 1956

EUGÈNE & WILLY STRENS

See notes, no. 58.

some with a single fish and some with two interlocked fish. In each printed design, a single ribbon of each species of fish begins at one corner of the design, weaves back and forth, and arrives at the opposite corner. This scheme is reminiscent of his 1926 meander of two interlaced ribbons on floor tiling in his Rome apartment (page 85). In 1947, one of the little carved blocks was used to print a single arched fish on an exhibition invitation (cat. 354).

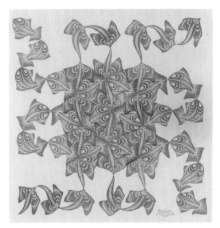

See notes, no. 59.

ESCHER NO. 60 [TWO LIZARDS]
Drawn at Baarn, December 1942
Colored pencil
252 × 217 mm (image);
305 × 230 mm (sheet)
Escher system VIID-VIIID variant 2;
Symmetry group pgg

The motifs and construction of this design satisfy exactly the same geometric contraints as those in drawing 59. Escher even chose the same coloring for the motifs and wove them—gold lizards traveling east and west and green lizards traveling north and south.

ESCHER NO. 61 [TWO CREATURES]
Drawn at Baarn, January 1944
Ink, watercolor, pencil
265 × 205 mm (image);
305 × 230 mm (sheet)
Escher system IVB-VC variant 2;
Symmetry group pg

This is Escher's first folio example of his two-motif system IVB-VC variant 2; its devilish beasts seem bent on consuming the doe-eyed creatures, but the frozen design

prevents them. Although Escher frequently insisted that he did not intend symbolic meaning in his work, it is hard not to interpret this design as a metaphor for the Nazis' devouring of Europe. On January 31, 1944, Escher's beloved teacher Samuel Jessurun de Mesquita and his family were taken in the night by the Nazis from their home in Amsterdam, never to return.

ESCHER NO. 62 [DEVIL]

Drawn at Baarn, January 1944
Colored pencil, ink, watercolor
154 × 280 mm (image);
230 × 305 mm (sheet)

Escher system IVB; Symmetry group *pg*

Related graphic work: [*Devils, vignette*], 1950 (cat. 370).

 [*New Year's greeting card, Eugène and Willy Strens, 1955*], October 1952. Woodcut in yellow and orange, printed from two blocks, with letterpress in gray, 156 × 135 mm (cat. 384).

The devils in this drawing march sullenly in cramped procession; the blue devils face to the left, red to the right, each color devil a glide-reflection image of the other. In the vignette based on this drawing (page 272), Escher depicts a single column of piled devils. Crouching, the fellow at the bottom holds up three others who balance on each other; the top one exults in his freedom. The New Year's greeting card is similar; it shows two columns of devils with pointing fingers. The card is one of a series representing the four elements and depicts fire.

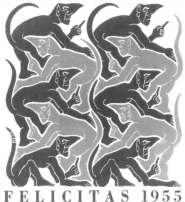

See notes, no. 62.

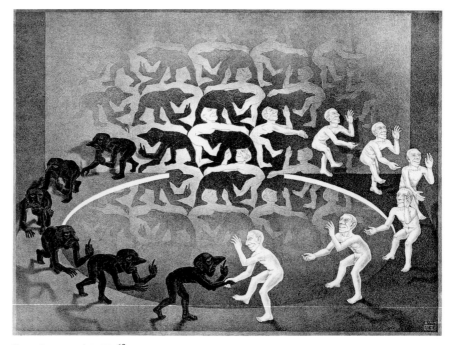

Encounter; see notes, no. 63.

ESCHER NO. 63 [PESSIMIST-OPTIMIST]

Drawn at Baarn, February 1944
India ink, colored pencil, opaque white
182 × 284 mm (image);
227 × 304 mm (sheet)

Escher system IVB-VC variant 2; Symmetry group *pg*

Published in an article "Het *Verbum* van M. C. Escher" by Dr. P. H. Pott, 1955; *Periodic Drawings* (plate 3), *World* (plate 122), *Magic Mirror*, *Art and Science*, and *Escher on Escher*.

Related graphic work: *Encounter*, May 1944. Lithograph, 342 × 464 mm (cat. 331).

The dark motifs in this drawing are similar to the devils of drawing 62 and contrast both in color and demeanor with the smiling marching men. The two motifs, which Escher identified as pessimist and optimist, perhaps suggested the idea for *Encounter*. Here the motifs free themselves from their locked positions, travel carefully around a circular void, and meet with the pessimist's grudging acceptance of the outstretched hand of the optimist.

ESCHER NO. 64 [LEAF]

Drawn at Baarn, August 1944
Watercolor
276 × 205 mm (image);
305 × 230 mm (sheet)

Escher system not given; Symmetry group *pgg*

Related graphic work: [*Trees and animals*], 1953. Wood engraving, 44 × 99 mm (cat. 391).

Other related work: Design for bank-note background, c. 1952 (unexecuted).

In this drawing, leaves sprout alternately left and right out of sinuous vines that grow endlessly upward (dark vines) or downward (light vines). Each dark vine can half-turn into an adjacent light one, while glide-reflections in a vertical direction (as well as translations) can superimpose each vine on itself. Escher indicates on the drawing that its source was one of his tilings by triangles that he recorded in 1944. The version of this design for bank-note background (drawing A4) is closer to that which can be seen as branches and leaves in the vignette of trees and animals. Escher also made a design for the van Dissel company utilizing the tree and animal motifs for table linen, but it was not executed.

ESCHER NO. 65 [MOTH]

Drawn at Baarn, September 1944
India ink, colored pencil, watercolor
206 × 206 mm (image);
304 × 228 mm (sheet)

This is the only similarity design in Escher's folio notebook. It is based on his design of isosceles right triangles found in the ab-

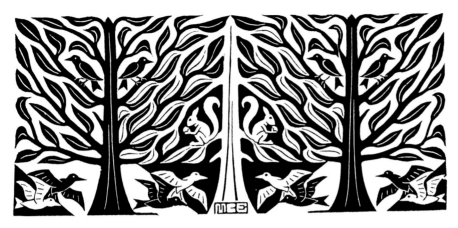

[Trees and Animals]; see notes, no. 64 and A4.

stract motif notebook (page 91, upper left) and has exactly the same symmetries. All the moths stream inward, head to tail, on the reflection axes of the design. The shape of the motifs and their geometric relationship to one another is most like that in drawing 38. If the tilted parallelograms of the underlying grid for that drawing were straightened into rhombuses, the moths there would become symmetric and that design could lead to this one by rolling it around a cylinder and making a stylized view of its projection through the hollow of the cylinder's core (see page 248).

ESCHER NO. 66 [WINGED LION]
Drawn at Baarn, October 1945
Ink, watercolor
173 × 280 mm (image);
305 × 230 mm (sheet)
Escher system IV[B];
 Symmetry group *pg*
Published in *Escher on Escher*.

Related graphic work: *Magic Mirror*,
 January 1946. Lithograph, 280 ×
 445 mm (cat. 338).

Other related work: Cover design for
 Grafiek en tekeningen, 1959.

In describing his lithograph *Magic Mirror*, which incorporates this drawing, Escher refers to the Lewis Carroll story *Through the Looking Glass*. "[The] little animal is born in and emerges from a vertical looking glass. More and more comes out of the mirror until at last the whole creature has freed itself from its image. As a fabulous animal, it transposes its reflection into reality—a well-known trick since Alice and her Looking-glass world. Thus two curved processions move on . . . moving from left to right and right to left. They meet in the

foreground, lose their three-dimensionality, become flat, and slide together as pieces of a jigsaw puzzle. Together they now form a horizontal plane, a tiled floor, on which stands the looking glass." [1964] Bruno Ernst's book, *The Magic Mirror of M. C. Escher* takes its title from this print. Escher chose this procession of winged lions from the more than 100 numbered periodic drawings he had created by 1959 to be used as the cover design for his book *Grafiek en tekeningen* (see page 276).

ESCHER NO. 67 [HORSEMAN]
Drawn at Baarn, June 1946
India ink, colored pencil, watercolor
213 × 214 mm (image);
304 × 228 mm (sheet)

Escher system IV[B]; Symmetry group *pg*

Published in an article by Escher in *Phoenix*, 1947; as frontispiece ("Hop, hop Hynke") in *Introduction to the Space Groups*, by P. Terpstra, 1955; in *Graphic Work, Periodic Drawings* (plate 17), *World* (plate 137), *Magic Mirror, Life and Work* (p. 150), and *Escher on Escher*.

Related graphic work: *Horseman*, July 1946 (cat. 342).
 Plate III, *Regelmatige vlakverdeling*, June 1957. Woodcut in red, 240 × 180 mm (cat. 418).

This procession of helmeted riders with glide-reflection counterchange symmetry is the most widely published of all of Escher's periodic drawings. From its rudimentary form, the motif emerged quickly under his hand (see page 111), a fact he often noted in his lectures. "[The] horseman, as a creature, was exceptionally obliging and willing. It happens rarely that my subjects so meekly allow [themselves] to be pictured in detail." [1964] P. Terpstra used the drawing in his 1955 text to illustrate periodic symmetry in the plane and again in his essay for *Grafiek en tekeningen* to illustrate the symmetry analysis of a periodic drawing. Beginning with C. N. Yang's 1962 book on particle physics, the drawing was widely interpreted by scientists and used as cover art and illustration for numerous mathematics and science texts. Escher expressed his amazement at this in a letter to C. V. S. Roosevelt in 1962. "Funny to receive again and again publications with this

Magic Mirror; see notes, no. 66.

III, *Regelmatige vlakverdeling;* see notes, no. 67.

V, *Regelmatige vlakverdeling;* see notes, no. 68.

brave little rider, illustrating scientific thoughts far beyond my comprehension." Escher's description of the woodcut *Horseman,* given in his 1947 article, is on pages 241–242. He chose drawing 67 for Plate III in *Regelmatige vlakverdeling* to illustrate glide-reflection symmetry.

ESCHER NO. 68 [TWO REPTILES]
Drawn at Baarn, March 1948
Colored pencil, ink, watercolor
305 × 330 mm (image);
305 × 230 mm (sheet)
Escher system VIIC variant 2;
 Symmetry group *pgg*
Published in *Periodic Drawings* (plate 5).
Related graphic work: Plate V, *Regelmatige vlakverdeling,* June 1957. Woodcut in red, 240 × 180 mm (cat. 420).

In classifying this drawing, Escher first wrote "VIIIC or VIIC variant 2?" and then crossed out the VIIIC; in fact, his notebook shows he recognized that these two 2-motif systems are geometrically the same (page 74). He chose this drawing for *Regelmatige vlakverdeling* to illustrate (in Plate V) a complex example of regular division of the plane, containing two motifs and having both glide-reflection and half-turn symmetry. To aid his explanation, he provided a schematic illustration of the design in which he made explicit an underlying grid of rhombuses; each motif is caught by a rhombus which joins its four vertices (the points where the motif touches three other motifs).

ESCHER NO. 69 [FISH/DUCK/LIZARD]
Drawn at Baarn, March 1948
Ink, watercolor
275 × 208 mm (image);
305 × 325 mm (sheet)
Escher triangle system;
 Symmetry group *p3m1*
Published in *Art and Science.*

These motifs represent the three elements of air, earth, and water. Each motif is symmetric, and all are aligned on an isometric grid of equilateral triangles, so that the periodic design has the same grid as its reflection axes. The whole design can be generated by one triangular region which contains half of each motif; the edges of that triangular region act as mirrors.

ESCHER NO. 70 [BUTTERFLY]
Drawn at Baarn, March 1948
Ink, watercolor
280 × 280 mm (image);
305 × 305 mm (sheet)
Escher triangle system I B$_3$ type 2;
 Symmetry group *p6*
Published in *Art and Science* and *Escher on Escher.*
Related graphic work: *Butterflies,* June 1950. Wood engraving, 281 × 260 mm (cat. 369).

On this drawing, Escher refers to drawing 79, in which the scaffold of overlapping circles for the design is made explicit. The outline of the motifs and their geometric

arrangement is the same in both drawings, but here each butterfly is a single color (with wing dots of a contrasting color). In drawing 79 each butterfly is made up of three differently colored parts. The perfect three-coloring of drawing 70 is intricate: two colors of butterflies alternate around each 6-fold center; their wing dots show the missing third color. The design has fascinated mathematicians; three articles discuss aspects of its geometric construction and possibilities for its coloring: J. F. Rigby [1986], B. Grünbaum [1986], and H. S. M. Coxeter [1986]. Escher's related wood engraving *Butterflies* depicts a development of form, dimension, and freedom. This print is closely related to a colored circular design made by Escher (see notes on drawing 79).

ESCHER NO. 71 [TWELVE BIRDS]
Drawn at Baarn, April 1948
India ink, colored pencil, watercolor
267 × 206 mm (image);
305 × 229 mm (sheet)
Escher system VC; Symmetry group *pg*
Published in *Periodic Drawings* (plate 12).
Related graphic work: *Sun and Moon,* April 1948 (cat. 357).
 Liberation, April 1955 (cat. 400).

Escher notes this drawing contains 12 different motifs; a rectangle containing all of them is at the center (it is almost one-third the height of the drawing and two-thirds its width). The rectangle fills the plane by repeated vertical glide-reflections and horizontal translations. The points in the drawing where six birds touch form a lattice of equilateral triangles, as in Escher's draw-

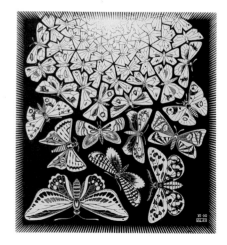

Butterflies; see notes, no. 70.

ings for *Verbum*. In drawing 71, the variety of contour lines which simultaneously define parts of two birds provides a visual summary of his ten years of experimenting to find ways such motifs can interlock. The two birds in drawing 47 are here, and partial contours of other bird motifs can be recognized. The woodcut *Sun and Moon* uses the flock of 12 in this drawing and modifies the birds' outlines only at the edges of the print. The lithograph *Liberation* contains the block of 12 birds at its center; the print shows the development of contrast, form, and dimension.

ESCHER NO. 72 [FISH/BOAT]
Drawn at Baarn, December 1948
Colored pencil, ink
267 × 200 mm (image);
305 × 270 mm (sheet)
Escher system IA-IA; Symmetry group *p1*
Published in *Escher on Escher*.

Related graphic work: [*New Year's greeting card, 1949, L. and K. Asselbergs*], November 1948. Woodcut, 152 × 139 mm (cat. 360).

On this drawing, Escher refers to drawings 18, 22, 29, and 30, all of which are his split-motif system IA-IA. In 1962, he made drawings 112 and 113 in which fish and boats coexist without one devouring the other. Drawing 72 was evidently created especially for the New Year's greeting card he was commissioned to design.

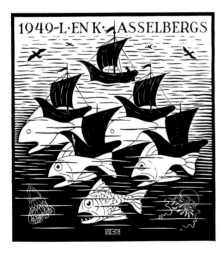

See notes, no. 72.

ESCHER NO. 73 [FLYING FISH]
Drawn at Baarn, July 1949
Ink, watercolor

120 × 300 mm (image);
305 × 230 mm (sheet)
Escher system IA; Symmetry group *p1*

Related graphic work: *Predestination*, January 1951 (cat. 372).
 Plate I, *Regelmatige vlakverdeling*, June 1957 (cat. 416).

On this drawing, Escher refers to drawings 38 and 74 which are also type IA; each shows a checkerboard-colored design whose motifs fly in a diagonal path. This drawing is on the same page as drawing 74, and the similarity of the motifs' silhouettes (if the direction in which the fish fly is reversed) was exploited by Escher in two graphic works (see notes on drawing 80). The motif of flying fish is not entirely fictional; Escher had occasionally seen flying fish on his Mediterranean voyages.

ESCHER NO. 74 [BIRD]
Drawn at Baarn, July 1949
Ink, watercolor
120 × 200 mm (image);
305 × 230 mm (sheet)
Escher system IA; Symmetry group *p1*
Published in *Graphic Work*.

Related graphic work: *Predestination*, January 1951 (cat. 372).
 Plate I, *Regelmatige vlakverdeling*, June 1957 (cat. 416).

Other related work: Tiled column in the Nieuwe Meisjesschool (New Girls' School) (now the Johanna Westermanschool), The Hague, June 1959. Porcelain tiles, "cloisonné" style, by Porceleyne Fles (Delft); column diameter 34 cm, height 300 cm.

By slightly altering the contours of the birds in this companion drawing to number 73, Escher integrated them with the flying fish to create two graphic works (see notes on drawing 80). In Plate I of *Regelmatige vlakverdeling*, the birds metamorphose from a checkerboard pattern of parallelograms in the panels of a meander. Escher's choice of the bird pattern in drawing 74 for a tiled column posed an interesting practical problem: how to use square tiles to produce a design in which the motif repeats diagonally. His solution was to choose a square which contains one white and one black bird (in pieces) and tile the column in a half-drop manner, a technique familiar to the designers of wallpaper patterns.

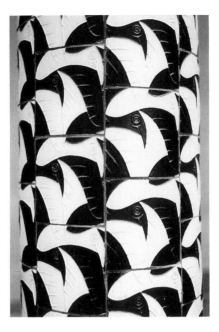

See notes, no. 74.

ESCHER NO. 75 [LIZARD]
Drawn at Baarn, July 1949
India ink, pencil, black and white poster paint
223 × 206 mm (image);
304 × 229 mm (sheet)
Escher system IIA;
 Symmetry group *p2*
Published in *Periodic Drawings* (plate 16) and *Art and Science*.

Although Escher's first systematic efforts to produce plane-filling motifs had concentrated on those which could fill the plane using just half-turns and translations, he did not produce a simple black and white counterchange half-turn pattern of asymmetric motifs until this one. Each lizard can exchange places with any of the four lizards of contrasting color which surround it by means of a half-turn (at head or tail) or translation (sideways).

ESCHER NO. 76 [HORSE/BIRD]
Drawn at Baarn, September 1949
Colored pencil, ink, watercolor
203 × 203 mm (image);
205 × 280 mm (sheet)
Escher system IV variant 2;
 Symmetry group *pg*
Related graphic work: See comments for drawing 76a.

Escher remarks that the points in this drawing where six motifs come together lie at the vertices of a rhombus and that this is not necessary for the design. He also notes two distinct grids: a rhombus lattice, which he labels A, and rows of parallelograms related by glide-reflections, which he labels B. The first grid can be obtained from the design of birds and horses in drawing 76 by joining the vertices (points where six motifs come together) on the boundary of each bird/horse pair with the bird above the horse. The second grid is obtained by joining the vertices around each bird/horse pair with the bird in front of the horse. Note that in the horizontal rows of interlocked motifs, the direction in which the motifs face alternates from row to row.

ESCHER NO. 76A [HORSE/BIRD]

Drawn at Baarn, [September 1949]
Pencil
89 × 101 mm (image)
Escher system IA variant 2;
 Symmetry group $p1$
Related graphic work: *Horses and Birds*,
 September 1949. Wood engraving, 87 ×
 72 mm (cat. 363).
 Metamorphosis III, 1967–1968 (cat.
 446).

On the page facing drawing 76 (the verso of drawing 75), Escher drew a fragment of a similar bird/horse pair and labeled it 76a. This time all motifs face in the same direction and are related only by translations. Although the lower contour of the bird is almost the same as that in drawing 76, here the bird has an open beak and is nipping the horse's ear. Escher chose this version for a vignette for an invitation card for several exhibits in 1949 and later for a new panel in his expanded 1967–1968 *Metamorphosis III*. In that continuous flow of images, he needed these motifs to all face the same way. He also used the rhombus lattice (made up of equilateral triangles) to accomplish a transition from a plane filling by translations to one with 6-fold rotations (page 261).

ESCHER NO. 77 [REPTILE]

Drawn at Les Diablerets, August 1949
India ink, colored ink, colored pencil,
 watercolor
204 × 206 mm (image);
304 × 231 mm (sheet)
Escher system VIB; Symmetry group pgg
Published in *Periodic Drawings* (plate 33).

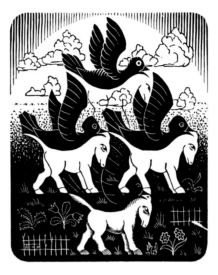

Horses and Birds; see notes, no. 76A.

On this drawing, Escher refers to drawing 36, which is the same system. The reptiles here march head to tail in orderly streams up and down the page. The arrangement of snakes in the earlier drawing appears to be more random, yet in both drawings exactly the same geometric transformations relate the motifs.

ESCHER NO. 78 [UNICORN]

Drawn at Baarn, October 1950
Colored pencil, watercolor
200 × 200 mm (image);
305 × 230 mm (sheet)
Escher "new system?";
 Symmetry group pg
Published in *Periodic Drawings* (plate 36)
 and *Art and Science*.
Related graphic work: [*New Year's greeting
 card, 1951, L. and K. Asselbergs*],
 October 1950. Wood engraving, 115 ×
 78 mm (cat. 371).

After completing this design in which columns of unicorns are colored cyclically in three colors, Escher discovered that this arrangement of motifs was not in his theory notebook. Motifs in a single column are related by translations in a vertical direction while motifs in adjacent columns are related by glide-reflections in a vertical direction. Thus it is closely related to his systems IV and V, but not one of the three-color transitional systems derived from IV and V on pages 12 and 13 in his notebook. In his design for a greeting card based on this drawing, one unicorn kneels to fit the

frame; Escher uses shading to suggest the cyclic coloring and shows six different tones.

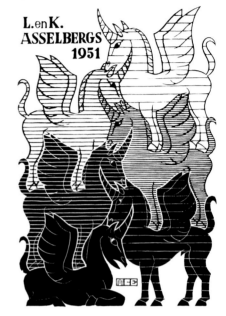

See notes, no. 78.

ESCHER NO. 79 [THREE-COLOR BUTTERFLY]

Drawn at Baarn, October 1950
Watercolor
280 × 280 mm (image);
305 × 303 mm (sheet)
Escher triangle system I B$_3$ type 2;
 Symmetry group $p6$
Published in *Periodic Drawings* (plate 41)
 and *Art and Science*.
Related work: Colored circular design
 with butterflies, c. 1950. Watercolor,
 diameter 627 mm (scale 1 : 12.5).

Escher notes this is a variant of drawing 70; although geometrically the same, the drawings give strikingly different visual impressions. Each butterfly here has three different colors: one for the front wings, one for the back wings and wing dots, and one for the body. This mulicoloring clearly reveals the pattern of overlapping circles on which the drawing is based. Escher's loose sketches of such patterns based on a hexagonal grid were collected in his abstract motif notebook (see page 93). He made a beautiful large circular watercolor design based on drawing 79 in which each butterfly has three colors (ignoring the white). In the design, these colors form successive rings of eight overlapping circles which occur in four colors: red and yellow alter-

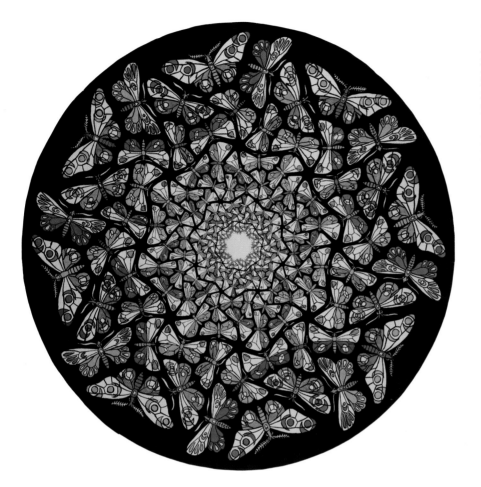

See notes, no. 79.

nate in the outermost ring, green and blue in the next ring, and so on, as the pattern repeats on smaller and smaller scale toward the center. J. F. Rigby [1986] notes several mathematical details of this design, including the fact that all circles intersect at right angles. The print *Butterflies* is a black-and-white version of part of the circular design. The colored design was evidently intended for a large execution (possibly for the ceiling for the Philips Company); Escher notes that it contains 192 butterflies and indicates a scale that would make it about 30 feet in diameter.

ESCHER NO. 80 [FLYING FISH/BIRD]
Drawn at Baarn, November 1950
India ink, pencil, opaque white
99 × 288 mm (image);
226 × 304 mm (sheet)

Escher system IA; Symmetry group *p1*
Published in *Periodic Drawings* (plate 29).
Related graphic work: *Predestination*,
January 1951 (cat. 372).
Plate I, *Regelmatige vlakverdeling*, June 1957. Woodcut in red, 240 × 180 mm (cat. 416).

In this drawing, Escher combines the motifs of drawings 73 and 74. He notes below the drawing that the two motifs share a common silhouette; they are congruent forms. This was a preliminary drawing for the lithograph *Predestination*; Escher gives a vivid description of the print's creation in a 1957 article (see page 238). In Plate I of *Regelmatige vlakverdeling* Escher interprets the silhouette shown on drawing 80 first as a bird (which, either black or white, is figure against contrasting ground), then as a flying fish, and finally, as both, with black birds and white fish interlocked.

ESCHER NO. 81 [BAT/BIRD/BEE/BUTTERFLY]
Drawn at Baarn, December 1950
Ink, watercolor
270 × 212 mm (image);
305 × 230 mm (sheet)

Escher system "related to VIIID";
Symmetry group *pmm*

Published in *Periodic Drawings* (plate 4).

Related work: Design for ceiling of Demonstration Laboratory, Philips Company, Eindhoven, May 1951.

Four symmetric flying creatures interlock in this drawing; their reflection axes form a rectangular grid. Escher created this for the commission by the Philips Company to design a large hung ceiling. Thick black lines separate the motifs in the drawing, and the black extends to cover the margins of the paper. The dark painted wood ceiling in which the lighted motifs glowed was a rectangle approximately 8 × 10 meters in size. It consisted of one panel (approximately 1.3 × 2.6 meters), in which pairs of the four flying creatures interlock exactly as in the drawing, and 40 square panels (each 1.3 × 1.3 meters), in which the creatures, arranged in the same manner, separate and diminish in size as they approach the outer edges.

ESCHER NO. 82 [BIRD/FISH]
Drawn at Baarn, February 1951
Ink, watercolor
205 × 205 mm (image);
305 × 230 mm (sheet)

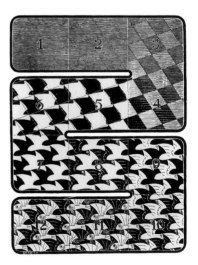

I, *Regelmatige vlakverdeling*; see notes, no. 80.

Escher system I^A-I^A; Symmetry group *p1*

Related work: Design for tile tableau for the facade of a private house in Amsterdam, 1960. Porcelain tiles by Porceleyne Fles (Delft); square tiles 213 × 213 mm, mural 170 × 280 cm (approx.).

On this drawing, Escher's penciled outline of one hexagon cut by a diagonal clearly illustrates his use of the splitting technique shown for this system in his notebook. He used the drawing in a commissioned design for a mural for the facade of a house in Amsterdam. The design, executed in glazed porcelain tiles, required several different tiles in order to create an aesthetic border. The diagonal movement of the motifs was achieved with square tiles using a half-drop match. A rectangular tile tableau made of proof tiles for the mural hung on a wall in Escher's Baarn studio.

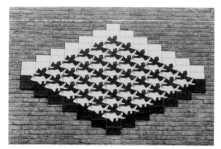

See notes, no. 82.

ESCHER NO. 83 [THIRTY-SIX DIFFERENT MOTIFS]

Drawn at Baarn, March 1951
Pencil, chalk
146 × 92 mm (image);
304 × 227 mm (sheet)

Published in *Life and Work* (page 80) and *Escher on Escher*.

Related graphic work: *Plane filling I*, March 1951 (cat. 373).

This is one of a few drawings in Escher's folio collection which is not periodic. He notes it is a "free" plane filling, based on a grid of rectangles whose vertices determine the points at which four motifs meet. The drawing is an essentially finished design for a mezzotint (which is not reproduced here); note the signature and date drawn in reverse image. In 1963, an American architect, George Paulus, sent Escher examples of different interlocking animal shapes he had devised (one was patented in 1947 as a puzzle). Escher acknowledged them, "You are the first who shares my (secondary) hobby for *ir*regular fillings" and enclosed a print of his mezzotint.

ESCHER NO. 84 [BIRD/FISH]

Drawn at Baarn, April 51
Indian ink, colored pencil
201 × 197 mm (image);
304 × 227 mm (sheet)

Escher system I^B-I^A; Symmetry group *p1*

Published in *Graphic Work* and *Art and Science*.

Related graphic work: [*Plane-filling motif with Fish and Bird*], 1951. Linoleum cut, 137 × 163 mm (cat. 376).

Other related work: Design for bank-note background, c. 1952 (unexecuted).

 Design for intarsia panels in sycamore and mahogany cabinet doors, local telephone bureau, Amsterdam, February 1954. Pencil, watercolor; "Right wall, middle door, scale, 1:3," 464 × 438 mm.

Escher notes on this drawing that the motifs' contours alone characterize them; no outline of the birds or fish shows in pen or pencil. He remarks the design is a variant of drawing 29; the birds and fish are related to each other in exactly the same way. This

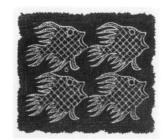

[*Fish and Bird*]; see notes, no. 84.

Intarsia design; see notes, no. 84.

drawing is one of three used for designs for three adjacent wooden cabinet doors executed in inlaid wood. A bird/fish design based on drawing 84 was on the center cabinet, one of two birds (based on drawing 92) was on one side, and one of two fish (based on drawing 93) was on the other. Three additional cabinets facing these showed the same designs in mirror image.

 Escher's design for bank-note background based on drawing 84 utilizes the device of first separating the fish so that the birds dissolve into ground, then closing the space to form birds, and then separating these so the fish dissolve into ground. In this manner he created a repeating pattern that looks like a regular black and white houndstooth weave, but which under close scrutiny is irregular and difficult to counterfeit. (The pattern is not shown here.)

ESCHER NO. 85 [LIZARD/FISH/BAT]

Drawn at Baarn, April 1952
Ink, pencil, watercolor
270 × 212 mm (image);
305 × 230 mm (sheet)

Escher triangle system;
 Symmetry group *p3m1*

Published in *Periodic Drawings* (plate 9) and *Escher on Escher*.

Related work: Surface design on cardboard rhombic dodecahedron, 1952.

 Surface design for carved ivory sphere, May 1963. Diameter 53 mm.

Escher calls this an "improvement" of drawing 69; here the three elements—earth, water, and sky—are represented as lizard, fish, and bat. This may refer to the more uniform shape of the three motifs: each roughly fits a diamond formed of two equilateral triangles. The diamond faces of a rhombic dodecahedron are similar; Escher could easily sketch this design on the 12 cardboard surfaces of the model he constructed. The design is especially suitable for a sphere, and Escher's sketches (right) for the netsuke carver Masatoshi, who carved it in ivory, show how to transform an equilateral triangle (whose edges lie along the backbones of three interlocked motifs) in the plane design into a spherical triangle having three right angles. Note Escher's precision about coloring. Escher was delighted with the carving and showed a slide of it side by side with one of drawing 85 in his lectures.

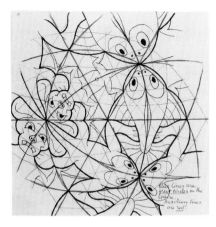

The ivory ball should be painted in these three colours.

The light intensity of every colour should be maintained: dark red, medium green-blue, light yellow.

See notes, no. 85.

ESCHER NO. 86 [BUG]

Drawn at Baarn, July 1952
Colored pencil, ink, watercolor
228 × 218 mm (image);
305 × 230 mm (sheet)

Escher system VIII[D] and IX[D];
 Symmetry group *p4g*

Published in *Periodic Drawings* (plate 26)
 and *Art and Science.*

Related graphic work: [*New Year's greeting
 card, Eugène and Willy Strens, 1953*],
 October 1952. Woodcut in blue-gray
 and brown, printed from two blocks,
 with letterpress in gray, 155 × 135 mm
 (cat. 382).

Escher notes this design is an improved
version of drawing 39. The rectangles
which cage the bugs in the earlier design
have been stretched; now each bug occu-
pies a square. This change creates symmet-
ric motifs and adds both reflection and
four-fold rotational symmetry to the pat-
tern. In using this design for a New Year's
greeting card, Escher turns the drawing 45°
and thus emphasizes its reflection symme-
try. The card is one of a series representing
the four elements and depicts earth.

EUGÈNE & WILLY STRENS

FELICITAS 1953

See notes, no. 86.

ESCHER NO. 87 [TWO BIRDS]

Drawn at Baarn, July 1952
Ink, watercolor
197 × 197 mm (image);
305 × 230 mm (sheet)

Escher system I[B]-I[A]; Symmetry group *p1*

Related graphic work: [*New Year's greeting
 card, Eugène & Willy Strens, 1954*],
 October 1952. Woodcut in green and
 brown, printed from two blocks, with
 letterpress in gray, 154 × 134 mm (cat.
 383).

In using this design for a New Year's greet-
ing card, Escher turns the drawing 45° so
that the birds appear to fly in opposite di-
rections in horizontal rows, an arrange-
ment which fits the square frame better.
The card is one of a series representing the
four elements and depicts air.

FELICITAS 1954

EUGÈNE & WILLY STRENS

See notes, no. 87.

ESCHER NO. 88 [SEA HORSE]

Drawn at Baarn, end of 1952
Ink, watercolor
190 × 190 mm (image);
305 × 230 mm (sheet)

Escher system III[A]; Symmetry group *p2*

Related work: Design for damask table
 linen manufactured by E. J. F. van
 Dissel & Zonen, Eindhoven, February
 1954. Drawing September 1953, pencil,
 235 × 235 mm (image of square design);
 the fish in triangular formation are at
 the outer corners of the tablecloth.

On this drawing, Escher refers to his earlier
drawing 11 of sea horses; here he modifies
the motif so that the plane filling requires
only two colors. Escher's sketch of triangles
on the facing page (inset) is a scaffold for
the sea horses—triangles and sea horses
have vertices and half-turn centers posi-
tioned identically. The damask linen which
Escher designed utilizing the sea horses in
drawing 88 and the fish in drawing 89 pos-
sesses an additional antisymmetry which is
not found in the drawings. In the doubly
woven damask design, each motif can be
viewed in each of two colors: light on one
side of the cloth and dark on the reverse
side. Thus turning over the cloth exchanges
colors in the design.

ESCHER NO. 89 [FISH]

Drawn at Baarn, September 1953
India ink, pencil, watercolor
190 × 198 mm (image);
304 × 227 mm (sheet)

Escher system III^D*; Symmetry group *pmg*

Published in *Periodic Drawings* (plate 20).

Related work: Design for damask table
linen manufactured by E. J. F. van
Dissel & Zonen, Eindhoven, February
1954.

In this drawing, Escher presents two dis-
tinct fish motifs, each of which can fill the
plane with repeated copies of itself by
means of half-turns. The first fish has
feathery fins and swims in diagonal rows in
the upper third of the drawing. The second
has plain fins outlined by simple curves; it
fills the plane in diagonal rows in the lower
third of the drawing. In the center of the
drawing, Escher makes a transition from
one motif to the other; fish have some plain
and some feathery fins. For the design for
damask linen, Escher chose the fish with
the simple outline.

ESCHER NO. 90 [FISH]

Drawn at Baarn, September 1953
Ink, watercolor
190 × 195 mm (image);
305 × 230 mm (sheet)

Escher system III^D; Symmetry group *p2*

Published in *Periodic Drawings* (plate 15).

This drawing shows a variation of the fish
with feathery fins in drawing 89; here their
twisted bodies no longer display bilateral
symmetry. Even if they retained perfect
bilateral symmetry, the way in which they
interlock (which is not the same as that in
drawing 89) would prevent the global
design from having reflection symmetry;
they would be examples of hypersymmet-
ric motifs (see page 341).

ESCHER NO. 91 [BEETLE]

Drawn at Baarn, September 1953
India ink, watercolor
189 × 194 mm (image);
304 × 224 mm (sheet)

Escher system I^B* also IV^B*;
 Symmetry group *cm*

Published in *Graphic Work, Periodic
Drawings* (plate 19), *Art and Science*, and
Escher on Escher.

Related graphic work: Plate II, *Regelmatige
vlakverdeling*, June 1957 (cat. 417).

In contrast with Escher's drawing 37 with

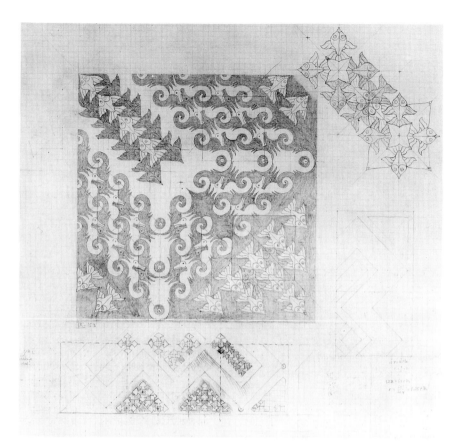

See notes, no. 88 and 89.

beetles, here all the beetles travel in the
same direction. In his 1964 lecture text, he
notes the plane filling with these beetles is
similar to the Moorish mosaic numbered 5
in his poster of illustrations (page 32).
Drawing 91 is used in Plate II in *Regelmatige
vlakverdeling*. In his essay there, Escher ob-
serves that the beetles are bilaterally sym-
metric and are seen from above, in contrast
with the bird and flying-fish motifs seen in
Plate I, each of which is asymmetric and
seen from the side.

 He then notes the three characteristics
of "things that one recognizes" that makes
them suitable for use as a motif in a regular
division of the plane: (1) their shape must
be definable with a single closed outline,
(2) their contour alone should strongly sug-
gest them, and (3) their outline must not
have indentations and bulges which make
adjacent figures difficult for the viewer to
distinguish. He notes the beetle is a border-
line case for condition (3). "The succession
of white and black legs would, if each were
a little thinner or longer, turn into a gray
hatched plane, and each separate leg
would be difficult to distinguish as part of a
particular beetle's body."

ESCHER NO. 92 [TWO BIRDS]

Drawn at Baarn, February 1954
Ink, watercolor
192 × 193 mm (image);
305 × 230 mm (sheet)

Escher system I^B-I^A; Symmetry group *p1*

Related work: Design for intarsia panels
in sycamore and mahogany cabinet
doors, local telephone bureau,
Amsterdam, February 1954. Pencil,
watercolor; "Right wall, left door, scale
1:3," 464 × 438 mm.

Escher notes this is related to drawings 87,
93, and 84; its design of two birds is a slight
variant of 87. The geometric layout of
drawings 84, 92, and 93 is the same: each is
based on an underlying grid of congruent
rectangles in which each rectangle is occu-
pied by one copy (in parts) of each of two
interlocked motifs. In drawing 92 the sil-
houettes of the two bird motifs are very
similar. By making only a minor change to
the outline of the one motif, a design of
congruent birds related by half-turns can be
formed but this version of the design
would be unacceptable to Escher: half the
motifs appear upside down.

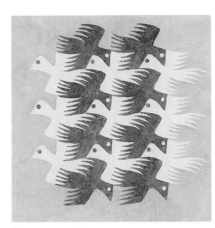

See notes, no. 92.

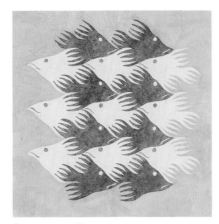

See notes, no. 93.

lined by three centrosymmetric curves. Although the design has no 3- or 6-fold rotations, the vertices of the birds (where six birds touch) form a lattice of equilateral triangles. The curves of the birds' outlines and their twisted interlocking give the design the appearance of a brocade. A preliminary drawing for Plate II of *Regelmatige vlakverdeling* shows that Escher originally chose this design to illustrate rotation symmetry; it was replaced by drawing 13 of dragonflies.

ESCHER NO. 93 [FISH]

Drawn at Baarn, February 1954
Ink, watercolor
188 × 193 mm (image);
305 × 230 mm (sheet)

Escher system IIIB; Symmetry group *p2*

Published in *Art and Science.*

Related work: Design for intarsia panels in sycamore and mahogany cabinet doors, local telephone bureau, Amsterdam, February 1954. Pencil, watercolor; "Right wall, right door, scale 1:3," 464 × 439 mm.

Escher notes this is related to drawings 92 and 84; the three were used for complementary designs on cabinet doors. His classification of drawing 93 as system IIIB (as well as our designation of symmetry group *p2*) is based only on the contour of the fish motif. Escher notes there is just one outline and has pencilled half-turn centers on a single white fish at the center of the drawing. For the door panel, Escher ignores the half-turn symmetry of the design and places eyes and mouths on the motifs so that light fish travel left while dark fish travel right. Now the design appears to have glide-reflection symmetry, but the fish are different: the dark ones have their tails turned up and the white ones have their tails turned down.

ESCHER NO. 94 [FISH]

Drawn at Baarn, August 1955
Watercolor
190 × 200 mm (image);
305 × 230 mm (sheet)

Escher triangle system I B$_2$ type 1;
Symmetry group *p6*

Published in *Art and Science.*

Related graphic work: [*Fish, vignette*], 1955. Woodcut, 88 × 76 mm (cat. 406).

Escher made his first periodic drawing of this type at the end of 1941 (drawing 44); he made no other example until 1954 and then made three such examples, one in August of each succesive year: drawings 99, 94, and 100. Here the fish cavort playfully; they touch fins at a center of 6-fold rotation and meet nose to nose and tail to tail at centers of 3-fold rotation. The woodcut vignette was commissioned by a collector for use as a greeting card.

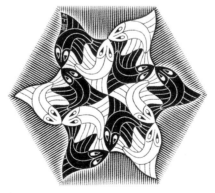

See notes, no. 94.

ESCHER NO. 95 [BIRD]

Drawn at Baarn, August 1955
Ink, watercolor
190 × 200 mm (image);
305 × 230 mm (sheet)

Escher triangle system variant of IIIA;
Symmetry group *p2*

Escher notes on this drawing that it is an exceptional case of IIIA; each bird is out-

ESCHER NO. 96 [SWAN]

Drawn at Baarn, December 1955
Ink, watercolor
202 × 202 mm (image);
303 × 225 mm (sheet)

Escher system IVD;
Symmetry group *pg*

Published in *Graphic Work, World* (plate 208), *Art and Science,* and *Escher on Escher.*

Related graphic work: *Swans,* February 1956. Wood engraving, 199 × 319 mm (cat. 408).

Other related work: Tiled column in the Nieuwe Meisjesschool (New Girls' School) (now the Johanna Westermanschool), The Hague, June 1959. Porcelain tiles, "cloisonné" style, by Porceleyne Fles (Delft); column diameter 34 cm, height 300 cm.

Below the colored design of swans on drawing 96, Escher has penciled two overlapping geometric grids. One is of kite shapes, gotten by joining the four vertices of a single swan (wingtip-wingtip-chesthead), and the other is the grid of rhombuses which corresponds to his system IVD. In the drawing, a swan, a kite, and a rhombus each have the same area, and each is related to its congruent images by the same glide-reflections and translations. In his lectures, Escher showed the drawing side by side with the print *Swans.* "My purpose in making this print was to give a demonstration of that same glide reflection principle [as in drawing 96]. Aiming to prove that the white swans are mirror-reflections of the black ones, I let them fly around in a path having the form of a recumbent 8. Each bird rises from plane to space like a flat biscuit sprinkled with sugar on one side and with chocolate on the other. In the centre of the 8, the white and the black swan-streams intersect and form together a pattern without gaps." [1964]

In adapting the design to tile a column, Escher chose a square which contains ex-

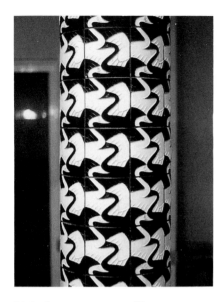

Tiled column; see notes, no. 96.

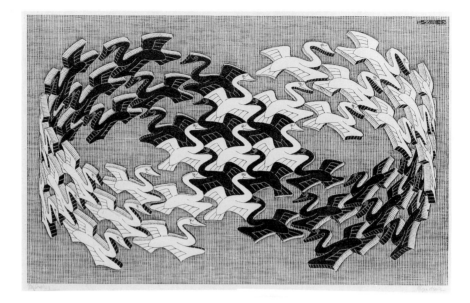

Swans; see notes, no. 96.

actly one black and one white swan (in pieces). Eight of the porcelain tiles encircle the column, and the continuous pattern is repeated vertically by matching the edges of these with tiles above and below. Two other uses of the swan design were sketched by Escher, but not executed. He originally chose this design to illustrate glide-reflection in *Regelmatige vlakverdeling*, but then replaced it with Plates III and IV. He also designed a mural of swans for the hall of a building.

ESCHER NO. 97 [BULLDOG]

Drawn at Baarn, December 1955
Ink
195 × 197 mm (image);
305 × 230 mm (sheet)
Escher system VC; Symmetry group *pg*
Published in *Periodic Drawings* (plate 18).
Related graphic work: Plate IV,
 Regelmatige vlakverdeling, June 1957.
 Woodcut in red, 240 × 180 mm
 (cat. 419).

Escher chose this drawing of ferocious dogs to illustrate glide-reflection symmetry (in Plate IV) in *Regelmatige vlakverdeling* in order to contrast it with the design of horsemen in Plate III. Although both designs have the same symmetry group, their colorings are significantly different: all white horsemen ride in one direction and all black horsemen ride in the opposite direction, but dogs of each color stand guard and face in both directions.

ESCHER NO. 98 [REPTILE]

Drawn at Baarn, December 1955
Ink, watercolor
200 × 200 mm (image);
305 × 230 mm (sheet)
Escher system VIB; Symmetry group *pgg*

The zigzag path of repeated motifs in this drawing is even more pronounced than that in Escher's earlier drawing 77, which is the same type.

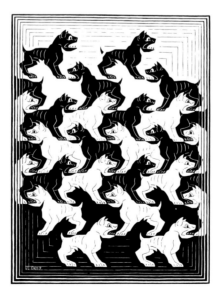

IV, *Regelmatige vlakverdeling*; see notes, no. 97.

ESCHER NO. 99 [FLYING FISH]

Drawn at Baarn, August 1954
India ink, pencil, watercolor
200 × 200 mm (image);
303 × 227 mm (sheet)
Escher triangle system I B$_2$ type 1;
 Symmetry group *p6*
Published in *Graphic Work* and *Life and Work* (page 72).
Related graphic work: [*Fish, vignette*],
 August 1954. Wood engraving, 75 ×
 82 mm (cat. 398).
 Plate II, *Regelmatige vlakverdeling*, June
 1957 (cat. 417).

On this drawing, Escher refers to drawing 44, whose motif has exactly the same silhouette. The vignette of a hexagonal portion of drawing 99 was made for the invitation card to an exhibition of Escher's work at the Stedelijk Museum in Amsterdam, held 27 August to 26 September, 1954, in conjunction with the 1954 International Congress of Mathematicians. The same vignette was used on the cover of a booklet "Het spel van wit en zwart" ("The game of White and Black"), by Pam G. Reuter, produced in 1949 for supporters of De Grafische, to which Escher belonged.

Escher chose the flying fish for *Regelmatige vlakverdeling* to illustrate (in Plate II) three different kinds of rotation centers. To assist his explanation, he sketched a portion of drawing 99 with a superimposed grid of equilateral triangles, and marked the centers of 2-, 3-, and 6-fold rotation. Comparing this plane filling with two oth-

ers in Plate II (of beetles and of dragonflies) he notes, "The six attitudes of these flying fish create the appearance of a greater freedom, a playfulness, and a spontaneity. This is not only because of the absence of right angles but also because the figures themselves are no longer symmetrical. Whoever has a feeling for the peculiar beauty of regular division of the plane will experience more pleasure from this last example than from the two previous ones."

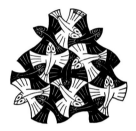

See notes, no. 99.

ESCHER NO. 100 [FLYING LETTER]
Drawn at Baarn, August 1956
Pencil, ink, watercolor
200 × 200 mm (image);
305 × 230 mm (sheet)

Escher triangle system I B₂ type 1; Symmetry group *p6*

Related graphic work: *New Year's greeting card for the P.T.T.*, September 1956. Wood engraving, 136 × 152 mm (cat. 412).

 Metamorphosis III, 1967–1968 (cat. 446).

Escher made this drawing of flying letters to use in a design for a greeting card commissioned by the Postal, Telephone, and Telegraph service. The angular shape of the winged envelopes clearly outlines a grid of regular hexagons, each of which shows a center of 6-fold rotation. Escher's wood engraving for the greeting card shows a hexagonal design with six tightly packed

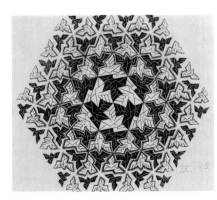

See notes, no. 100.

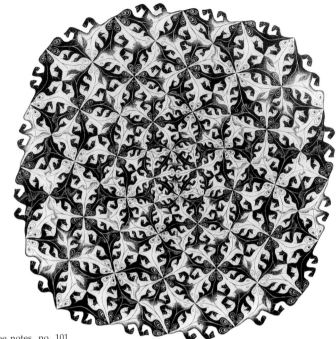

Division; see notes, no. 101.

letters whirling about its center; adjoining letters separate from the tight mass and fly off to their destinations. Escher chose drawing 100 to insert as a new panel in *Metamorphosis III* (see page 261); his earlier *Metamorphosis II* did not contain any regular divisions with 6-fold rotations.

ESCHER NO. 101 [LIZARDS]
September 1956
India ink, pencil, watercolor
295 × 145 mm (image);
304 × 227 mm (sheet)

Related graphic work: *Division*, July 1956. Woodcut, diameter 375 mm (cat. 411).

Escher notes this drawing is a "division" of system X^E and refers to drawing 35, which is its source. Escher worked on this drawing about the same time he created his two *Smaller and Smaller* prints; he used the same geometric scaffold for drawing 101 as that in the vertical descent version of *Smaller and Smaller* (see notes on drawing 35). In this drawing, however, not only do the triangles split as they descend to a base line; the lizards themselves split. In several triangular regions, a single lizard is replaced by a red lizard emerging out of a blue one. The print *Division* shows a similar pattern, with the division process directed from the outer edge toward the center. Its arrangement of motifs is very orderly yet the print has just half-turn symmetry.

ESCHER NO. 102 [RAY FISH]
Drawn at Baarn, March 1958
Ink
200 × 200 mm (image);
305 × 230 mm (sheet)

Escher system IV^B; Symmetry group *pg*

Published in *Graphic Work* and *Periodic Drawings* (plate 30).

Related graphic work: *Path of Life I*, March 1958 (cat. 424).

 Path of Life II, March 1958. Woodcut in gray-green and black, printed from two blocks, 370 × 370 mm (cat. 425).

In this drawing, all dark ray fish swim head to tail toward the upper right, while light ray fish in the same formation all head toward the lower right. In the two *Path of Life* prints, Escher transforms intersecting pairs of parallel streams of fish into loops of two joined spiraling streams. In each print, the white rays are "born" infinitesimally small in the center and, as they grow in size, they swim outward, head to tail in a spiral path.

Path of Life II; see notes, no. 102.

out, stretched as taut as the wings of a glider."

ESCHER NO. 113 [FISH/BOAT]

Drawn at Baarn, January 1962

Watercolor

112 × 200 mm (image);

305 × 230 mm (sheet)

Escher system IC-IC Symmetry group *p1*

Published in *Periodic Drawings* (plate 1a).

Related graphic work: *Metamorphosis III*, 1967–1968 (cat. 446).

Other related work: Design for painted concrete column, Provinciale Waterstaat en Planologische Dienst (Provincial Bureau of Water Management and Planning), Haarlem, March 1962.

Escher uses the boats in drawing 112 and 113 as a transition between the two designs in the metamorphosis on the column. First the boats separate from the flying fish and sail free at the center of the column; then they settle in to define the grumpy fish in drawing 113. In 1967, Escher chose the two designs of drawings 112 and 113 to include as new panels in his *Metamorphosis III*. This time he used the boats to provide a horizontal transition between the two designs (see page 260). There, birds metamorphose into the flying fish of drawing 112 and the fish of drawing 113 swim free of the boats in order to define the next creature: a horse.

ESCHER NO. 114 [FISH/FROG]

Drawn at Baarn, January 1962

Watercolor

120 × 200 mm (image);

305 × 230 mm (sheet)

Escher system IC-IC; Symmetry group *p1*

Published in *Periodic Drawings* (plate 1b).

Related work: Design for painted concrete column, Provinciale Waterstaat en Planologische Dienst (Provincial Bureau of Water Management and Planning), Haarlem, March 1962.

See comments on drawings 111, 112, and 113. In the metamorphosis on the column, the fish of drawing 113 sink away from the boats and transform into the fish in this drawing, which in turn define the frogs. At the bottom of the column, the frogs break free and, on dry land, appear to contemplate the metamorphosis unfolding above them. A similar squatting frog appears in one of Escher's 1931 woodcuts for *XXIV Emblemata* (cat. 175).

Preliminary column design, pencil, 600 × 295 mm. See notes, nos. 111 to 114.

ESCHER NO. 115 [FLYING FISH/BIRD]

Drawn at Baarn, March 1963
Ink, watercolor
198 × 198 mm (image);
305 × 230 mm (sheet)
Escher system IID;
 Symmetry group *p2*
Published in *Periodic Drawings* (plate 2)
 and *Art and Science*.

Escher made this drawing at the request of
Carolina MacGillavry to provide an exam-
ple of a periodic pattern which has only
translation and half-turn symmetry (classi-
fied as *p2*) and in which no symmetry of the
design interchanges colors. Here each ver-
tex of every motif is a half-turn center; Es-
cher had no such two-motif system in his
theory notebook. In selecting illustrations
for her 1965 book from Escher's folios, Mac-
Gillavry found that all Escher's previous
periodic drawings which were of type *p2*
possessed symmetries which permute the
colors of the motifs.

ESCHER NO. 116 [FISH]

Drawn at Baarn, April 1963
Ink, watercolor
200 × 200 mm (image);
305 × 230 mm (sheet)
Escher system VIB; Symmetry group *pgg*
Published in *Periodic Drawings* (plate 34)
 and *Art and Science*.

Escher made this drawing at the request of
Carolina MacGillavry, for her 1965 book.
Although he had other examples of the
same color symmetry type (drawings 36,
77, and 98), this drawing provides an illus-
tration which is simpler to analyze visually.
Fish of the same color and in the same as-
pect line up in neat diagonal rows; the col-
ors of the rows, as well as the direction of
the fish, alternate from row to row. G.
Shephard [1986] illustrates how this peri-
odic tiling may be also perfectly colored
with three or four colors.

ESCHER NO. 117 [CRAB]

Drawn at Baarn, April 1963
Colored pencil, ink, watercolor
235 × 235 mm (image);
305 × 235 mm (sheet)
Escher system II$^{C^*}$; Symmetry group *pmg*
Published in *Periodic Drawings* (plate 23)
 and *Art and Science*.

Escher made this improved version of
drawing 40 for publication in MacGillavry's

book. In the earlier drawing, he marked the
half-turn centers with circles and joined
these to show the pattern's glide-reflection
axes. Escher put no such markings on this
version of the design made more than
twenty years later; he presents a strongly
defined motif with shading to suggest its
three-dimensional form.

ESCHER NO. 118 [LIZARD]

Drawn at Baarn, April 1963
Chalk, ink, watercolor
247 × 246 mm (image);
362 × 270 mm (sheet)
Escher system XE; Symmetry group *p4*
Published in *Art and Science*.

Escher notes this drawing is a color variant
of drawing 35. The design of lizards is al-
most the same, but now four colors are
used rather than the minimum two needed
to distinguish adjacent motifs. Rough pre-
liminary sketches show Escher envisioned
this design as one of interlocked circles of
color. In the drawing, four lizards of the
same color make head-to-tail circuits; these
circles of color give the pattern the appear-
ance of a rich brocade. The arrangement in
drawing 118 is similar to the circle design
called IIIA in Escher's abstract-motif note-
book (page 92), and the coloring is also re-
lated. The date of the drawing suggests it
might have been created for MacGillavry's
book which analyzes color symmetry of
periodic patterns; however, it was not in-
cluded.

ESCHER NO. 119 [FISH]

Drawn at Baarn, February 1964
Ink, watercolor
243 × 243 mm (image);
362 × 270 mm (sheet)
Escher system XE; Symmetry group *p4*
Related work: *Square Limit*, April 1964.
 Woodcut in red and gray-green,
 printed from two blocks, 340 × 340 mm
 (cat. 443).

After creating four circle-limit designs
based on Coxeter's hyperbolic tessellations
in which motifs diminish in size as they
approach the boundary of a circle, Escher
devised his own algorithm of repeatedly
dividing isosceles right triangles to create
Square Limit. At the center of the print, the
interlocked fish appear almost exactly as in
drawing 119, but then in the next layer out-
ward, two smaller fish occupy the place of
one fish in the drawing. Although Escher
was pleased with his solution to the prob-

lem of depicting an outward progression of
infinite repetition within the confines of a
bounded frame, he was apologetic in his
letter to Coxeter and called it "simple as a
flat filling." The sketch Escher sent to
Coxeter to explain the print is shown
below.

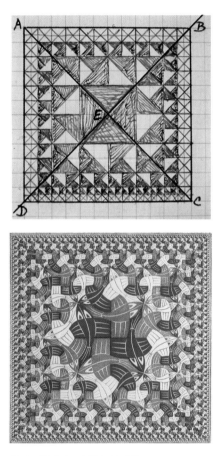

Square Limit; see notes, no. 119.

ESCHER NO. 120 [FISH/BIRD]

Drawn at Baarn, May 1964
Ink, watercolor
157 × 246 mm (image);
362 × 270 mm (sheet)
Escher system IC-IC; Symmetry group *p1*
Related work: A similar pattern appears
 in the tapestry designed by Escher for
 the weavers Ed. de Cneudt in Baarn,
 1949, (page 292).

Escher notes this drawing is a variant of
drawings 29 and 84. Bird and fish interlock
in a similar way in drawing 84 and at the
top of the 1949 tapestry he designed. At the
time this drawing was made, Escher had a
commission to design a mural for the Pak-
ket Postgebouw (parcel post building) in

Amsterdam. His sketches show a horizontal metamorphosis similar to the vertical one in the 1949 tapestry. That commission was not executed.

ESCHER NO. 121 [FISH/BIRD]
Drawn at Baarn, May 1964
Ink, watercolor
157 × 246 mm (image);
362 × 270 mm (sheet)

Escher system I^C-I^C; Symmetry group *p1*

Related work: A similar pattern appears in the tapestry designed by Escher for the weavers Ed. de Cneudt in Baarn, 1949, (page 292).

On the same page as drawing 120, this design is also like one in a tapestry designed by Escher in 1949. The bird and fish in drawing 121 are similar to those in the lower portion of that tapestry. See additional comments on drawing 120.

ESCHER NO. 122 [FISH]
Drawn at Baarn, April 1964
India ink, pencil, watercolor
150 × 210 mm (image);
357 × 245 mm (sheet)

Escher system [X^{E^*}]; Symmetry group *p4g*

Published in *Escher on Escher*.

Related graphic work: *Circle Limit I*, November 1958. Woodcut, diameter 418 mm (cat. 429).
 Circle Limit III, December 1959 (cat. 434).

Although Escher made folio drawings 122 and 123 in 1964, he originally created the designs for use in his circle-limit prints, more than five years earlier. In his lectures, Escher showed the two drawings together with *Circle Limit III* and pointed out the three different modes of plane filling with the same symmetrical fish motif. He found drawing 122 the least interesting of the three because the head-to-head and tail-to-tail fish did not suggest continuous flow. In *Circle Limit I*, Escher's angular fish are arranged as in drawing 122 along "lines" which intersect at right angles in that hyperbolic plane. In 1965, Escher was able to create flow in a design based on drawing 122 (see comments on drawing 125).

One square from drawing 122 occupies the center of *Circle Limit III* (page 251). At each of its corners, that central square touches two other "squares" from drawing 122 and three "triangles" from drawing 123. Only in a hyperbolic world can these six "regular polygons" surround a single

point. H. S. M. Coxeter [1979] discusses mathematical details of Escher's print and D. Dunham [1986] shows a different circle-limit design using drawings 122 and 123.

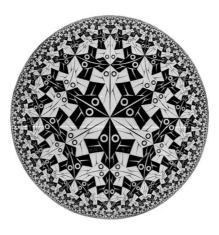

Circle Limit I; see notes, no. 122.

ESCHER NO. 123 [FISH]
Drawn at Baarn, April 1964
India ink, pencil, watercolor
150 × 210 mm (image);
357 × 245 mm (sheet)

Escher [triangle system I A_3 type 2*];
 Symmetry group *p31m*

Published in *Escher on Escher*.

Related graphic work: *Circle Limit III*, December 1959 (cat. 434).

Here, symmetric fish of a single color swim head to tail in streams, following the three directions traced by a triangle lattice; within each triangle, fish of three different colors meet at a center of 3-fold rotation. In *Circle Limit III* (page 251), Escher achieves the same continuity of movement. Each fish is born at the edge of the print, grows as it travels along a circular arc, then shrinks as it continues its path to the border. Escher used both drawings 122 and 123 in *Circle Limit III*, which is a hyperbolic tessellation of "squares" and "triangles." He carved five different woodblocks to print *Circle Limit III:* one for black lines and four for the colors. Each block printed a 90° sector, so one complete print required 20 printings.

ESCHER NO. 124 [LIZARD]
Drawn at Baarn, September 1965
Ink
240 × 240 mm (image);
360 × 265 mm (sheet)

Escher system VII^D; Symmetry group *pgg*

On this design, Escher notes drawing 33, in which sharp-beaked lizards interlock in the same manner. The little lizards in drawing 124 are similar to those in drawing 104, but now their bodies twist in S curves and interlock by means of glide-reflections and half-turns.

ESCHER NO. 125 [FISH]
Drawn at Baarn, August 1966
Ink, watercolor
228 × 228 (image);
360 × 265 mm (sheet)

Escher system IX^{D^*}; Symmetry group *p4g*

Related graphic work: *Path of Life III*, November 1966. Woodcut in red and black, printed from two blocks, 366 × 371 mm (cat. 445).

The two motifs in this drawing have the same silhouette; it is very similar to that of the fish in drawing 122. There, fish aligned on the white grid of lines abut face to face and tail to tail. Here, Escher changes the internal detail of every other fish along a path to create a different-looking winged creature. Now streams of black fish and creatures all travel in one direction, perpendicular to similar streams of white motifs. Escher (as usual) classifies the design according to the motif's contour alone. With internal detail counted, the design's global symmetry changes: each motif is symmetric, but red lines in the drawing are not reflection axes for the pattern. In *Path of Life III*, pairs of red lines that are perpendicular in the drawing trace out a loop made up of two spiral paths. White creatures are born in the center of the print, grow while following a spiral path outward to the edge where they turn, change color, and follow another spiral path inward while diminish-

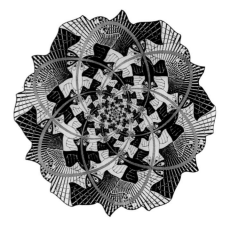

Path of Life III; see notes, no. 125.

ing in size until they disappear into their place of origin.

ESCHER NO. 126 [FISH/BIRD]

Drawn at Baarn, March 1967
Ink, watercolor
230 × 275 mm (image);
255 × 300 mm (sheet)

Escher system "elements from IV and V"; Symmetry group *pg*

Published in *Art and Science.*

Related work: Design for tiled column for New Lyceum in Baarn, 1968. Porcelain tiles by Porceleyne Fles (Delft); column diameter 60 cm, height 260 cm.

Escher could not find this two-motif system among those in his theory notebook, and so simply noted that it had elements from systems IV and V. The shapes in his illustration of system IV[B] variant 1 on page 23 in his notebook suggest this bird and fish; also, there each motif appears in black and in white, in image and mirror image. His unicorn drawing 78 provides an example of the system missing from his notebook and from which this two-motif system can be derived. The six portions of the boundary of one bird/fish pair are related to each other by the same geometric transformations as the corresponding six portions of the unicorn's outline (see sketch; T = translation, G = glide-reflection). Escher chose the bird/fish pattern for a tiled column in the entrance hall to a school. The design required two square tiles (see drawing 136). In drawing 126, Escher notes "these eyes are a mistake." For white fish to be counterchange images of black ones, their eyes should be black rings.

ESCHER NO. 127 [BIRD]

Drawn at Baarn, March 1967
Ink, watercolor
200 × 200 mm (image);
305 × 230 mm (sheet)

Escher system I[D]; Symmetry group *p1*

Published in *Art and Science.*

Escher notes this bird is an "apparently 2-sided symmetric motif"; in fact, just the wings fail to be exact mirror images of each other. It is easy to construct a similar but perfectly symmetric bird which fills the plane in exactly the same manner (see sketch). However, that all-over pattern has no reflection symmetry. Drawing 127 caught the attention of B. Grünbaum and prompted him to ask what other kinds of hypersymmetric tiles can exist [1986]; that question is not yet completely answered.

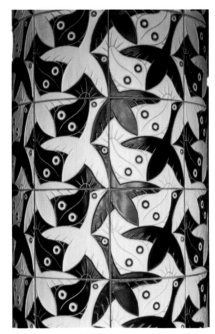

See notes, no. 126.

See notes, no. 126.

ESCHER NO. 128 [BIRD]

Drawn at Baarn, April 1967
Ink, watercolor
205 × 195 mm (image);
305 × 230 mm (sheet)

Escher system I[D]; Symmetry group *p1*

This perky bird and Escher's eagle (no. 17) are the only birds in his collection that do not fly, but stand in neat rows. At the bottom of the drawing, Escher shows how he created the bird by altering the edges of a square.

See notes, no. 127.

ESCHER NO. 129 [FISH/HORSE]

Drawn at Baarn, July 1967
Ink
240 × 242 mm (image);
297 × 262 mm (sheet)

Escher system I[C]-I[C]; Symmetry group *p1*

Related graphic work: *Metamorphosis III,* 1967–1968 (cat. 446).

Escher made this drawing for a new panel in *Metamorphosis III*; it links two other new panels in the print (see page 260). The fish in drawing 113 swim free of the boats, then close in to define the horses in this pattern; the horses in turn separate and gain independent existence in a fenced pasture. From there, the horses again become two-dimensional and close in to interlock with birds as in drawing 76a.

ESCHER NO. 130 [FISH/HORSE]

Drawn at Baarn, July 1967
Ink
192 × 233 mm (image);
270 × 358 mm (sheet)

Escher system "elements from IV and V"; Symmetry group *pg*

Escher made this drawing for possible inclusion in his expanded print *Metamorphosis III*. The plane filling does not appear in Escher's long print, probably for the same reason that drawing 76 does not appear. In order to have a continuous flow to the picture story, the replicas of each motif must all occur in the same aspect. Thus Escher chose drawings 76a and 129, which have no glide-reflection symmetry, instead of drawings 76 and 130, which do. In classifying this drawing, Escher makes the same comment as on drawing 126: "elements from IV and V." In fact, this two-motif system is exactly the same type as that bird/fish design.

ESCHER NO. 131 [PENTAGON WITH FLOWER]

Drawn at Baarn, July 1967
Ink, watercolor
200 × 200 mm (image);
300 × 235 mm (sheet)

Escher system "related to VIII"; Symmetry group *p4g*

Related graphic work: *Metamorphosis III,* 1967–1968 (cat. 446).

Related work: Design developed for tiled column for New Lyceum in Baarn (see drawings 134 and 136).

On this drawing, Escher refers to drawings 42 and 43, both of which have designs of stars and diamonds as their source. The geometric design shown with the notes on drawing 42 is also the basis for this drawing: The stars become flowers and the fused diamonds form the crosses of leaves. With this interpretation, the pattern is one of three separate motifs—leaves black and flowers white. But Escher traces a grid of congruent pentagons, and this single shape with its embossed flower creates the same plane filling. Escher chose this for a new panel in *Metamorphosis III*, which added a new "chapter" at the outset of that picture story (see page 258). The checkerboard squares deform like a collapsible rack and produce a new mosaic of squares and diamonds; the diamonds sprout new points and divide into stars; stars become flowers (with bees seeking their pollen), and then the process reverses until the checkerboard is again restored.

ESCHER NO. 132 [FLOWER]

Drawn at Baarn, December 1967
Ink, watercolor
281 × 200 mm (image);
300 × 230 mm (sheet)

Symmetry group *p4g*

Related work: See drawings 131, 134, and 136.

This is a second version of drawing 131, in which Escher has added red and blue to the pentagon grid and to the centers of the flowers. The single square shown at the bottom of the drawing can create the plane filling by means of translations alone; this was quite likely a proposed design for one of the tiled columns for the New Lyceum in Baarn. The introduction of color not only enlivens the design, but also adds color symmetry.

ESCHER NO. 133 [INTERLACED HEXAGON]

Drawn at Baarn, December 1967
Ink, watercolor
203 × 203 mm (image);
305 × 227 mm (sheet)

Symmetry group *pgg*

Escher's fascination with multiple interpretations of a single geometric design is apparent in his series of drawings 131 to 134. In drawing 133, Escher removes the flowers from drawing 132 and focuses on that pattern's two overlapping hexagonal grids,

one red and one blue. Here, he makes the hexagonal grids white and black and interweaves them against a gray background. The over-under interlacing destroys the 4-fold symmetry present in the earlier version, but the other symmetries remain.

ESCHER NO. 134 [FLOWER]

Drawn at Baarn, December 1967
Ink, watercolor
278 × 203 mm (image);
302 × 227 mm (sheet)

Symmetry group *pgg*

Related work: Design for tiled column for New Lyceum in Baarn, 1968. Porcelain tiles by Porceleyne Fles (Delft); column diameter 60 cm, height 260 cm.

In this drawing, Escher combines the interlacing of the hexagons in drawing 133 with the flower patterns in drawings 131 and 132 and turns the pattern 45° so that the hexagons are aligned horizontally and vertically. For both practical and aesthetic reasons, this pattern is more suited to cover a vertical column. At the bottom of the page, Escher has drawn the two squares for tiling the column in the Baarn school (see drawing 136).

THERE IS NO RECORD OF FOLIO DRAWING 135.

ESCHER NO. 136 [TWO TILE PAIRS]

[Drawn at Baarn, 1968]
Ink, watercolor
305 × 237 mm (image);
305 × 237 mm (sheet)

Published (in part) in *Art and Science*.

Related work: Designs for two tiled columns for New Lyceum in Baarn, 1968.

Escher sent this design drawing to the Delft manufacturer of the tiles for two columns to be covered with the periodic designs in drawings 126 and 134. Only one tile mold was required for the design of birds and fish, but the single tile had to be glazed in both positive (A_1) and negative (A_2) versions. Each tile contains two birds and two fish (in pieces) in direct and in mirror image. At the top of the drawing, Escher notes that now the eyes of the white fish are good; the mistake noted in drawing 126 has been corrected. The simpler design of flowers also required two versions (B_1 and B_2) due to the "woven" strips and the curvature of the tiles. The tiles are 233 ×

See notes, no. 134.

233 mm; the tiling on each column is 11 tiles high and 8 tiles around. Escher's tiling scheme for each column is at the bottom of the page.

ESCHER NO. 137 [GHOST]

Drawn at Laren, May 1971
Ink, watercolor
333 × 243 mm (image);
360 × 270 mm (sheet)

"System of R. Penrose's jigsaw puzzle"; Symmetry group *p6*

Published in *Art and Science*.

This last of Escher's folio drawings is unusual in several ways. He made the design with motifs which he called little "ghosts," after solving a puzzle invented by the physicist Roger Penrose. Penrose [1986] tells of his visit to Escher in 1962; he gave the artist a number of identical wooden puzzle pieces (see sketch) and challenged him to find the unique way in which they could fill the plane. The pieces interlock in many different ways and in all but one arrangement the tiling cannot be continued forever. Escher solved the puzzle, sketched the solution, and sent it to Penrose, who (a few years later) supplied a geometric characterization of the tile. The same curve joins adjacent vertices of a 60°-120° rhombus but in different aspects: left edge rotates 120° into top edge, top edge rotates

60° into right edge, and right edge glide-reflects into bottom edge. This simple construction produces a remarkable result: the plane filling by copies of the single motif is non-isohedral. Glide-reflections which relate adjacent motifs are not symmetries of the tiling. Martin Gardner [1988] shows another non-isohedral tiling by a similar tile invented by Penrose. Escher's coloring of ghosts in this drawing is highly symmetric, but not perfect.

See notes, no. 137.

PERIODIC DESIGN A1 [BAT]

[Rome, c. 1926]
Ink, transparent and metallic, printed in
 five colors on black satin.
Wall hanging 1460 × 946 mm

Symmetry group *cm*

Escher used an individual carved block to print each bat in this design. The block for the black bats contains only the internal detail of the motif. The idea for the motifs may have come from shapes etched in stucco in the Alhambra; the symmetry of some wall patterns there with stylized vines, leaves, and cones is very similar. Escher alternates colors on the bats in each column: gold-red-silver-red and blue-black-green-black; thus, there are twice as many black and red bats as others.

PERIODIC DESIGN A2 [FOUR BIRDS]

Drawn at Ukkel, 1940
Pencil
310 × 232 mm (sheet)

Symmetry group *p1*

Related work: Decorative intarsia wood
 panel for the mayor's office in the
 raadzaal (council hall), Leiden Stadhuis
 (Leiden Town Hall), 1940 (page 269).

This is one of Escher's preliminary drawings for a panel for the mayor's office in the new Leiden Town Hall. The outline of the block of four birds can be seen in the upper part of the drawing; in the lower half some birds break free of their cramped cage.

Another sketch (below) shows Escher's square grid; the block of four birds can fill the plane by translations. On the facing page, his schematic drawing shows how flight paths of the birds cross in the panel; each bird is represented by a square with an arrow. The design depicts the growth of Leiden from 1186 to 1940, and successive rings of the expanding city are shown on a map in contrasting shades of wood. Farm fields border the city, and it is from these that the birds metamorphose, reminiscent of Escher's *Day and Night*. Escher's sketchbooks show the source for these interlocking birds was a simple tiling by crosses (in his lecture poster, page 32).

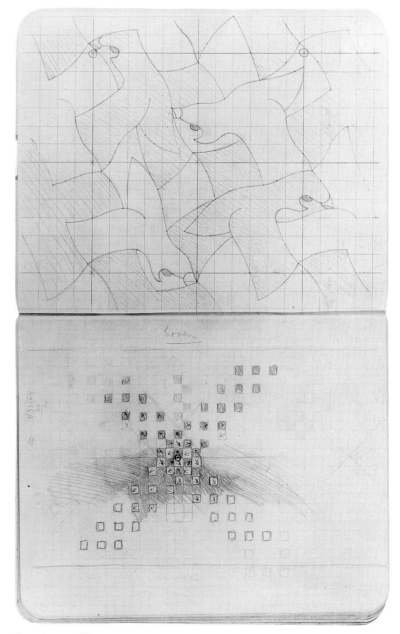

See notes, no. A2.

PERIODIC DESIGN A3 [OVERLAPPING PARALLELOGRAMS]

Drawn at Ukkel, 1940

Watercolor, gouache, ink

168 × 112 mm (image)

Symmetry group *cmm*

Related work: Design for glass panes for book-cabinet doors, office of the Town Clerk in the *raadzaal* (council hall), Leiden Stadhuis (Leiden Town Hall), 1940. Executed by F. van Tetterode.

Escher's geometric design for etched glass panes for book cabinets can be obtained in several ways. One can begin with a pattern of identical parallelograms regularly spaced in rows which are diagonal to the rectangular frame of the drawing, then reflect that pattern through a vertical line at the center of the frame, and superimpose the reflection on the original. The new pattern is rich in symmetry: reflections (vertical and horizontal), half-turns, glide-reflections and translations. Each book-cabinet door had six glass panes with this design.

PERIODIC DESIGN A4 [LEAF]

Drawn at Baarn, October 1950

Pencil, colored pencil

83 × 94 mm (image)

Symmetry group *pgg*

Published in *Het Nederlandse bankbiljet en zijn vormgeving*, J. Bolten, 1987.

Related graphic work: See comments on drawing 64.

Related work: Design H for bank-note background, *f* 25, *Stevin* (unexecuted).

At a quick glance, this design looks like four identical vines, all growing upward with leaves shaded in two colors. However, a closer view reveals it is actually two sets of vines, light ones growing upward and dark growing downward, each filling the spaces between the other's leaves.

PERIODIC DESIGN A5 [SEVEN CIRCULAR BAND DESIGNS]

Drawn at Baarn, October 1950

Published in *Het Nederlandse bankbiljet en zijn vormgeving*, J. Bolten, 1987 [shown there on design F for bank note].

Related work: Designs for borders of circular vignettes on bank note, *f* 25, *Stevin* (unexecuted).

On this drawing, Escher shows portions of seven different periodic "frieze" designs.

These were used on a bank-note design to frame circular vignettes depicting scientific contributions by Simon Stevin. The circles are tangent, and Escher winds a band of a single design like an S curve around half of one circle and half of a neighboring circle, from one point of tangency to the next.

PERIODIC DESIGN A6 [LATTICE OF OVERLAPPING HEXAGONS]

Drawn at Baarn, October 1950

Colored pencil

69 × 80 mm (image)

Symmetry group *p3*

Published in *Het Nederlandse bankbiljet en zijn vormgeving*, J. Bolten, 1987.

Related work: Design for bank-note background, *f* 10, *van Leeuwenhoek* (unexecuted).

This design is based on drawing 11 in Escher's abstract motif notebook. In this version made in very small scale, Escher only uses two colors rather than four; it is almost impossible to recognize the geometric plan of the design. Each line of the lattice is outlined at its edges with one color, with a line of the second color in between. Three of these center "lines" of green meet at each 3-fold center of the design.

PERIODIC DESIGN A7 [DECORATED 3:4:5 RIGHT TRIANGLE]

Drawn at Baarn, c. 1951

Colored pencil

104 × 135 mm (image);

279 × 212 (sheet)

Symmetry group *pgg*

Related work: Design for bank-note background, *f* 25, *Stevin* (unexecuted).

This pattern is based on drawing 2 in Escher's abstract motif notebook; some preliminary sketches are on the pages facing that drawing. The coloring of this design is most unusual: it is a two-color counterchange. To see that the coloring is compatible with the symmetries of the pattern, it is treated as a four-color pattern. The blue triangles with white decoration may be labeled *b* and their counterchange images (white triangles with blue decoration) labeled *b′*; similarly the red triangles with white are labeled *r* and their counterchange images *r′*. Translation symmetries do not change any colors, but other symmetries of the pattern interchange pairs of colors:

half-turns interchange *b* and *b′* and interchange *r* and *r′*

glide-reflections (horizontal axis) interchange *b* and *r* and interchange *b′* and *r′*

glide-reflections (vertical axis) interchange *b* and *r′* and interchange *r* and *b′*.

PERIODIC DESIGN A8 [ENTWINED CIRCLES]

Drawn at Baarn, October 1950

Colored pencil

77 × 123 mm (image)

Symmetry group *p6*

Related work: Design G for bank-note background, *f* 25, *Stevin* (unexecuted).

Escher recorded designs of interlaced circles based on a square array of centers in his abstract motif notebook, and gathered there his loose drawings of similar designs based on a hexagonal array of centers. One such design is a preliminary drawing for this bank-note background (see page 93).

PERIODIC DESIGN A9 [OVERLAPPING CURVES]

Drawn at Baarn, 1953

Ink

197 × 190 mm (image);

273 × 215 mm (sheet)

Symmetry group *p6m*

Related work: Design for bank-note background, *f* 50, *Huygens* (unexecuted).

In the third round of designs for bank-note backgrounds, Escher proposed several symmetric line designs and moirés. On this single drawing, he shows portions of four separate periodic designs with the same symmetry. All have motifs of intersecting curves inside a circle, and each motif has the symmetry of a perfect snowflake or six-petaled flower.

PERIODIC DESIGN A10 [OVERLAPPING CURVES]

Drawn at Baarn, January 1953

Ink

163 × 163 mm (image);

280 × 190 mm (sheet)

Symmetry group *p4m*

Related work: Design for bank-note background, *f* 50, *Huygens* (unexecuted).

This grid of intersecting curves has the same symmetry as a simple grid of squares. Yet the carefully controlled varying distance between the curves gives the visual impression of a three-dimensional mesh draped over regularly spaced spheres. In 1945, Escher used a similar distortion of rectangular shapes to create the impression of a bulge in his lithograph *Balcony* (cat. 334).

PERIODIC DESIGN A11 [OVERLAPPING CURVES]

Drawn at Baarn, February 1953

Colored ink

171 × 171 mm (image)

Symmetry group *p4g*

Related work: Design for bank-note background, *f* 50, *Huygens* (unexecuted).

This line design in two colors is also based on a square grid, but now the curved lines form a pattern of waves that cross at right angles at centers of 4-fold rotation. Lines squeeze close to one another at reflection axes for the pattern; the visual effect is one of a rippling fabric.

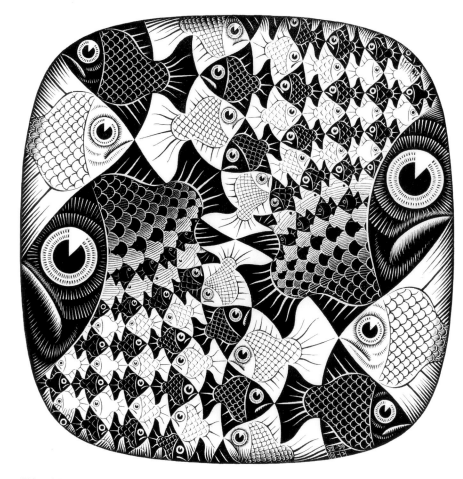

Fish and Scales; see notes, no. A13.

See notes, no. A12.

PERIODIC DESIGN A12 [LETTER E]

Drawn at Baarn, 1953

Pencil

212 × 163 mm (sheet)

Symmetry group *p2* [*pgg*]

Related graphic work: [*"E is een Ezel"* ("E is a donkey")], 1953. Wood engraving, 97 × 65 mm (cat. 392).

Escher made sketches of interlocked letter E's as he worked out designs for wood engravings to illustrate the letters M and E (Maurits Escher) for a booklet *Grafisch ABC* produced by the society De Grafische to be given to its donors. Two versions of the interlocked E's are sketched: upright and recumbent. Although both have translation symmetry, the first has both half-turn and glide-reflection symmetry (pgg), while the second has only half-turn symmetry (p2). In the print, Escher thickens the layer of letters, and removes one block of the jigsaw puzzle so that the braying donkey (*ezel*) can poke its head through.

PERIODIC DESIGN A13 [FISH]

Drawn at Baarn, February 1958

India ink

145 × 361 mm (image);
179 × 373 mm (sheet)

Symmetry group *pg*

Published in newspaper article in *Nieuwe Utrecht Dagblad*, February 1958.

Related graphic work: [*Fish vignette*], November 1956. Wood engraving, 81 × 81 mm (cat. 414).

　Whirlpools, November 1957 (cat. 423).
　Fish and Scales, July 1959. Woodcut, 378 × 378 mm (cat. 433).

Other related work: Two wall paintings, one in the family waiting room and the other in the aula, of the funeral service building at the Third Public Cemetery, Utrecht, 1958. Design drawing for aula (page 322), watercolor and gouache, diameter 170 mm (scale 1:20).

This is Escher's final design drawing for one of the two murals representing life-

passage that he painted in the fall of 1958. He used five different stencils to lay out this design; the finished wall painting was 101.5 × 280 centimeters, revised from the estimate on the drawing. The outline of the fish motifs in the design suggests they can half-turn or glide-reflect into an adjacent position; Escher chose the glide-reflection to create parallel rows of fish traveling in opposite directions. (The mirror-image mural noted by Escher on the drawing was never made.) The large companion mural (3.4 meters in diameter) at the front of the aula shows four spiraling streams: white fish represent birth and life, swimming outward from the center, while black fish make a return journey, ending in death. These fish, while similar in shape to those in the other mural, are depicted in a view from above to show the whorl. In 1956, Escher made a vignette of interlocked fish traveling in concentric circles; their outline is almost the same as those for the spiral

Aula mural design; see notes, no. A13.

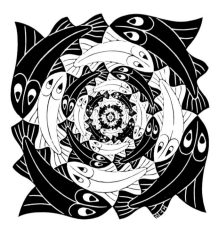

[*Fish*]; see notes, no. A13.

mural. This vignette is on the title page in his 1960 book *Grafiek en tekeningen*. While designing the Utrecht murals, Escher also made *Whirlpools*, in which the same fish from the vignette now follow a single path that begins and ends in a tightly coiled spiral. Leter, he used streams of interlocked fish (related in the same manner as those in drawing A13) in *Fish and Scales*. There, motifs are simultaneously fish or scales, depending on the scale at which the scene is read. The composition has half-turn symmetry, and there is the suggestion that the self-replication continues forever.

PERIODIC DESIGN A14 [FISH]
Drawn at Baarn, [c. July 1958]
India ink, pencil
209 × 160 mm (image);
209 × 165 mm (sheet)

Symmetry group *cm*

Related graphic work: *Sphere surface with Fish*, July 1958. Woodcut in gray, gold, and reddish brown, printed from three blocks, 340 × 340 mm (cat. 427).

Escher's dual fascination with spirals and with spheres led to the idea of depicting streams that spiral around a globe, traveling from pole to pole. He decided to use motifs to show the direction of movement and filled sketchbook pages with designs of arrows and of fish. He chose these symmetric black and white fish which all swim in the same direction for the woodcut *Sphere Surface with Fish*. The print shows a globe with the usual lines of latitude and longitude (printed in gold), and each stream of fish navigates a rhumb line using those grid lines as guideposts, and traces out a loxodrome. Three months later, Escher made the woodcut *Sphere Spirals* (cat. 428) which depicts four similar spiral bands that girdle a transparent sphere.

Sphere Surface with Fish; see notes, no. A14.

Concordance

When trying to access the scope of Escher's pioneering work in the field of periodic tilings and color symmetry, the kind of question most frequently asked is: How many of each type of "X" did Escher make? Escher's own table (which was on the first page of his second folio notebook of drawings) tabulates his drawings with recognizable motifs according to his various systems in the 1941–1942 notebook. The tables in this concordance contain additional information which can provide answers when that question "How many . . . ?" is asked with regard to the wide range of classifications used today; however the answers must be interpreted in light of Escher's personal assumptions and restrictions. He always required that adjacent motifs in a tiling be of contrasting color, and rarely broke the rule that a tiling use a minimum number of colors to achieve this. Since the number of possible types for various systems of classification of tilings and patterns have been determined by mathematicians and scientists according to their definitions and assumptions, there are necessarily many omissions of types in Escher's collection of examples. Reflection symmetry is rarely present in Escher's tilings; in fact, when it does occur, it is a consequence of using symmetric motifs or a result of meeting the design requirements for a commission. A few statistics at the end of this introduction to the tables partially summarize the scope of Escher's work.

The body of Escher's work listed in Tables 1, 2, and 3 consists of all periodic drawings reproduced in Chapter 3 (Escher's numbered folio drawings and 14 additional drawings) and the numbered drawings in the abstract motif notebook, which are identified by the prefix AM.

Notation and References. The *symmetry group* of a periodic design is the collection of all isometries (translations, rotations, reflections, and glide-reflections) which leave the design invariant; that is, they superimpose the design on itself so that it appears unchanged. There are 17 plane symmetry groups. Our tables use the now-standard notation for the symmetry group of a design: the short form of notation in the *International Tables for X-Ray Crystallography*. A table of comparative notation for the plane symmetry groups is useful when dealing with the early literature; such a table, as well as an explanation of the meaning of the current notation is contained in the article "The Plane Symmetry Groups: Their Recognition and Notation," by the author.

A tiling with congruent tiles is *isohedral*, or *tile-transitive*, if, for every choice of two tiles in the tiling, there is an element in the symmetry group of the tiling which sends one of the tiles onto the other. All but one of Escher's tilings with a single motif are isohedral. For the seven plane symmetry groups that do not contain reflections, H. Heesch characterized the 28 types of asymmetric tiles that are isohedral; his classification chart is reproduced here. For all 17 plane symmetry groups, B. Grünbaum and G. C. Shephard determined the 81 types of isohedral tiles; we use their notation for isohedral types. A table in their book *Tilings and Patterns* (pages 288–290) shows an illustrative tiling for each of the 81 types.

All Escher's periodic drawings have two or more colors and almost all are perfectly colored; that is, each symmetry of the uncolored design permutes the colors unambiguously. In a perfectly colored design, symmetries which permute the colors are called *color symmetries*; they are color-exchanging transformations of the design. A perfectly colored design has associated to it two groups: G, the symmetry group of the design considered as uncolored, and H, a subgroup of G which leaves one color fixed. This means that every isometry in H sends each motif of a particular chosen color to another one of the same color, while (perhaps) exchanging other colors. The pair (G,H) determines the *color symmetry group* of the design.

In the case of perfectly colored designs with two colors, the subgroup H which fixes one color necessarily fixes the other; in this case, H is the subgroup which fixes both colors. There are 46 two-color plane symmetry groups. In his articles "Coloured Symmetry" and "Escher's Lizards," H. S. M. Coxeter explains his notation G/H for the color symmetry group of a perfectly colored design with two colors; we use this notation in Table 3. There are many other notations in the literature; the book *Symmetries of Culture*, by D. K. Washburn and D. W. Crowe, has a table of comparative notations for two-color plane symmetry groups (pages 280–281). Escher made many designs with two motifs and two colors; in these the symmetry group is transitive on each set of congruent motifs (these are called *2-isohedral tilings*). When each motif occurs in each of the two colors, there are color symmetries of the design and it is classified according to its two-color symmetry group. However, many of the two-motif, two-color designs have all replicas of one motif the same color (there are no color symmetries of the design) and motifs which adjoin are of contrasting color. A. Dress calls these "Heaven and Hell" tilings [1986], after the design in Escher's drawing 45, which is prototypical. In Table 3, we denote such tilings by the symbol HH.

The difficulty of finding a characterizing notation for color symmetry groups of perfectly colored designs with three or more colors is discussed by Marjorie Senechal in her article "Color Symmetry." Her article "Color Groups" indicates which isohedral types of tilings can be perfectly colored with a specified number of colors. In *Tilings and Patterns*, Grünbaum and Shephard show illustrative patterns for the 46 two-color groups (pages 408–413) and illustrative patterns for the 23 three-color plane symmetry groups (pages 414–416). In *The Mathematical Theory of Chromatic Plane Ornaments*, T. W. Wieting shows illustrative patterns for the 96 four-color plane symmetry groups (pages 285–332). In Table 3, we reference the Grünbaum and Shephard examples (using their notation) for two-color groups and three-color groups and the Wieting examples (using his notation) for four-color groups.

We have not tabulated the symmetry groups of the spheres and polyhedra that Escher covered with repeating motifs. (The author cannot resist leaving at least one exercise for the reader.) A helpful reference for this task is "Spherical Tilings with Transitivity Properties," by B. Grünbaum and G. C. Shephard.

Some Statistics. There are seven plane symmetry groups without reflections: *p1, p2, p3, p4, p6, pg, pgg.* All are amply represented by Escher's

drawings. All but one of the 17 plane symmetry groups are represented in our tables; the missing group is *pm*. Escher was certainly aware of this symmetry type; he noted it in his investigations on symmetric patterns. Some of his bank-note background designs (not shown here) also show this symmetry. Of the 28 Heesch types of isohedral tiles (see next page), Table 1 shows that 22 are represented by Escher's drawings. Four of those missing from this table are in his 1941–1942 notebook: TTTTTT is Escher's system I^A-I^A (figure 2, notebook page 3), TCTCC is Escher's system II^A-III^A (center left, notebook page 4), CGG is Escher's system VII^D (lower right, notebook page 14), and $C_3C_3C_3C_3$ is Escher's triangle system I A_3 type 2. The Heesch type CC_3C_3 was specifically excluded by Escher when he stated in the notebook that he was not considering tilings in which more than six motifs meet at a single vertex. The remaining Heesch type, TCTGG, seems to have been missed.

There are 36 types of isohedral tiles without central symmetry that are not forced to have at least one edge a straight line segment; in his drawings, Escher shows examples of 28 of them. On page 4 of his 1941–1942 notebook, Escher shows all five of the asymmetric types of "Conway criterion" tiles [see Schattschneider, 1980]; he has many examples of four of these types in his drawings. There are 18 two-color groups in which reflection is not a color-exchanging symmetry; 14 of these are represented in Escher's drawings. There are 37 different types of two-color "Heaven and Hell" tilings in which each tile has at least three vertices [Dress, 1986]; Escher's drawings illustrate 11 of these. However, in these 11 are 8 of the 10 possible types of "Heaven and Hell" tilings with asymmetric tiles. Escher's drawings which are perfectly colored with three colors provide examples of 9 different three-color symmetry groups. An additional 2 examples can be found in his notebook. The remaining 12 three-color symmetry groups not found in his work all have reflection symmetry. Although Escher rarely used four colors, his 7 perfectly colored drawings with four colors tabulated in Table 3 represent 4 different four-color groups.

The statistics above give some idea of how many different symmetry types of colored periodic tilings are represented in Escher's work. However, these counts ignore what to many is the most imaginative aspect of his tilings—the motifs themselves. If we count categories (see the Index to Drawings by Motif), there are more than 40 "species" that populate his drawings, with birds, fish, and lizards most prevalent. Escher gave his reasons for the frequent use of these motifs in his "Theorie" notebook (pages 77–78), and elaborated these views in *Regelmatige vlakverdeling*. If each different motif in the collection of his drawings in Chapter 3 is counted, there are more than 235 distinct creatures and objects. The variety is extraordinary in light of the double restriction imposed on these motifs—severe geometric constraints had to be met in order for a motif to fill out a periodic tiling and, in addition, Escher required his motifs to be recognizable.

Heesch's table (above) classifying the 28 types of asymmetric tiles that can fill the plane in an isohedral manner without using reflections. From *Flächenschluss*, H. Heesch and O. Kienzele, 1963. The letters denote the geometric transformations that relate edges of the tile (edges are pieces of the boundary which join adjacent vertices). T = translation, G = glide-reflection, C = half-turn, C_3 = 120° rotation, C_4 = 90° rotation, C_6 = 60° rotation. The sequence of letters characterizing a tile is obtained by traveling a circuit around its boundary and associating to each edge the appropriate letter. Edges with a center of half-turn symmetry are related to themselves; other edges are related to an adjacent or to an opposite edge by a translation, glide-reflection, or rotation.

Escher's inventory of his numbered drawings according to his classification system (on the facing page). This chart was on the verso of drawing 25, which was the first page of his second folio notebook.

Inhoud van schriften I en II en III

67/?

systeem	groep	één-motief-systemen in 2 kleuren	2-motief-systemen in 2 kleuren	overgangs-systemen	één-motief overgangs-systemen in 3 kleuren	2-motief overgangs-systemen in 2 kleuren
I	A	38, 73, 74, 80	47, 48, 49, 50, 52,	IA → IA	(28) (drie motieven) X	18, 22, 29, 30, 72
	B	91*		IB → IA		76a, 82
	C			IC → IA		84, 87, 92
	D	105, 106, 127, 128		ID → IA		111, 112, 113, 114, 120, 121
II	A	75				27
	B					
	C	40*, 117				
	D		115	IIA → IIIA	1, 5, 6, 7, 8, 11,	
III	A	9, 88, 95		IIB → IIIA		
	B	93,		IIC → IIIA		
	C	51*		IID → IIIA		
	D	37*, 89*, 90,		IIID → IIIA		
IV	B	19, 62, 66, 67, 91*, 102	76	IIIC → IIIA		
	D	96		IIIA → IIIA		
V	C	31, 32, 71*, 97,	24, 26			
	D	108, 109, 110,		IIB → VC	77	34, 61, 63
VI	B	36, 77, 98, 116	41, 58,	IVD → VC		
	D			VD → VB		
VII	C	33, 107		VIB → VIIC	10,	
	D	124		VID → VIIC		
VIII	C	39,	68,	VID → VIB		
	D	86,		VIIC → VIIIC	2, 16,	46,
IX	D	12*, 13*, 15, 23, 104, 125		VIID → VIIIC		59, 60,
X	E	35, 101, 118, 119	45*	IXD → XE	3*, 14, 20,	

* = symmetrie

II) „Driehoek"-systemen

Type	Systeem A: slechts 3-tallige assen						Systeem B: 6-, 3-, en 2-tallige assen					
	één motief systemen IA			twee motief systemen IIA			één motief systemen IB			twee motief systemen IIB		
	2 kleuren IA2	3 kleuren IA3	4 kleuren IA4	2 kleuren IIA2	3 kleuren IIA3	4 kleuren IIA4	2 kleuren IB2	3 kleuren IB3	4 kleuren IB4	2 kleuren IIB2	3 kleuren IIB3	4 kleuren IIB4
C1												
C2												
1		4*, 21, 25,		53*, 54*			44, 94, 99, 100	55, 56	57,			
2					43,			70, 79,				
3												
4												

Table 3. SYMMETRY CLASSIFICATIONS FOR ESCHER'S PERIODIC DRAWINGS

Key to symbols in the last column: Those beginning with the number 4 refer to illustrations in Wieting, pp. 285–332. HH denotes a "Heaven and Hell" tiling [Dress, 1986]. For designs with three or more colors, NC denotes no color-changing symmetries. All other symbols for designs with two or three colors refer to illustrations in Grünbaum and Shephard, pp. 408–416. Notation for 2-color group: G (symmetry group of uncolored design)/H (subgroup that fixes colors).

Escher number	Escher system	Symmetry group	Number of motifs	Number of colors	Isohedral type	Heesch type	2-color group	Color symmetry group reference
1	IIA-IIIA	$p2$	1	3	IH4	TCCTCC		$p2[3]$
2	VIIIC-VIIC	pgg	1	3	IH6	CG$_1$CG$_2$G$_1$G$_2$		$pgg[3]$
2^1		pgg	1	4	IH27	CG$_1$G$_2$G$_1$G$_2$		4.12.01
3	IXD-XE*	$p4g$	1	3	IH29			none2
4	Tr I A$_3$ type 1*	$p31m$	1	3	IH16			$p31m[3]_1$
5	IIA-IIIA	$p2$	1	3	IH4	TCCTCC		$p2[3]$
6	IIA-IIIA	$p2$	1	3	IH4	TCCTCC		$p2[3]$
7	IIA-IIIA	$p2$	1	3	IH4	TCCTCC		$p2[3]$
8	IIA-IIIA	$p2$	1	3	IH4	TCCTCC		$p2[3]$
9	IIIA	$p2$	1	2	IH46	CCCC	$p2/p1$	$p2[2]_1$
10	VIIC-VIB	pgg	1	3	IH5	TCCTGG		$pgg[3]$
11	IIA-IIIA	$p2$	1	3	IH4	TCCTCC		$p2[3]$
12	IXD*	$p4g$	1	2	IH73		$p4g/cmm$	$p4g[2]_2$
13	IXD*	$p4g$	1	2	IH71		$p4g/cmm$	$p4g[2]_2$
14	IXD-XE	$p4$	1	3	IH28	CC$_4$C$_4$C$_4$C$_4$		none2
15	IXD	$p4$	1	2	IH55	C$_4$C$_4$C$_4$C$_4$	$p4/p2$	$p4[2]_2$
16	VIIIC-VIIC	pgg	1	3	IH27	CG$_1$G$_2$G$_1$G$_2$		$pgg[3]$
17	VC-IVB	pg	1	3	IH3	TG$_1$G$_2$TG$_1$G$_2$		$pg[3]_2$
18	IA-IA	$p1$	2	2				HH
19	IVB	pg	1	2	IH44	G$_1$G$_1$G$_2$G$_2$	$pg/p1$	$pg[2]_1$
20	IXD-XE	$p4$	1	4	IH28	CC$_4$C$_4$C$_4$C$_4$		4.04.01
21	Tr I A$_3$ type I	$p3$	1	3	IH7	C$_3$C$_3$C$_3$C$_3$C$_3$C$_3$		$p3[3]_1$
22	IA-IA	$p1$	2	2				HH
23	IXD	$p4$	1	2	IH55	C$_4$C$_4$C$_4$C$_4$	$p4/p2$	$p4[2]_2$
24	VC var 2	pg	2	2				HH
25	Tr I A$_3$ type I	$p3$	1	3	IH7	C$_3$C$_3$C$_3$C$_3$C$_3$C$_3$		$p3[3]_1$
26	VC var 2	pg	2	2				HH
27	ID-IA	$p1$	2	2				HH
28	I-I	$p1$	3	3				NC
29	IA-IA	$p1$	2	2				HH
30	IA-IA	$p1$	2	2				HH
31	VC	pg	1^3	2	IH43	TGTG	pg/pg	$pg[2]_2$
32	VC	pg	1	2	IH43	TGTG	pg/pg	$pg[2]_2$
33	VIIC	pgg	1	2	IH51	CGCG	pgg/pg	$pgg[2]_1$

Table 3. Continued

Escher number	Escher system	Symmetry group	Number of motifs	Number of colors	Isohedral type	Heesch type	2-color group	Color symmetry group reference
34A	IVB-VC var 3	pg	2	2			$pg/p1$	$pg[2]_1$
34B	IVB-VB	pg	2	2			$pg/p1$	$pg[2]_1$
34		pg	2	2			$pg/p1$	$pg[2]_1$
35	XE	$p4$	1	2	IH79	CC$_4$C$_4$	$p4/p4$	$p4[2]_1$
36	VIB	pgg	1	2	IH53	CCGG	pgg/pg	$pgg[2]_1$
37	IIID*	pmg	1	2	IH69		pmg/pm	$pmg[2]_4$
38	IA	$p1$	1	2	IH41	TTTT	$p1/p1$	$p1[2]$
39	VIIIC	pgg	1	2	IH52	G$_1$G$_2$G$_1$G$_2$	$pgg/p2$	$pgg[2]_2$
40	IIC*	pmg	1	2	IH66		pmg/pmg	$pmg[2]_1$
41	VIB var 2	pgg	2	2			pgg/pg	$pgg[2]_1$
42	VI-VII-VIII	$p4$	4	4				NC
43	Tr II A$_3$ type 2	$p3$	2	3				NC
44	Tr I B$_2$ type 1	$p6$	1	2	IH88	CC$_6$C$_6$	$p6/p3$	$p6[2]$
45	XE*	$p4g$	2	2				HH
46	VIIC-VIIIC var 2	pgg	2	2				HH
47	IA var 2	$p1$	2	2				HH
48	IA var 2	$p1$	2	2				HH
49	IA var 2	$p1$	2	2				HH
50	IA var 2	$p1$	2	2				HH
51	IIIC	$p2$	1	2	IH84	CCC	$p2/p1$	$p2[2]_1$
52	IA var 2	$p1$	2	2				HH
53	Tr II A$_2$ type 1*	$p31m$	2	2				HH
54	Tr II A$_2$ type 1*	$p31m$	2	2				HH
55	Tr I B$_3$ type 1	$p6$	1	3	IH31	C$_3$C$_3$C$_6$C$_6$		$p6[3]_1$
56	Tr I B$_3$ type 1	$p6$	1	3	IH31	C$_3$C$_3$C$_6$C$_6$		$p6[3]_1$
57	Tr II B$_2$ type 1	$p6$	2	2			$p6/p3$	$p6[2]$
58	VIB var 1	pgg	2	2			pgg/pg	$pgg[2]_1$
59	VIID-VIIID var 2	pgg	2	2				HH
60	VIID-VIIID var 2	pgg	2	2				HH
61	IVB-VC var 2	pg	2	2				HH
62	IVB	pg	1	2	IH44	G$_1$G$_1$G$_2$G$_2$	$pg/p1$	$pg[2]_1$
63	IVB-VC var 2	pg	2	2				HH
64		pgg	1	2	IH6	CG$_1$CG$_2$G$_1$G$_2$	pgg/pg	$pgg[2]_1$
65			1	2				
66	IVB	pg	1	2	IH44	G$_1$G$_1$G$_2$G$_2$	$pg/p1$	$pg[2]_1$
67	IVB	pg	1	2	IH44	G$_1$G$_1$G$_2$G$_2$	$pg/p1$	$pg[2]_1$
68	VIIC var 2 ?	pgg	2	2				HH
69	Triangle	$p3m1$	3	3				NC

Table 3. Continued

Escher number	Escher system	Symmetry group	Number of motifs	Number of colors	Isohedral type	Heesch type	2-color group	Color symmetry group reference
70	Tr I B$_3$ type 2	p6	1	3	IH21	CC$_3$C$_3$C$_6$C$_6$		p6[3]$_2$
71	VC	pg	12	2				NC
72	IA-IA	p1	2	2				HH
73	IA	p1	1	2	IH41	TTTT	p1/p1	p1[2]
74	IA	p1	1	2	IH41	TTTT	p1/p1	p1[2]
75	IIA	p2	1	2	IH47	TCTC	p2/p2	p2[2]$_2$
76	IV var 2	pg	2	2				HH
76a	IA var 2	p1	2	2				HH
77	VIB	pgg	1	2	IH53	CCGG	pgg/pg	pgg[2]$_1$
78	new system?	pg	1	3	IH2	TG$_1$G$_1$TG$_2$G$_2$		pg[3]$_1$
79	Tr I B$_3$ type 2	p6	1	3	IH21	CC$_3$C$_3$C$_6$C$_6$		p6[3]$_2$
80	IA	p1	1	2	IH41	TTTT	p1/p1	p1[2]
81	related to VIIID	pmm	4	4				NC
82	IA-IA	p1	2	2				HH
83			36	2				
84	IB-IA	p1	2	2				HH
85	Triangle	p3m1	3	3				NC
86	VIIID	p4g	1	2	IH71		p4g/cmm	p4g[2]$_2$
87	IB-IA	p1	2	2				HH
88	IIIA	p2	1	2	IH46	CCCC	p2/p1	p2[2]$_1$
89	IIID*	pmg	1	2	IH69		pmg/pm	pmg[2]$_4$
90	IIID	p2	1	2	IH46	CCCC	p2/p1	p2[2]$_1$
91	IB* also IVB*	cm	1	2	IH68		cm/pm	cm[2]$_3$
92	IB-IA	p1	2	2				HH
93	IIIB	p2	1^3	2	IH46	CCCC	p2/p1	p2[2]$_1$
93	IIIB	p1	2	2				HH
94	Tr I B$_2$ type 1	p6	1	2	IH88	CC$_6$C$_6$	p6/p3	p6[2]
95	Tr var IIIA	p2	1	2	IH84	CCC	p2/p1	p2[2]$_1$
96	IVD	pg	1	2	IH44	G$_1$G$_1$G$_2$G$_2$	pg/p1	pg[2]$_1$
97	VC	pg	1	2	IH43	TGTG	pg/pg	pg[2]$_2$
98	VIB	pgg	1	2	IH53	CCGG	pgg/pg	pgg[2]$_1$
99	Tr I B$_2$ type 1	p6	1	2	IH88	CC$_6$C$_6$	p6/p3	p6[2]
100	Tr I B$_2$ type 1	p6	1	2	IH88	CC$_6$C$_6$	p6/p3	p6[2]
101			1	2				
102	IVB	pg	1	2	IH44	G$_1$G$_1$G$_2$G$_2$	pg/p1	pg[2]$_1$
103	Triangle	p31m	1	3	IH36			p31m[3]$_2$
104	IXD	p4	1	2	IH55	C$_4$C$_4$C$_4$C$_4$	p4/p2	p4[2]$_2$
105	ID	p1	1	2	IH41	TTTT	p1/p1	p1[2]

Table 3. Continued

Escher number	Escher system	Symmetry group	Number of motifs	Number of colors	Isohedral type	Heesch type	2-color group	Color symmetry group reference
106	ID	p1	1	2	IH41	TTTT	p1/p1	p1[2]
107	VIIC	pgg	1	2	IH51	CGCG	pgg/pg	pgg[2]$_1$
108	VD	pg	1	2	IH43	TGTG	pg/pg	pg[2]$_2$
109	VD	pg	1	2	IH43	TGTG	pg/pg	pg[2]$_2$
109	II	pg border						
110	VD var 2	pg	2	2				HH
111	IC-IC	p1	2	2				HH
112	IC-IC	p1	2	2				HH
113	IC-IC	p1	2	2				HH
114	IC-IC	p1	2	2				HH
115	IID	p2	2	2				HH
116	VIB	pgg	1	2	IH53	CCGG	pgg/pg	pgg[2]$_1$
117	IIC*	pmg	1	2	IH66		pmg/pmg	pmg[2]$_1$
118	XE	p4	1	4	IH79	CC$_4$C$_4$		4.04.02
119	XE	p4	1	2	IH79	CC$_4$C$_4$	p4/p4	p4[2]$_1$
120	IC-IC	p1	2	2				HH
121	IC-IC	p1	2	2				HH
122		p4g	1	2	IH71		p4g/cmm	p4g[2]$_2$
123		p31m	1	3	IH36			p31m[3]$_1$
124	VIID	pgg	1	2	IH51	CGCG	pgg/pg	pgg[2]$_1$
125	IXD*	p4g	1^3	2	IH71		p4g/cmm	p4g[2]$_2$
125	IXD*	pg	2	2			pg/p1	pg[2]$_1$
126	from IV and V	pg	2	2			pg/pg	pg[2]$_2$
127	ID	p1	1	2	IH41	TTTT	p1/p1	p1[2]
128	ID	p1	1	2	IH41	TTTT	p1/p1	p1[2]
129	IC-IC	p1	2	2				HH
130	from IV and V	pg	2	2			pg/pg	pg[2]$_2$
131	related to VIII	p4g	1 or 3	2				NC
132		p4g	2	2^4			p4g/cmm	p4g[2]$_2$
133		pgg	2	2^4			pgg/p2	pgg[2]$_2$
134		pgg	2	2				NC
137	from Penrose	p6	1	3				none2
A1		cm	1	6	IH12			none2
A2		p1	4					
A3		cmm		3				NC
A4		pgg	1	2	IH6	CG$_1$CG$_2$G$_1$G$_2$	pgg/pg	pgg[2]$_1$
A5		borders						
A6		p3		2				

Table 3. Continued

Escher number	Escher system	Symmetry group	Number of motifs	Number of colors	Isohedral type	Heesch type	2-color group	Color symmetry group reference
A7		*pgg*	1	4^5	IH51	CGCG		4.12.01
A8		*p6*		3				NC
A9		*p6m*						
A10		*p4m*						
A11		*p4g*						
A12		*p2 [pgg]*	1	2	IH4	TCCTCC	*p2/p1*	$p2[2]_1$
A13		*pg*	1	2	IH44	$G_1G_1G_2G_2$	*pg/p1*	$pg[2]_1$
A14		*cm*	1	2	IH68		*cm/pm*	$cm[2]_3$
AM1	Triangle	*p31m*	3	3^4				$p31m[3]_2$
AM2	VIIC	*pgg*	1	2	IH51	CGCG	*pgg/pg*	$pgg[2]_1$
AM3	Triangle	*p6*	1	3	IH34			$p6[3]_2$
AM4		*p6*	2	2				NC
AM5		*p6*	2	2				NC
AM6		*p4*	1	2			*p4/p4*	$p4[2]_1$
AM7	Triangle	*p6*	2	2^4			*p6/p3*	$p6[2]$
AM8	Triangle	*p3*	3	3				NC
AM9	Triangle	*p3*	2	2				HH
AM10	Triangle	*p3*	3					NC
AM11	Triangle	*p3*	1^6	4				4.03.01

Notes

[1] 1926 print on fabric shown in Chapter 1.

[2] Not perfectly colored.

[3] Contour only is considered for this classification.

[4] Only colors that are permuted are counted.

[5] See notes on drawing A7 for interpretation as a perfectly colored design with four colors.

[6] A hexagon of one color is taken as the motif in this layered pattern.

Afterword

In the fourteen years since this book first appeared, much has happened to enrich its story. New information has been found that adds to the historical account of Escher's quest to unravel the secrets of "regular divisions of the plane." Interest in Escher's symmetry work has grown on scientific, artistic, and popular fronts. Questions and ideas arising from his tessellations have been explored. Computer technology and software have allowed effortless creation of periodic and other tilings, a boon for designers, scientific researchers, teachers, and hobbyists. The explosion of Internet usage and Internet postings has greatly increased awareness of Escher's work.

In 1998, the centennial of Escher's birth was celebrated around the world with exhibitions and conferences that brought new attention to all aspects of Escher's work; it also highlighted the work of many contemporary artists inspired by Escher. The museum exhibitions were thronged with visitors. Perhaps the greatest recognition of Escher's popularity was the opening of a new museum Escher in Het Palais, in The Hague, The Netherlands, which since fall 2002 has provided a permanent exhibition site for his work.

This new chapter allows us to briefly survey some new discoveries about Escher's story, discuss some mathematical problems posed by his symmetry work, note the impact of computers in raising awareness of Escher, and point to the contemporary work of several of his artistic heirs. In addition, we have added to our bibliographies new books, articles, videos, CD Roms and selected web sites that showcase the work of Escher and those inspired by him.

New discoveries

Another link between Pólya and Escher In the Fall of 1937, Escher embarked on his three-year exhaustive search to find and categorize geometric shapes that can produce a regular division of the plane. The impetus for this was an illustration of 17 tilings in a technical article by the mathematician George Pólya, which had been published in 1924 (see pages 22-31). A very unexpected recent occurrence allows us to add to that story. In spring 2003, many years after Pólya's death, two suitcases of his papers surfaced; they had been found in the attic of his house in Stanford, California. Among the papers were many yellowing pages and small notebooks that date from the 1920s and 1930s—over 250 pages of sketches and brief notes testify to his intention to write a book entitled "The Symmetry of Ornament," aimed at artists and laymen.

Unknown to Escher, who after 1937 filled little copybooks of squared paper with his sketches that would become tilings by creatures, Pólya had earlier filled his own copybooks with original sketches of geometric tilings and recorded many other examples from books on decorative art and ornament along with brief jottings of his ideas. Many of these pages

George Pólya's tiling of snakes.

On the back of the drawing, he notes the tiling appears better in reverse.

Sent to M.C. Escher, at his Uccle address. (Pólya papers, Stanford University Archives.)

and copybooks were stuffed into a manila envelope labeled in bold red crayon "Serious Design Research." Pólya had hinted in his 1924 article that he planned to write a book for laymen, and this intrigued Escher, who asked the mathematician in a 1937 letter whether this had been done. Pólya replied that it had not. The new evidence shows that Pólya had serious plans for such a book, but it never materialized beyond the stage of a rough outline and many sketched illustrations. Perhaps other mathematical interests took precedence, or the necessity to leave Zurich and resettle in America in 1940 forced him to abandon the project.

The reason Escher had written to Pólya in 1937 was to express his gratitude for the visual information he found in the mathematician's 1924 article and, in appreciation, he made a gift to Pólya of his print *Development I* (page 30). A few loose pages in the recent find give tantalizing evidence of the effect on Pólya of Escher's letter and print. On a large page of squared paper, Pólya sketched a rough tiling by snakes, and on the reverse side of the page, noted that this was sent to Escher at his Uccle address in Belgium. On the back of the drawing, the mathematician traced the reverse image of the snakes, remarking that this representation appears better. On a smaller page of squared paper, Pólya reproduced the snakes tiling in half scale with the direction of their travel reversed; this is likely the sketch he sent to Escher. The heads of Pólya's snakes are remarkably like the heads of Escher's lizards in *Development I*. Yet unlike Escher's compact coiled figures, Pólya's zigzag snakes are stretched out, interlocked in a simple, yet unusual manner, using only translations. In fact, this tiling of snakes is an example of Escher's system I^A-I^A, which is the first transitional system demonstrated in his Notebook (page 62). Polya's snakes tiling fills a gap in Escher's own storehouse of periodic drawings—all of Escher's examples of the I^A-I^A system have two different creatures interlocking, while Polya's sketch provides an example with just a single creature.

Perhaps Pólya's snakes in turn inspired Escher. In July 1941, Escher produced a symmetry drawing of snakes (no. 36, page 144); these creatures are unique among all his symmetry drawings. His snakes are sinu-

ous, a slithering mass of green and white bodies, their interlocking much more complex than Pólya's scheme, using half-turns and glide-reflections, an example of his system VIB. Yet the open jaw, and even the kinks of Polya's primitive snakes might have sparked the idea for Escher's unusual drawing.

Escher's two missing transitional systems With his lack of formal mathematical training, it is remarkable how much Escher discovered in his personal search to answer the question "What geometric rules govern the shapes of tiles in a regular division of the plane?" In the Concordance, we discuss the similarity of Escher's classification system for tiles to that of the mathematician H. Heesch, and document Escher's discovery of all but two of Heesch's 28 types of tiles that are "fundamental domains" for regular divisions that have no reflection symmetry (see pages 325–326).

Escher was puzzled when he tried to classify his drawing of unicorns (page 178); such a tile was missing from his Notebook pages of transitional systems (pages 62–69). In Heesch's notation, the unicorn tile's boundary can be labeled $TG_1G_1TG_2G_2$ (two opposite edges related by a translation, and two pairs of adjacent edges related by glide-reflections; see page 317). Where did the unicorn tile for drawing number 78 come from? Could this type of tile arise from one of Escher's quadrilateral systems using his method of "transition," pivoting a portion of the boundary of a tile into a new position? Does Escher derive such a tile in any of his many sketchbooks or loose pages documented on microfiche? The first question may never be answered satisfactorily; there is scant evidence in the sketches recorded on microfiche as to how Escher arrived at the unicorn outline. But in combing through his sketches, we found at least two other examples of rough tiles of this same Heesch type, $TG_1G_1TG_2G_2$. Both are contained on his sketch page shown below.

Pólya's smaller redrawing of the snakes, with their direction of travel reversed.

Escher's sketched tiling shows how he turned the tile into a bird, and at the right of the tiling, the suggestion of a fish; a different tile shape is at the upper right corner of the page. Both tiles are of the same Heesch type as his unicorn.

Escher's bird tile of Heesch type $TG_1G_1TG_2G_2$ can be obtained by transition. Begin with a tile of Escher's type IV, and pivot boundary piece AB to position AC. Make all tiles undergo the same change.

The sketch shows Escher beginning to smooth the edges of one tile into a standing bird; there are also faint traces of turning the same tile into a fish. Neither of these rough ideas were completed to a finished periodic drawing. If he had finalized this sketch into a periodic drawing of birds, it would have been his second in which all birds stand erect, rather than fly. In drawing 128 (page 221), all birds face the same way and a checker-board-like coloring with two colors suffices to make each individual bird recognizable. His rough sketch shown here is far more complex, with birds facing in opposite directions, and would require three colors for recognizability of individual tiles.

Somehow Escher had discovered this Heesch type, but with the exception of the unicorn, he used it only when making the outline of a double tile, that is, a locked pair of motifs, as in his drawing 126 (see page 317). Other double tiles of this type can also be found in drawings 24, 26, 110, and 130 (pages 134, 136, 207, and 223). It would have been possible for Escher to arrive at this type through his process of transition: in the illustration above we demonstrate how it can be done beginning with a tile of his type IV and arriving by transition at his own rough sketch of birds.

Since Escher clearly was aware of this Heesch tile type, why doesn't it appear as a transition in his Notebook? A possible explanation emerges when we look at all the transitions he did include, and infer from them what suppositions he made in choosing a piece of tile boundary to pivot. In all cases, he pivots a piece of boundary on one edge of the tile to a position where it is joined to an adjacent edge of the tile. However, these two adjacent edges are never related to each other by a motion (such as a glide-reflection). In the transition we show, the trick is to choose point A on an edge of a tile and C on an adjacent edge that is the glide-reflected image of the edge on which A lies, and then follow the transitional procedure to produce a new tiling.

Escher appears to have discovered this bird tile in an entirely different manner, one that he never documented explicitly in his Notebooks. In the latter section of his Notebook, he addresses ways in which to split tiles into two different shapes. We find on his page 23 (page 72), two ways to

split tiles in a tiling of type IVB. His variant 1 splitting carves a deep V into the interior of the tile, joining two adjacent vertices. While the new tile and the remainder of the original tile can join to form the original tile, *any* pair of different new tiles that are adjacent can also be joined to form a single new tile. And if that is done for one particular pair, the exact outline of Escher's bird tile is formed! The outline of the other tile on Escher's sketch page can also be produced from this same splitting. Our illustration at the right shows this derivation of the new tiles. Also on Escher's page 23 (page 72), Escher's splitting of type VC (variant 2) by joining opposite edges related by a glide-reflection also produces tiles that can be paired to produce Heesch type TG$_1$G$_1$TG$_2$G$_2$.

The Heesch tile type that Escher missed entirely, TCTGG (two opposite edges related by a translation, two adjacent edges related by a glide-reflection, and one edge having half-turn symmetry), intrigued computer scientist Kevin Lee, who reports in his article in *M.C. Escher's Legacy* that he was able to show that this type also can be obtained by transition, beginning with Escher's type VI. The sequence of transition is shown below. Had Escher found it, he would have named it VI-VI, since when the transitional process is complete, a new type VI tile emerges. How could Escher possibly have missed this? In examining his Notebook summaries of transitional systems and also searching his many sketches of trials of transitions, it is apparent that he never considered the case for a tile of type VI where a new edge arises by pivoting from one edge with a half-turn center to an adjacent edge with a half-turn center. All his trials and summaries show only the case where the new edge joins an edge with a half-turn center to one without a half-turn center. This always leads to the transition VI-VII. He devotes many pages of trials to showing the transitions between systems VI, VII, and VIII and includes an unusual three-way transition in his Notebook (page 69). His excitement in finding this three-way transition is shown with exclamation marks on several of his trial sketches and in his jotted comment on Notebook page 14 (page 67).

Escher's split tiles of type IV (page 72) reassemble to form his Heesch type TG$_1$G$_1$TG$_2$G$_2$ bird tile (colored blue). The second tile on his sketch page arises from amalgamating a different pair of tiles in this same splitting (colored green).

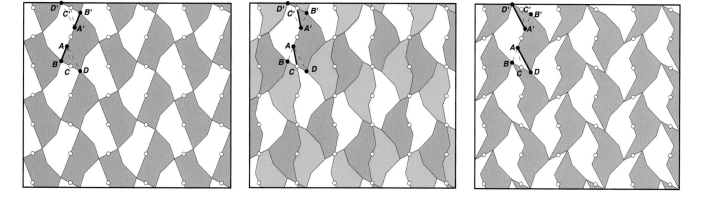

The transition Escher missed. (1) Begin with a tile of type VI, similar to that shown on page 63, top right. Small circles mark half-turn centers. (2) The boundary piece from *A* to *B* pivots about *A* to position *AC*, and the half-turn symmetry simultaneously replaces *A'B'* with *A'C'*, changing the shape of the tile. All tiles change in the same manner. The new edges created by the transition process are related by translation, so the tile is of the required type, TCTGG. (3) The pivoting continues so that boundary piece *AC* moves to position *AD*, *A'C'* moves to *A'D'*, and the final tile is again Escher's type VI.

The missing Heesch type TCTGG can arise from reassembling Escher's split tiles of type VII or VIII. Small circles mark half-turn centers. Several different amalgamations are possible from each splitting; two are colored here for each case.

A tiling by hypersymmetric birds, based on Escher's drawing 127.

Perhaps the satisfaction of this discovery led him to overlook the missing VI–VI transition.

The technique of beginning with a tiling by a single tile, splitting that tile into two new ones, and then gluing a pair of adjacent different new tiles to form a single new tile was an important discovery made by Escher. He seems not to have explored this methodically as he did his technique of transition. Had he done so, he would certainly have found all 28 of Heesch's types. The missing type TCTGG can be produced by splitting a type VII tile (variant 2) with a curve that joins half-turn centers on opposite edges or from splitting a type VIII tile by joining corresponding points on a pair of opposite edges, as seen on his Notebook page 25 (page 74) (see illustration at left). In fact, Escher's periodic drawing no. 68 (page 170) is one in which the two creatures can be fused into a single tile of this missing type.

Mathematical questions suggested by Escher's symmetry work

Escher posed his own geometric questions and methodically sought answers in order to create his tilings. He might be amused to know that his tilings continue to provide a source for questions posed and explored by mathematicians, computer scientists, and others.

Hypersymmetric tiles In his symmetry drawing 127 (page 220), Escher noted that the birds are "<u>apparently</u> 2-sided symmetric"; his careful sketch at the bottom of the drawing reveals the asymmetry of their wings. Escher's remark led mathematician Branko Grünbaum to ask: Could these birds be made truly symmetric and still tile the plane? He found the answer is yes, as the illustration at lower left shows. Unfortunately, in making the tiles symmetric, edges are forced to be parallel, so the motifs look more like airplanes than birds. What is interesting about this symmetric bird tile, however, is that the line that can split it into two matching mirror halves is not a mirror line of symmetry for the whole tiling, and there is no tiling by this tile in which the mirror symmetry of the tile is also a symmetry of the tiling. Grünbaum named such tiles "hypersymmetric" since they possess symmetry that no tiling by them possesses.

Did Escher make any tiles that are hypersymmetric? Escher always added an asterisk * to his classification symbol whenever a tile was symmetric; in every case but drawing 12 (page 125), the symmetry of the tile also is a symmetry of the tiling. Here it is the detail on the butterfly, not its outline, that causes it to be hypersymmetric. Escher classified according to outline, ignoring interior detail, and so we, too, are only interested in the shape of the tile. In that case even the butterfly of drawing 12 is not hypersymmetric. If we look at Escher's tilings in which the tiles are almost symmetric, we can ask if any of these tiles can be "symmetrized," that is, with minor adjustments to the outline, can they be made perfectly

symmetric yet still be recognizable as Escher's creature, and be able to tile in the same manner as Escher's tile? If so, we can then ask if the new tiles are hypersymmetric.

In addition to the birds in Escher's drawing 127, tiles that are almost symmetric occur in his drawings 38, 39, 46, 55, 70, 75, 79, 90, 102, 108, and 109 (pages 145, 146, 151, 158, 172, 176, 178, 189, 199, 205, and 206). Escher himself symmetrized the bugs in drawing 39 to make those in drawing 86 (page 185). The later drawing, he notes, is an "improvement of no. 39"; this might refer to the fact that the pattern was to be used on a greeting card and the symmetrized bugs better fit its rectangular outline. In the new drawing, the symmetry of the tiles induces mirror symmetry in the whole tiling, so the symmetrized bugs are not hypersymmetric. It also might appear that Escher symmetrized the feathery fish of drawing 90 (page 189) to produce those in drawing 89 (page 188). But in fact, the mirror-symmetric fish of drawing 89 can never fit together in the same manner as those in drawing 90. What about others in the list of candidates for symmetrization? The most obvious first choice to try to symmetrize is the tile of paired fish in drawing 46 (page 151) which Escher notes are "<u>apparently</u> symmetrical." It is not difficult to symmetrize the joined pair of fish so they still tile in the manner he devised. But the symmetrized tiles can also tile in a different manner, in which the mirror line of the tile is also a mirror line of the tiling (see illustration, upper right). So these new tiles also are not hypersymmetric. Escher's slight asymmetries in his fish in drawing 46 allow them to fit together only in the way he planned.

After examining all the possibilities for symmetrization listed above, we had success only with the rayfish in drawing 102. In all other cases, either the the symmetrized tile was not hypersymmetric, or the symmetrized tile was not recognizable as Escher's creature (for example, symmetrizing the butterfly of drawing 70 turns it into a pure trapezoid, and symmetrizing the fish in drawing 90 produces angular arrowheads, shown at right). The symmetrized rayfish from drawing 102 can fit together in the same way as in Escher's drawing, as well as in other ways (see below). But no tiling by this new tile has mirror symmetry, so the new tile is hypersymmetric. The mathematical question of categorizing all hypersymmetric tiles is unsolved—although many types of hypersym-

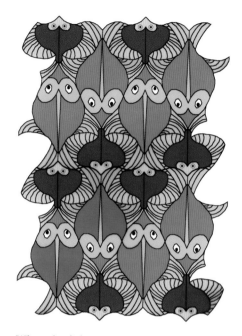

When the fish pair in Escher's drawing 46 are symmetrized, they can also tile in this manner, so they are not hypersymmetric.

Symmetrizing Escher's fish motif in drawing 90 produces a hypersymmetric tile that resembles an arrowhead.

Symmetrized fish, based on Escher's motif in drawing 102, can fit together in other ways, but cannot produce a tiling with mirror symmetry.

metric tiles have been found, there has been no definitive characterization of all that are possible.

Reconciling local and global symmetry Escher's definition of "regular division of the plane", adapted from a 1924 paper by mathematician F. Haag, required that all tiles be congruent and each tile be surrounded in exactly the same way (see pages 27, 112). Escher's system that categorized tiles capable of such tilings described only how a single tile was related (by translation, rotation, or glide-reflection) to each of the tiles that surrounded it (pages 57–61). When mathematicians and crystallographers seized on Escher's intriguing tilings by creatures to illustrate their system of classification of tilings by symmetry groups, they did not ask how he came to make his tilings. Conveniently, every one of his "regular division" drawings by a single creature satisfied their very different criterion of regularity, namely, tile-transitivity. This means that in a tiling, not only is each tile congruent to every other tile, but in addition, for every choice of two tiles in the tiling, there is a motion (a translation, rotation, reflection, or glide-reflection) that will take the first tile to the second and that same motion will also exactly superimpose the whole tiling on itself so that every tile fits exactly onto another tile. In other words, after the whole tiling has been acted on by such a motion, the repositioned tiling looks exactly the same. Mathematicians call such motions symmetries of the tiling, and say the tiling is tile-transitive, or isohedral. An obvious mathematical question to ask is: why does Escher's "local" condition of regularity seem to produce tilings that satisfy a very different "global" condition of regularity? In 1996, mathematician Nikolai Dolbilin and the author published two research articles that give some answers to this question. Most of Escher's tiles are asymmetric, and it was proved that this condition is enough to have Escher's condition produce tile-transitive tilings. In the few cases where his tiles are symmetric, an additional condition is satisfied that guarantees tile-transitivity. Although a proof that Escher's condition implies tile-transitivity has been proved for all polygons and for a large class of other tiles, there is not yet a proof for every possible tile shape. And, somewhat mysteriously, the implication is not true for tilings in space or in the hyperbolic plane.

"Escherizing" shapes into tiles In his essay "M.C. Escher at Work," George Escher describes how his father had the uncanny ability to see recognizable shapes in otherwise formless blobs and random scratches (page 109). It was this capacity that allowed the artist to begin with a tiling by simple polygons and bit by bit, tease each angular shape into a recognizable figure that could fill the plane (see, e.g., pages. 106–111). Many, if not most, of his early periodic drawings used this technique, transforming the geometric tilings of the Alhambra as well as some found in journal articles and other printed sources. Imagination, instinct, whimsy, and luck all come into play in this game, and success is rare. Often Escher had to abandon an idea with only a partial figure, the remainder impossible to complete, or unsatisfying to his critical eye and personal criteria. For example, it is quite possible that the rough sketch of the bird figure on page 337 was abandoned because of the bird's very thin legs. The outline failed to meet Escher's criterion recorded in his book *Regelmatige vlakverdeling*, that

"there should be no excessively deep or shallow indentations or bulges in the outline. These…make the figure [embedded in a tessellation] difficult to grasp in its entirety."

A slightly different, but related way to produce a tiling by recognizable figures, is to begin not with a simple tiling, but rather take just a single shape and mold it into one that can tile the plane. Once Escher had worked out his "layman's theory," he could begin with a rough idea for a motif and then see if its boundary could be made to conform to one of the tile types in his system. If so, then he was assured that it would produce a regular division of the plane. In 2000, computer scientists Craig Kaplan and David Salesin set themselves the problem of writing a computer program that could take any shape and attempt to "Escherize" it, that is, with as little distortion as possible, transform it into a shape that would tile the plane. The success of the program was demonstrated with their tiling by copies of an "Escherized" version of Escher's own 1929 self-portrait.

Escher's combinatorial patterns The experiments that Escher carried out from 1938 to 1942, producing scores of patterns by repeatedly sketching or printing a simple motif in a square grid according to a completely deterministic scheme was, for the artist, a pastime that eventually he tired of (see pages 44–52). Yet the combinatorial problems he set for himself as well as other problems suggested by his experiments have caught the eye of several mathematicians and computer scientists. Shortly after this book was published, the author received mail from two different computer scientists who wanted to determine exactly what Escher had done, and also to find, using a computer search, the answers to some of Escher's questions. Escher had posed the following problem for himself:

> *Choose an asymmetric motif, place it in a small square, then fill out a 2 × 2 grid of four squares with copies of this small decorated square in any orientation. Translate the filled 2 × 2 grid horizontally and vertically to fill the plane. How many different patterns can be produced by a single motif, following this algorithm?*

Escher, by sheer doggedness (sketching all possibilities), correctly answered the question when only rotated orientations of the motif-filled square (chosen from four possible) are allowed: there are 23 different patterns. When both rotated and reflected versions (eight possible) of the motif-filled square are allowed, the problem is much more difficult, and Escher only examined two special cases: (1) in the 2 × 2 grid, two motifs have the same rotated orientation, and two motifs have the same reflected orientation, and (2) in the 2 × 2 grid, two motifs have different rotated orientations, and two motifs have different reflected orientations. In case (1), Escher found (again, through an exhaustive search by sketching) the correct answer: 10 different patterns. In case (2), it appears that he lost interest near the end of his search, yet he managed to find 36 different patterns. A computer program written by Eric Hanson found the answer to a more general version of Escher's two restricted cases: he allowed the 2 × 2 grid to contain any two rotated copies and any two reflected copies of the motif-filled square. For this case, he found there are 67 different patterns,

Craig Kaplan and David Salesin's "Escherization" of the artist's self-portrait.

A computer-generated ribbon pattern from Escher's motif, following his algorithm and coloring rules. This design is unchanged by turning it over (interchanging all under-over relationships), and is produced by repeating the 2 × 2 block:

1	<u>3a</u>
3a	<u>1</u>

(See page 48).

and his program verified Escher's case 1 result of 10 patterns and determined 39 different patterns in Escher's case 2. Computer scientist Dan Davis pursued the most general problem: fill the 2 × 2 grid with any four orientations of the motif-filled square (chosen from 8 possible orientations). His computer program sorted through the 4096 possible choices for placements in the 2 × 2 grid and found there are just 154 different patterns generated; he also verified Hanson's results. Articles by the author and by Dan Davis give details on how mathematicians and computer scientists can approach and solve these problems.

Among the patterns that Escher produced with his experiments, the most intriguing, both from an aesthetic and a mathematical point of view, are those which appear to be interwoven ribbons. Using an algorithm similar to the one described above, he first printed the outline of a ribbon pattern using small carved square wooden blocks (with 16 possible orientations created by rotations, reflections, and interchanges of the under-over weave). He then hand-colored each design so that continuous strands were of a single color and strands that crossed had different colors (see pages 48-49). While Escher produced more than 30 of these colored interlaced patterns, he wisely never attempted to find out how many different patterns are possible. Those he did produce and display resemble real woven or knitted patterns; he hoped these would be of interest to tile manufacturers for commercial production. Unfortunately, his hopes were not realized.

The complexity of the ribbon patterns and their coloring according to Escher's rule provided a challenge to several mathematicians and computer scientists: Automate (by computer) the generation of the ribbon patterns and also their coloring. Rick Mabry and Stan Wagon wrote *Mathematica* programs to solve the problems, and in doing so, discovered that the coloring problem was far more thorny than they had imagined. The size of the rectangular patch of a pattern that could be colored (which they called the "Big Tile") and then repeated by translation to produce a consistent coloring of the pattern according to Escher's rules varied from pattern to pattern, and so there seemed to be no simple method to determine what this size was. Determining for any pattern (not just those with Escher's ribbon motif) that such a "Big Tile" always exists and that its size can be determined computationally became a Ph.D. thesis topic for Ellen Gethner, who successfully solved the problem by designing an efficient algorithm for constructing the Big Tile.

Today, those with access to the Internet can interactively create Escher's combinatorial ribbon patterns as well as original ones. Steve Passiouras's site "Escher Tiles" invites the user to choose how to fill the 2 × 2 grid of squares with copies of Escher's ribbon motifs and then instantly displays the allover ribbon pattern for that choice. How many different patterns can be generated from the 65,536 possible choices for placements of Escher's motifs in the 2 × 2 grid? Treating the patterns as real interlaced ribbons, with a front and back side, Passiouras, and independently Ellen Gethner and J. Joseph Fowler, have determined that there are 1124 different ribbon patterns when patterns are considered to be the same if one can be obtained from the other by rotating, translating, reflecting in a mirror, and/or turning over (turning over interchanges all the under-over relationships of the ribbons). Generalizations of Escher's algorithm and related problems continue to be rich sources of research problems.

Other tiles, other tilings Although Escher's investigations were guided by his definition of regular division of the plane, he also showed an interest in "irregular" divisions (his terminology). He produced two lithographs of interlocked figures in which no two of the tiles are the same (drawing no. 83, page 182 is one of these), and there is no suggestion that these blocks of figures can fill the plane by repetition. In his 1922 tessellation of eight heads, all the figures are different, but the block of eight can be repeated by translations to fill the plane (see page 8). Just as Escher was nearing the end of his career, some mathematicians and scientists began to take serious interest in tilings in which there were just one, two, or a small number of different tiles that repeated in interesting ways, but in which not every tile was surrounded in the same way.

A 2-isohedral tiling has the property that each tile is surrounded in one of two possible ways. All of Escher's tilings with two different motifs are 2-isohedral; in these all congruent tiles are surrounded in the same way (see pages 70–76). But it is also possible to have a 2-isohedral tiling with just one tile shape. Escher's last periodic drawing (page 137) is such an example; it was based on a puzzle of identical wooden pieces given to him by Sir Roger Penrose in 1962. In the drawing, Escher's little ghosts are congruent, but the heads of some ghosts meet the heads of five others, while the heads of some other ghosts meet the wings of two ghosts and the tail of a third. Every ghost tile falls into one of these two classes. Escher made this tiling shortly after receiving a letter from Penrose at the end of April 1971 explaining exactly how his puzzle piece was obtained from a rhombus by altering its four sides, and offering a rough sketch of a chicken that could tile in the same manner. Evidently the artist preferred to work out his own tile shape for the scheme (see pages 318–319).

Penrose's name today is widely known for his "Penrose tilings," which no doubt would have fascinated Escher. The most studied versions of these arise from tiling the plane with a pair of tiles—either two rhombuses, or a kite and dart—following strict rules as to how the edges of adjacent tiles are to be matched. There are an infinite number of tilings by these pairs, but none have translation symmetry (hence the pairs of tiles are called "aperiodic"). The Penrose pairs of polygons have also been adapted into recognizable Escher-like tiles. Robert Fathauer transformed the kite and dart into a scorpion fused with a diamondback rattlesnake and a Phoenix bird. Penrose himself transformed his kite and dart into a fat hen and skinny rooster. His puzzles *Gamebirds* and *Perplexing Poultry* with these pieces can be fiendishly challenging—the shapes of the tiles force one to follow his matching rules, but do not guarantee a successful tiling merely by placing pieces where they seem to fit. The small patch of a tiling shown has several circles of five hens or five roosters; this local five-fold symmetry occurs somewhat haphazardly throughout the tiling, and is typical in all Penrose tilings.

Escher's interest in capturing infinity in a finite space led him to devise tilings in which the figures are similar to one another and repeat forever, diminishing in size as they are pulled to a central point or creep to its boundary (e.g., see pages 249–253, 294, 296, 315, 322). This work anticipated that of several artists (and mathematicians) who today devise and study "self-similar" tilings. In these tilings, the figures repeat according to a geometric rule of scaling or a recursive algorithmic rule that dictates

A patch of tiling by Penrose's aperiodic hen and rooster tiles.

how, from a given part of the pattern, the next repetition on a smaller scale is to be produced. At the final stage, the tiling may fill out the interior of a circle, a square, or some other well-defined closed figure. The tiling also might have a more jagged final outline. Peter Raedschelders and Robert Fathauer have produced several original tilings of this kind by recognizable figures; many appear in *M.C. Escher's Legacy.* Robert F. Kauffmann is another Escher-inspired artist who makes original self-similar tilings. In all these, as in Escher's prints, the ever smaller repetitions (that theoretically continue forever) eventually end, limited by the hands' capabilities or by the resolution of a computer image. The print of birds by Peter Raedschelders shown here carries out four iterations of an algorithm that directs how, at the feet of each bird, two new birds repeat on a smaller scale. And, in the manner of Escher, this artist allows some of his creatures to escape their rigorously dictated positions.

Recursive rules can also lead to the production of figures that are "fractal"; such shapes have the strange property that at each stage in their creation, they are made up of repeated parts, each a scaled copy of the whole. Escher's print *Fish and Scales* (page 321), while not fractal, plays with this idea. Here, scales of the large fish are themselves smaller fish which, in turn, have scales. Fractal tiles often have outlines that are infinitely jagged, impossible to draw at the final stage. Some fractal outlines suggest creatures and are named accordingly—Benoit Mandelbrot was the first to name a fractal tile "twin dragon." Robert Fathauer has produced intertwined fractal serpents and a fractal dragon; Robert Kauffmann has produced "dragons" based on Mandelbrot's fractals. The "twin dragon" tile has the special property that its congruent copies can fit together to fill the plane in the manner of simpler tiles. Several mathematicians have described rules to produce such fractal tiles; Christoph Bandt is one of the pioneers in this field.

A self-similar tiling
by Peter Raedschelders.

The computer and Escher

The computer as a tool Computers came in to existence in Escher's lifetime, but they were then only for the technically trained. No one could have guessed that thirty years after his death, computers would be taken for granted, pervasive in their presence in offices, classrooms, homes, libraries, hotels, and even cafés. Many people have speculated how currently available computers and software might have affected Escher's work; my own view is that they would have affected it very little. Even though some technical tools were available to Escher in his time, he chose simple time-tested tools, relying on hand and eye to realize his ideas. Escher loved to sketch, to work out ideas with many trials, to understand and express with his hands—hands that connected pencil to paper, gouges to wood block, ink to roller; hands that patiently rubbed a small spoon against a block to create a unique print. A recent "Speed Bump" cartoon mimicked Escher's famous print of hands drawing hands; it shows a circuit of two hands, each with a computer mouse pointing a cursor at the other. But these could not be Escher's hands. Computer tools have not yet achieved the spontaneous, immediate, intuitive, tactile qualities of the artist's hands so beautifully expressed by Escher's print.

Although computers might have had little effect on Escher's technique, the capabilities of computers today allow almost anyone to use this tool to produce original tilings and patterns. In the 1970s, a frequent exercise in computer graphics courses was to write a program that could take some primitive motif as input and then output a pattern (on a screen or a plotter) that was generated by transformations of a specified symmetry group. To reproduce one of Escher's tilings was a difficult challenge. In the 1980s, with the advent of personal computers that had better graphics capabilities, commercial software based on the same principles became available; two early programs were "Escher Sketch" by Terry Flaherty, and "Symmetry Studio" by Timothy Binkley. As computer graphics capabilities continued to improve, and personal computers progressed with high speed and color, several more commercial programs were developed, and other programs were made available for downloading from the Internet or for interactive use on web sites. Today there are three essentially different types of programs to produce periodic tilings and patterns.

Programs of one type are based on the earlier models, but far richer in their capabilities. These take as input an imported picture or a motif drawn by the user and produce a repeating pattern with that motif, having a specified symmetry group. Two programs of note are *KaleidoMania!* by Kevin Lee, and *Spiegelkunstenaar* (Mirror Artist) by Hans Kuiper. Simple versions of interactive symmetry group-based programs can be found on the Internet. *Kali,* one of the first such programs, was originally developed by Nina Amenta for an SGI computer at the Geometry Center in Minneapolis and later was transformed by Mark Phillips into a Java program. With any of these programs based on symmetry groups, the user can, just by doodling or moving a cursor across a picture, instantaneously create a repeating pattern of a chosen symmetry type. For the casual user, rare instances of serendipity may produce a beautiful or

intriguing pattern; the program acts like an electronic kaleidoscope, multiplying a motif or picture fragment according to strict geometric rules. For the creation of a particular pattern or tessellation, however, the user must have knowledge of geometric transformations, how they interact, and the role of the hidden geometric grid that underlies a pattern. Such programs can be great incentives for learning about transformation geometry and symmetry, and educational materials for their classroom use are available.

Escher created his tessellations by first molding the shape of a single tile; the programs described above do not reflect his technique at all. Only since the mid 1990s have tile-based computer programs become available. *TesselMania!* and its successor, *Tessellation Exploration,* by Kevin Lee, use an approach much more like Escher's. The user chooses a polygon tile shape and selects the kinds of geometric transformations that will relate parts of its boundary to each other so that adjacent tiles will fit together like jigsaw pieces. The tile is then gradually deformed into a satisfying shape by using the cursor to poke and pull the boundary. The software knows that if an indentation is poked on one part of the tile boundary, then another part of the boundary is also affected, and carries out these other adjustments automatically. At any stage, the tessellation by the tile can be viewed; often the user is surprised to see copies of the tile upside down or reversed as they fit together. The CD Rom *Escher Interactive* provides a simple program based on similar principles, as does the web-based *Tess.* Although school students as well as hobbyists can find pleasure in producing "Escher-like" tessellations with these programs, their real value is in providing an enticing way to learn about how transformations govern the shapes and repetition in tessellations.

For those with geometric background, more general-purpose and flexible geometry software can be used to create tessellations. So-called dynamic geometry software allows users to sketch arbitrary geometric shapes and to use geometric transformations to transform parts or all of the shape. The user can sketch bits of the boundary of a tile with drawing tools controlled by the cursor, select some of these and dictate how the computer should rotate, reflect, or translate them to make up other parts of the boundary. At any stage, the tile outline can be manipulated to a desired shape by dragging the mouse. Finally, transformations specified by the user can repeat the tile to fill out a tessellation. *The Geometer's Sketchpad, Cabri Geometry,* and *Cinderella* are programs of this type. With these, the user has much more control (and responsibility) in producing a tessellation. The illustrations in our earlier sections on Escher's missing transition systems and hypersymmetric tiles were made with *The Geometer's Sketchpad.*

Special computer programs encourage exploration of hyperbolic tilings (like those in Escher's *Circle Limit* prints) and tilings of the sphere (as on Escher's carved wooden balls). Jeffrey Week's unique freeware program, *Kaleido Tile* allows the user to produce polygonal tessellations of the plane, the sphere, or the hyperbolic plane, and to explore their relationships by altering polygon angles or by dragging the cursor to change edge lengths of polygons. Dynamic geometry programs such as those described above can also be used to create "micro worlds" in which one can explore tilings of the hyperbolic plane and the sphere.

A tessellation of Donald Duck tiles made by Hans Kuiper with his software *Spiegelkunstenaar.*

Computer software engages students and others in playing the game of designing patterns and tilings and in this game, the players can gain appreciation for Escher's pioneering symmetry work. Not only in classrooms, but in hobby rooms as well, many attempt to approach Escher's prowess, and proudly display their efforts on bulletin boards both real and virtual.

At another level, the ever-expanding computational and graphics capabilities of computers have had an enormous impact on mathematical research about patterns and tilings of all kinds—not only of the types that Escher made, but also fractal tilings, self-similar tilings, nonperiodic tilings, and patterns and packings of three-dimensional space and spaces of higher dimensions. Researchers often write special computer programs in order to address questions in which visualization of tilings or vast computational power is necessary. We have already mentioned several examples of the use of computers in tackling problems that arise from Escher's symmetry work. Two additional examples are provided by the work of Douglas Dunham, who explores hyperbolic tilings, and has produced many based on Escher's motifs (several appear in *M.C. Escher's Legacy*), and also the work of Daniel Huson and Olaf Delgado whose program *FunTiles* was used to investigate the question of how new tilings can arise from isohedral tilings. They were able to prove that all 2-isohedral tilings can arise from isohedral tilings by a process of splitting the tiles into new ones and/or gluing tiles to form new ones, and the process can be repeated over and over again to produce all *k*-isohedral tilings. They were unaware that 50 years earlier, Escher had discovered and used this technique.

Despite my view that Escher would not have used computers to create his work, there is one use of the computer that Escher probably would have embraced: computer animation. In his prints, creatures from his tessellations move and morph—he did not want them to be forever trapped in the page, caged in their geometrically determined positions. He wrote about this in *Regelmatige vlakvedeling* (see page 243), and he had hoped to create a continuous scan of his *Metamorphosis III* for a lecture at his 1968 retrospective exhibition by slowly pulling a filmstrip of the lengthy print by a projector lens (see page 257). The flow of the creatures in this print and its earlier smaller version *Metamorphosis II* has suggested to many Escher's idea of animating it. Two films about Escher, *The Fantastic World of M.C. Escher* and *Maurits Escher: Painter of Fantasies,* used cameras to pan the story print. Today a web site shows a continuous scrolling of a digitized *Metamorphosis II* to advertise a Java program. In the film *Infinite Escher,* computer animation frees individual creatures in *Metamorphosis II* from their frozen positions and puffs them into colorful plastic beach toys that move. There are other animations as well. In the film *Escher, Van Gogh and Seurat: Art at Play,* the birds and fish in Escher's print *Sky and Water I* (page 263) come to life. Tessellations dance and morph in a video by Claude and Dominique Lamontgane on the CD Rom *M.C. Escher's Legacy.* On that same CD Rom, an animation by Rinus Roelofs shows how Escher's tiling by reptiles (drawing no. 25) can literally turn over to become the tiling by Chinese boys (drawing no. 4), demonstrating that tilings with the same underlying geometric grid, if suitably superimposed and cleverly cut in to jigsaw pieces, can be transformed into each other. Other programs can animate individual tiles; on the CD Rom *Escher*

Interactive, eleven of Escher's creatures can morph into one another or into any other shape the user provides. (Escher himself gave a frame-by frame view of how to morph a parallelogram into a bird or flying fish; see page 305.) And today, a few tessellation artists are able to carry out for their tiles what Escher could only imagine: on his web site *Tessellating Animation,* Makoto Nakamura's tessellated creatures leap, swoop, swim, and dissolve.

The Internet as a resource In 1960, the publication of *The Graphic Work of M.C. Escher* brought wide public attention to the relatively unknown Dutch graphic artist. Today, freely available information and thousands of images on the Internet have made his name and work known worldwide. The search engine Google reported that in 2002, Escher was among its top five most requested artists. In tribute, on June 17, 2003, Google made a birthday salute to Escher with a subtlety and wit befitting the artist: the OO in the Google logo on its title page was replaced by a hand emerging from each O in order to draw the neighboring O. Those who noticed the unofficial logo and clicked their cursor on the OO activated a page filled with postage-stamp size images of Escher works, each one with the URL (address) of a web site containing that image. The page also served as an advertisement for the search engine, which announced that there were 13,000+ sites with Escher images, found in 0.46 seconds (and all were listed in subsequent pages). That day, an avalanche of "hits" to the official Escher web site maintained by Cordon Art swamped their server, forcing it to shut down. Even so, they enjoyed the unique recognition given Escher.

The Internet can be mined for information of all kinds on Escher, posted on student-project web sites as well as slickly professional ones, and every gradation in between. The three museums with major collections of Escher's work, The National Gallery of Art in Washington, DC, The National Gallery of Canada in Ottawa, Ontario, and Escher in the Palace, a satellite of the Gemeentemuseum in The Hague, The Netherlands, all have web sites that give background on the artist and display some of his work. The latter two web sites have multiple media presentations with animations and videos in addition to text and images. The official M.C. Escher web site provides information and illustrations about Escher's life and work (including 58 of his symmetry drawings) and also news of exhibitions, information on copyright and licensing, downloads of three virtual reality films on Escher's prints with impossible structures, and links to many other sites. This and several other sites also carry information on the wide array of commercially available Escher memorabilia: reproductions, calendars, posters, books, videos, puzzles, ties, tee shirts, and the like.

In addition to the interactive web sites that enable anyone to make Escher ribbon patterns or original tessellations, there are also virtual galleries of work by contemporary artists and hobbyists inspired by Escher. Many of the artists have personal web sites to inform others about their work. A web site that drew much attention in 2002 explains and animates a mathematical "completion" of Escher's lithograph *Print Gallery.* Some web sites are especially valuable resources for teachers, supplementing books on transformation geometry, symmetry, and tessellations with

Google logo from June 17, 2003.

activities and links to other sites. The Internet is most often the portal to finding out more about Escher and the impact of his work on others, but this unregulated depository needs to be used with some caution. The quality of sites and the accuracy of information on them varies from excellent and informative to disappointing and inaccurate. Yet searches and the web of links that connect sites allow users to find many gems among them.

The artistic legacy of Escher's symmetry work

The events in 1998 that celebrated the centennial of Escher's birth not only brought new attention to the artist himself, but also identified many others who acknowledge Escher as their inspiration. A conference held in Rome and in Ravello, Italy (two special places in Escher's life) brought together many artists, scientists, educators, and others to share their insights on Escher's work and display their own creations. For an artist who in his lifetime felt that he was alone in his fascination with visual expression of mathematical ideas, and whose work was deemed by many in the academy as too cerebral, it was an affirmation of his rich legacy by those who continue to explore the artistic paths he blazed. They create tessellations and use them in two and three-dimensional art, depict concepts of infinity and duality, explore the artistic possibilities suggested by geometric objects, play with perceptual ambiguity, create illusions and impossible objects, depict unusual perspectives on plane and sphere, use mirrors and metamorphosis in surprising ways, and use animation and virtual reality to enter strange worlds. Articles and illustrations of the work of many of these contemporary artists appear in the book and CD Rom *M.C. Escher's Legacy.*

Escher lectured and wrote about the process of making tessellations; his lecture poster (page 35) was enlivened as he manipulated flourescent red-orange cardboard replicas of the poster tiles to demonstrate the actions of translation, rotation, and glide-reflection. Although he had struggled alone to figure out techniques to create tilings, he wanted to help others to understand. In this same spirit, many recent books and articles (in addition to the software discussed earlier) give instruction on how to make tessellations. Two authors are of particular note. Jill Britton, whose target audience is students (and their teachers) in middle-school and beyond, has several books and a rich web site dedicated to the subject of symmetry and tessellations. Jinny Beyer, a designer and quilt artist, uses her own vocabulary to explain to her audience of quilt-makers how to design and stitch quilts in which the pieces are not the traditional squares, but free forms that tessellate.

Among the many artists today whose work is inspired by Escher, the symmetry work of three deserves particular attention. The first is Marjorie Rice, whose story has some parallels with Escher's. Like Escher, she had no mathematical education beyond high school (where she had only general mathematics). Yet, as a busy mother of five, one of her recreations was to solve mathematical puzzles. Intrigued by a 1975 *Scientific*

Marjorie Rice's arrangement of seashells in this tessellation follows that of the underlying grid of congruent equilateral pentagons. Each distinct shell appears in six different orientations.

American column by Martin Gardner, she set out in her own way to solve a problem about tiling: *what are the various conditions on sides and angles of a pentagon that will guarantee it will tile the plane?* Nine classes of pentagon tiles had already been identified, yet in the course of a methodical and patient search lasting two years, she ultimately found four new classes. And also like Escher, whose favorite pentagon tiling (see pages 28, 224–227) is a hidden underlying grid in his tessellation of shells and starfish (page 148), she, too, used her pentagonal grids to produce some beautiful and complex tilings.

Makoto Nakamura not only devises tessellations by recognizable figures, but like Escher, uses them as integral parts of his fanciful compositions. In his paintings, interlocked flat figures gradually emerge into

Makoto Nakamura. *Forest of Memory.* 1994. Gouache.

three-dimensional form and walk, run, fly, or swim, creating the picture's story. But Nakamura also camouflages his tessellations as texture—in foliage, waves, feathers, and clouds. The discovery of these hidden interlocked creatures adds an extra measure of delight for the viewer. Nakamura has also explored three-dimensional layered tilings by various animal shapes. In these, the animal's body is outlined on a slab of wood, and other slabs that outline its legs, wings, and sometimes, ears, are added to both sides of the body in new layers. The three-layered tiles then fit together exactly and can be stacked to completely fill space.

Rinus Roelofs began a formal study of applied mathematics and after four years, changed direction and completed an art degree, concentrating in sculpture. Like Escher, he likes to work out ideas with hand-drawn sketches, but then uses computer software to turn those sketches into views of three-dimensional works that can be animated, printed as pictures, or have their data interpreted by special "3-D printers" into real models in wax or plastic. Just as Escher was fascinated by interwoven layers of grids of circles and of hexagons (see pages 87, 92–93, 226, 232), Roelofs also has explored such grids and the questions they suggest (see his article "Not the tiles, but the joints..."). One exploration led to an unusual sculpture. He began with a grid of three layers of interwoven regular hexagons, then shifted the layers a bit so that the pattern of a regular octahedron would fit the symmetry of the interlaced grid. He then cut out and folded the pattern into its three-dimensional form, wrapping the interlaced grid around the polyhedron. From that model, he noticed that

Rinus Roelofs. An interlacing of three grids of regular hexagons (above right) leads to a modified interlacing on the flat pattern of an octahedron (above left). Folding this up produces a grid-covered paper model of an octahedron (below right). Rendering the grid on the model as three-dimensional interlaced bands in space leads to a bronze sculpture (next page).

the bands outlining the hexagons all connected continuously, and if the white of the paper were to disappear, the interlaced bands could actually be realized as the interweaving of just one layer of the hexagons. Finally, he used the software *Rhinoceros* to turn his paper model into a pleasing sculpture that was cast in bronze.

In his 1958 book *Regelmatige vlakverdeling (The Regular Division of the Plane)* Escher opens by lamenting his artistic isolation in pursuing his fascination with symmetry:

> Why am I the only one fascinated by it?...
>
> In mathematical quarters, the regular division of the plane has been considered theoretically, since it forms part of crystallography. Does this mean that it is an exclusively mathematical question? In my opinion, it does not. Crystallographers have put forward a definition of the idea, they have ascertained which and how many systems or ways there are of dividing a plane in a regular manner. In doing so, they have opened the gate to an extensive domain, but they have not entered this domain themselves.... [A] long time ago, I chanced upon this domain in one of my wanderings.... Sometimes I think I have trodden all the paths and admired all the views; and then I suddenly discover a new path and experience fresh delights.
>
> I walk around all alone in this beautiful garden, which certainly does not belong only to me, but whose gate is open to everyone.

Today, Escher is not alone. His work has infected others with the same enthusiasm, and they walk not only the paths he trod, but, like him, discover new paths and experience fresh delights.

Rinus Roelofs

Ownership and Illustration Credits

Original works by M. C. Escher illustrated in this book are from the collections listed below. Ownership of each item is referenced by page number and identified by the name of the collection. Photographs of illustrations in this book may not be reproduced without permission of Cordon Art, B. V., Nieuwstraat 6, 3743 BL Baarn, The Netherlands. (Numbers in parentheses refer to Escher's periodic drawing number.)

Arnhem-GM	Arnhem Gemeentemuseum, Arnhem, The Netherlands.
Cooksey	Patrick C. Cooksey, United States.
Enchedé	Museum Enschedé, Postbus 114, 2000 AC Haarlem, The Netherlands. Illustrations are with permission of De Nederlandsche Bank.
Firos	Paul and Belinda Firos, Experience in Visual Arts Museum, Athens, Greece.
Hague-GM	Haags Gemeentemuseum, Stadhouderslaan 41, 2517 HV The Hague, The Netherlands.
Jerusalem	Charles and Evelyn Kramer Collection, Israel Museum, Jerusalem.
Mintz	Arthur and Abby Mintz, United States.
Nagasaki	Huis Ten Bosch, Nagasaki, Japan.
NGA	National Gallery of Art, Washington D.C., 20565, United States.
CVSR	The Cornelius van S. Roosevelt Collection.
Rosenwald	The Rosenwald Collection.
Schwarz	The Seymour and Iris Schwartz Collection.
O'Leary	George P. O'Leary, United States.
Price	Jeffrey Price, Stamford, CT, United States.
Private	Private collections, United States.
Sachs	Michael S. Sachs, Inc. P. O. Box 2837, Westport, CT 06680, United States.
Turner	Dr. Stephen R. Turner, Winston-Salem, NC, United States.
Veldhuysen	W. F. Veldhuysen, Nieustraat 6, 3743 BL Baarn, The Netherlands.
Von Ehr	James R. Von Ehr II, Texas, United States.
Walker	Rock J. Walker, San Diego, CA, United States.

124 (no. 10) Hague-GM
125 (nos. 11, 12) Von Ehr
125 (no. 13v) Hague-GM
126 (no. 13) Hague-GM
127 (no. 14) Hague-GM
127 (no. 15) Private
128 (no. 16) Walker
129 (no. 17) Walker
130 (no. 18) Hague-GM
130 (no. 19) Sachs
131 (no. 20) Hague-GM
132 (no. 21) Jerusalem
133 (no. 22) Hague-GM
133 (no. 23) Walker
134 (no. 24) Sachs
135 (no. 25) Hague-GM
136 (no. 26) Sachs
137 (no. 27) Private
137 (no. 28) Sachs
138 (no. 29) Sachs
139 (no. 30) Sachs
140 (no. 31) Sachs
140 (no. 32) Sachs
141 (nos. 33, 35) Hague-GM
142 (no. 34A) Sachs
143 (no. 34) Hague-GM
143 (no. 34B) Sachs
144 (no. 36) Von Ehr
145 (no. 37) Hague-GM
145 (no. 38) Sachs
146 (no. 39) Hague-GM
147 (no. 40) Turner
147 (no. 41) Nagasaki
148 (no. 42) Hague-GM
149 (no. 43) Private
150 (no. 45) Hague-GM
151 (no. 44) Von Ehr
151 (no. 46) Hague-GM
152 (nos. 47, 48) Sachs
153 (nos. 49, 50) Sachs
154 (no. 51) Sachs
155 (no. 52) Sachs
156 (no. 53) Sachs
157 (no. 54) Hague-GM
158 (no. 55) Sachs
159 (no. 56) Hague-GM
160 (no. 57) Sachs
161 (no. 58) Nagasaki
162 (no. 59) Hague-GM
163 (no. 60) Sachs
164 (no. 61) Nagasaki
165 (no. 62) Sachs
165 (no. 63) Hague-GM
166 (no. 64) Sachs
167 (no. 65) Hague-GM
168 (no. 66) Turner
169 (no. 67) Hague-GM
170 (no. 68) Turner
171 (no. 69) Sachs
172 (no. 70) Sachs
173 (no. 71) Hague-GM
174 (no. 72) Sachs
175 (nos. 73, 74) Turner
176 (no. 75) Hague-GM

177 (no. 76) Private
177 (no. 76a) Hague-GM
178 (no. 77) Hague-GM
178 (no. 78) Von Ehr
179 (no. 79) Sachs
180 (no. 80) Hague-GM
180 (no. 81) Sachs
181 (no. 82) Sachs
182 (no. 83) Hague-GM
183 (no. 84) Hague-GM
184 (no. 85) Veldhuysen
185 (no. 86) Turner
186 (no. 87) Sachs
187 (no. 88) Sachs
188 (no. 89) Hague-GM
189 (no. 90) Nagasaki
190 (no. 91) Hague-GM
191 (nos. 92, 93) Von Ehr
192 (no. 94) Walker
193 (no. 95) Von Ehr
194 (no. 96) Sachs
195 (no. 97) Mintz
196 (no. 98) Sachs
197 (no. 99) Hague-GM
197 (no. 100) O'Leary
198 (no. 101) Hague-GM
199 (no. 102) Turner
200 (no. 103) Hague-GM
201 (no. 104) Sachs
202 (no. 105) Hague-GM
203 (no. 106) Sachs
204 (no. 107) Sachs
205 (no. 108) Walker
206 (no. 109) Sachs
207 (no. 109II) Sachs
207 (no. 110) Veldhuysen
208 (nos. 111, 112) Hague-GM
209 (nos. 113, 114) Von Ehr
210 (no. 115) Sachs
211 (no. 116) Private
212 (no. 117) Sachs
213 (no. 118) Turner
214 (no. 119) Sachs
215 (nos. 120, 121) Firos
216 (nos. 122, 123) Hague-GM
217 (no. 124) Sachs
218 (no. 125) Sachs
219 (no. 126) Sachs
220 (no. 127) Sachs
221 (no. 128) Turner
222 (no. 129) Sachs
223 (no. 130) Sachs
224 (no. 131) Private
225 (no. 132) Sachs
226 (no. 133) Sachs
227 (no. 134) Walker
228 (no. 136) Sachs
229 (no. 137) Turner
230 (no. A1) Sachs
231 (nos. A2, A3) Sachs
232 (nos. A4, A5) Enschedé
232 (no. A6) Enschedé
232 (no. A7) Turner
232 (no. A8) Enschedé

232 (no. A9) Hague-GM
233 (no. A10) Hague-GM
233 (no. A11) Enschedé
233 (no. A12) Sachs
234 (nos. A13, A14) Sachs
239 NGA-CVSR
240, right Price
240, left, center Sachs
242, upper Sachs
244, left Hague-GM
244, center; right Sachs
246 (polyhedra) Sachs
246 (ball) NGA-CVSR
247 Sachs
258-262 *Metamorphosis III* NGA-CVSR
263 NGA-CVSR
265 NGA-CVSR
267 Sachs
269, lower Private
271, upper Sachs
271, left Jerusalem
271, lower right Private
272 NGA-CVSR
273, lower Sachs
276 NGA-CVSR
286, left von Ehr
286, right Sachs
288, upper left Hague-GM
292, center Arnhem-GM
292, right NGA-CVSR
293 NGA-Rosenwald
294, right NGA-CVSR
295 (tin) Sachs
297, lower Sachs
299, center Private
299, right Walker
299, lower Private
300, lower Private
301, lower NGA-CVSR
305, upper Sachs
306, left, center Hague-GM
306, lower Private
307, left NGA-CVSR
307, center; right Private
308 Sachs
309 (all) Private
310, upper right NGA-CVSR
311, upper left Private
311, lower left Hague-GM
313 Dutch Ministry of Agriculture and
 Fisheries
314 Sachs
315, upper NGA-CVSR
316, center NGA-CVSR
319 Sachs
322, upper Sachs
326 H. Heesch
327 Hague-GM
337 Sachs

Bibliography

1 B. G. ESCHER'S LIST OF REFERENCES SENT TO M. C. ESCHER ON NOVEMBER 1, 1937

Entries are in chronological order, as in the original.

Haag, F. "Die regelmässigen Planteilungen." *Zeitschrift für Kristallographie* 49 (1911): 360–369.

Haag, F. "Die regelmässigen Planteilungen und Punktsysteme." *Zeitschrift für Kristallographie* 58 (1923): 478–488.

Pólya, G. "Über die Analogie der Kristallsymmetrie in der Ebene." *Zeitschrift für Kristallographie* 60 (1924): 278–282.

Niggli, P. "Die Flächensymmetrien homogener Diskontinuen." *Zeitschrift für Kristallographie* 60 (1924): 283–298.

Haag, F. "Die Planigone von Fedorow." *Zeitschrift für Kristallographie* 63 (1926): 179–186.

Niggli, P. "Die topologische Strukturanalyse I." *Zetischrift für Kristallographie* 65 (1927): 391–415.

Niggli, P. "Die topologische Strukturanalyse II." *Zeitschrift für Kristallographie* 68 (1928): 404–466.

Laves, F. "Ebenenteilung in Wirkungsbereiche." *Zeitschrift für Kristallographie* 76 (1931): 277–284.

Laves, F. "Ebenenteilung und Koordinationszahl." *Zeitschrift für Kristallographie* 78 (1931): 208–241.

Heesch, H. "Über topologisch gleichwertige Kristallbindungen." *Zeitschrift für Kristallographie* 84 (1933): 399–407.

2 WORKS BY M. C. ESCHER

ARTICLES

"Antisymmetrical arrangements in the plane, and regular three-dimensional bodies as sources of inspiration to an artist." *Acta Crystallographica* 13 (1960): Abstract 14.1, 1083.

"Hoe ik er toe kwam, als graficus, ontwerpen voor wandversiering te maken." *De Delver* 14, no. 6 (March 1941): 81–86. In *Het oneindige,* ed. W. J. van Hoorn et al, 93–99.
> Translation:
> "How did you as a graphic artist come to make designs for wall decorations?" Translated by Karin Ford, in *Escher on Escher,* 83–88.

"Inleiding." ("Introduction.") *Catalogus M. C. Escher, no. 118.* Amsterdam: Stedelijk Museum, late summer 1954.

"Nederlandse grafici vertellen van hun werk." *Phoenix Maandschrift voor Beeldende Kunst* 2, no. 4 (June 1947): 90–95.

"Oneindigheidsbenaderingen." In *De wereld van het zwart en wit,* ed. J. Hulsker, 41–49. Amsterdam: Wereld-Bibliotheek, 1959. Also in *De werelden van M. C. Escher,* ed. J. L. Locher. Also in *Het oneindige,* ed. W. J. van Hoorn et al, 138–142.
> Translations:
> "Approaches to Infinity." In *The World of M. C. Escher,* 37–40.
> "Approaches to Infinity." Translated by Karin Ford, in *Escher on Escher,* 123–127.

"Preface." *Symmetry Aspects of M. C. Escher's Periodic Drawings* by C. H. MacGillavry. Utrecht: Oosthoek, 1965. Reprinted as *Fantasy and Symmetry,* 1976.

"Samuel Jessurun de Mesquita." In *Catalogus tentoonstelling S. Jessurun de Mesquita and Dr. J. Mendes da Costa,* 6–10. Amsterdam: Stedelijk Museum, March–April 1946.

"Timbre-poste pour l'aviation." *Les timbres-poste des Pays-Bas de 1929 à 1939,* 59–60. The Hague: 1939.

PUBLISHED LECTURE TEXTS

"Het onmogelijke," lecture given November 9, 1963 at the home of Garmt Stuiveling. In *Het oneindige,* ed. W. J. van Hoorn et al, 151–152.
> Translation:
> "The Impossible." Translated by Karin Ford, in *Escher on Escher,* 135–136.

Lecture given November 16, 1953 to Friends of the Stedelijk Museum in Alkmaar. In *Leven en werk van M. C. Escher,* ed. F. H. Bool et al, 71–74.
> Translation:
> Translated by Tony Langham and Plym Peters, in *M. C. Escher: His Life and Complete Graphic Work,* 70–73.
> Excerpts published as "On Being a Graphic Artist" in *M. C. Escher: 29 Master Prints,* 4–6.

"Perspectief," lecture given in March 1954 at the Haags Gemeentemuseum and in Leiden. In *Het oneindige,* ed. W. J. van Hoorn et al, 143–150.
> Translation:
> "Perspective." Translated by Karin Ford, in *Escher on Escher,* 128–134.

Lecture given in March 1961 to the Rotary Club in Baarn about his sea voyage to Canada in 1960. In *Leven en werk van M. C. Escher,* ed. F. H. Bool et al, 103–114.
> Translation:
> Translated by Tony Langham and Plym Peters, in *M. C. Escher: His Life and Complete Graphic Work,* 103–114.

Lecture texts (in English) prepared for 1964 United States lecture tour. In *Escher on Escher,* edited by Janet Wilson, 25–53 and 54–80. The title "The Lectures That Were Never Given" is misleading; see Loeb 1982.

Acceptance speech upon receiving the Culture Prize of the City of Hilversum, March 5, 1965. In *Het oneindige,* ed. W. J. van Hoorn et al, 22–26. Excerpts in *Leven en werk van M. C. Escher,* ed. F. H. Bool et al, 125.
> Translations:
> "A graphic artist with heart and soul." Translated by Karin Ford, in *Escher on Escher,* 19–22.
> Excerpts translated by Tony Langham and Plym Peters, in *M. C. Escher: His Life and Complete Graphic Work,* 124–125.

PUBLISHED INTERVIEWS OF ESCHER

"M. C. Escher: Op-art graficus? AO-dialoog met Maurits C. Escher." *Actuele Onderwerpen - reeks boekje 1172.* Amsterdam: Actuele Onderwerpen, 1967.

Bibeb, "M. C. Escher: Ik vind wat ik zelf maak het mooiste en ook het lelijkste" ("What I myself make seems to me the most beautiful and the most ugly"). In *De mens is een ramp voor de wereld (People are a Disaster for the World),* 68–84. Amsterdam: Van

Gennep, 1969. Originally published in *Vrij Nederland*, April 20, 1968.

PUBLISHED LETTERS

"Wit-grijs-zwart." *Mededelingen van 'De Grafische'* no.13 (September 1951): 8–10; no. 20 (November 1953): 7–10; no. 24 (February 1956): 14–15 and 15–17. In *Het oneindige*, ed. W. J. van Hoorn et al, 19–21.
> **Translation:**
> "White-Gray-Black." Translated by Karin Ford, in *Escher on Escher*, 16–18.

"Het ambacht," an open letter to Oey Tjeng Sit. *Het Mededelingenblad van de Nederlandse Kring van Grafici en Tekenaars* no. 5 (December 1950): 4–7. In *Het oneindige*, ed. W. J. van Hoorn et al, 13–15.
> **Translation:**
> "The Craft." Translated by Karin Ford, in *Escher on Escher*, 10–12.

"Onze broeder," an open letter to Oey Tjeng Sit. *Het Mededelingenblad van de Nederlandse Kring van Grafici en Tekenaars* no. 3 (June 1950): 5–7 and 19–20. In *Het oneindige*, ed. W. J. van Hoorn et al, 16–18.
> **Translation:**
> "Our Brother." Translated by Karin Ford, in *Escher on Escher*, 13–15.

Rudolf Escher en M. C. Escher. Beweging en metamorfosen. Een briefwisseling. Letters between M. C. Escher and Rudolf Escher; foreword by L. D. Couprie. Amsterdam: Muelenhoff, 1985.

Excerpts of many of Escher's letters to his sons and to various friends are used to chronicle his thoughts and activities in *Leven en werk van M. C. Escher*, ed. F. H. Bool et al.
> **Translation:**
> Translated by Tony Langham and Plym Peters, in *M. C. Escher: His Life and Complete Graphic Work*.

BOOKS AND PAMPHLETS

Grafiek en tekeningen M. C. Escher. Contribution by P. Terpstra. Zwolle: J. J. Tijl, 1960 (first printing 1959). Revised and enlarged edition, 1966.
> **Translations:**
> *The Graphic Work of M. C. Escher.* London: Oldbourne Book Co., 1961.
> *The Graphic Work of M. C. Escher.* New York: Duell, Sloan and Pearce, 1961.
> *The Graphic Work of M. C. Escher.* Revised and expanded edition. Translated by John E. Brigham. New York: Meredith, 1967.

Regelmatige vlakverdeling. Limited edition of 175 numbered copies. Utrecht: Stichting De Roos, 1958. In *Leven en werk van M. C. Escher*, ed. F. H. Bool et al, 155–174. Also in *Het oneindige*, ed. W. J. van Hoorn et al, 101–137.
> **Translations:**
> *The Regular Division of the Plane.* Translated by Tony Langham and Plym Peters, in *M. C. Escher: His Life and Complete Graphic Work*, 155–173. Also in *M. C. Escher (1898–1972). Regular Divisions of the Plane at the Haags Gemeentemuseum*, ed. Flip Bool, 8–49.
> *The Regular Division of the Plane.* Translated by Karin Ford, in *Escher on Escher*, 90–127.

M. C. Escher. Polygoon filmstrip K766. Commentary to accompany set of thirty-five 35 mm color slides. Text in English, French, and German. Hilversum, The Netherlands: N. V. Filmfabriek Polygoon, 1966.

BOOKS ILLUSTRATED BY ESCHER

Escher, M. C. and Drijfhout, A. E. *XXIV Emblemata, dat zijn zinnebeelden.* (Epigrams by A. E. Drijfhout (G. J. Hoogewerff) and woodcuts by M. C. Escher.) Bussum, The Netherlands: C. A. J. van Dishoeck, 1932.

Stolk, A. P. van. *Flor de Pascua—Spreuken 14, vers 33.* (*Easter Flower—Proverbs 14, verse 33.*) Baarn, The Netherlands: Hollandia Drukkerij, 1921.

Walch, Jan. *De vreeselijke avonturen van Scholastica.* Bussum, The Netherlands: C. A. J. van Dishoeck, 1933.

NOTEBOOKS, SKETCHES, AND DRAWINGS

M. C. Escher: The authentic collection of all Escher drawings from the Gemeentemuseum, The Hague, on microfiche. Zug, Switzerland: Inter Documentation Company, 1980. (Includes copybooks and notebooks.

3 WORKS ABOUT THE LIFE AND WORK OF M. C. ESCHER

BOOKS

Bool, F. H., J. R. Kist, J. L. Locher, and F. Wierda. *Leven en werk van M. C. Escher.* Amsterdam: Muelenhoff, 1981.
> **Translation:**
> *M. C. Escher: His Life and Complete Graphic Work.* Translated by Tony Langham and Plym Peters. New York: Harry N. Abrams, 1982; Abradale Press, 1992.

Bool, Flip, ed., and Ruth Koenig, trans. *M. C. Escher (1898–1972). Regular Divisions of the Plane at the Haags Gemeentemuseum.* (In Dutch and English.) The Hague: Haags Gemeentenuseum, 1986.

Coxeter, H. S. M., M. Emmer, R. Penrose, and M. L. Teuber, eds. *M. C. Escher: Art and Science.* Amsterdam: North-Holland, 1986. Thirty-six articles which comment on Escher's work. Articles referred to in our text are listed separately.

Emmer, Michele. *Il fascino enigmatico di Escher.* Naples: CUEN, 1989.

Ernst, Bruno (J. A. F. de Rijk). *De toverspiegel van M. C. Escher.* Amsterdam: 1976.
> **Translation:**
> *The Magic Mirror of M. C. Escher.* Translated by John E. Brigham. New York: Random House, 1976; Taschen America, 1995.
> ———. *Escher Tovenaar op Paper* (in Dutch). Zwolle, The Netherlands: Waanders, 1998.

Fellows, Miranda, and Bridgeman Art Library. *The Life and Works of Escher.* Bristol, UK: Parragon, 1995.

Hazeu, Wim. *M. C. Escher. Een biografie* (in Dutch). Amsterdam: Muelenhoff, 1998.

Hoorn, W. J. van, and F. Wierda, eds., with a contribution by J. W. Vermeulen. *Het oneindige: M. C. Escher over eigen werk.* Amsterdam: Muelenhoff, 1986.
> **Translation:**
> *Escher on Escher: Exploring the Infinite.* Translated by Karin Ford and edited by Janet Wilson. New York: Harry N. Abrams, 1989.

Locher, J. L., C. H. A. Broos, M. C. Escher, G. W. Locher, and H. S. M. Coxeter. *De werelden van M. C. Escher.* Amsterdam: Muelenhoff, 1971.

Translation:
The World of M. C. Escher. New York: Harry N. Abrams, 1972.

M. C. Escher International Ex Libris Competition: Homage to the Dutch Graphic Artist M. C. Escher. Foreword by W. F. Veldhuysen, essay by Jos van Waterschoot. Baarn, The Netherlands: M. C. Escher Foundation, 1999.

M. C. Escher's Universe of Mind Play (exhibition catalog). Tokyo: Odakyu Department Store, 1983.

Schattschneider, Doris, and Michele Emmer, eds. *M. C. Escher's Legacy: A Centennial Celebration* (with CD Rom). Berlin and Heidelberg: Springer-Verlag, 2003. Forty articles that comment on Escher's work and his influence on contemporary artists. Articles referred to in our text are listed separately.

Thé, Erik, designer. *The Magic of M. C. Escher.* Introduction by J. L. Locher and foreword by W. F. Veldhuysen. New York: Harry N. Abrams, 2000.

Vermeulen, J.W. *M. C. Escher, een eigenzinnig talent* (in Dutch). Kampen: Kok Lyra,1995.

Wegman, William, designer. *M C. Escher: 29 Master Prints.* New York: Harry N. Abrams, 1983.

ARTICLES
Albright, T. "Visuals—Escher." *Rolling Stone* 52 (1970).

Broos, C. H. A. "Escher: Science and Fiction." In *The World of M. C. Escher*, ed. J. L. Locher, 29–36. 1972.

Coxeter, H. S. M. "The Mathematical Implications of Escher's Prints." In *The World of M. C. Escher*, ed. J. L. Locher, 49–52. 1972.

———. "The Non-Euclidean Symmetry of Escher's Picture 'Circle Limit III'." *Leonardo* 12 (1979): 19–25, 32.

———. "Angels and Devils." In *The Mathematical Gardner*, ed. David A. Klarner, 197–209 & Plate IV. Boston: Prindle, Weber & Schmidt, 1981. Book reprinted as *Mathematical Recreations: A Collection in Honor of Martin Gardner*. Mineloa, NY: Dover, 1998.

Ebbinge Wubben, J. C. "M. C. Escher: 'Noodlot'." *Openbaar Kunstbezit* 1 (1957): 6a–6b.

Emboden, William A., Jr. "To Cast a Lovely Dream: Natural History and the Art of M. C. Escher." *Terra* (Natural History Museum of Los Angeles County) 11, no. 2 (Fall 1972): 3–8, 10.

Ernst, Bruno (J. A. F. de Rijk). "The Vision of a Mathematician." In *M. C. Escher: His Life and Complete Graphic Work*, ed. F. H. Bool et al, 135–154. 1982.

Escher, George A. Reminiscences of my father and his work, in a letter to C. V. S. Roosevelt , June 8, 1974.

———. "Letter to the Editor." *Scientific American* 232, no. 1 (January 1975): 8–9. See Marianne L. Teuber 1974.

———. "A Son's Memories of His Father." In *M. C. Escher, His Life and Complete Graphic Work*, ed. F. H. Bool et al, 40–46. 1982.

———. "M. C. Escher at Work." In *M. C. Escher: Art and Science*, ed. H. S. M. Coxeter et al, 1–11. 1986.

———. Letter to the Author, December 22, 1989.

"Escher's Eerie Games." *Horizon* 8, no. 4 (1966): 110–115.

"Everyman's Artist (The Work of M. C. Escher)." *Brewer's Guild Journal* 46, no. 548 (June 1960): 333–344.

Flocon, Albert. "A la frontière de l'art graphique et des mathématiques: Maurits-Cornelis Escher." *Jardin des Arts* 131 (1965): 9–17.

"The Gamesman." *Time* (October 25, 1954): 68.

Gardner, Martin. "The Eerie Mathematical Art of Maurits C. Escher." *Scientific American* 214 (April 1966): 110–121. In

Mathematical Carnival. Washington, D. C.: Mathematical Association of America, 1989.

Graham, John L. "Frame of Reference in the Graphic Work of M. C. Escher." Master's thesis, Calfornia State College, Sonoma, 1977.

's-Gravesande, G. H. "Nieuw werk van M. C. Escher." *Elsevier's geïllustreerd mandschrift* 48, deel 96 (1938): 312–314.

———. "M. C. Escher en zijn experimenten: een uitzonderlijk graphicus." *De vrije bladen* 17, no. 5 (May 1940): 3–32.

———. "De graphicus M. C. Escher." *Halcyon* 1, no.1–4 (1940).

———. "De graphicus M. C. Escher." *Boekcier* 1, no.4 (August 1946): 25–27.

———. "M. C. Escher en de zwarte kunst." *Maandblad voor beeldende kunsten* 20, no. 1 (1948): 18–21.

Grünbaum, Branko. "Mathematical Challenges in Escher's Geometry." In *M. C. Escher: Art and Science*, ed. H. S. M. Coxeter et al, 53–68. 1986.

Gruyter, W. Jos. de. "M. C. Escher." *Nieuwe Courant* (now *Het Vaderland*) (June 5, 1946): 2.

Ham, Willem van der. "De verloren Eschers." *De Tijd* (23 September, 1988): 54–59.

Hofmeijer, D. H. "The Wonderous World of M. C. Escher." *Circuit* (The Hague) (26 June 1969): 1–7.

Hofstadter, Douglas R. "Mystery, Classicism, Elegance: an Endless Chase After Magic." In *M. C. Escher's Legacy,* ed. D. Schattschneider and M. Emmer, 24–51. 2003.

Hoogewerff, G. J. "M. C. Escher, grafisch kunstenaar." *Elsevier's geïllustreerd maandschrift* 40, deel 82 (1931): 225–235.

Kist, J. R. "Spel van vormen en denkbeelden." *Toeristenkampioen* 11 (1 June 1969): 1.

———. Recollections of M. C. Escher (Mauk) by Mr. B. Kist (Bas), from the preserved letters and materials of B. Kist. In the Roosevelt collection, National Gallery of Art, Washington D. C., 1973.

Krol, Gerrit. "De werelden van M. C. Escher." *Hollands maandblad* (The Hague) 13, no. 290 (January 1972): 8–12.
Translation:
"World Without End: The Work of M. C. Escher." Translated by Michael Hoyle, in *Delta: A Review of Arts, Life and Thought in the Netherlands* 15, no. 2 (Summer 1972).

Locher, G. W. "Structural Sensation." In *The World of M. C. Escher*, ed. J. L. Locher, 41–48. 1972.

Locher, J. L. "The Work of M. C. Escher." In *The World of M. C. Escher*, ed. J. L. Locher, 7–28. 1972.

Loeb, Arthur L. "On my meetings and correspondence between 1960 and 1971 with the graphic artist M. C. Escher." *Leonardo* 15, no. 1 (1982): 23–27.

Loveland, Ronald J. "Graphic Imagery of M. C. Escher." Master's thesis, University of Wyoming, 1967.

MacGillavry, Carolina H. "The Symmetry of M. C. Escher's 'Impossible' Images." *Computers and Mathematics With Applications* 12B (1986): 123–138. In *Symmetry*, ed. István Hargittai, 123–138. 1986.

———. "Hidden Symmetry." In *M. C. Escher: Art and Science*, ed. H. S. M. Coxeter et al, 69–81. 1986.

Maor, Eli. "Maurits C. Escher—Master of the Infinite." In *To Infinity and Beyond*, 164–178. Boston: Birkhäuser, 1987.

Nemerov, Howard. "The Miraculous Transformations of Maurits Cornelis Escher." *Artist's Proof* 3, no. 6 (Fall–Winter 1963–1964): 32–39.

Offerhaus, Johannes. "Escher and Hoogewerff. A Meeting in the Thirties." In *M. C. Escher: Art and Science*, ed. H. S. M. Coxeter et al, 329–337. 1986.

Penrose, Roger. "Escher and the Visual Representation of Mathematical Ideas." In *M. C. Escher: Art and Science*, ed. H. S. M. Coxeter et al, 143–158. 1986.

Platt, Charles. "Expressing the Abstract." *New Worlds* 58, no. 173 (1967): 44–48.

Pott, P. H. "Het 'Verbum' van M. C. Escher." *Thoth, tijdschrift voor vrijmetselaren* 2 (1955): 135–146.

"Prying Dutchman." *Time* (April 2, 1951): 50.

Rigby, J. F. "Butterflies and Snakes." In *M. C. Escher: Art and Science*, ed. H. S. M. Coxeter et al, 211–220. 1986.

Schattschneider, Doris. "M. C. Escher's Classification System for his Colored Periodic Drawings." In *M. C. Escher: Art and Science*, ed. H. S. M. Coxeter et al, 82–96, 391–392. 1986.

———. "The Pólya-Escher connection." *Mathematics Magazine* 60 (1987): 293–298.

———. "Escher: A Mathematician in Spite of Himself." *Structural Topology* 15 (1988): 9–22. Reprinted in *The Lighter Side of Mathematics*, Richard Guy and Robert E. Woodrow, eds., Mathematical Association of America, 1994.

Schrijver, E. "Over het werk van M. C. Escher." *De Delver* (March 1940): 22–23.

Severin, Mark F. "The Dimensional Experiments of M. C. Escher." *Studio* (London) (1951): 50–53.

"Speaking of Pictures." *Life* (May 7, 1951): 8–10.

Teuber, Marianne L. "Sources of Ambiguity in the Prints of Maurits C. Escher." *Scientific American* 231, no. 1 (July 1974): 90–104. See also letter to the editor from George A. Escher, *Scientific American* 232 , no. 1 (January 1975): 8–9, and Teuber's response.

———. "Perceptual Theory and Ambiguity in the Work of M. C. Escher against the Background of 20th Century Art." In *M. C. Escher: Art and Science*, ed. H. S. M. Coxeter et al, 159–178. 1986.

Vermeulen, Jan W. "Ik loop hier moederziel alleen rond." In *Het oneindige*, ed. W. J. van Hoorn et al, 155–171.

Translation:

"I'm Walking Around All by Myself Here." Translated by Karin Ford, in *Escher on Escher*, 139–153.

Wilkie, Ken. "The Wierd World of Escher the Impossible." *Holland Herald* (Amsterdam) 9, no. 1 (1974): 20–43.

MOVIES

Bosdriesz, Jon, Margreet Plukker, and Tony Wilkinson. *The Life and Works of M. C. Escher.* (Also titled *Metamorphose M. C. Escher, 1898–1972.*) Radio Netherlands Television, 1998. Distributed by Acorn Media.

Byrnes, Richard A., and Jomarie Pipolo. *M. C. Escher: Master of Graphic Arts*. New Canaan, Connecticut : Double Diamond, 1998. Distributed by Lucerne Media, Morris Plains, New Jersey.

Doty, Lisa. *Maurits Escher: Painter of Fantasies*. Document Associates, Canadian Broadcasting Corporation, 1968.

Emmer, Michele. *M. C. Escher: Geometries and Impossible Worlds*. Rome: M. Emmer productions, 1996. Distributed by the author.

———. *M. C. Escher: Symmetry and Space*. Rome: M. Emmer productions, 1996. Distributed by the author.

———. *The Fantastic World of M. C. Escher*. Rome: M. Emmer productions, 1996. English edition distributed by Acorn Media (USA) and Springer-Verlag; Japanese edition distributed by Shinko Tsusho Co, Tokyo; French, Italian, and Spanish editions distributed by the author.

Gelder, Han van. *Adventures in Perception*. Dutch Ministry of Foreign Affairs, 1969. Distributed by The Roland Collection of Films and Videos on Art.

Sanborn, John, Perillo, Mary, and Winkler, Dean. *Infinite Escher* (with Sean Ono Lennon). New York: Sony Corp, 1990. Distributed by Electronic Arts Intermix (EAI), New York, NY.

Thomas, Gayle, Jacques Giraldeau, Suzanne Gervais, and François Aubry. *Escher, Van Gogh and Seurat: Art at Play*. National Film Board of Canada, 1999.

Wennekes, Leon. *M. C. Escher revisited in VR valley*. Amersfoort, The Netherlands: Wennekes Multimedia, 1998. (3D computer animation film for the centennial Escher exhibition at the Kunsthal, Rotterdam, The Netherlands, 1998.)

———. *De ultieme Escher VR-ervaring/The ultimate Escher VR-experience*. Amersfoort, The Netherlands: Wennekes Multimedia, 2002. (Virtual Reality (VR) film for the 'Escher in Het Palais' museum, The Hague, The Netherlands.)

CD ROM

Chanowski, Michael M. *Escher Interactive. Exploring the Art of the Infinite*. Dorpsweg, The Netherlands: Eyeware Interactive, 1996. Distributed by Harry N. Abrams and Byron Preiss Multimedia.

4 OTHER SOURCES. THE USE OF M. C. ESCHER'S WORK BY OTHERS. BACKGROUND ON REGULAR DIVISION OF THE PLANE.

Abercrombie, M. L. J. "Foulkes and Escher: Visual Analogues of Some Aspects of Group Analysis." *Group Analysis. International Panel and Correspondence* 2, no. 3 (January 1970).

Bandt, C. "Self-Similar Sets 5. Integer Matrices and Fractal Tilings of R^n." Proceedings of the American Mathematical Society, 112 (1991): 549–562.

Beyer, Jinny. *Designing Tessellations. The Secrets of Interlocking Patterns*. Chicago: Contemporary Books, 1999.

Bigalke, Hans-Günther, and Heinrich Wippermann. *Reguläre Parkettierungen. Mit Anwendungen in Kristallographie, Industrie, Baugewerbe, Design und Kunst*. Mannheim: BI Wissenschaftsverlag, 1994.

Boer, J. H. de. "Opening Address." In *Reactivity of Solids, Proceedings of the 4th International Symposium on the Reactivity of Solids*, ed. J. H. de Boer, 1–6. Amsterdam: Elsevier, 1961.

Bøggild, J. K. "Breeding tessellations." *Mathematics Teaching* 90 (1980): 31–36.

Bogtman, W. *Het ontwerpen van ornamenten op systeem en naar natuurvormen*. Haarlem: 1905.

Bolton, Dr. J. *Het Nederlandse bankbiljet en zijn vormgeving*. Amsterdam: De Nederlandsche Bank, 1987.

Bongartz, K., W. Borho, D. Mertens, and A. Steins. *Farbige Parkette. Mathematische Theorie und Ausführung mit dem Computer*. Basel: Birkhäuser, 1988.

Bourgoin, J. *Les éléments de l'art arabe: trait des entrelacs*. Paris: Firmin-Didot, 1879. Plates republished as *Arabic Geometrical Pattern and Design*. New York: Dover, 1974.

Bradley, A. Day. *The Geometry of Repeating Design and Geometry of Design for High Schools*. New York: Teachers College, Columbia University, 1933.

Brinkman, A. A. A. M. "De symmetrie in het werk van M. C. Escher." *Chemie & Techniek Revue* 21 (1966): 271–273.

Britton, Jill. *Investigating Patterns: Symmetry and Tessellations*. White Plains, N.Y.: Dale Seymour, 2000.

———. "Escher in the Classroom." In *M. C. Escher's Legacy*, ed. D. Schattschneider and M. Emmer, 305–317; additional art on CD Rom. 2003.

Britton, Jill, and Dale Seymour. *Introduction to Tessellations*. Palo Alto: Dale Seymour Publications, 1989.

Brückner, Max. *Vielecke und Vielflache: Theorie und Geschichte*. Leipzig: B. G. Teubner, 1900.

Bunch, Bryan. *Reality's Mirror: Exploring the Mathematics of Symmetry*. New York: Wiley, 1989.

Bushell, Raymond. "Masatoshi: The Last of the Netsuke Artists." *Arts of Asia* (Hong Kong) (July/August 1973).

Caglioti, Giuseppe. "The World of Escher and Physics." In *M. C. Escher: Art and Science*, ed. H. S. M. Coxeter et al, 287–296. 1986.

Calvert, A. F. *The Alhambra*. London: George Philip & Son, 1904.

Calvin, Melvin. *Chemical Evolution*. Eugene, Ore.: Oregon State System of Higher Education, 1961.

Cook, Theodore Andrea. *The Curves of Life*. London: Constable, 1914. Reprint. New York: Dover, 1979.

Coxeter, H. S. M. "Crystal Symmetry and Its Generalizations," (Presidential Address) in "A Symposium on Symmetry." *The Transactions of the Royal Society of Canada* 51, ser. 3, sec. 3 (June 1957): 1–13.

———. *Introduction to Geometry*, 2d ed. New York: Wiley, 1969.

———. "Coloured Symmetry." In *M. C. Escher: Art and Science*, ed. H. S. M. Coxeter et al, 15–33. 1986.

———. "Escher's Lizards." *Structural Topology* no. 15 (1988): 23–30.

———. "The Trigonometry of Escher's Woodcut *Circle Limit III*." In *M. C. Escher's Legacy*, ed. D. Schattschneider and M. Emmer, 297–305. 2003. Revision of "The Trigonometry of Escher's Woodcut 'Circle Limit III.'" *The Mathematical Intelligencer* 18 no.4 (1996): 42–46 and *HyperSpace* 6 no.2 (1997): 53–57.

Critchlow, Keith. *Order in Space*. New York: Viking Press, 1970; Thames and Hudson, 2000.

———. *Islamic Patterns. An Analytical and Cosmological Approach*. New York: Schocken, 1976. Reprint: Inner Traditions, 1999.

Crowe, Donald. "The Mosaic Patterns of H. J. Woods." *Computers and Mathematics With Applications* 12B (1986): 407–411. In *Symmetry*, ed. István Hargittai, 407–411. 1986

Cundy, H. Martyn, and A. P. Rollett. *Mathematical Models*, 2d ed. Oxford: Oxford University Press, 1961.

Davis, Dan. "On a Tiling Scheme from M. C. Escher." *Electronic Journal of Combinatorics* 4, no. 2 (1997): #R23.

Day, Lewis F. *Pattern Design*. London: Batsford, 1903. Reprint: Dover, 2000.

Dixon, Robert. *Mathographics*. Oxford: Basil Blackwell, 1987; Dover, 1991.

Huson, Daniel H. "The generation and classification of k-isohedral tilings of the Euclidean plane, the sphere, and the hyperbolic plane." *Geometrica Dedicata*, 47 (1993) 269–296.

Dolbilin, Nikolai, and Doris Schattschneider. "The Local Theorem For Tilings." In *Quasicrystals and Discrete Geometry*, ed. J. Patera.

Fields Institute Monographs, v. 10, 193–199. Providence, Rhode Island: American Mathematical Society, 1998.

Dress, Andreas W. M. "The 37 Combinatorial Types of Regular 'Heaven and Hell' Patterns in the Euclidean Plane." In *M. C. Escher: Art and Science*, ed. H. S. M. Coxeter et al, 35–46. 1986.

Dress, Andreas W. M., and Daniel Huson. "Heaven and Hell Tilings." *Structural Topology* 17 (1990): 25–42.

Dunham, Douglas J. "Hyperbolic Symmetry." *Computers and Mathematics With Applications* 12B (1986): 139–153. In *Symmetry*, ed. István Hargittai, 139–153. 1986.

———. "Creating Hyperbolic Escher Patterns." In *M. C. Escher: Art and Science*, ed. H. S. M. Coxeter et al, 241–248. 1986.

———. "Families of Escher Patterns." In *M. C. Escher's Legacy*, ed. D. Schattschneider and M. Emmer, 286–296; additional art on CD Rom. 2003.

———. "Creating Repeating Hyperbolic Patterns—Old and New." *Notices of the American Mathematical Society* 50, no. 4 (April 2003): 452–455.

El-Said, Issam, and Ayse Parman. *Geometric Concepts in Islamic Art*. London: World of Islam Festival Publishing Company, 1976.

Emmer, Michele. "Comments on A. L. Loeb's Correspondence with the Graphic Artist M. C. Escher." *Leonardo* 17, no.3 (1984): 1–2.

———. "Movies on M. C. Escher and their Mathematical Appeal." In *M. C. Escher: Art and Science*, ed. H. S. M. Coxeter et al, 249–262. 1986.

———, ed. *Structural Topology*, 15 and 17 (Escher Special). Montreal: University of Montreal, 1988, 1990.

———, ed. *The Visual Mind: Art and Mathematics*. A *Leonardo* Book. Cambridge, Massachusetts: MIT Press, 1993.

———. "Animando Escher." In *Matematica e cultura*, M. Emmer, ed., Milano: Springer Italia, 2004.

Emmer, M. and M. Manaresi, eds. *Mathematics, Art, Technology and Cinema*. Berlin: Springer, 2003.

Engel, Peter. *Geometric Crystallography*. Dordrecht, The Netherlands: Reidel, 1986.

———. "On Monohedral Space Tilings." In *M. C. Escher: Art and Science*, ed. H. S. M. Coxeter et al, 47–52. 1986.

Ernst, Bruno. *Pythagoras Festival*. Groningen, The Netherlands: Wolters-Nordhoff, 1970.

Fathauer, Robert. "Fractal Tilings Based on Kite-and Dart-Shaped Prototiles." *Computers and Graphics*, 25 (2001): 323–331.

———. "Extending Escher's Recognizable-Motif Tilings to Multiple-Solution Tilings and Fractal Tilings." In *M. C. Escher's Legacy*, ed. D. Schattschneider and M. Emmer, 154–165; additional art on CD Rom. 2003.

Fedorov, E. S. "Symmetry in the plane" (in Russian). *Zapiski Rus. Mineralog. Obscestva* ser. 2, 28 (1891): 345–390 + 2 plates.

Friedman, Mildred, ed. *De Stijl: 1917–1931, Visions of Utopia*. Catalog of an exhibition organized by the Walker Art Center. New York: Abbeville, 1982.

Galyarskii, E. I., and A. M. Zamorzaev. "Similarity Symmetry and Antisymmetry Groups" (in Russian). *Kristallografiya* 8 (1963): 691–698. English translation: *Soviet Physics— Crystallography* 8 (1964): 553–558.

Gans, Dr. L. *Nieuwe Kunst: De Nederlandse bijdrage tot de Art Nouveau*. (New Art: The Netherlands' contribution to Art Nouveau.) Utrecht: Oosthoek, 1966.

Gardner, Martin. "Concerning the Diversions in a New Book on Geometry." *Scientific American* 204 (April 1961): 164–175.

————. *The Unexpected Hanging*. New York: Simon and Schuster, 1969. NOW NO SWIMS ON MON, credited to John McClellan, is in "Rotations and reflections," from a 1962 column in *Scientific American*.

————. "Tiling with Polyominoes, Polyiamonds, and Polyhexes." *Scientific American* 233 (August 1975): 112–115. In *Time Travel and Other Mathematical Bewilderments*, 177–187. New York: W. H. Freeman, 1988.

————. "Extraordinary nonperiodic tiling that enriches the theory of tiles." *Scientific American* 236, no. 1 (January 1977): 110–112; 115–121. In *From Penrose Tiles to Trapdoor Ciphers: Essays on Recreational Mathematics*, 1–29. New York: W. H. Freeman, 1989.

————. *The Ambidextrous Universe: Mirror Asymmetry and Time-Reversed Worlds*. New York: Scribners, 1979.

————. *The New Ambidextrous Universe: Symmetry and Asymmetry from Mirror Reflections to Superstrings*. New York: W. H. Freeman, 1990.

Gelbrich, G., and K. Giesche. "Fractal Escher Salamanders and Other Animals." *Mathematical Intelligencer* 20, no. 2 (Spring 1998): 31–35.

Gethner, Ellen. "Computational Aspects of Escher Tilings." PhD thesis in computer science, supervised by David G. Kirkpatrick and Nicholas Pippenger. University of British Columbia, May 2002.

Giftwrap by Artists: M. C. Escher. Introduction by Arlene Raven. New York: Harry N. Abrams, 1987.

Glasser, L. "Teaching Symmetry." *Journal of Chemical Education* 44, no. 9 (September 1967): 502–511.

Gombrich, E. H. "How to Read a Painting." *Saturday Evening Post* (July 29, 1961): 20–21; 64–65. In *Meditations on a Hobby Horse*, 154–159. New York: Phaidon, 1963.

————. *The Sense of Order: A Study in the Psychology of the Decorative Arts*. Ithaca, New York: Cornell University Press, 1979. Second edition: Phaidon Press, 1995.

Gómez, Rafael Pérez, and Manuel Vela Torres, eds. *La Alhambra (Epsilon)*. Granada: Asociación de Profesores de Matemáticas de Andalucía, 1987.

Goodman-Strauss, Chaim. "Compass and Straightedge in the Poincaré Disk." *American Mathematical Monthly* 108 (2001): 38–49

Grafisch ABC. The Netherlands: De Grafische, 1953.

Gregory, Richard L. *The Intelligent Eye*. New York: McGraw-Hill, 1970.

Gregory, Richard L., and E. H. Gombrich. *Illusion in Nature and Art*. New York: Scribners, 1973.

Grünbaum, Branko. "Periodic Ornamentation of the Fabric Plane: Lessons from Peruvian Fabrics." *Symmetry* 1, no. 1 (1990): 45–68.

————. "Levels of Orderliness: Global and Local Symmetry." In *Symmetry 2000*, ed. I. Hargittai and T.C. Laurent, 51–61. London: Portland Press, 2002.

Grünbaum, Branko, and Geoffrey C. Shephard. "Spherical Tilings with Transitivity Properties." In *The Geometric Vein. The Coxeter Festschrift*, ed. C. Davis, B. Grünbaum, and F. A. Sherk, pp. 65–94. New York: Springer-Verlag, 1982.

————. *Tilings and Patterns*. New York: W. H. Freeman, 1987.

Grünbaum, Branko, Zdenka Grünbaum, and G.C. Shephard. "Symmetry in Moorish and Other Ornaments." *Computers and Mathematics With Applications* 12B (1986): 641–653. In *Symmetry*, ed. István Hargittai, 641–653. 1986.

Guilbert, Jean-Claude, ed. *Het fantastisch realisme*. The Hague: Forum-Boekerij, 1973.

Haak, S. "Transformation Geometry and the Artwork of M. C. Escher." *Mathematics Teacher* 69 (1976): 647–652.

Hargittai, István, ed. *Symmetry: Unifying Human Understanding*. New York: Pergamon, 1986.

Heesch, Heinrich. *Reguläres Parkettierungsproblem*. Cologne and Opladen: Westdeucher Verlag, 1968.

Heesch, Heinrich, and Otto Kienzle. *Flächenschluss. System der Formen lückenlos aneinanderschliessender Flachteile*. Berlin: Springer, 1963.

Hofstadter, Douglas. R. *Gödel, Escher, Bach: An Eternal Golden Braid*. New York: Basic Books, 1979; 1999.

————. "Parquet Deformations: Patterns of Tiles That Shift Gradually in One Dimension." *Scientific American* (July 1983): 14–20.

Hollist, J. Taylor. "M. C. Escher's Association with Scientists." In *Bridges: Mathematical Connections in Art, Music, and Sciences*, ed. R. Sarhangi, 45–52. Winfield, Kansas: Southwestern College, 2000.

Holt, Michael. *Mathematics in Art*. New York: Van Nostrand, 1971.

Jones, Owen. *The Grammar of Ornament*. London: Quartich, 1856. Reprint. New York: Van Nostrand, 1972. Reprint plates only. New York: Dover, 1988. CD Rom: Octavo Corp., 1998.

Kaplan, Craig S., and Salesin, David H. "Escherization." In *Proceedings of the 27th International Conference on Computer Graphics and Interactive Techniques (SIGGRAPH)*, 499–510. New York: ACM Press/Addison Wesley, 2000.

Kim, Scott. *Inversions*. New York: BYTE books, 1981. Reprint. New York: W. H. Freeman, 1989. New Edition. *Inversions: A Catalog of Calligraphic Cartwheels*. Emeryville: Key Curriculum Press, 1996.

Klamkin, M. S., and A. Liu. "Simultaneous Generalizations of the Theorems of Ceva and Menelaus." *Mathematics Magazine* 65 (1992) 48–52.

Koptsik, V. A. "A General Sketch of the Development of the Theory of Symmetry and Its Applications in Physical Crystallography over the Last 50 Years" (In Russian). *Kristallografiya* 12 (1967): 755–774. English translation *Soviet Physics—Crystallography* 12 (1968): 667–683.

Lee, Kevin. "Adapting Escher's Rules for 'Regular Division of the Plane' to Create Tesselmania!®." In *M. C. Escher's Legacy*, ed. D. Schattschneider and M. Emmer, 393–407; software on CD Rom. 2003.

Lewis, Donald J. *Introduction to Algebra*. New York: Harper & Row, 1965.

Liu, Y., R. T. Collins, and Y. Tsin ``A Computational Model for Periodic Pattern Perception Based on Frieze and Wallpaper Groups." *IEEE Transactions on Pattern Analysis and Machine Intelligence* 26, no.3 (2004): 354-371.

Loeb, Arthur L. *Color and Symmetry*. New York: Wiley-Interscience, 1971; Krieger 1978.

The M. C. Escher Jigsaw Puzzle Book. New York: Harry N. Abrams, 1996.

MacMahon, P. A. *New Mathematical Pastimes*. London: Cambridge University Press, 1921.

Mabry, Rick, Stan Wagon, and Doris Schattschneider. "Automating Escher's Combinatorial Patterns." *Mathematica in Education and Research* 5, no. 4 (1996–97): 38–52.

Mandelbrot, B. B. *The Fractal Geometry of Nature*. New York: W.H. Freeman, 1982.

The Mathematics Teacher 67, no. 4 (1974). Special issue on tessellations.

McClure, Mark. "Digraph Self-Similar Sets and Aperiodic Tilings." *Mathematical Intelligencer,* 24, no. 2 (2002): 33–42.

Moser, Koloman. *Die Quelle.* Vienna and Leipzig: M. Gerlach, 1901–1902.

Müller, Edith A. *Gruppentheoretische und Strukturanalytische Untersuchungen der Maurischen Ornamente aus der Alhambra in Granada.* Inaugural-dissertation, University of Zürich. Rüschlikon, Switzerland: Baublatt, 1944. Escher visited Dr. Müller in 1948 in Zurich to find out more about her thesis and told her why and how he came to make his graphic works with regular divisions of the plane.

Nakamura, Makoto. "New Expressions in Tessellating Art: Layered Three-Dimensional Tessellations." In *M. C. Escher's Legacy,* ed. D. Schattschneider and M. Emmer, 207–214; additional art on CD Rom. 2003.

Nebehay, Christian M. *Ver Sacrum, 1898–1903.* New York: Rizzoli, 1977.

Norman, J., and S. Stahl. *The Mathematics of Islamic Art. A Packet for Teachers of Mathematics, Social Studies, and Art.* New York: Metropolitan Museum of Art, 1979.

O'Daffer, P. G., and S. R. Clemens. *Geometry: An Investigative Approach.* Menlo Park, Cal.: Addison-Wesley, 1976; 2nd ed. 1992.

Osborn, John. "Amphography, the Art of Figurative Tiling." *Leonardo* 26 (1993): 289–291.

Passiouras, Steve, J. Joseph Fowler, and Ellen Gethner. "Counting Escher's Ribbon Patterns." To appear.

Penrose, Roger. "Pentaplexity: A Class of Non-Periodic Tilings of the Plane." *Eureka* 39 (1978): 16–32. Reprinted in *The Mathematical Intellelligencer,* 2 (1979/80): 32–37.

———. *Gamebirds* and *Perplexing Poultry.* (Puzzles.) Brighouse, United Kingdom: Pentaplex, 1995. Extended review of these puzzles by Doris Schattschneider in *SIAM News* 28, no. 6 (July 1995): 8, 14.

Pólya, George. Unpublished papers (includes notes and sketches). Stanford University Archives.

Racinet, Auguste. *L'ornement polychrome.* Paris: Firmin-Didot, 1869–1873 (ser. 1); 1885–1887 (ser. 2). Reprint of plates only. *Racinet's Historic Ornament in Full Color* (ser. 1) and *Auguste Racinet: Full-Color Picture Sourcebook of Historic Ornament* (ser. 2). New York: Dover, 1988, 1989.

Raedschelders, Peter. "Tilings and Other Unusual Escher-Related Prints." In *M. C. Escher's Legacy,* ed. D. Schattschneider and M. Emmer, 230–243; additional art on CD Rom. 2003.

———. "Semimagic tilings based on an asymmetrical tile." *Geombinatorics* X, no. 1 (July 2000): 45–50.

Ranucci E. R., and J. L. Teeters. *Creating Escher-Type Drawings.* Palo Alto, Cal.: Creative Publications, 1977.

Reuter, Pam G. *De tekens van de dierenriem. (The Signs of the Zodiac).* Limited edition of 500 copies. The Netherlands: De Grafische, 1963.

Rice, Marjorie. "Escher-Like Patterns from Pentagonal Tilings." In *M. C. Escher's Legacy,* ed. D. Schattschneider and M. Emmer, 244–251; additional art on CD Rom. 2003.

Rigby, J. F. "Napoleon, Escher, and Tessellations." *Mathematics Magazine* 64 (1991): 242–246 and *Structural Topology* 17 (1991): 17–23.

———. "Escher, Napoleon, Fermat and the Nine-point Centre." In *M. C. Escher's Legacy,* ed. D. Schattschneider and M. Emmer, 420–426. 2003.

Rival, Ivan. "Picture Puzzling. Mathematicians Are Rediscovering the Power of Pictorial Reasoning." *The Sciences*, January / February 1987: 41–46.

Roelofs, Rinus. "Not the Tiles, But the Joints: A Little Bridge Between M. C. Escher and Leonardo Da Vinci." In *M. C. Escher's Legacy,* ed. D. Schattschneider and M. Emmer, 252–264; additional art on CD Rom. 2003.

Ros, J. D. *Het ontwerpen van Vlakornament.* Rotterdam: 1905.

Rosenqvist, I. Th., "The Influence of Physico-Chemical Factors upon the Mechanical Properties of Clays." *Norwegian Geotechnical Instutute (Oslo) Publication* 54 (1963): 1–10.

Schattschneider, Doris. "The Plane Symmetry Groups: Their Recognition and Notation." *American Mathematical Monthly* 85 (1978): 439–450.

———. "Tiling the Plane with Congruent Pentagons." *Mathematics Magazine* 51 (1978): 29–44.

———. "Will it tile? Try the Conway Criterion!" *Mathematics Magazine* 53 (1980): 224–233.

———. "In Praise of Amateurs." In *The Mathematical Gardner*, D. Klarner, ed., Boston: Prindle, Weber & Schmidt, 1981, pp. 140–166. Book reprinted as *Mathematical Recreations: A Collection in Honor of Martin Gardner.* Mineloa, NY: Dover, 1998.

———. "In Black and White: How to Create Perfectly Colored Symmetric Patterns." *Computers and Mathematics With Applications* 12B (1986): 673–695. In *Symmetry*, ed. István Hargittai. 1986.

———. "Escher's Metaphors: The Prints and Drawings of M. C. Escher Give Expression to Abstract Concepts of Mathematics and Science." *Scientific American* 271, no. 5 (November 1994): 66–71.

———. "Escher's Combinatorial Patterns." *The Electronic Journal of Combinatorics* 4, no. 2 (1997): #R17.

———. "The Many Faces of Symmetry in the Work of M. C. Escher." In *Symmetry 2000*, ed. I. Hargittai and T.C. Laurent, 173–184. London: Portland Press, 2002.

Schattschneider, Doris, and Nikolai Dolbilin. "One Corona is Enough for the Euclidean Plane." In *Quasicrystals and Discrete Geometry,* ed. J. Patera. Fields Institute Monographs, v. 10, 207–246. Providence, Rhode Island: American Mathematical Society, 1998.

Schattschneider, Doris, and Wallace Walker. *M. C. Escher Kaleidocycles.* New York: Ballantine, 1977. New editions. Corte Madera, Cal.: Pomegranate Artbooks, 1987 and Berlin: Taschen, 1987.

Schouten, J. F. "Waan, waarneming en werkelijkheid." *Akademiedagen* 15 (1963): 13–17.

Schwartzenberger, R. L. E. "Colour Symmetry." *Bulletin of the London Mathematical Society* 16 (1984): 209–240.

Seherr-Thoss, Sonia P. and Hans C. *Design and Color in Islamic Architecture: Afghanistan, Iran, Turkey.* Washington: Smithsonian Institution Press, 1968.

Seltz, Peter, and Mildred Constantine, eds. *Art Nouveau: Art and Design at the Turn of the Century.* New York: Museum of Modern Art, 1975.

Senechal, Marjorie. "Color Groups." *Discrete Applied Mathematics* 1 (1979): 51–73.

———. "Geometry and Crystal Symmetry." *Computers and Mathematics with Applications* 12B, nos. 3/4 (1986): 565–578. In *Symmetry*, ed. István Hargittai, 565–578. 1986.

———. "Escher Designs on Surfaces." In *M. C. Escher: Art and Science,* ed. H. S. M. Coxeter et al, 97–110. 1986.

———. "Color Symmetry." *Computers and Mathematics With Applications* 16, nos.5–8 (1988): 545–553.

———. "The Algebraic Escher." *Structural Topology* 15 (1988): 31–42.

Senechal, Marjorie, and George M. Fleck, eds. *Patterns of Symmetry.* Amherst: University of Massachussets Press, 1977.

Shephard, Geoffrey. C. "What Escher Might Have Done." In *M. C. Escher: Art and Science*, ed. H. S. M. Coxeter et al, 111–122. 1986.

———. "Super and Superb Colourings of Tilings." *Structural Topology* 15 (1988): 43–74.

Shubnikov, A. V. "Symmetry of Similarity" (in Russian). *Kristallografiya* 5 (1960): 489–496. English translation *Soviet Physics—Crystallography* 5 (1961): 469–476.

Shubnikov, A. V., and N. V. Belov. *Colored Symmetry.* Oxford: Pergamon Press, 1964.

Shubnikov, A. V., and V. A. Koptsik. *Symmetry in Science and Art.* Translated from the Russian by G. D. Archard and edited by D. Harker. New York: Plenum, 1974.

Singh, Gary. "If Escher Had a Computer." *IEEE Computer Graphics & Applications* 22, no. 3 (May 2002): 4–5.

Smit, B. de, and H. W. Lenstra, Jr. "The Mathematical Structure of Escher's Print Gallery." *Notices of the American Mathematical Society* 50, no. 4 (April 2003): 446–451.

Speiser, Andreas. *Die Theorie der Gruppen von Endlicher Ordnung.* Berlin: Springer, 1927.

Stevens, Peter S. *Handbook of Regular Patterns: An Introduction to Symmetry in Two Dimensions.* Cambridge: MIT Press, 1980.

Talbot, Jonathan. "Seals Two" (lithograph). *New Jersey Music and Arts* (October 1973).

Terpstra, P. *Introduction to the Space Groups.* Groningen: J. B. Wolters, 1955.

———. *Some Notes on the Mathematical Background of Repetitive Patterns.* London: Oldbourne, 1961.

Thé, Eric, illustrator. *The M. C. Escher Coloring Book.* New York: Harry N. Abrams, 1995.

Thompson, D'Arcy Wentworth. *On Growth and Form.* New York: Macmillan, 1942. The complete revised edition: Dover, 1992.

Varnedoe, Kirk. *Vienna 1900: Art, Architecture and Design.* New York: Museum of Modern Art, 1986.

Vince, Andrew. "Replicating Tessellations." *SIAM J. Discrete Mathematics* 6 (1993): 501–521.

Vulihman, Valentin. "Escher-like Tessellations on Spherical Models." In *M. C. Escher's Legacy*, ed. D. Schattschneider and M. Emmer, 442–447; additional art on CD Rom. 2003.

Wade, David. *Pattern in Islamic Art.* Woodstock, New York: Overlook, 1976.

Wagenaar, J. W. "The Importance of the Relationship 'Figure and Ground' in Fast Traffic." *Ophthalmologica* 124, no. 5 (November 1952): 310–315.

Washburn, Dorothy K., and Donald W. Crowe. *Symmetries of Culture: Theory and Practice of Plane Pattern Analysis.* Seattle: University of Washington Press, 1988.

Weyl, Herman. *Symmetry.* Princeton: Princeton University Press, 1952. Reprint ed. 1983.

Whitehead, Edward P. "Symmetry in Protein Structure and Function." In *M. C. Escher: Art and Science*, ed. H. S. M. Coxeter et al, 297–304. 1986.

Wieting, Thomas W. *The Mathematical Theory of Chromatic Plane Ornaments.* New York: Marcel Dekker, 1982.

Woods, H. J. "Counterchange Symmetry in Plane Patterns." *Journal of the Textile Institute* (Manchester) 27 (1936): T305–T320.

Yang, Chen Ning. *Elementary Particles. A Short History of Some Discoveries in Atomic Physics.* Princeton: Princeton University Press, 1962.

———. "Symmetry Principles in Physics." *The Physics Teacher* 5, no. 7 (October 1967): 311–315.

Zusne, Leonard. *Visual Perception of Form.* New York: Academic, 1970.

5 SELECTED WEB SITES

Appel, Rüdiger. *Metamorphose: a Java applet scroller.* http://www.3quarks.com/Applets/Metamorphose/index.html

Britton, Jill. *Symmetry and Tessellations.* http://ccins.camosun.bc.ca/~jbritton/jbsymteslk.htm

Crompton, Andrew. Original tessellations by Crompton and many others. http://www.cromp.com/tess

Emmer, Michele. *The Leonardo Gallery: Homage to Escher.* http://mitpress2.mit.edu/e-journals/Leonardo/gallery/gallery331/homageescher.html

M. C. Escher Foundation and Cordon Art B.V. *The Official M. C. Escher Web Site.* http://www.mcescher.com/

Escher in the Palace museum, The Hague, The Netherlands. http://www.escherinhetpaleis.nl

Fathauer, Robert. *Dr. Fathauer's Encyclopedia of Fractal Tilings.* http://members.cox.net/fractalenc/encyclopedia.html

Hardaker, Wes, and Gervais Chapuis. *Escher Web Sketch.* http://www-sphys.unil.ch/escher/

Kuiper, Hans. *Spiegelkunstenaar (MIRROR ARTIST).* http://web.inter.nl.net/hcc/Hans.Kuiper/domususa.htm

Lenstra, Hendrik and Bart de Smit. *Escher and the Droste effect: Applying mathematics to Escher's "Print Gallery."* http://escherdroste.math.leidenuniv.nl/

Mathematics and Art. 2003 Mathematics Awareness Month Resources. http://mathforum.org/mam/03

Math Forum. Search for Math on the words "Escher tessellation." http://mathforum.org

Nakamura, Makoto. *Tessellating Animation.* http://www18.big.or.jp/~mnaka/home.index.html

National Gallery of Art, Washington, D.C. *Tour: M. C. Escher—Life and Work.* http://www.nga.gov/collection/gallery/ggescher/ggescher-main1.html. *The M. C. Escher Collection.* http://www.nga.gov/cgi-bin/psearch?Request=S&Hname=Escher&Person=201590

National Gallery of Canada. *M. C. Escher Mindscapes.* http://cybermuse.gallery.ca/cybermuse/youth/escher/index_e.jsp

Nicolaides, Kimon. *The Esteemed M. C. Escher.* http://www.herring.org/escher.html

Passiouras, Steve. *Escher Tiles.* http://www.eschertiles.com/

Roelofs, Rinus. http://www.rinusroelofs.nl

Schattschneider, Doris. *Catalog of Isohedral Tilings by Symmetric Tiles.* http://mathforum.org/dynamic/one-corona/

Totally Tessellated. http://www.abc.lv/thinkquest/tq-entries/16661/

Ziring, Neal. *M. C. Escher Pages.* http://users.erols.com/ziring/escher.htm

Indexes

INDEX TO PERIODIC DRAWINGS AND RELATED WORK

Escher's periodic drawings reproduced in Chapter 3 are listed here by number (bold type). Following each drawing number, page references are as follows: *reproduction of the drawing, illustrations of Escher' related work;* mention of the drawing in the text; *notes on the drawing.*

INDEX TO GRAPHIC WORKS

Escher's numbered drawings used in graphic works are listed immediately after the title and Bool catalog number of each graphic work. The page on which a graphic work is reproduced is given in *italic type* and pages on which the work is mentioned in the text are given in roman type.

GENERAL INDEX

Pages containing illustrations are given in italics. Graphic works and numbered periodic drawings reproduced in the book are not listed in this index. Graphic works are listed by title in the Index to Graphic Works, page 367. Drawings shown in Chapter 3 are listed by motif in the Index to Drawings by Motif, page 365, and are listed by number in the Index to Periodic Drawings and Related Work, page 366.